DRAWING MAMALS

WITHDRAWN

-1970 Broad Street • East Petersburg, PA 17520 • www.carvingworld.com
LIBRARY
ST. LOUIS COMMUNITY COLLEGE

AT FLORISSANT VALLEY

DRAWING MAINS

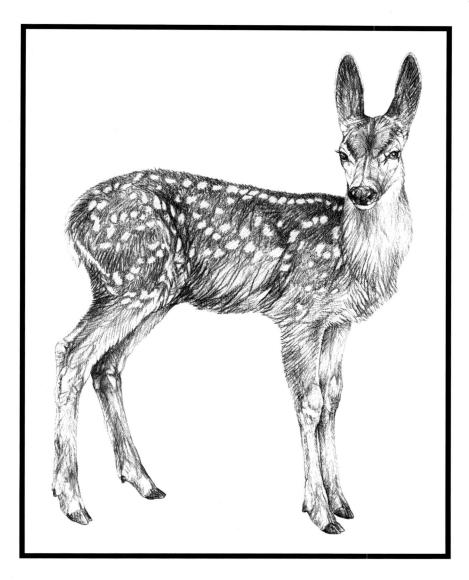

by Doug Lindstrand

Dedicated, with love, to my sisters: JoAnn, Joyce, and Karen.

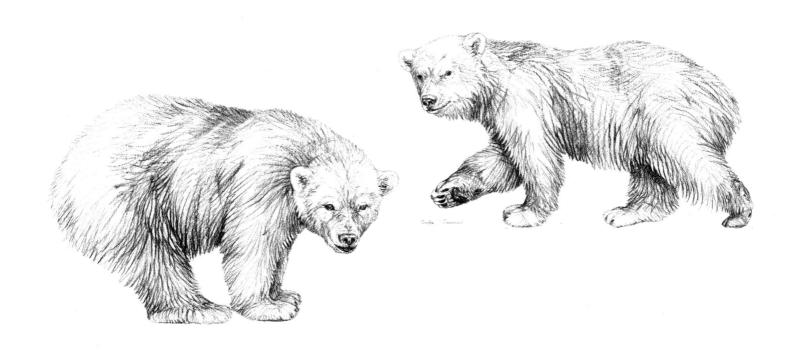

Copyright ©1999 by Douglas W. Lindstrand This book, Drawing Mammals, may not be reproduced in whole or in part, by mimeograph, photo process, any electronic or mechanical device, or by any other means, without permission from the publisher.

Library of Congress Catalog Card Number 99–94353 ISBN 1-56523-141-4 First printing: May 1999 Second printing: October 2000

To order your copy of this book, please send check or money order for the cover price plus \$3.00 shipping to: Fox Chapel Publishing Company Inc. Book Orders
1970 Broad Street
East Petersburg, PA 17520

Or visit our website at www.carvingworld.com

Manufactured in Korea

Other Doug Lindstrand Books: Alaska Sketchbook, 200 pages, ISBN 1-56523-142-2 Drawing America's Wildlife, 216 pages, ISBN 0-9608290-6-7 Drawing Big Game, ISBN 1-56523-140-6

INDEX

BEAR FAMILY (Ursidae)	P. 22-49
Black	
Brown (Grizzly)	
Polar	
CANINE FAMILY (Canidae)	P. 50-64
Coyote	
Gray Wolf	
CAT FAMILY (Felidae)	P. 65-73
Mountain Lion	
PRONGHORN FAMILY (Antilocapridae)	P. 74-83
Pronghorn	
WILD CATTLE FAMILY (Bovidae)	P. 84-136
Bison	
Mountain Goat	
Muskox	
Sheep (Mt. bighorn, Desert bighorn, Dall, Stone)	
DEER FAMILY (Cervidae)	P. 137-207
Caribou (Barren-ground, Woodland)	
Deer (Blacktail, Mule, Whitetail)	
Elk (Rocky mountain, Roosevelt)	
Moose	

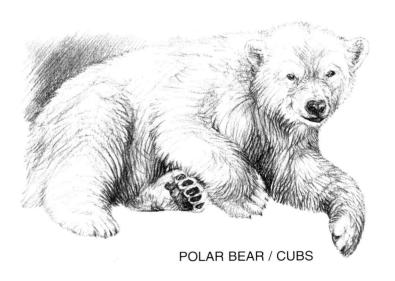

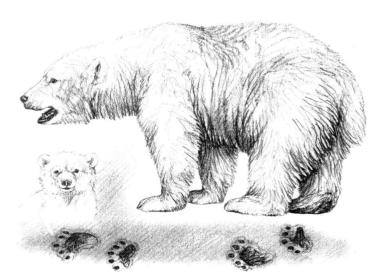

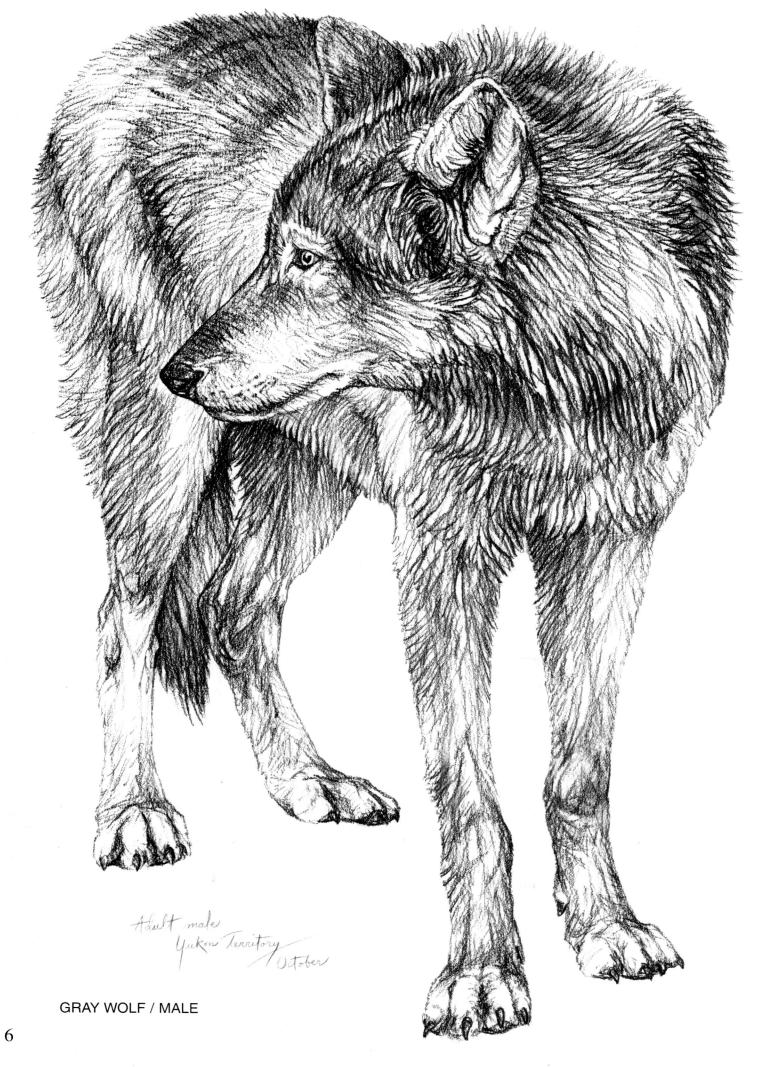

FORWARD

The goal of this book is to portray twenty "favorite" North American mammals in various poses, ages, and seasons. The artist drew the animals dimensions as accurately as possible, and by adding photographs and biological text, hopes his endeavor will be helpful to other artists, carvers, etc.

So then, from the noble Gray wolf of the Yukon Territory to the tiny Key deer of Florida, the "reference guide" titled "DRAWING MAMMALS" by Doug Lindstrand.

SOURDOUGH STUDIO

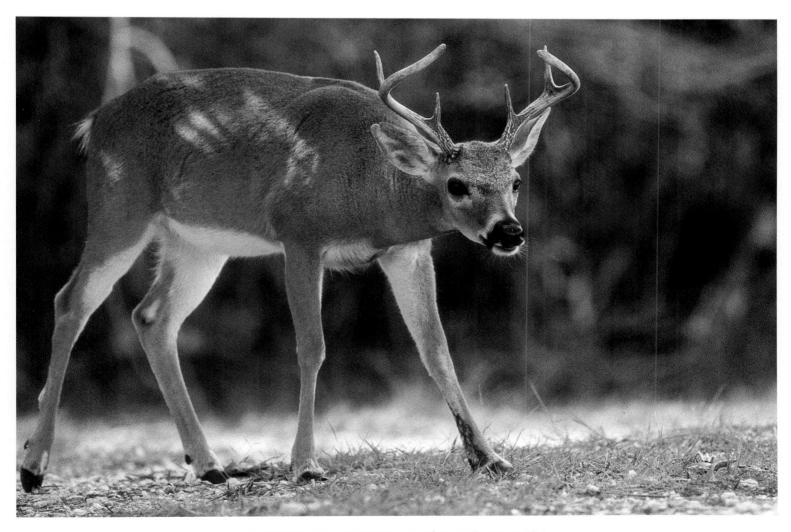

FLORIDA "KEY" DEER / BUCK (NOVEMBER)

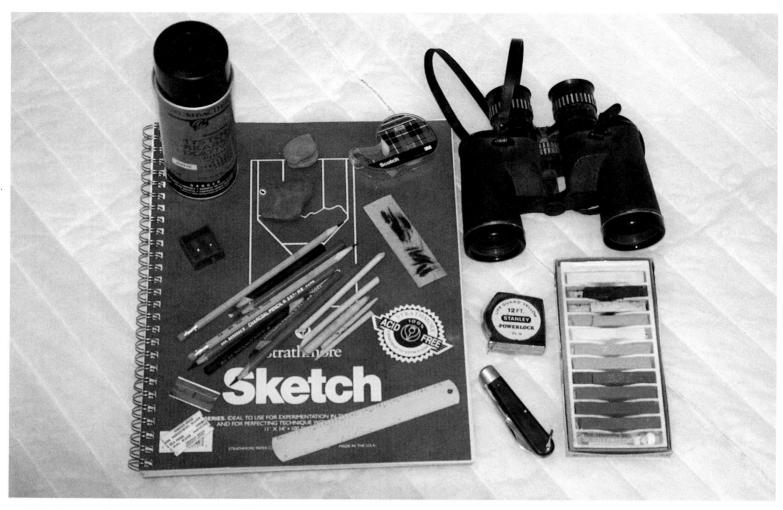

This is my field-pack contents: sketchbook, pencils (my "favorite" is HB charcoal), French stumps, sharpening tools, kneaded erasers, spray fixative, tape, rulers, pastels, and binoculars.

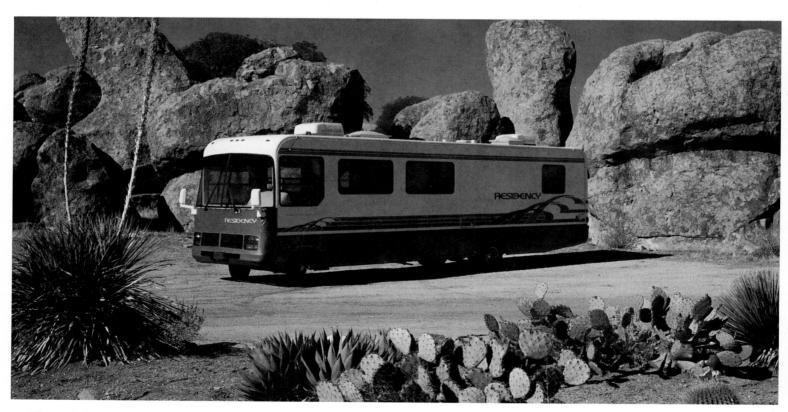

The artist's "roving studio". A motorhome/camper makes a great "base camp". From these comfortable headquarters you can make daily (or longer) treks afield. Then, upon return, have a place to resupply, draw, sleep and shower. Naturally, when your treks keep you away overnight, it is smart to either park in a secure area or have someone keep-an-eye on it for you.

INTRODUCTION

Drawing, to me, is one of the basic tools of an artist's foundation. From a limited mastering of this medium, one can better pursue all other artistic endeavors; from painting to sculpting. One only has to look back in history to men such as Michelangelo, da Vinci, and Picasso to fully appreciate how their drawing talents enabled them to ultimately produce artwork that, after all these years, still touches and inspires us all. The magnificent ceilings of the Sistine chapel; the mysterious "Mona Lisa"; and the controversial "Guernica", all probably started with a few scribbles on a scrap of paper. The pencil, then, is to an artist what a hammer is to a carpenter. A useful and necessary tool. How far you wish to pursue "building your house" of drawing skills will be a personal choice, but to some of us it has become a preferred medium with which to portray our subjects. You can, believe it or not, actually make a "living" chasing wild animals around the woods with pencil and paper in hand.

This "Drawing Mammals" book is a portfolio of charcoal drawings, notes, and photographs that were compiled via my travels around North America. It was an exciting project, a true "adventure". Canada, Mexico, and the United States are truly wondrous lands filled with magnificent wildlife. I hope you too will someday take the time and effort to explore and appreciate North America for yourselves. In fact, I hereby ASSIGN IT as "homework" to all artists. After all, obtaining original reference material is a MUST for any person who hopes to sell their artwork or make art a career choice. There is no substitute for being in the field with your quarry. Then, once you have acquired this knowledge and material via your observations, photographs, notes and field-sketches, you can confidently and accurately portray the animal back at your studio. With a little hard work, I'm sure your "masterpieces" will ultimately hang next to da Vinci's "Mona Lisa" at the Louvre in Paris. (Well, artists are always being accused of being "dreamers", right? Might as well dream big!) Seriously, I sincerely hope you find fun and satisfaction with your drawing and that, if you so desire, find a market for your creations. We are living in an era where wildlife and wilderness is appreciated, and more and more people are choosing scenes of wildlife and wilderness to decorate their homes and businesses. It is a way, perhaps, of bringing the tranquil sense of nature into our hearts and minds. Historically, there has never been a time when nature artists and photographers were more in demand.

So then, if you want to become fabulously rich in the new millennium, become a lawyer, CEO, or computer programmer. If, however, you want to be relatively poor but have a FUN career, become an artist.

ARTIST'S COMMENTS

I've always had an interest in art and in wildlife, and knew that I would someday seek and find a job that involved one or both of these. Being a wildlife artist seems to "fill these shoes" nicely.

In 1970, after an art degree from college and a short stint as a commercial artist, I decided to travel to either Australia or Alaska and free-lance. Since Alaska seemed somewhat closer to my Minnesota home (and Mom's famous blueberry pie), I chose that destination. I left my Corvette convertible with my sister to sell, bought a 4WD Bronco, and headed for the "Last Frontier". Thirty years later I'm still here. This magnificent, awesome country is my "home" now. Alaska is truly a nature lovers paradise. (Where else would one routinely see moose and bears walking down Main street?) Here an artist could never run out of inspiration or subject matter.

Of course,I do occasionally take trips "outside" to pursue other wildlife to sketch, study and photograph. My last major trek was an eight month motorhome journey crisscrossing America from Alaska to Florida. This trip was necessary to find certain birds and mammals that I needed more reference on, and allowed me to finish a recent "Drawing America's Wildlife" book and also to obtain some material needed for this "Drawing Mammals" book. And although I also paint wildlife, this book will be done exclusively with charcoal pencils.

Naturally, we all have our personal "favorite" critters, but I chose the twenty large mammals that I seem to see most often in wildlife art and which can probably be called artists favorites. These animals include both prey and predator and vary in environment from the caribou of the frozen Alaskan tundra to the desert bighorns of the arid Arizona mountains. I have attempted to portray these selected mammals as accurately as possible, and to show them in various positions, ages and gender. I also drew them in various seasons; showing the moose, for instance, in different stages of antler growth.

As for actual drawing instruction, I'd prefer to leave that to each artist to discover for themselves, and to the dozens of art books which may be useful to beginners wishing to learn more about composition, perspective, etc. "Drawing Mammals" is not intended as a "how to" manual, but will include a few pages of personal tips on drawing and photography. Its purpose, instead, was my hope that it might be a useful addition to studio libraries of other artists, carvers, etc. A "reference guide" of sorts. Also, I have purposely omitted backgrounds and habitats on these illustrations. This helps to portray the mammal more clearly (especially paws, hooves, etc.) to the viewer.

FIELD-SKETCH TO FINAL DRAWING

**The following is an example of how I'll turn a field-sketch or doodle into a final drawing. I use field-sketching to capture an idea, pose, or "essence" of something in nature. I seldom do much detail in the field, preferring my studio for that. Also, to better illustrate these "steps", I transferred the transparent paper "refinements" to regular paper in order to photograph it for this book.

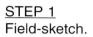

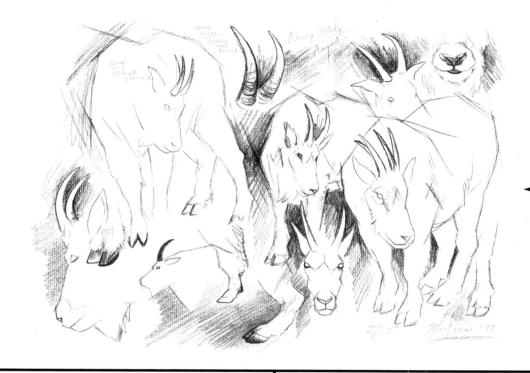

Selected image.

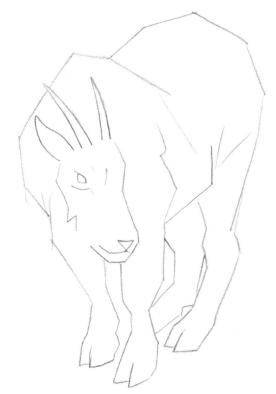

STEP 2

Lay transparent paper over your field-sketch and trace the main lines. Then lay another sheet of transparent paper over the first and continue this "refining" until the dimensions are suitable.

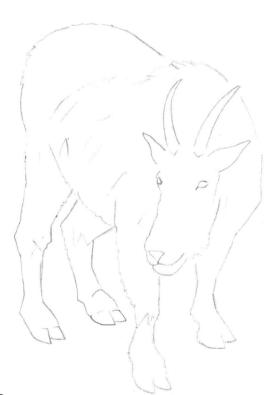

STEP 3

Flip over your "final" refinement and pencil along the main lines. Then flip it back over, position it on the drawing paper or illustration board, and then "rub" the lines in order to transfer the image.

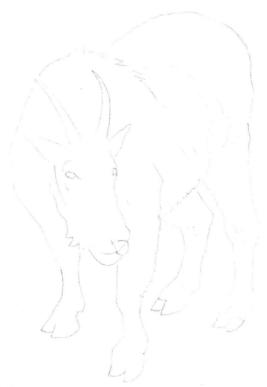

STEP 4

You now have the outline of your animal transferred. You may have to slightly darken the transfer lines before beginning. After that, it's just a matter of filling in between-the-lines. Of course, surrounding you, will be your library of reference material (books, photos, field-sketches, etc.) to help if needed.

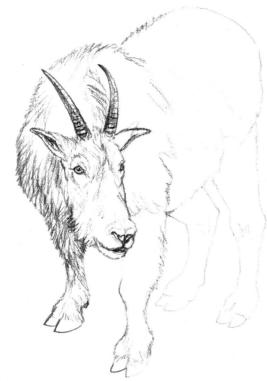

STEP 5

Being right handed, I begin my drawings at the left side in order to prevent smudging. I save putting in the darkest tones until the drawing is basically done. It's best to evaluate the entire drawing before choosing where to add the blackest blacks. Making these "steps" a part of your routine should help make your finished art more saleable; because you have done most of your "correcting" prior to reaching your illustration board or paper.

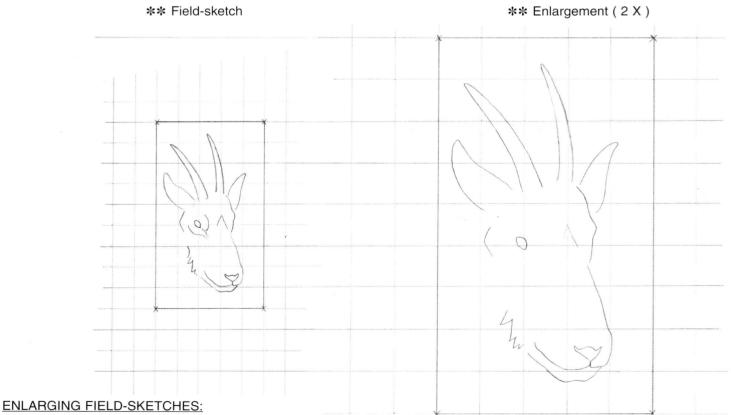

Usually you'll have to enlarge or reduce your field-sketches, and employing a grid of reference points should help guide you. (Naturally, the two grids must be proportional to one another.) This can be done at any stage prior to transferring the final refinement to your illustration board or paper. I, personally, normally make one refinement to help "shape the animal" prior to enlarging/reducing.

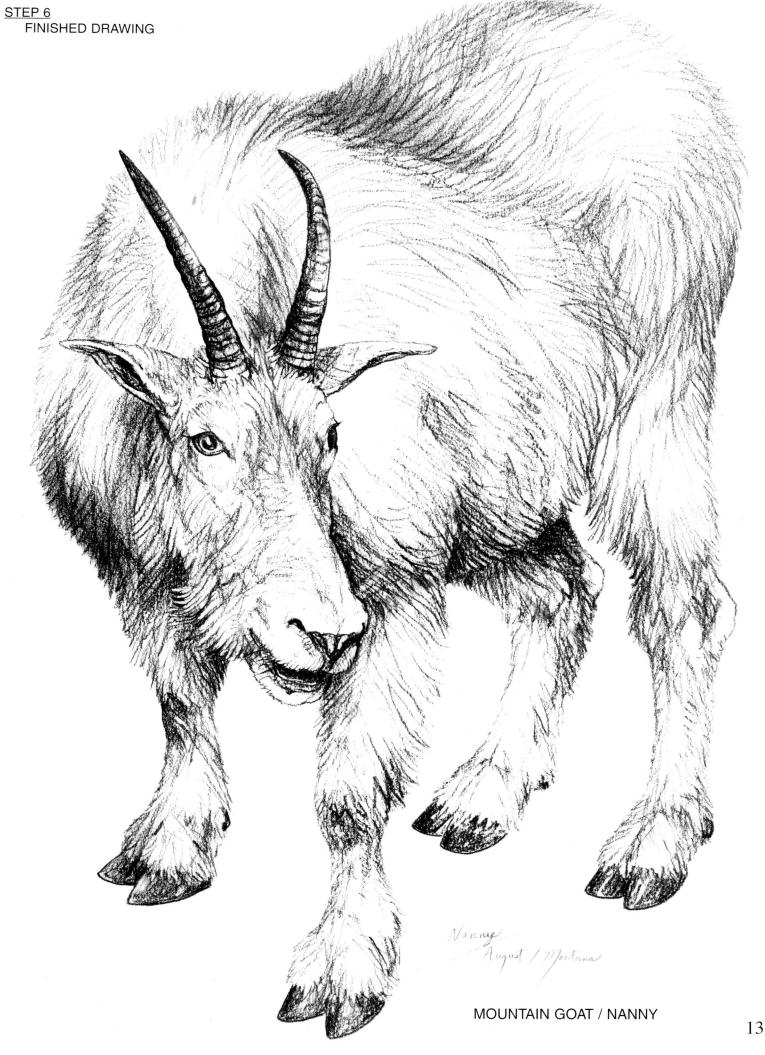

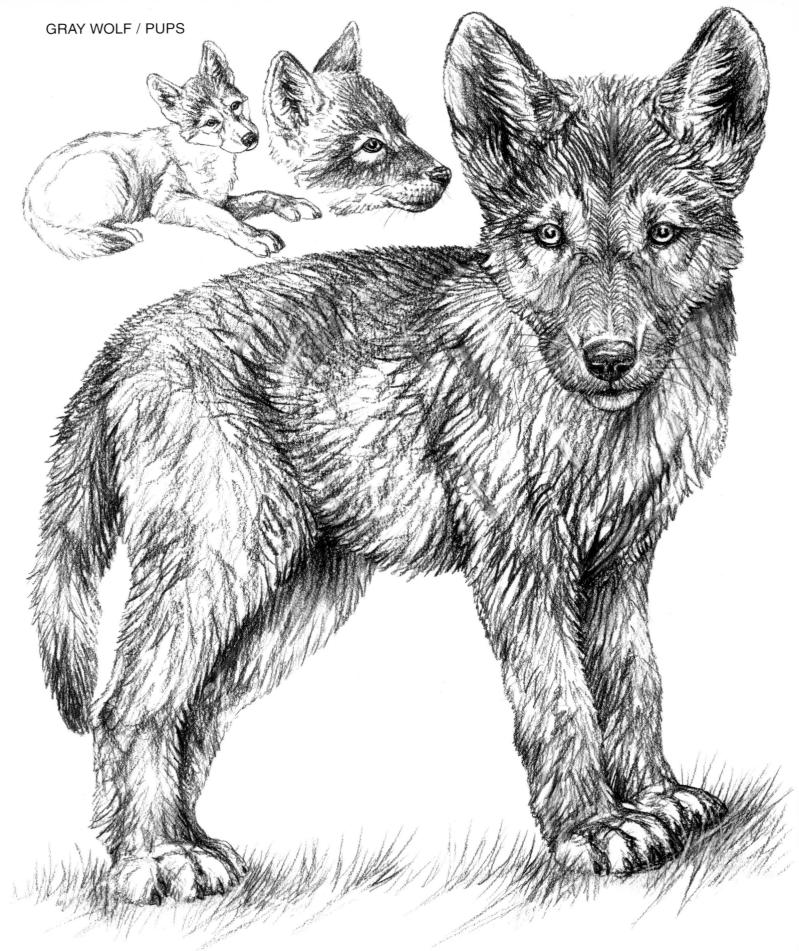

** I added this drawing to show that even though I follow a routine of "steps" to refine my field-sketches (prior to transferring the outline to my illustration board), sometimes they still "go bad". This wolf pup's head is too big! Even though I realized it sooner, I finished the drawing to illustrate the point. Once you realize that a drawing has "gone bad", don't waste time trying to "rescue" it. Scrap it, make your corrections, and begin anew.

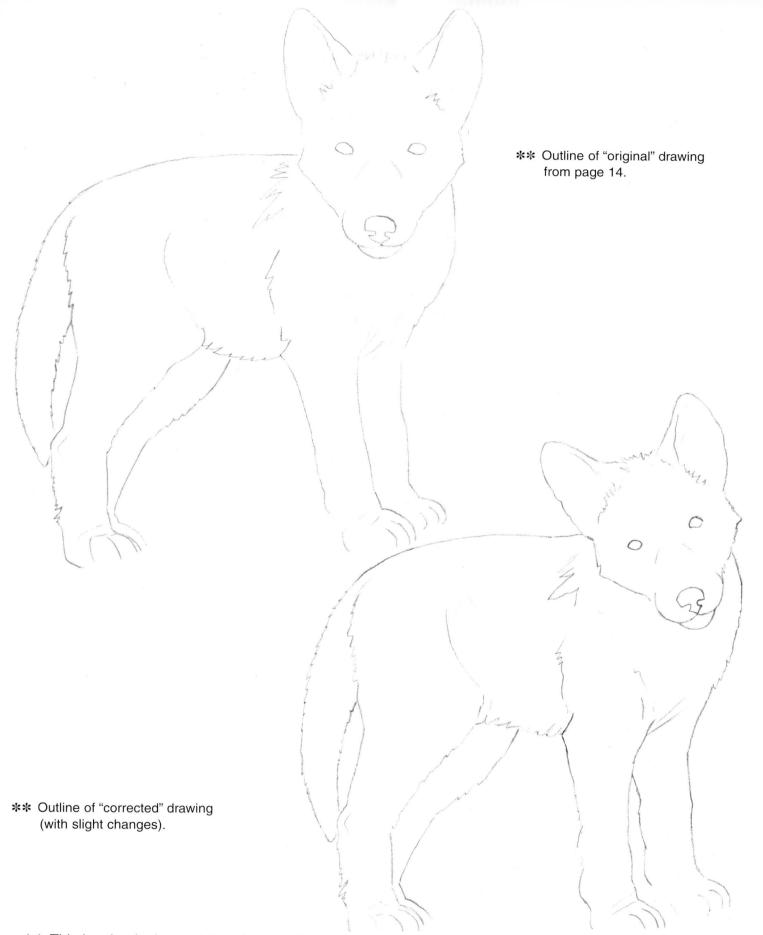

** This is a beginning revision of the wolf pup. I reduced the head about 10%. Since I had a finished drawing to "play with", I made a copy on a copy machine, and then made other copies in various reductions. After cutting-and-pasting, I found a head size that fit the body. Nowadays all sorts of "tools" can be used to aid and simplify your artwork. This cutting-and-pasting (via a "5¢-a-copy" copy machine) was an effective and time-saving substitute to my normal "grid" enlarging / reducing method.

PHOTOGRAPHING WILDLIFE

Cameras have certainly become a valuable and useful aid to wildlife artists nowadays. No longer does one have to go afield and kill an animal in order to obtain the knowledge necessary to illustrate it. Today "shoot" also refers to taking pictures, whereas yesteryears artists truly had to shoot or trap wildlife in order to collect hide and skin specimens for their reference. The photograph is, by far, a superior replacement to a dead animal. Of course, it can be argued that because of the camera, artists must now strive to "match" these striking photographs by producing artwork that is more and more detailed and accurate. Defining "what is art?" is surely outside the scope of this book, but this illustrates how things (including wildlife art) are continuously evolving. Just as the Wright brothers probably never envisioned the 737, so John James Audubon surely never envisioned the beauty, accuracy, and detail of paintings by present day artists such as Carl Brenders and Roger Tory Peterson. So then, how each individual artist chooses to use photographs to assist their creativity is up to them, and whether one thinks of their own creations as "illustrations" or as "art", is also up to them. The term "wildlife art" is different things to different people. Now, however, our goal is to get the photographs needed to give us these choices.

We'll begin with the equipment. Any sort of camera can aid you, but unless you have a very tame or cooperative animal (such as in zoos, or pets, etc.), you will probably want a 35mm SLR (single lense reflex) camera fronted with a telephoto lense. My experience has taught me to prefer a "major" brand camera versus the "bargain" brands. Also, I prefer "zoom" lenses, because they allow one to adjust the telephoto power to fit the situation. Since animals "refuse to sit still", it is handy to be able to adjust the power versus constantly changing lenses. Believe me, most times you'll seemingly have only a split-second to "shoot" the animal. If you're fumbling with changing lenses, forget it, that suckers gone! In my field-pack I carry two favorite lenses; a 70-210mm and a 75-300mm, each on a separate camera body. For very distant or dangerous animals, however, you may desire a more powerful "fixed" lens. I carry a 600mm fixed lens that I often use for bears, Mountain lions, etc. This allows me to not harass the creature or needlessly put myself in a dangerous position. Still, things happen, and over the years I have been charged by grizzlies, moose, and elk; snarled at by wolves and coyotes; hissed at by various cats; and glared at with distain by bands of Bighorns. As I age, I find myself preferring longer-and-longer lenses to photograph my quarry with. I do, after all, only have nine lives, and can easily count the demise of seven or eight.

When I firstly arrived in Alaska, I lived alone at remote cabins for a few years in order to study wildlife and also to practice and improve my drawing skills. Here, in this wilderness, animals were unaccustomed to seeing humans. One Spring, upon flying in to a lakeside cabin, I saw a pack of wolves at what later proved to be a denning site. It was about 5 miles from my cabin and most everyday (after cutting my mandatory ration of wood and hauling lake water) I would hike there to sit and observe them. After a few days they became aware of me and their leisurely behavior and interaction changed. I continued my visits and was able to slowly approach closer and closer. Although the pack did reluctantly accept me, I had surely intruded and caused them to act unnaturally. I would never do that again. Now, with added maturity, I realize that I am trespassing in the "homes" of these noble and magnificent creatures, and therefore feel duly obligated to give them the space and respect they truly deserve. Also, I want my "ninth life" to go on for another fifty years. . .

Now that we've got our camera and lenses, we'll also need film and a good tripod. When shopping for a tripod, look for one that is light but sturdy. Also make sure it doesn't take a "rocket scientist" to operate. Remember that "split-second" you have, as mentioned previously. As for film, here you may wish to experiment a little with different brands and speeds. Find one that matches your needs. In theory, the more powerful your lenses, the faster the film you must use. Higher speed films tend to not have the same quality as slower speed films, but it allows one to "shoot" in poorer light (such as dusk and dawn); times when the animals are active, Also, whether you use print or slide film will be a personal choice. Magazine editors usually prefer slides, but print film is more "forgiving" regarding exposure. Kodak and Fuji are both excellent films and I personally carry 100 ASA to 400 ASA slide film.

So, now that you have all your camera gear, you can stuff it into a comfortable backpack and take off. But then, where does one go? You go to where the animals are; you go to the National parks of Canada, Mexico, and the United States. This is where you are most likely to get near enough to wildlife to sketch and photograph it without it instantly flying or bounding away. Since these creatures are not hunted and have become accustomed to people and vehicles, these wilderness parks are "heaven" to those of us seeking wildlife. Be cautious, however, as these seemingly tame and cuddly critters are still wild animals, and can prove dangerous under various circumstances. Be especially wary around mothers with newborns; predators who are feeding or protecting a kill; and keep a safe distance from large mammals during the Autumn mating season. These are all potentially dangerous situations that could cost you your life. No photo or sketch is worth that! Whereas the National parks of North America are the source of most of my reference photographs (and field sketches), I also obtain them from everywhere else too. State parks, backyard gardens and bird feeders, zoos,

museums, and even taxidermy shops. Plus, since I live in Alaska, something wild will surely waddle down Main street soon. You too will find your sources, all it takes is a little searching, time, and patience. After thirty-some years in the "business", I could surely write a very, very large book on where NOT to go and of what NOT to do. Unfortunately, the limitations of this book precludes that.

So, I'll end with these final thoughts. In order for you to excel as the unique, gifted wildlife artist you surely are, you'll firstly need to acquire the reference material necessary. To do this, you must venture afield. You'll surely experience days of rain, blizzards, bugs and wet socks, but you'll cherish your outdoor experiences with the animals. Imagine yourself camped on the shores of a wilderness lake, cooking up a freshly caught trout over a campfire. Overhead, a majestic Golden eagle soars past hillsides painted with the yellows and oranges of Autumn and glides up and over mountain ridges teeming with scampering snow-white Dall lambs. And, imagine that tomorrow at dawns first light, you'll crawl out of your soft, warm sleeping bag and climb to these same ridges to sit amongst ripened wild blueberries as these fearless and trusting lambs play around you. Now those wet socks don't feel so bad, do they?

Remember, computer programming or this. . .

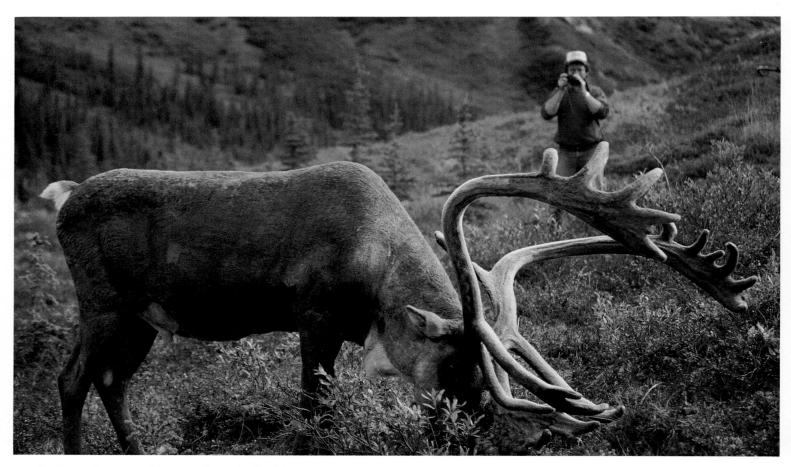

Author photographing caribou bull. When photographing wildlife, you will sense when you are intruding into an animals "space". If they appear nervous or agitated, slowly back-off. In this photo, the lone bull came towards us because we had positioned ourselves overlooking a likely trail.

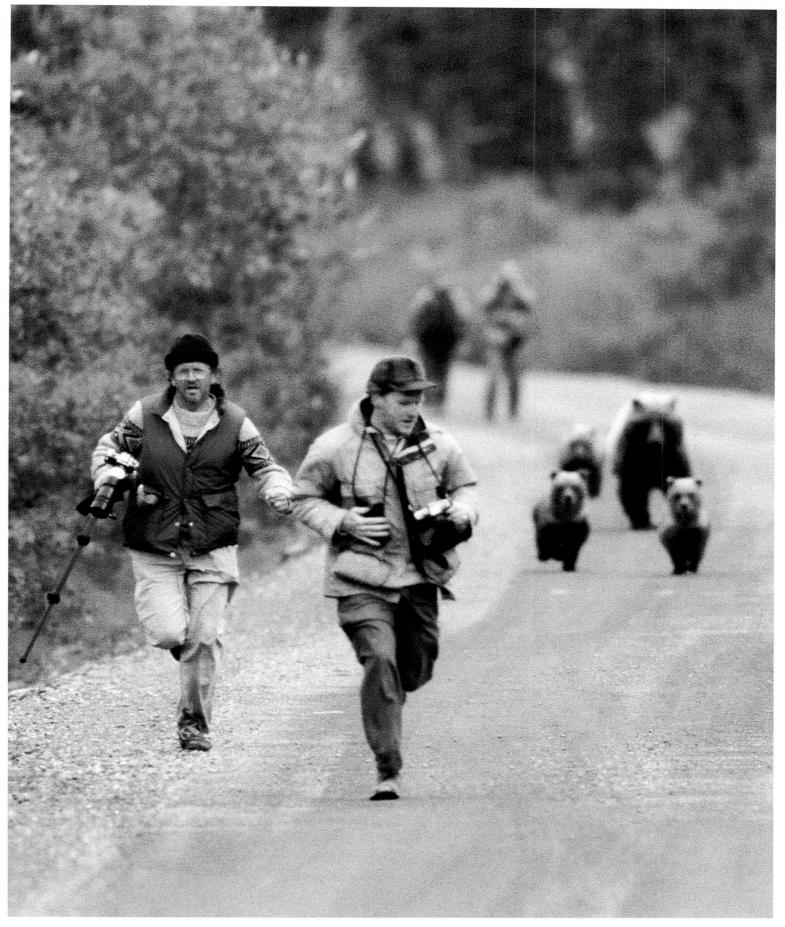

Here is a situation where a grizzly sow and cubs came out of the brush and split-up a group of hikers walking down the road in Denali National Park. When the two hikers started running, the grizzlies gave chase, and probably would've attacked the hikers had they not reached my vehicle up the road. So, unless you have a safe escape, NEVER RUN AWAY from a predator! It will "trigger" their instinct to chase their prey.

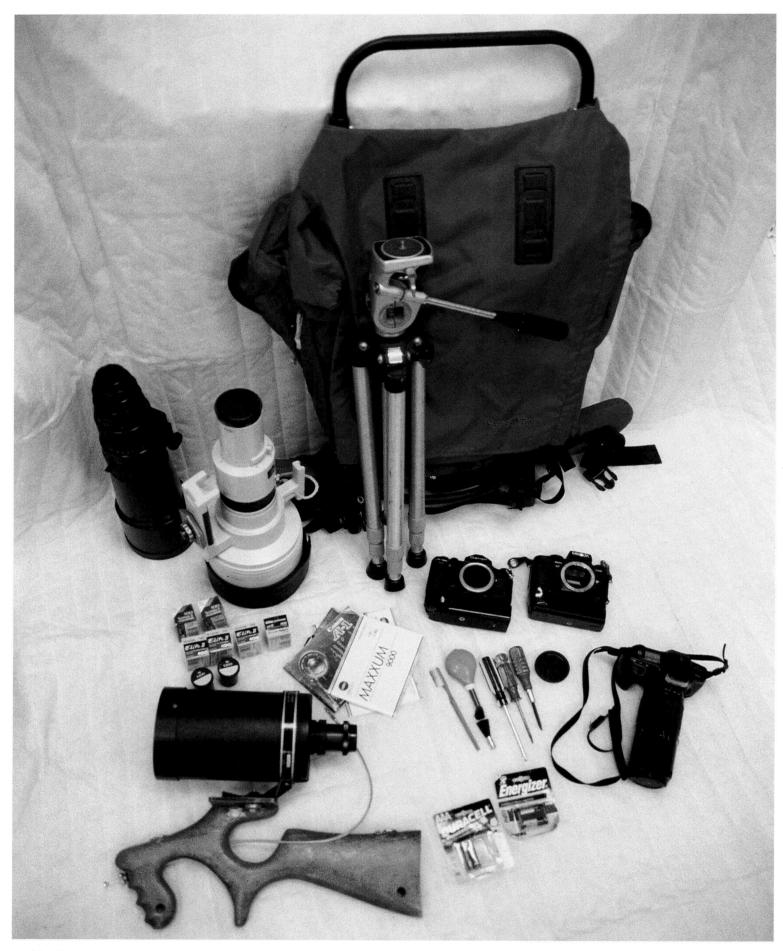

You'll need a variety of equipment to photograph animals with. Pack your chosen gear into a comfortable pack. ALWAYS bring extra batteries and film. Nothing is more frustrating than being a million-miles-from-nowhere and running out of something.

TWENTY "FAVORITE" MAMMALS

BLACK BEAR

The Black bear (Ursus americanus) is the most abundant and widely dispersed of the three species of North American bears. States like Washington and Oregon have sizeable populations, while states like Nevada and Missouri have few. Their color ranges from the white Kermode bear of British Columbia to the more common cinnamon or black coated bears that roam elsewhere. The Yakutat area of Alaska has a small number of "blue" colored (or "glacier") Blacks. Also, many of the dark colored bears have a patch of white on their chests.

Black bears are the smallest of North America's bears. They are also the only bear here that can climb a tree as an adult. Males are larger than females and an adult "boar" is 39" - 40" at the shoulder and 50" - 75" from nose to tail. Weights vary widely, but 200 - 400#'s is the normal range. Black bears are distinguished from Brown bears by their straight facial profile, no shoulder "hump", and sharply curved claws.

Mating occurs from June through July and cubs are born in a den about seven months later. When the female (sow) emerges from her hibernation den in the Spring, she'll have one to four (5#) cubs at her side, and they'll nurse until winters hibernation comes again. In the wild a Black bear will live for about 15 years.

Black bears are creatures of opportunity regarding food. Although vegetation is their main food, they also are efficient predators and scavengers. Their scavenging "habits" are what usually brings them into conflict with humans. Where available, salmon and berries are an important source of nutrition.

Although no wild animal should be fed (except possibly in specific spots and for specific animals: example, the elk of Jackson Hole, Wyoming), bears especially should not be fed. Because of their unpredictable behavior, fed-bears often become dead-bears.

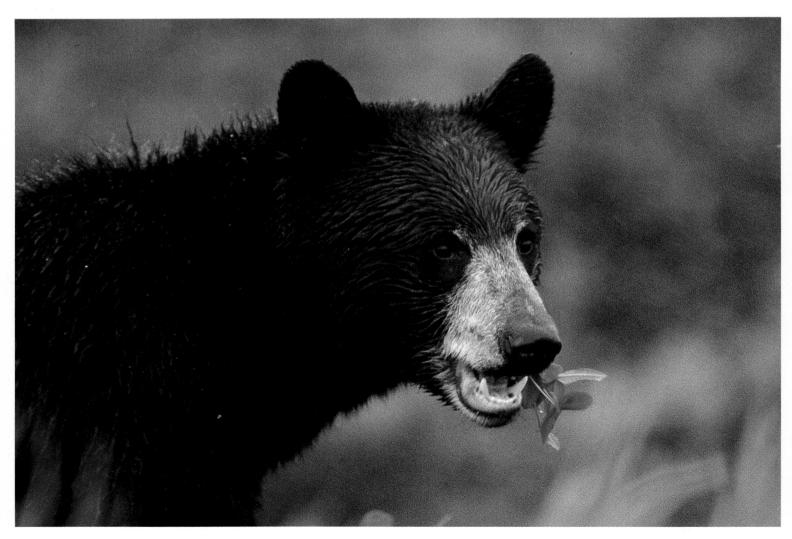

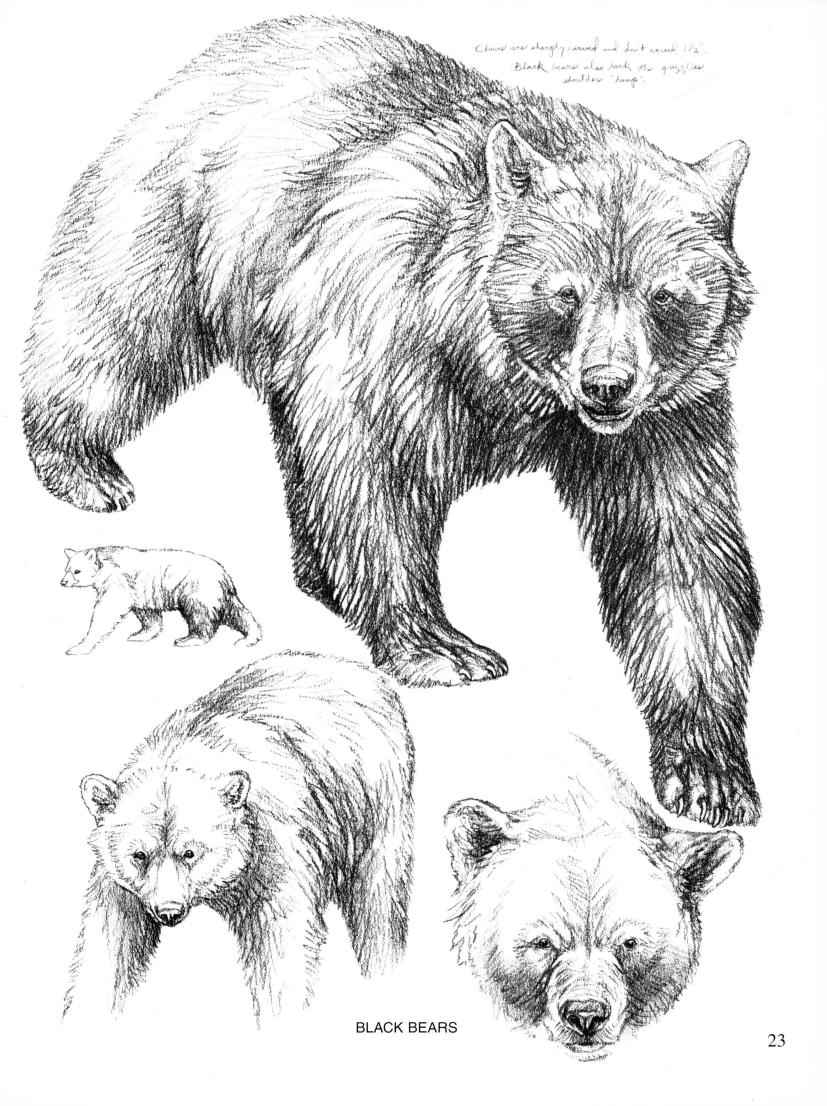

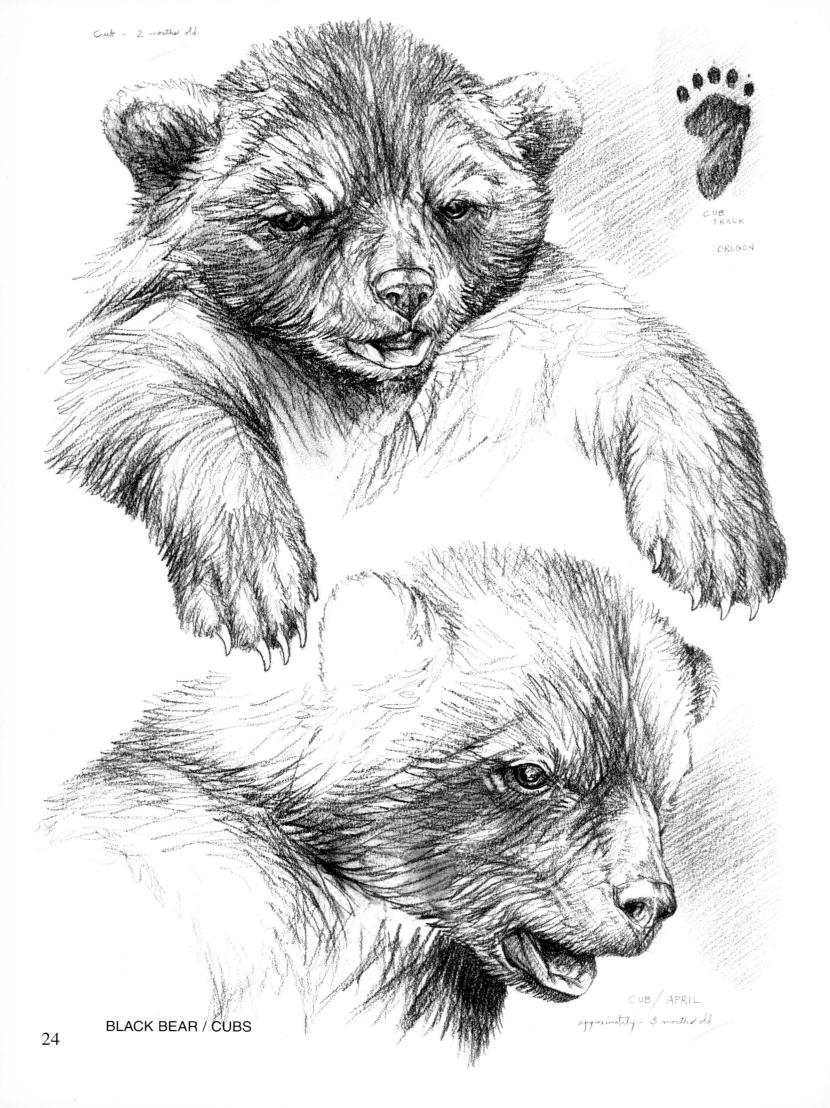

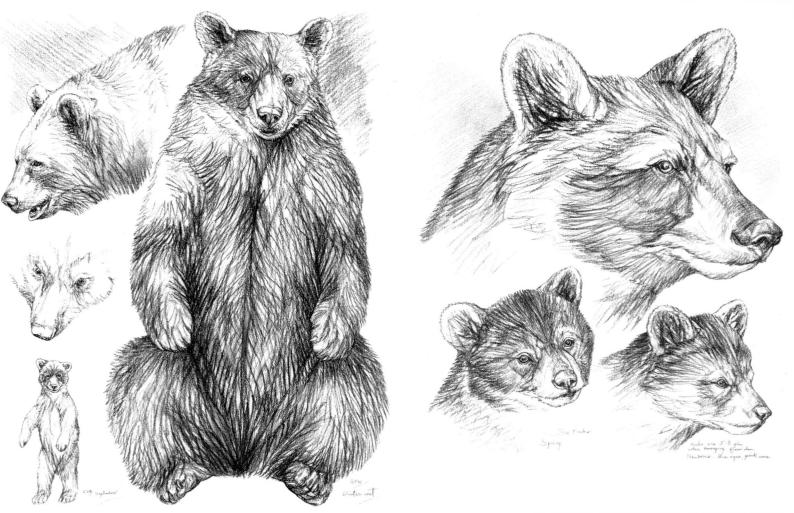

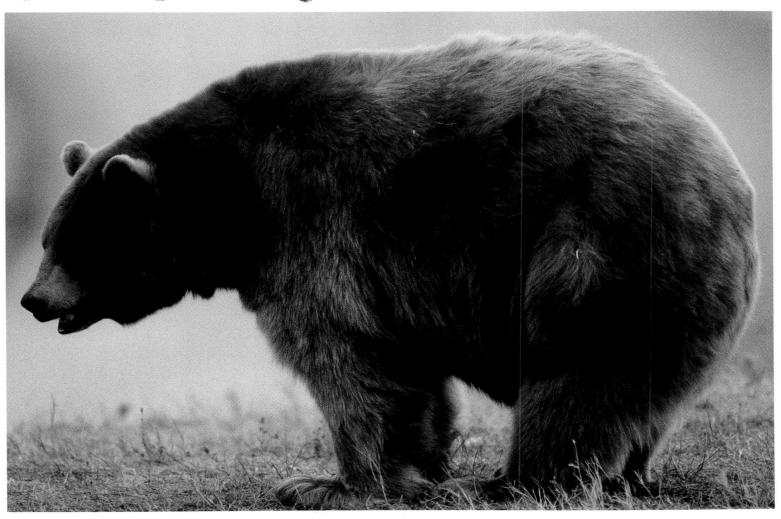

BLACK BEAR / BOAR (AUGUST)

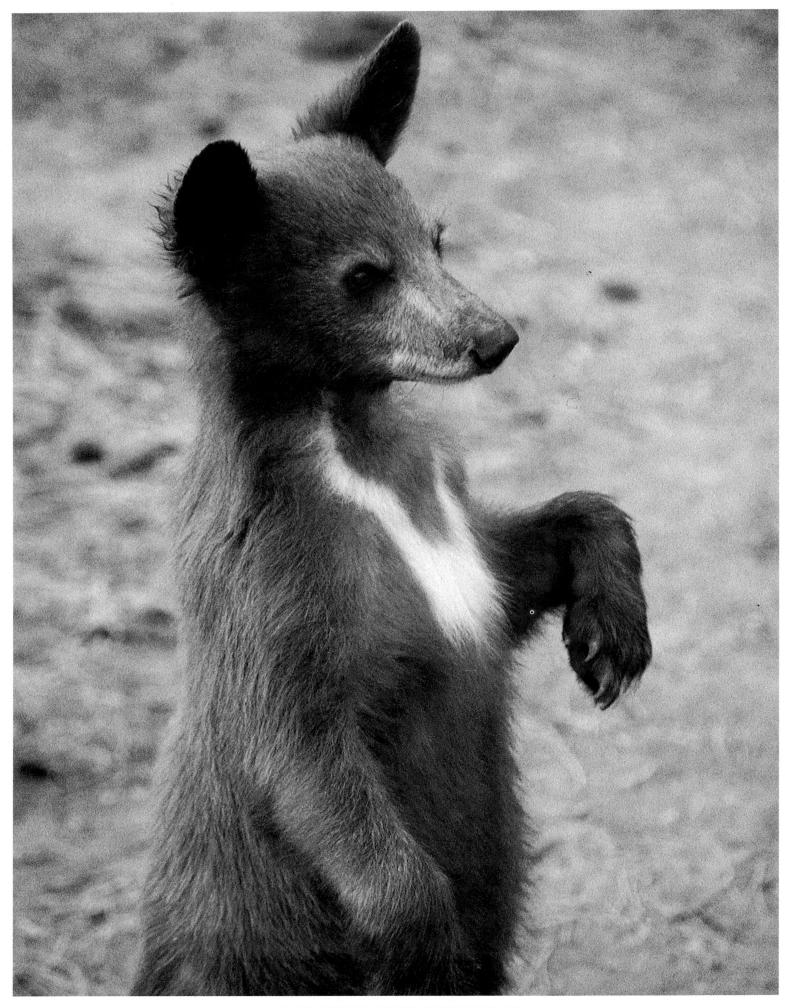

BLACK BEAR / CUB (SEPTEMBER)

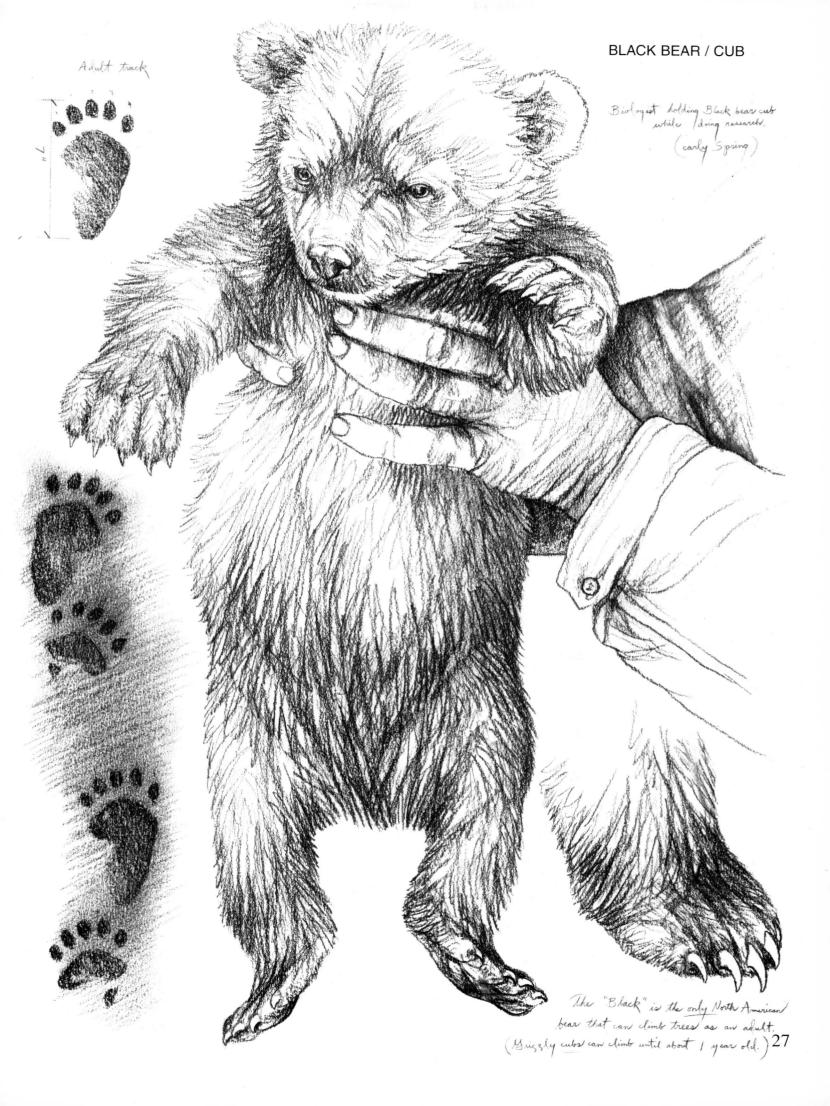

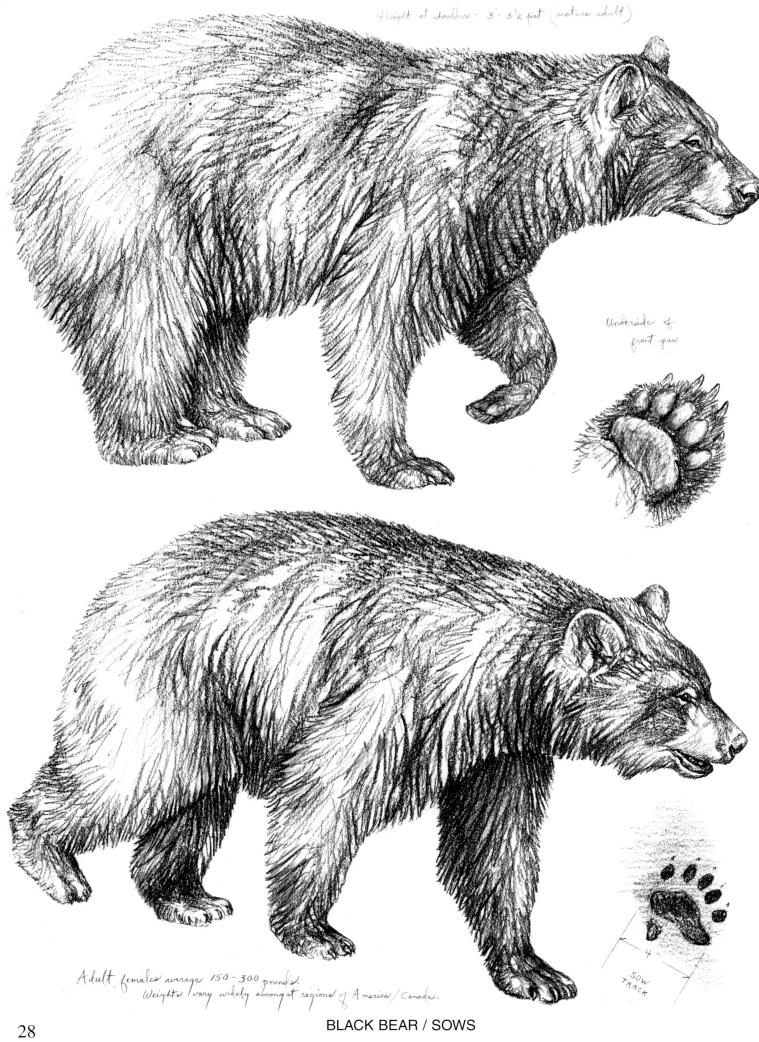

BROWN / GRIZZLY BEAR

The Brown/Grizzly bear (Ursus arctos) is a close relative of the Black bear, but is larger, has less noticeable ears, a more pronounced shoulder "hump", straighter claws, and a somewhat concave facial profile. "Brown" is used to refer to coastal area bears, whereas "grizzly" is used to refer to inland area bears. (Taxonomists do consider the Kodiak Island Brown bear as a distinct subspecie.) The Brown/Grizzly is a threatened/ endangered animal outside of Alaska and Canada. Montana, Wyoming and Idaho are about the only states south of the border that have meaningful populations. When human populations headed West, the "feared" beast was destroyed at every encounter until only a few now survive outside Alaska and Canada. Despite his phenomenal strength and courage, the "King" could not compete against the rifle.

Brown/Grizzlies colors range from light blond to dark brown. Males are larger than females and a mature Brown "boar" (after "fattening up" on salmon prior to denning) will often weigh over 1000 pounds. And although very large males can weigh 1500 pounds, the more average range is 500 - 800#'s. (Females (sows) weigh one-half to three-quarters as much.) Mature males are about 48" high at the shoulder and 60" - 80" from nose to tail. When standing on their hind feet, they measure about 8 feet tall.

Mating occurs from May through July and cubs (commonly two, and weighing about 1 pound) are born in the females winter den the following January/February. The cubs will often den with their mother for two winters before separating to establish their own territories. In the wild, a male will normally live about 20 years and the females about 25 years. Captive bears have lived over 45 years. The more northern bears often hibernate for over 6 months each year, while those living further south (such as Kodiak Island) may only hibernate for short periods of cold weather or food shortage. Pregnant females, of course, do den.

Brown/Grizzly bears are considered the most dangerous and unpredictable of all North American bears, so always use caution when hiking or photographing in grizzly country. Making noise and traveling in groups is the best protection against surprising one. Of course, when photographing, use long lenses. Especially keep a safe distance between you and sows with cubs; mating bears; and bears on a kill. Brown/Grizzlies are very aggressive and will attack if surprised or approached during any of these situations.

Brown/Grizzly bears are omnivorous and feed on anything from roots to insects to mammals. It is an efficient predator and often feeds on newborns, such as fawns and calves. Also, its phenomenal sense of smell enables it to detect carrion from miles away. During the summer's salmon-runs, the normally solitary creatures are often seen sharing streams with dozens of others, and take time from gorging to socialize and play-fight.

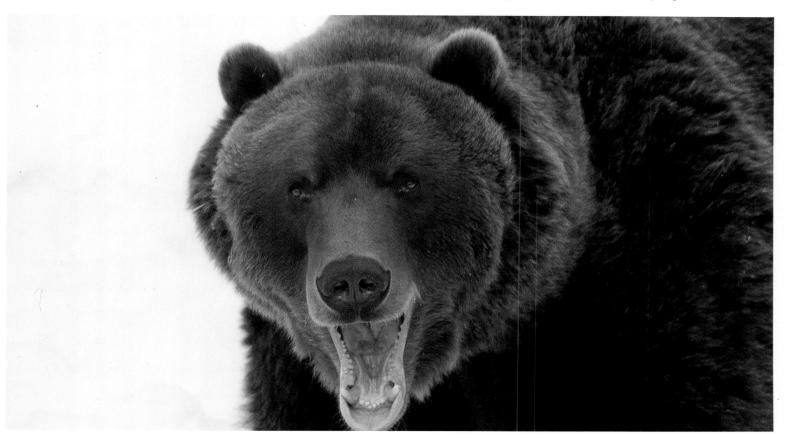

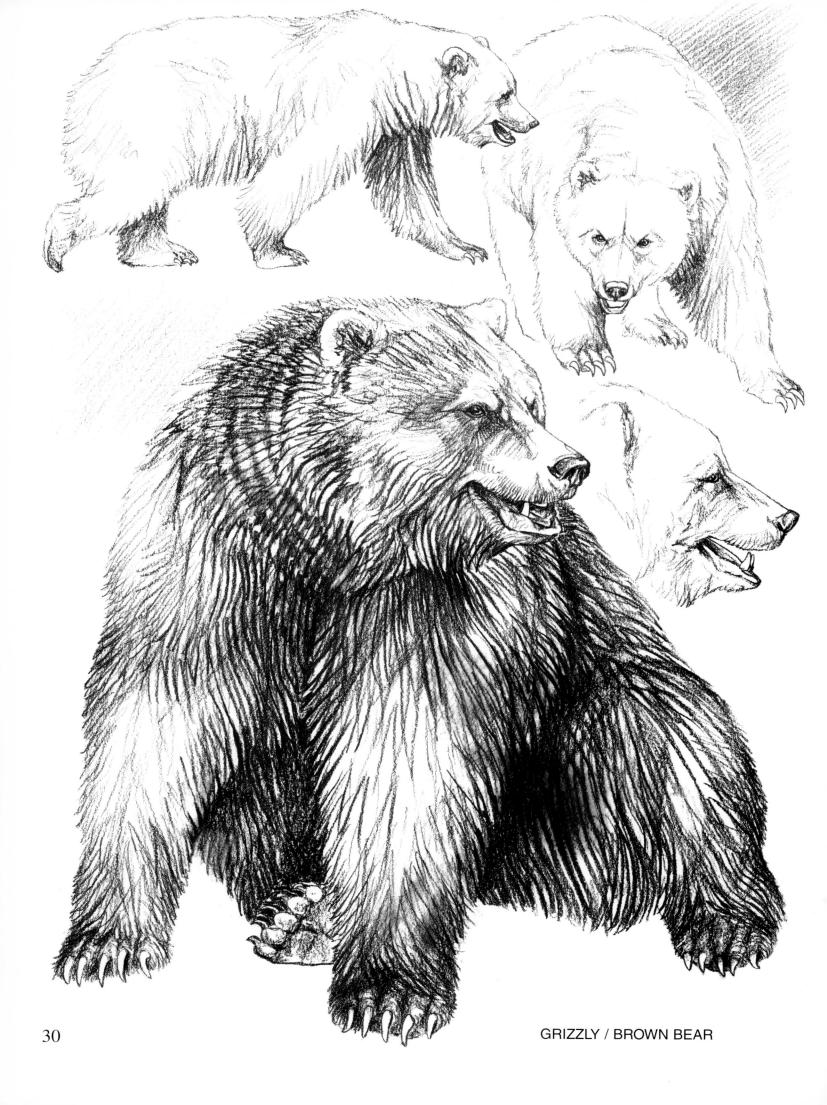

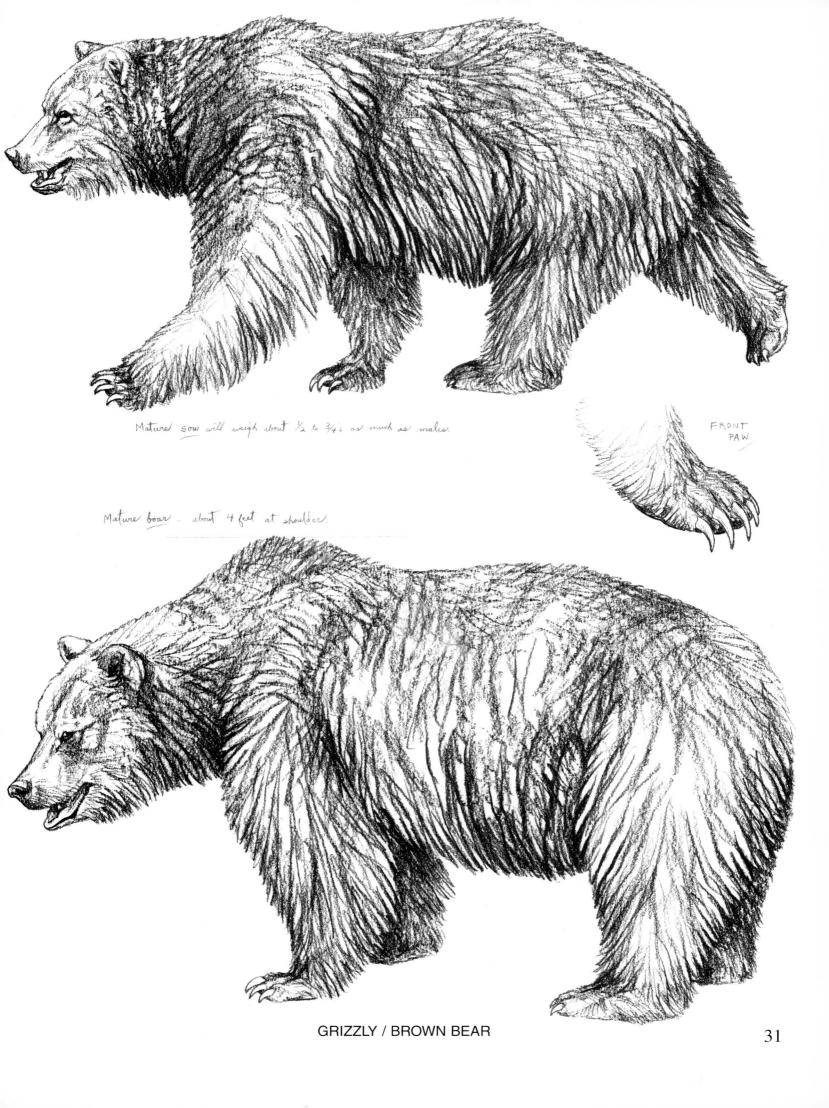

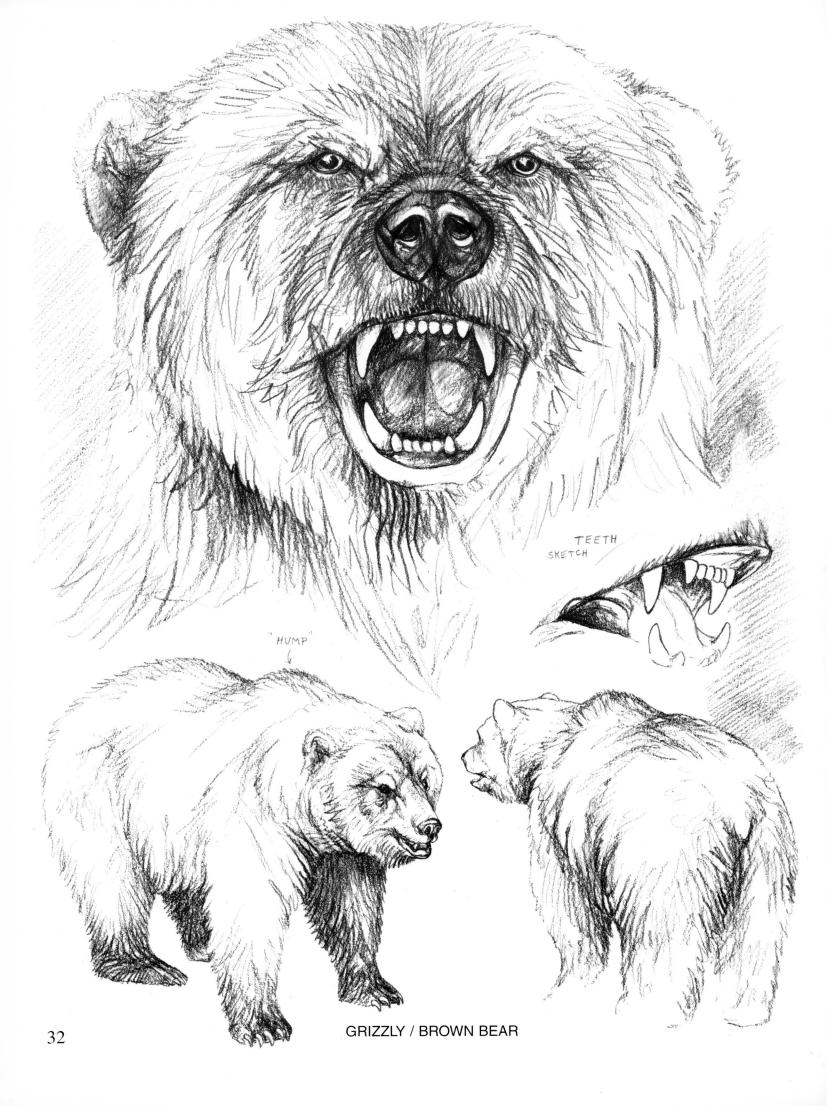

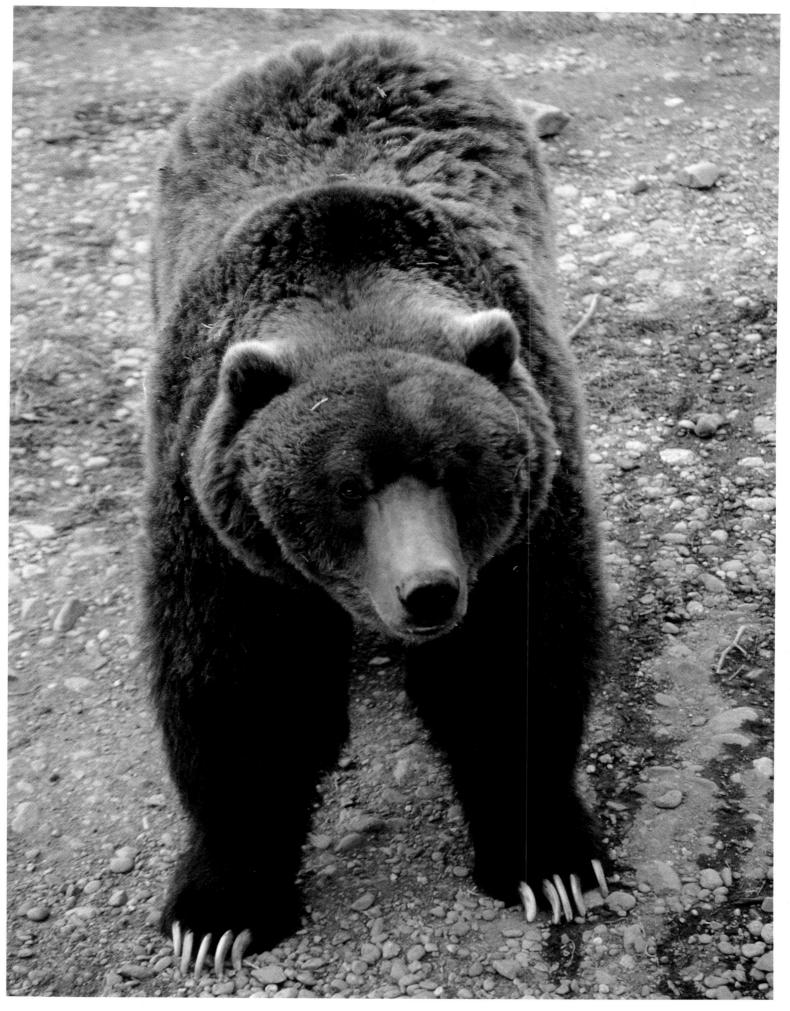

BROWN BEAR / BOAR (MAY)

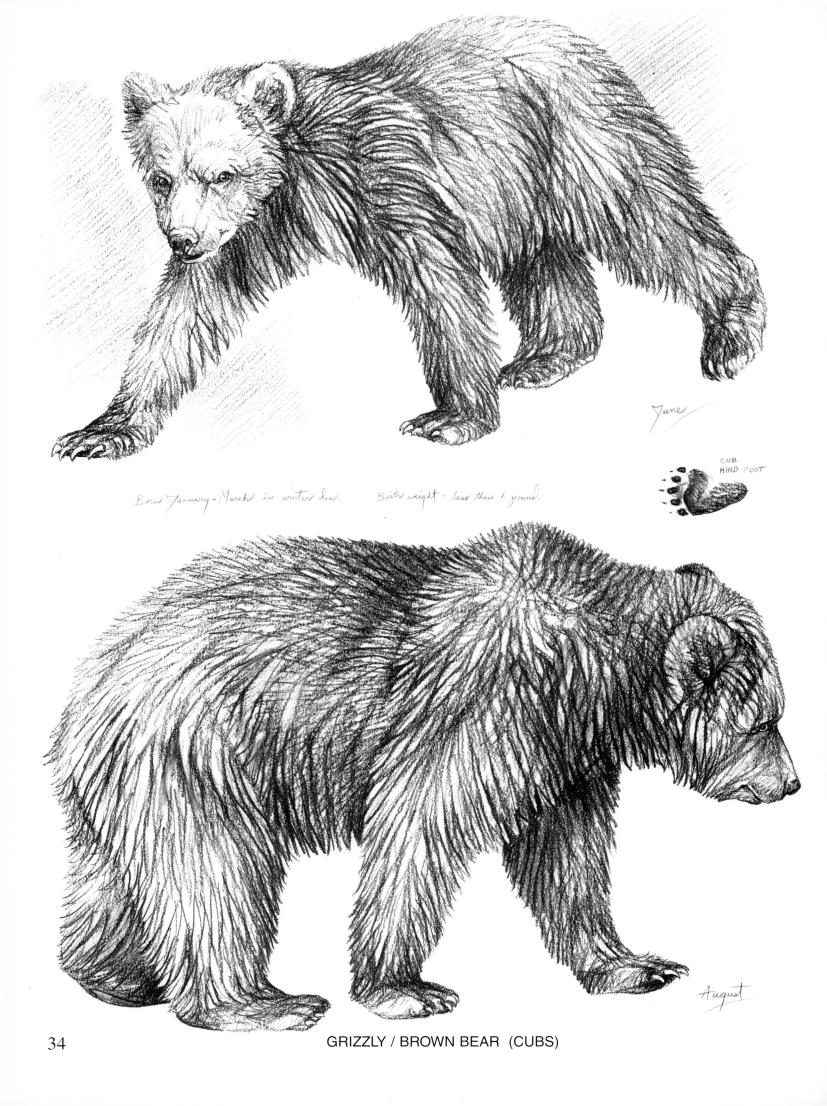

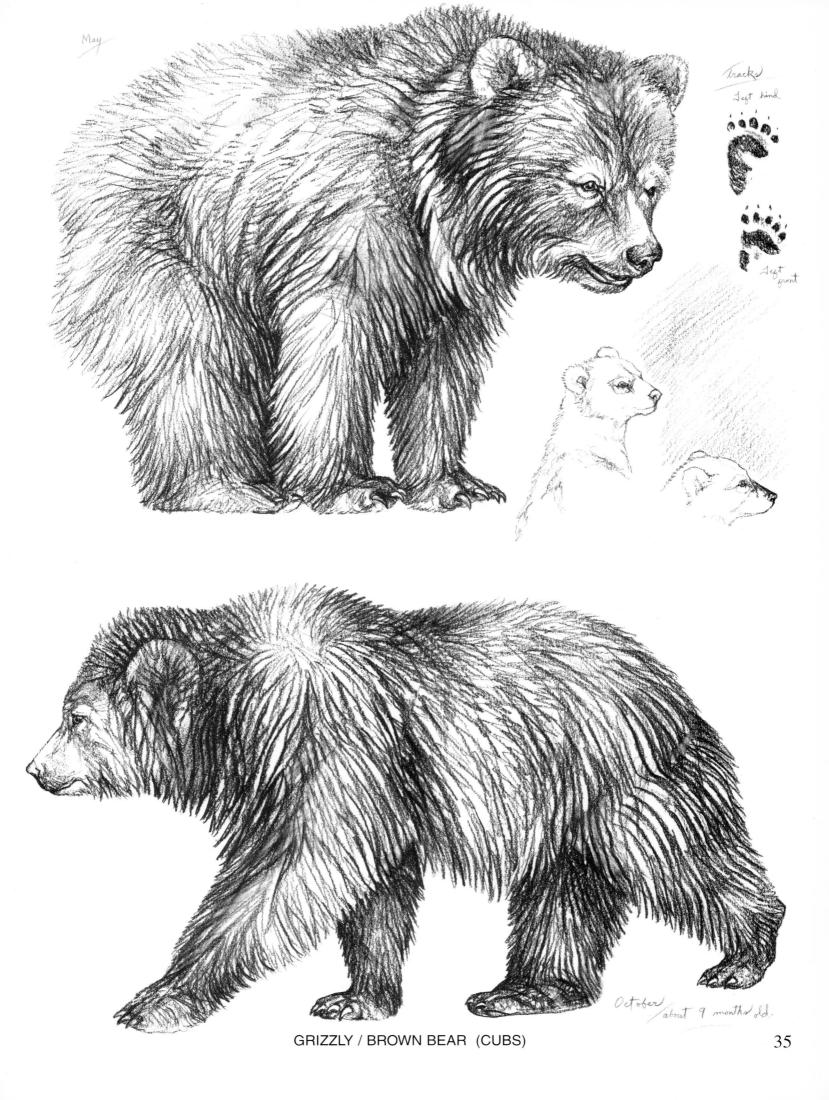

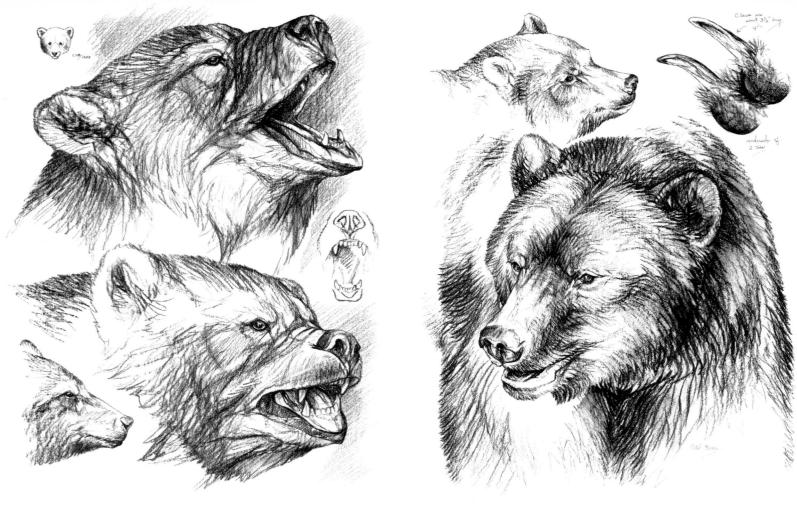

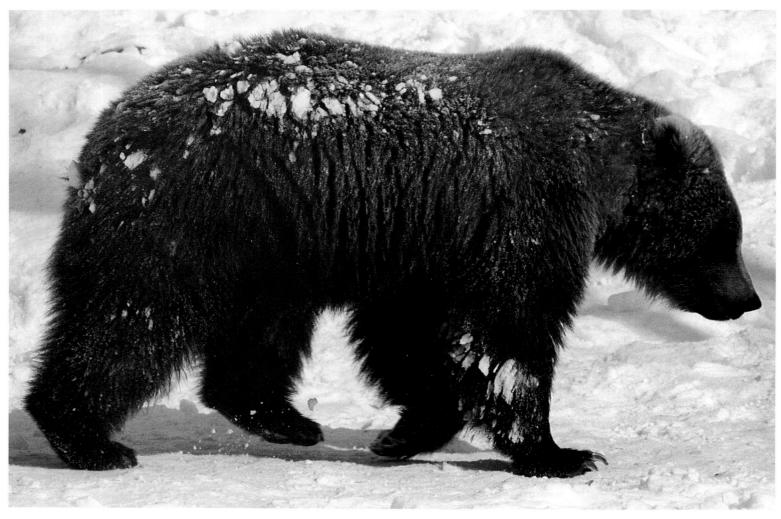

GRIZZLY / SOW (OCTOBER)

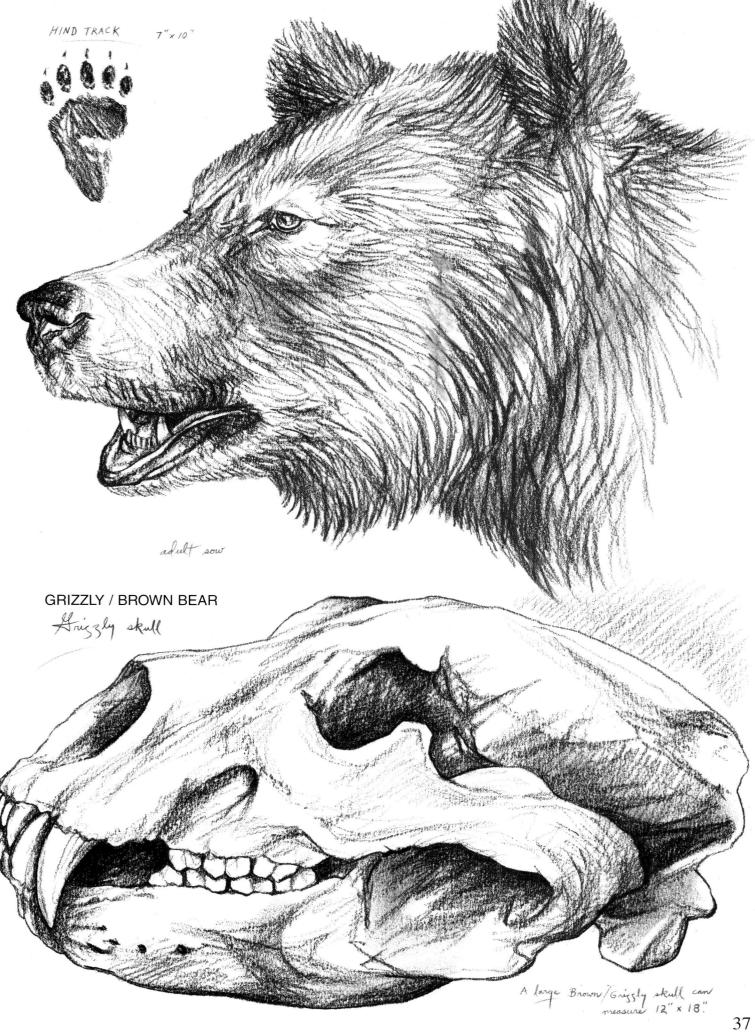

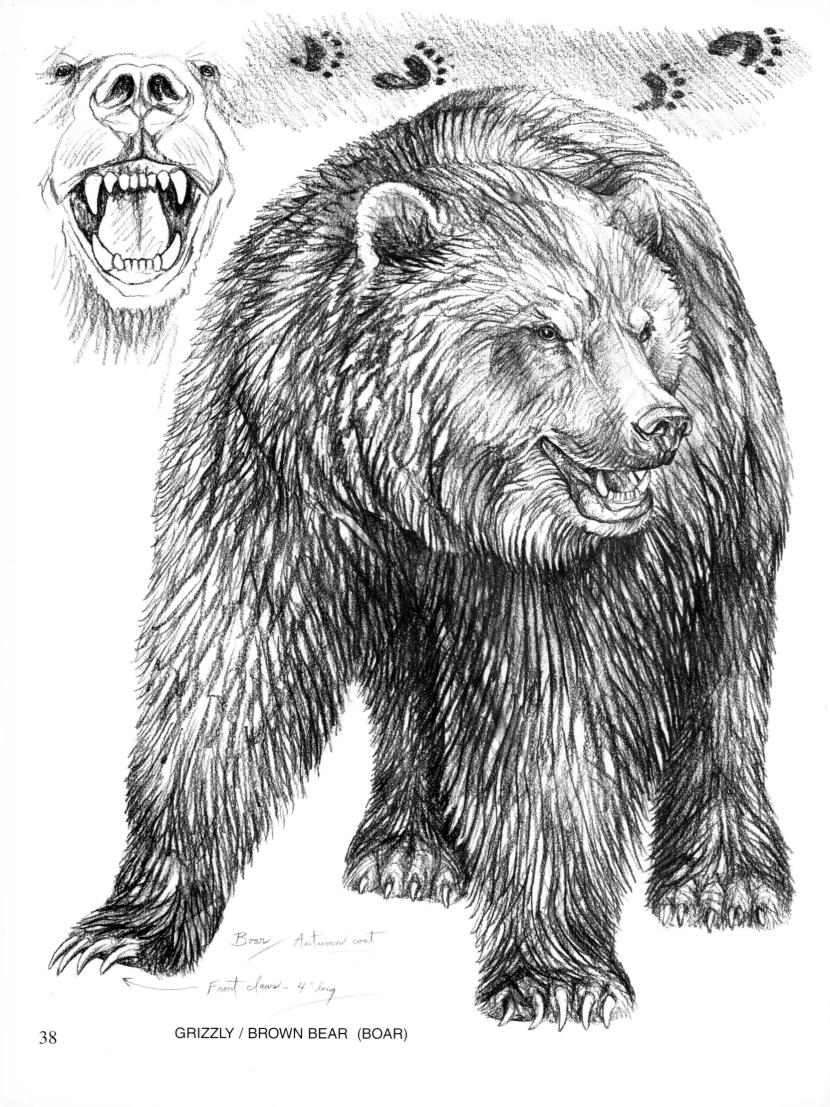

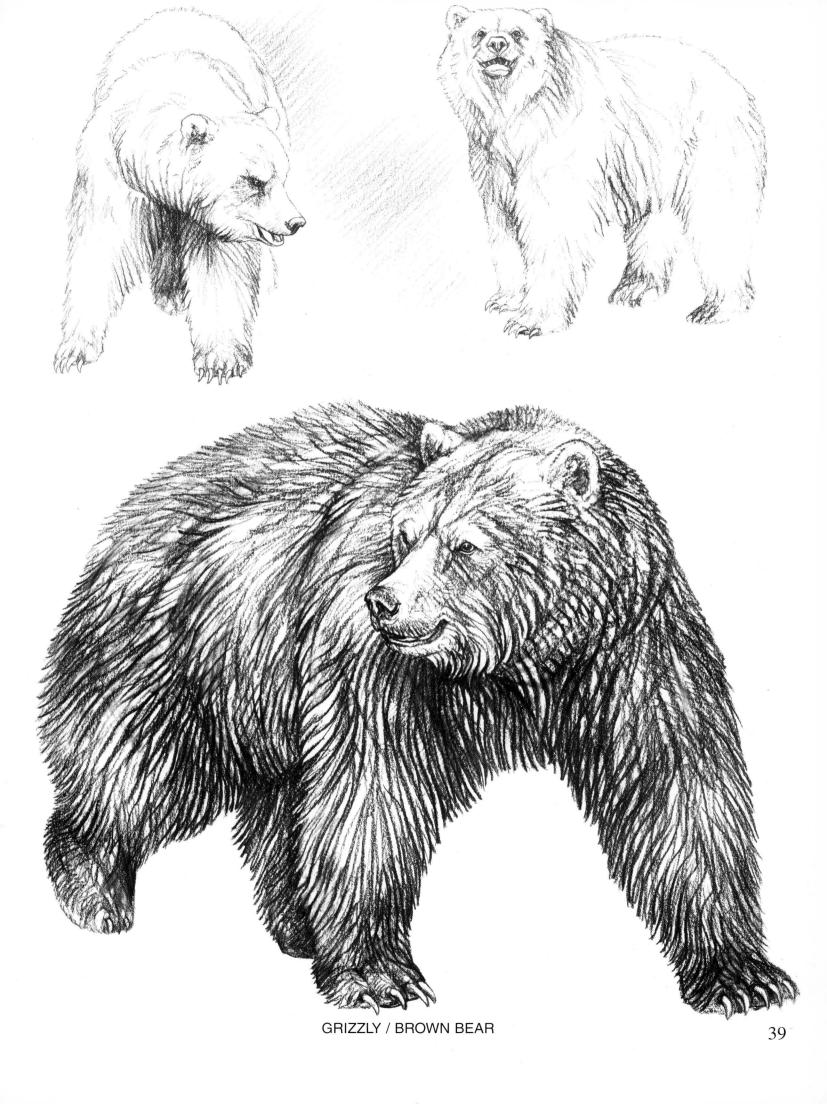

POLAR BEAR

The Polar bear (Ursus maritimus) occurs only in the northern hemisphere and is the regions top carnivore. Polar bears are closely related to Brown bears and large adults of both species are similar in weight; large males weighing 600 - 1500#'s and mature females weighing 450 - 700#'s. Males (boars) are about 48" high at the shoulder and average between 8 and 10 feet from nose to tail. This long necked, short eared Arctic denizen is distinguished by its white fur and black nose, eyes, and lips. It is a creature well suited for its environment.

Most Polar bears are solitary creatures, choosing to associate only during the mating season of April/May. The male then roams the sea ice from one receptive female to another. Fights between competing males are fierce and can end in death to one or both foes. Pregnant females (sows) seek out a winters den by November and usually gives birth in December. Litters of two are the most common and the mother and cubs emerge from their den in late Spring. By then the cubs weigh about 20 pounds and are able to keep up to the sows pace. It is a dangerous time for them, as roaming boars will attempt to kill newborn cubs. Older sows have learned to seek areas that hungry males do not frequent. Life expectancy is about 25 years in the wild.

Although most abundant near coastlines, the Polar bear roams widely and can occur throughout the Arctic basin. Their main food is ringed seals, but they are scavengers and their acute smelling prowess enables them to detect carrion from vast distances. Creatures such as whales or walrus often die as the result of an injury or wound and later wash up on shore or the ice pack. Polar bears are extremely patient and wily, and are able to stalk near enough to a careless, resting seal to slay it with a deadly swipe or bite. Or they may hover atop a "breathing hole" in the ice and ambush their prey.

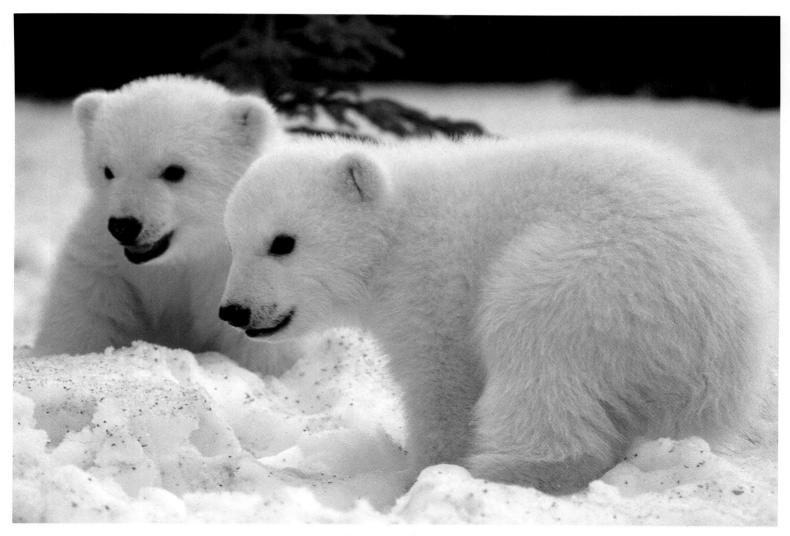

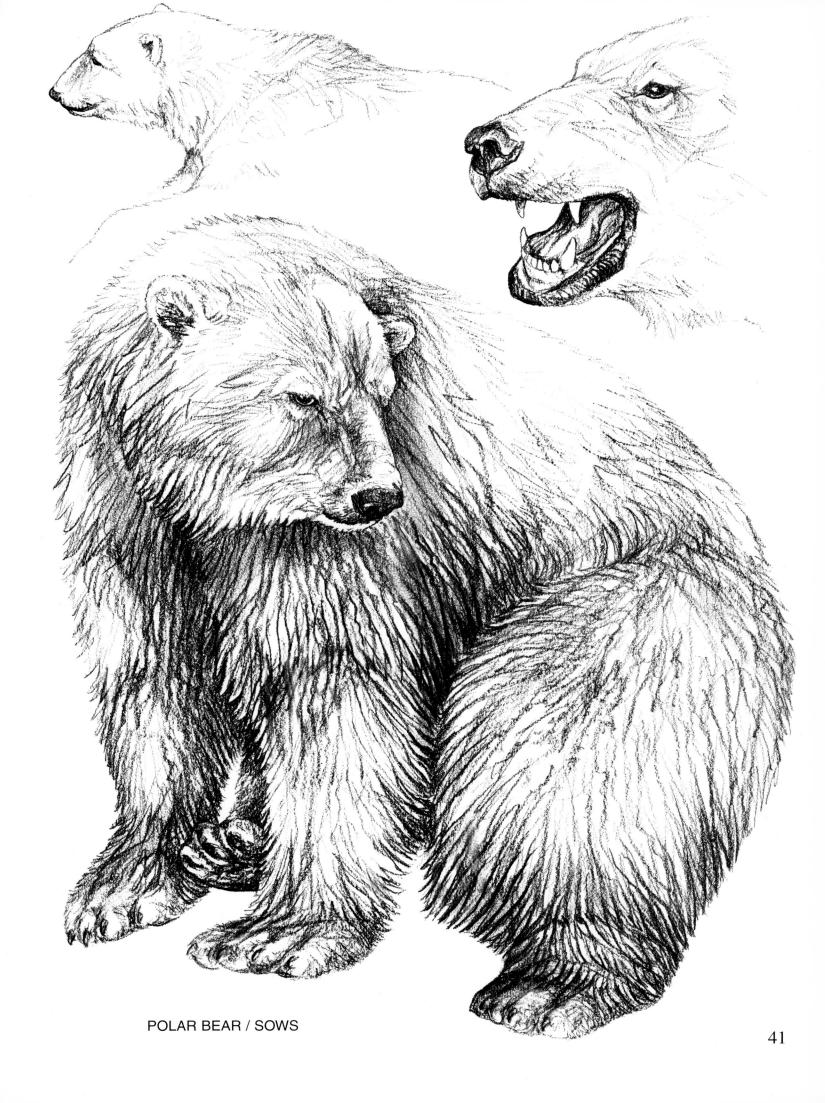

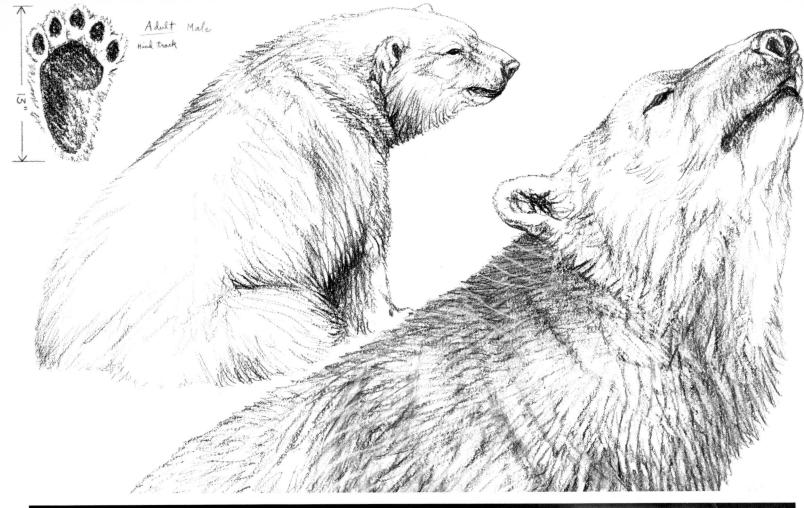

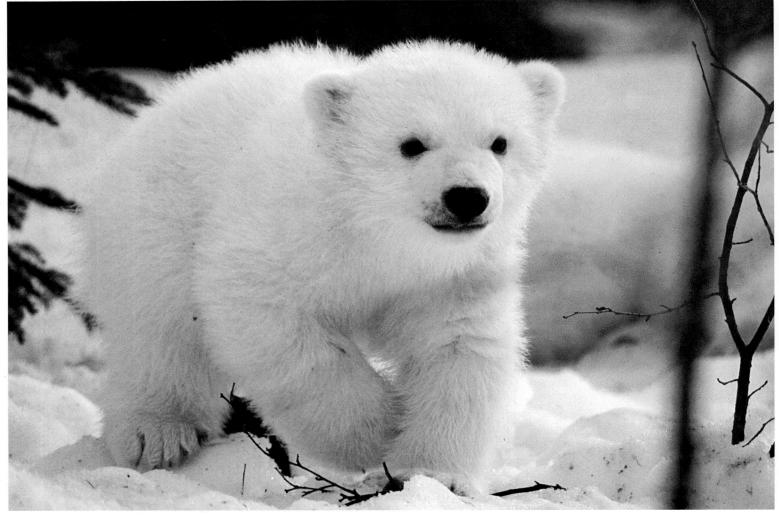

POLAR BEAR / CUB (MAY)

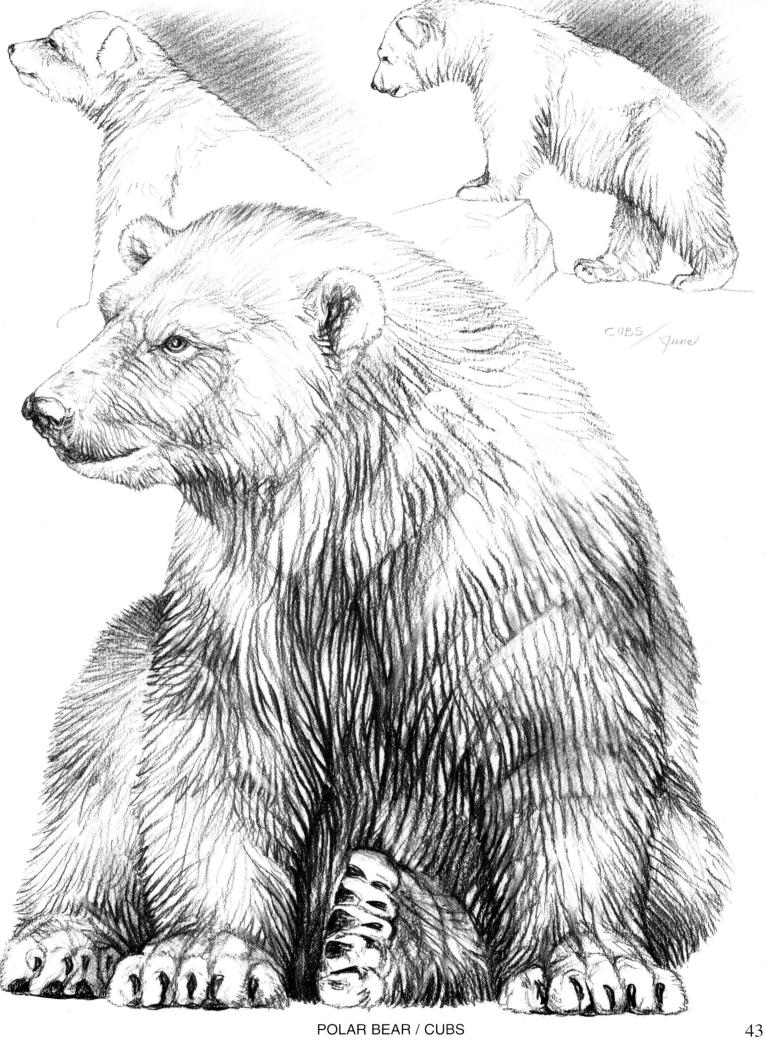

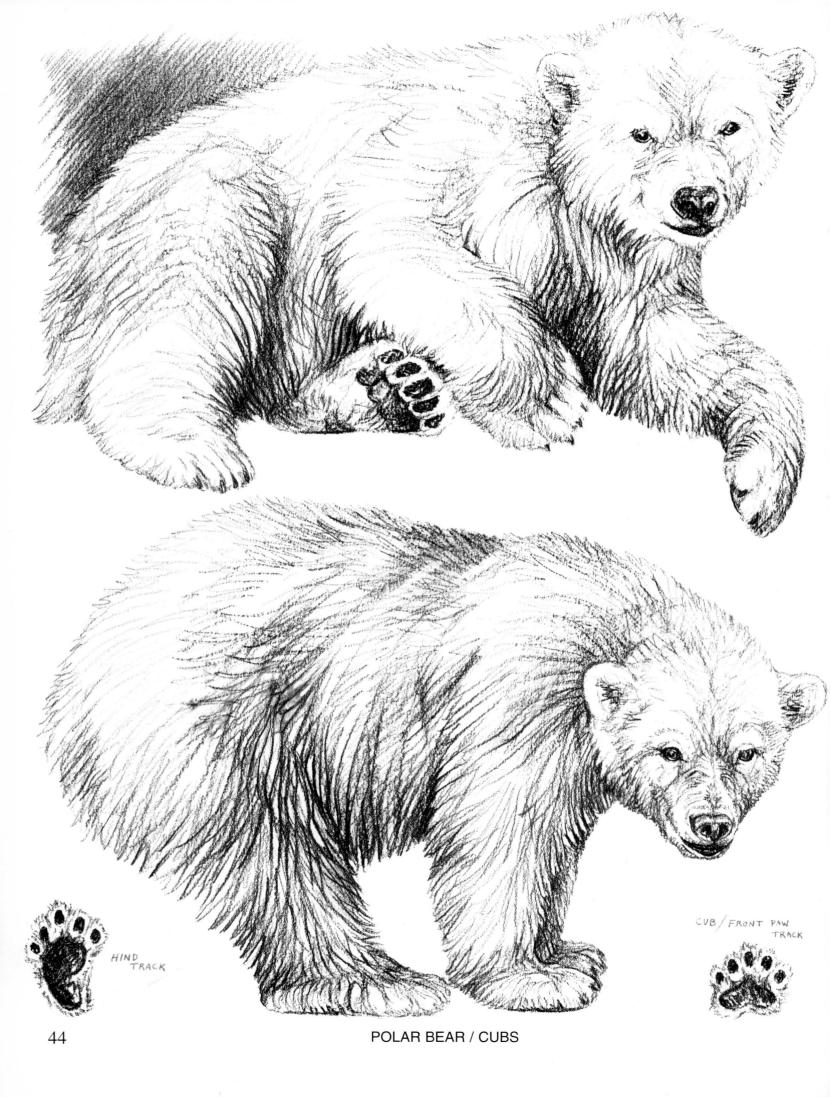

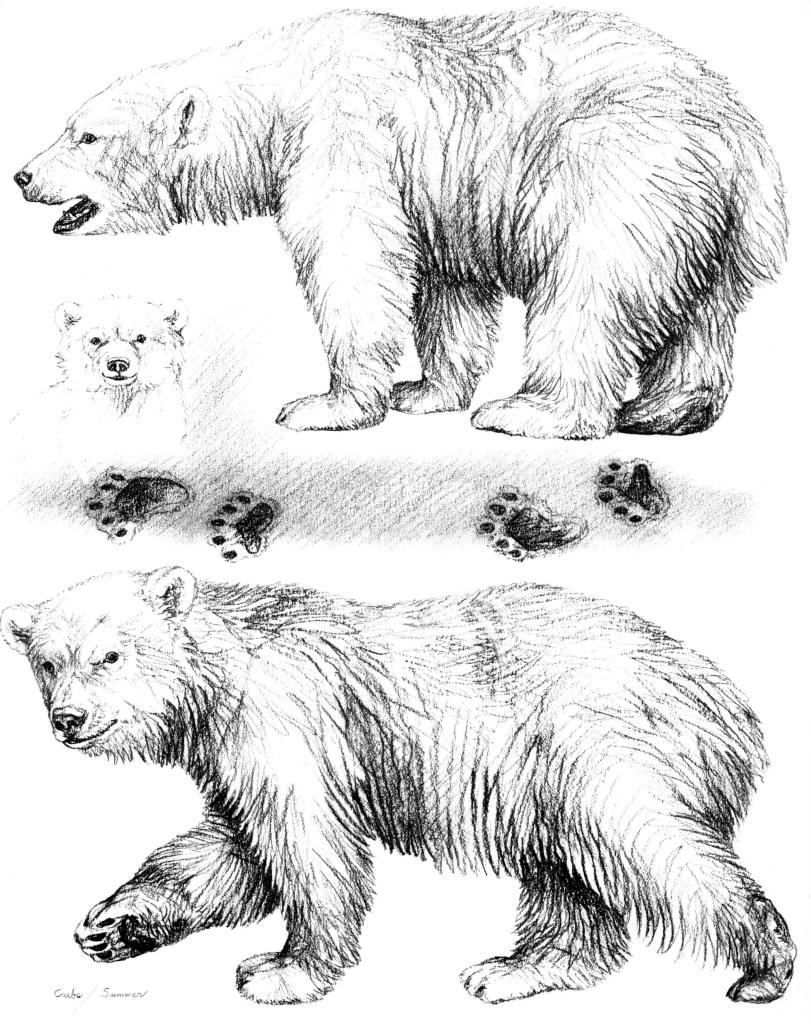

POLAR BEAR / CUBS

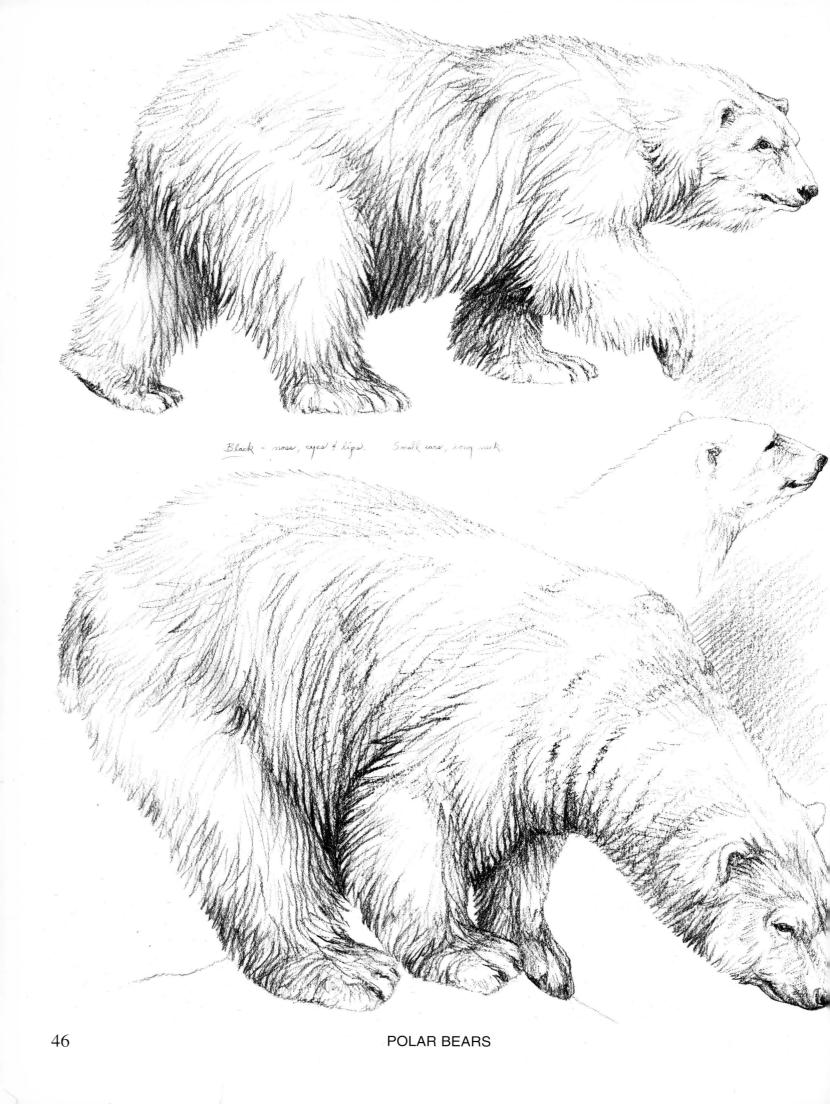

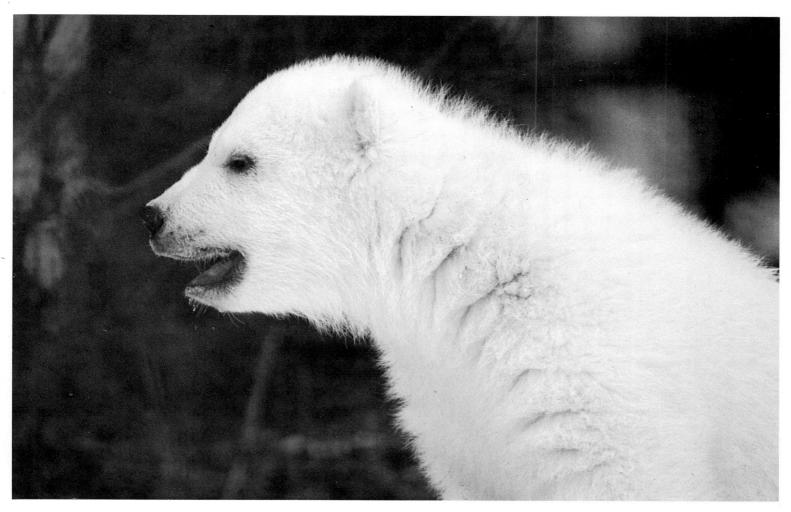

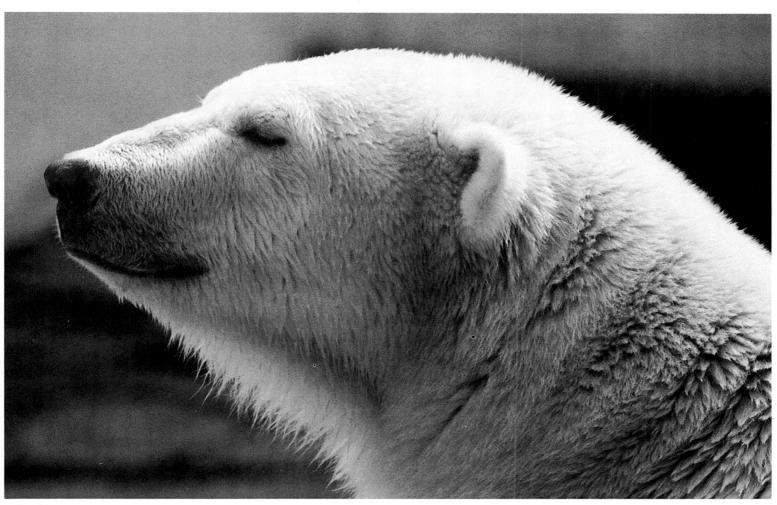

TOP: POLAR BEAR / CUB (MAY)

BOTTOM: POLAR BEAR / SOW (JUNE)

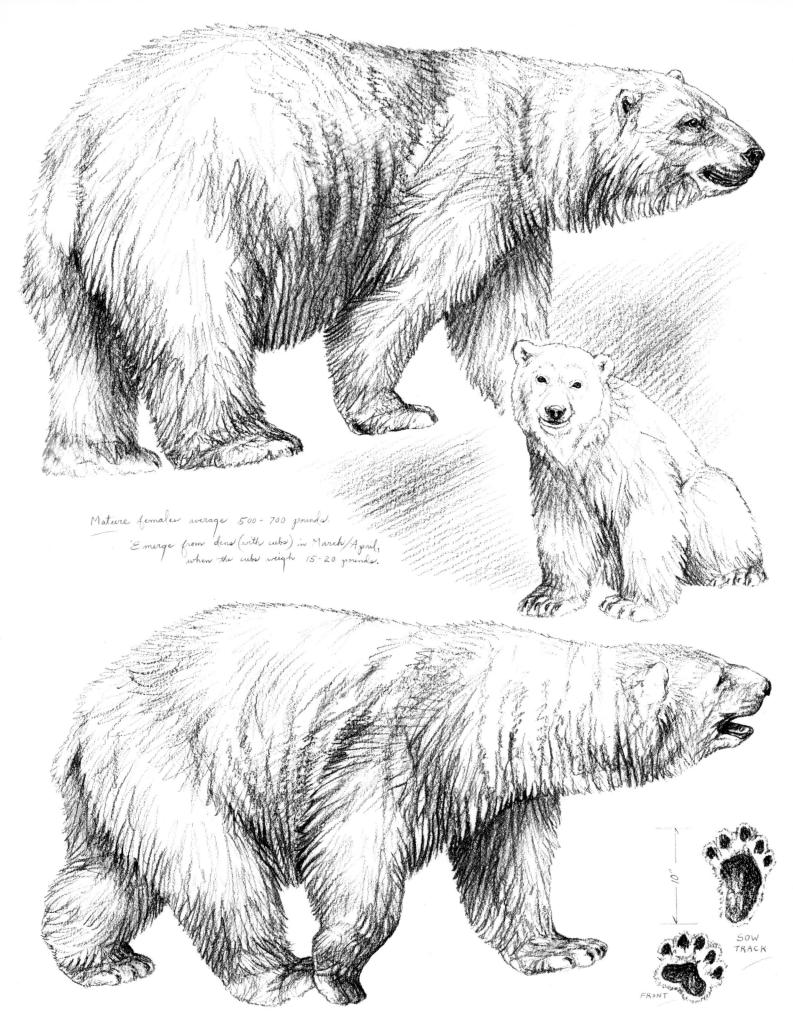

POLAR BEAR / SOWS

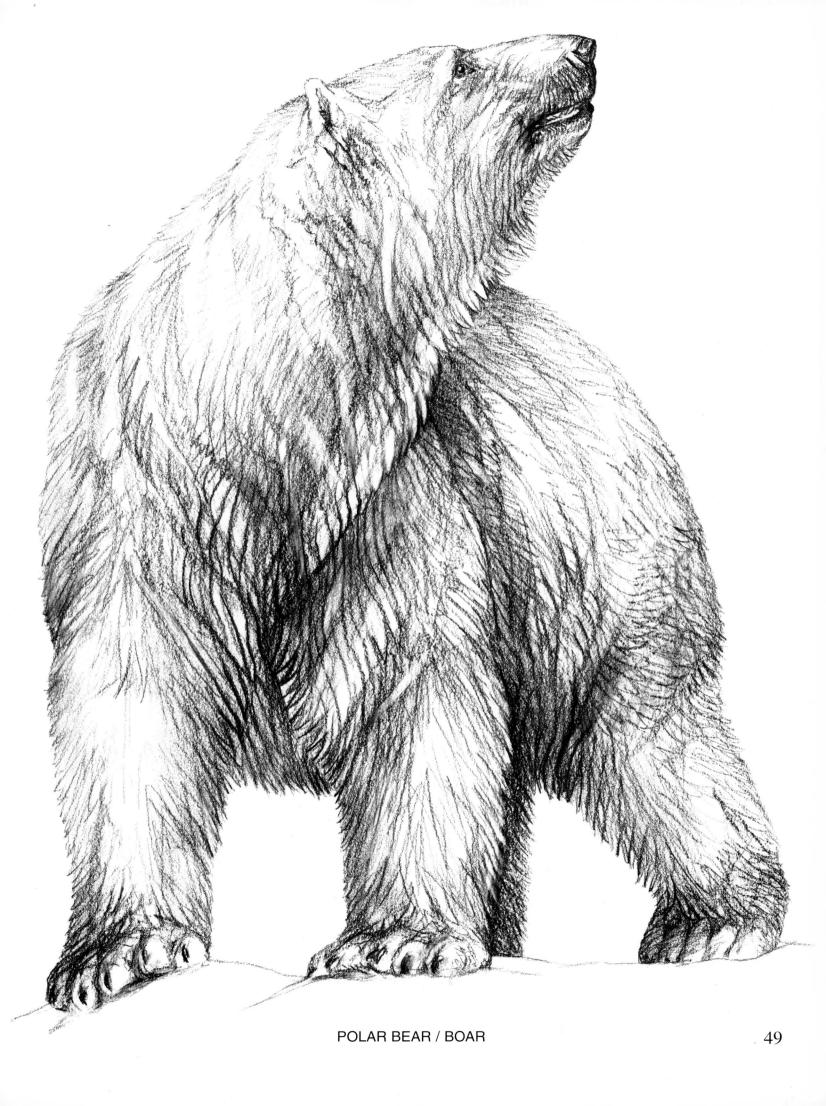

COYOTE

The sly and adaptable coyote (Canis latrans) is a member of the dog family and inhabits most of America and the southern and western edges of Canada. Coyotes hunt alone, in pairs, and sometimes in packs. Pairs have been observed chasing prey (such as rabbits) in relays, whereas (since the prey normally runs in wide circles) a "fresh" coyote resumes the chase after the first one tires. If separated, the pair will communicate via a mournful howl that ends with a series of yips. This very vocal "song dog" also howls to pronounce territories.

The coyote has a slender, pointed nose, prominent ears, and a tail tipped in black. Grayish coat with areas of white (underside and upper lip), rust and tan. Average weights are 25 - 40#'s (about one-third the size of a northern wolf); shoulder height is about 24"; length (including tail) is 40" - 50".

Coyotes mate in February / April and the litter size is determined by the food supply available. If times are lean, few pups will be born. Pups normally leave their parents by winter, to hunt their main prey of rabbits (or hares) and rodents. Occasionally a pair of coyotes will hunt and kill larger mammals such as newborn pronghorn and deer.

Despite mans "war" on the coyote (hunting, poisoning, and trapping), the wily "song dog" continues to prosper and extend his range. Because of our continued march and development into the coyotes range, it is only natural that the coyote (and other wildlife) must adapt. That is why pets, livestock, and even young children are now being attacked on rare occasions.

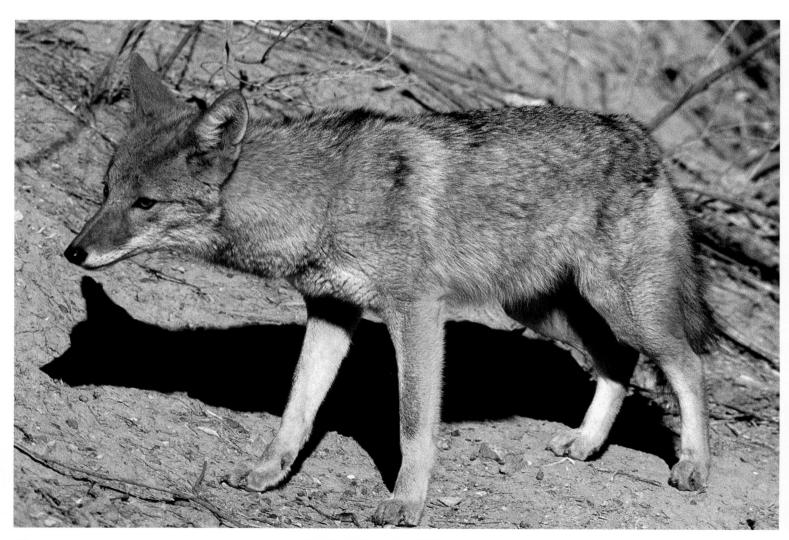

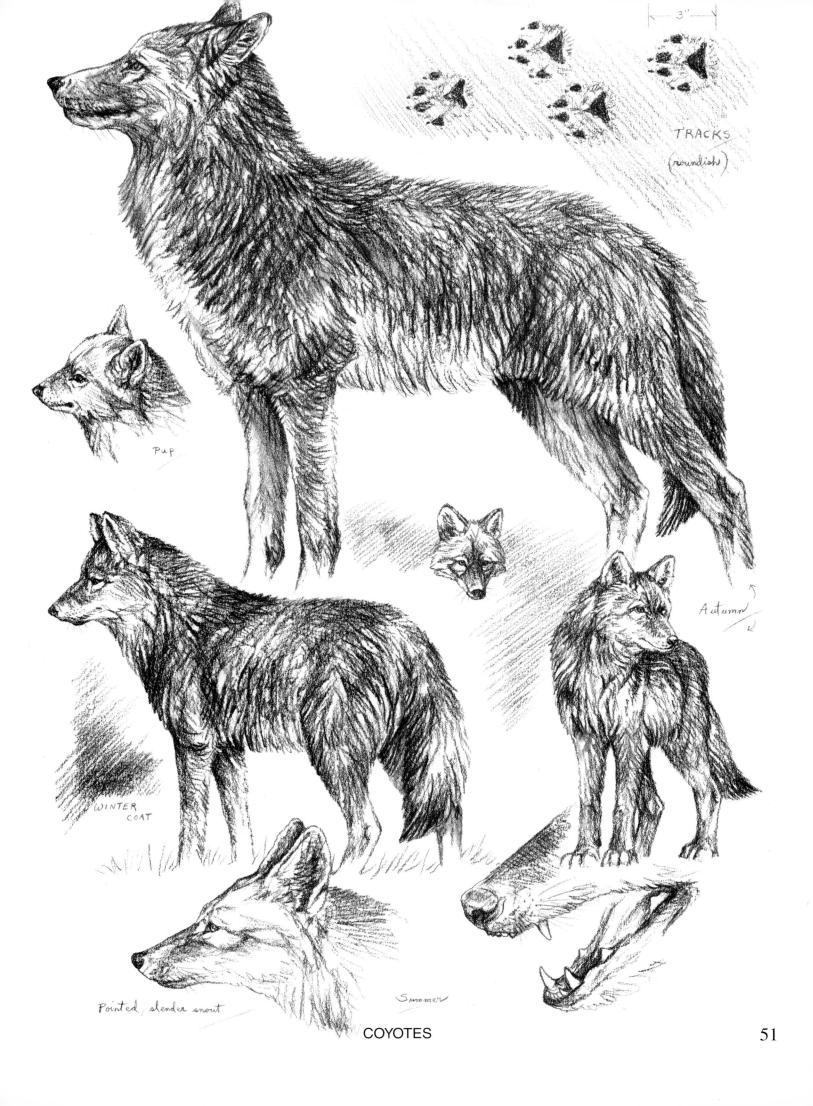

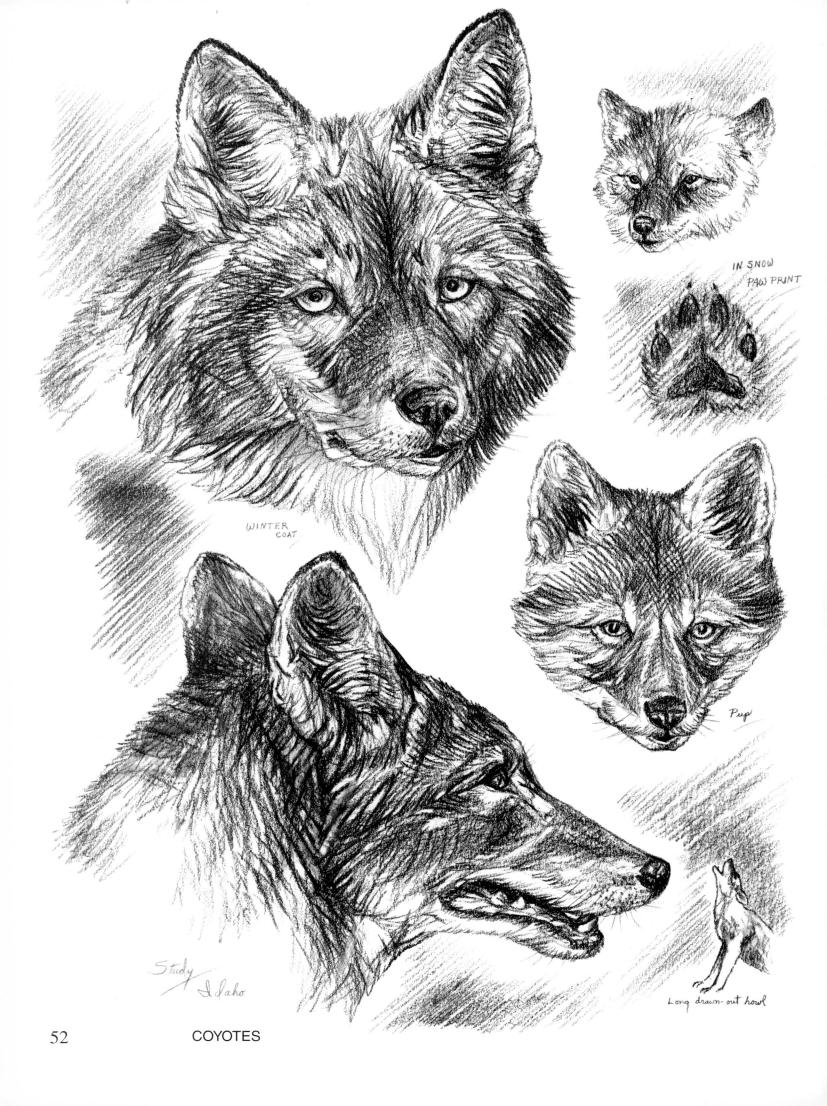

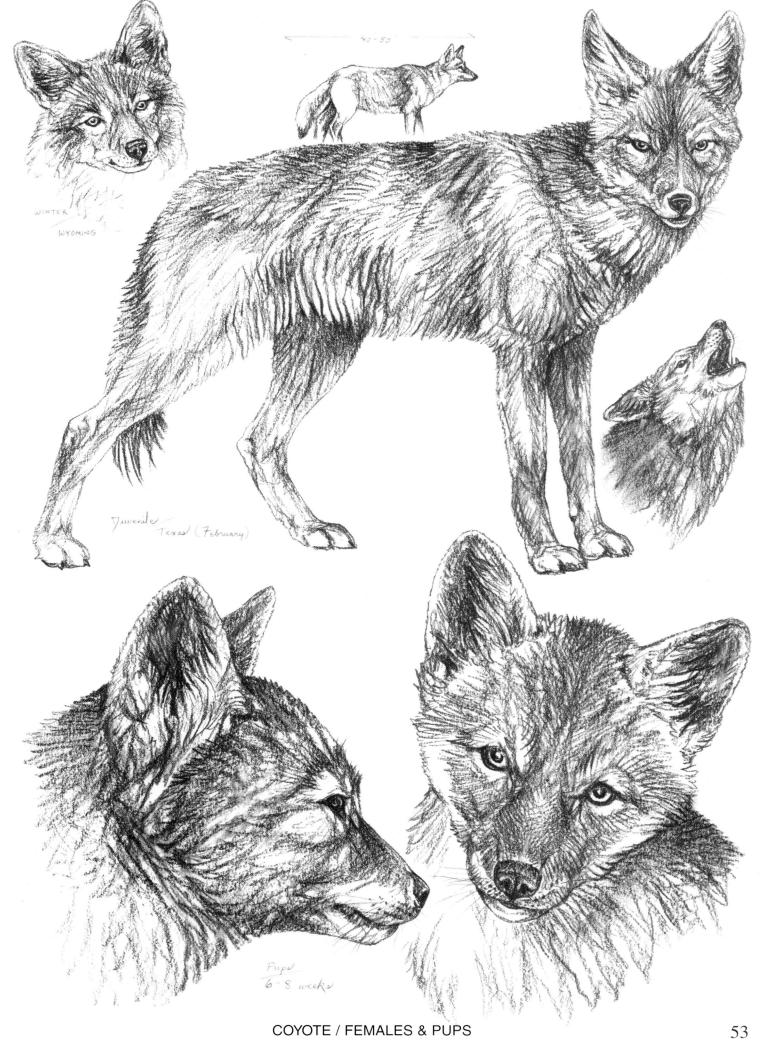

COYOTE / FEMALES & PUPS

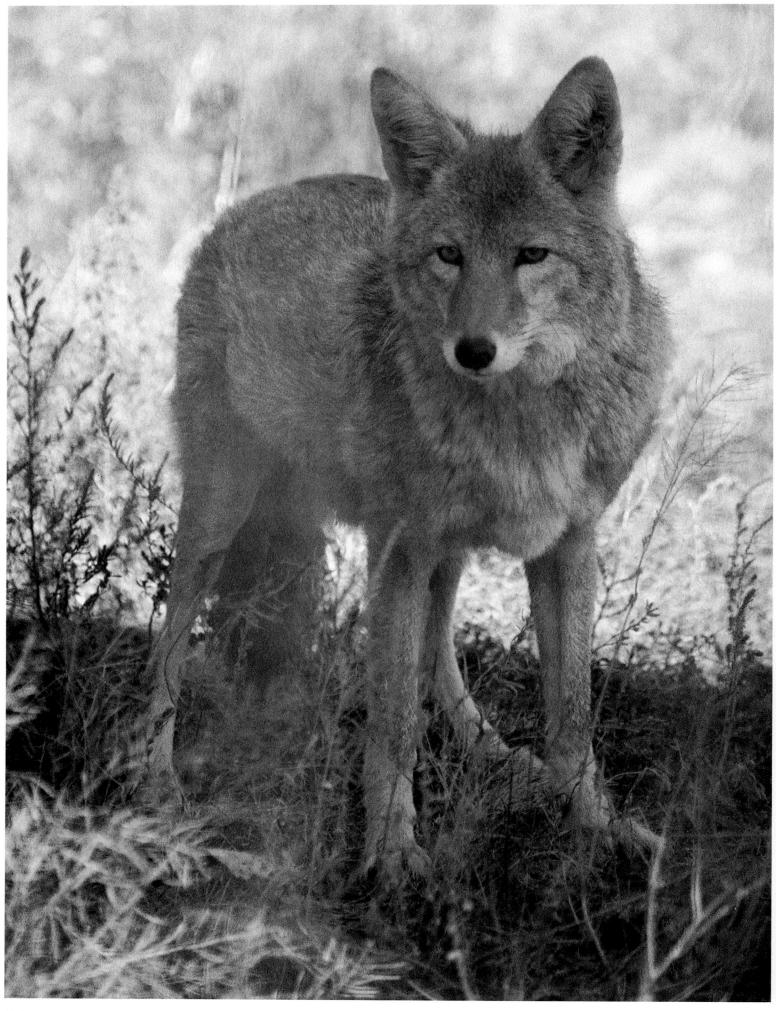

54

COYOTE / MALE (JANUARY)

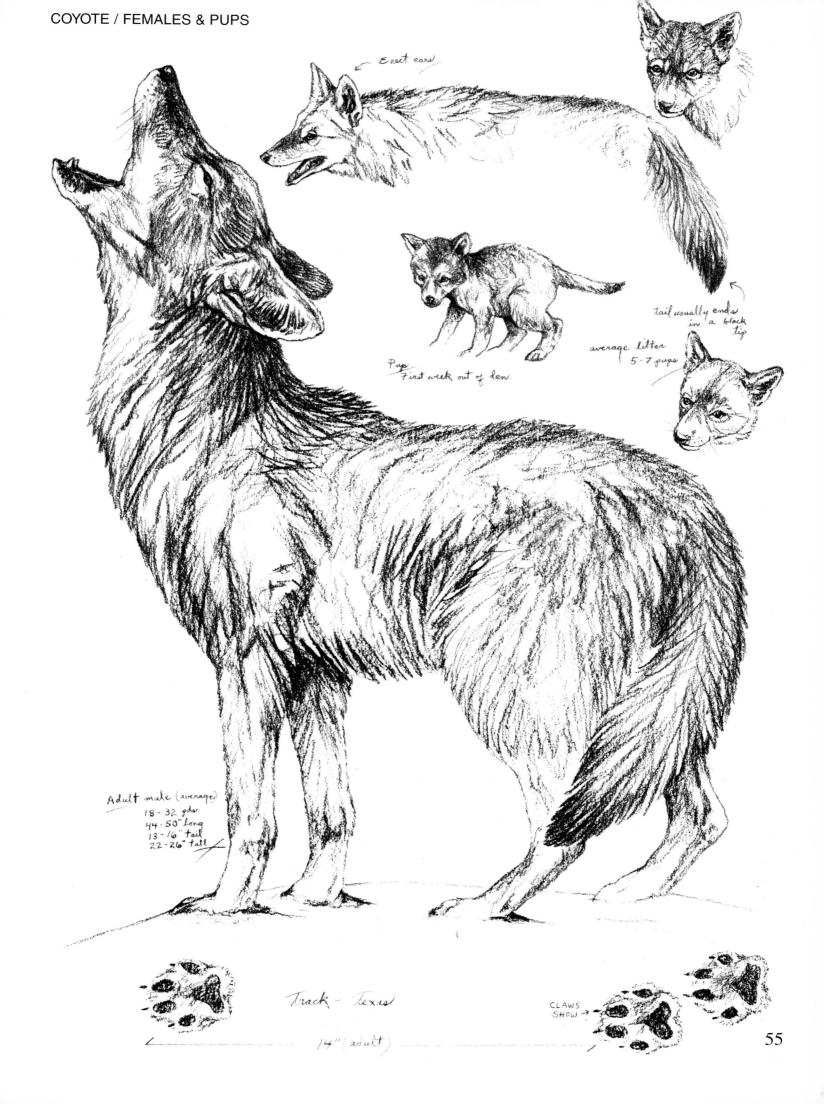

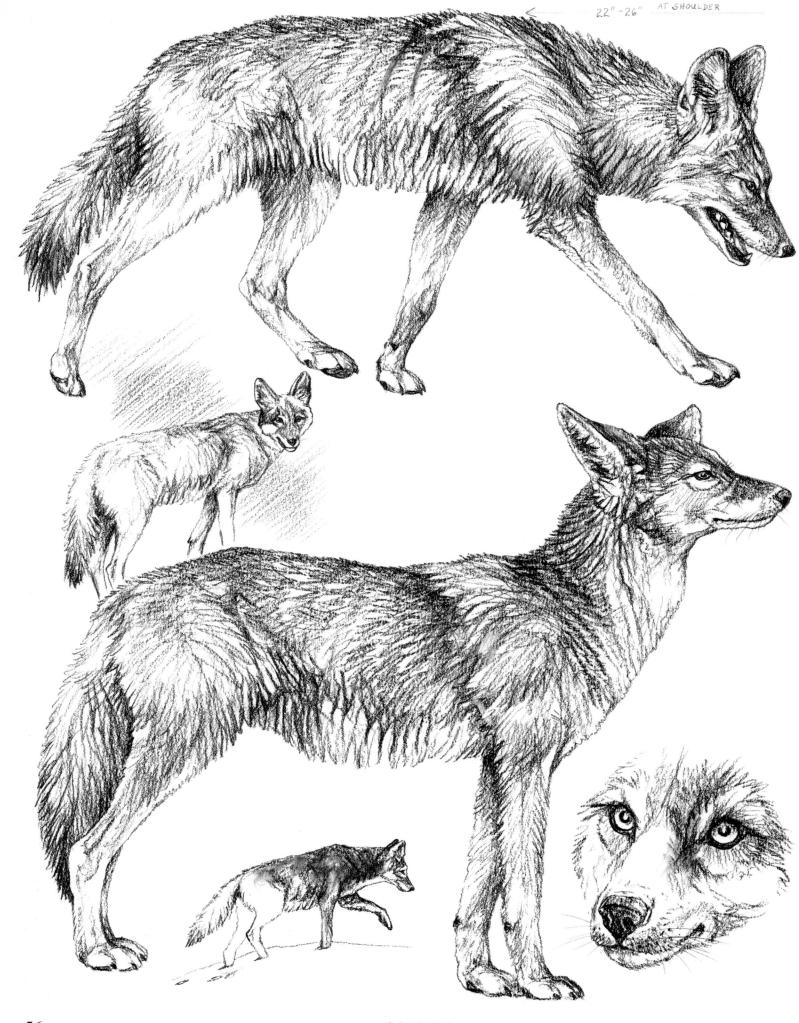

56 COYOTES

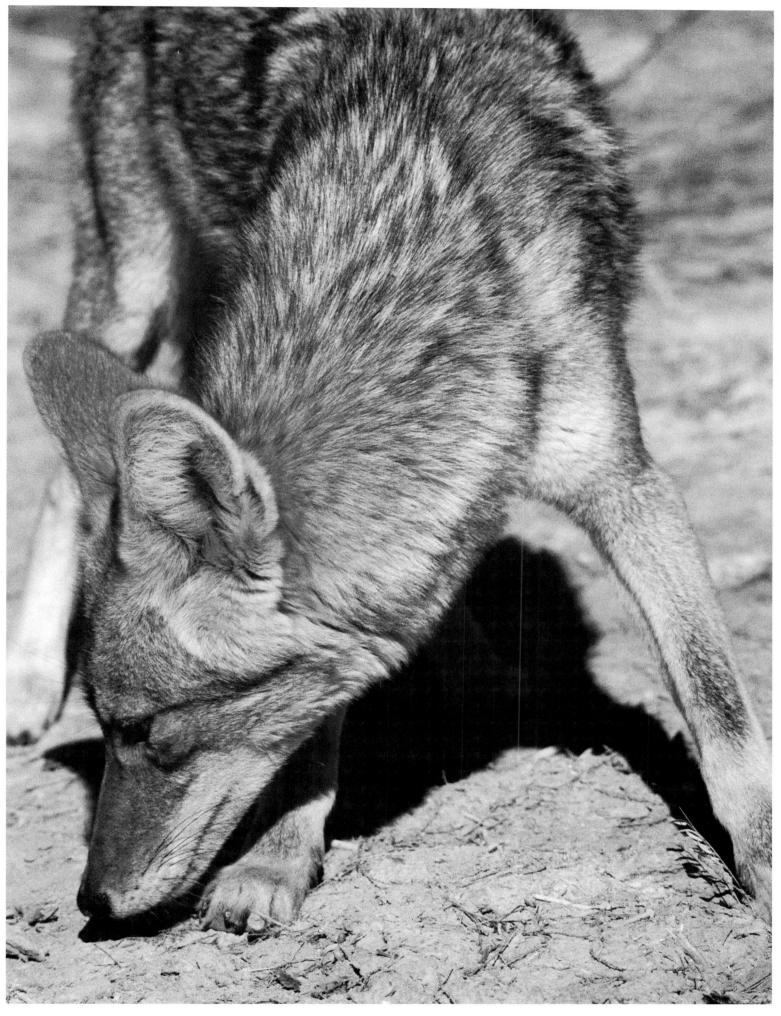

COYOTE / MALE (SEPTEMBER)

GRAY WOLF

The Gray wolf (Canis lupus) is a member of the Canidae family. Much larger than its coyote "brother", it weighs 75 - 125#'s on average. Males are larger than females. A wolf's coloration ranges from white to black, with gray being the most common shade. The more northern wolves are usually lighter colored than their southern counterparts. The bushy tailed (black tipped) predator stands about 36" at the shoulder and is 60" - 80" long.

A social animal, the Gray wolf lives in packs of 2 to 12 (usually 6 - 8), that is made up of parents, pups and relatives. The dominant male and female of the pack are called "alpha" and are the only ones that mate. A litter of (usually) 4 - 6 pups is born in a den in April/June. All members of the pack take a hand in raising the pups. The pack is a very defined and orderly group whereby all members know their "position" in the hierarchy.

The Gray wolf once roamed most of North America, but is now confined to Alaska, Canada, and the northern borders of the continental United States. It is now being reintroduced into areas where it once flourished but was eliminated. Controversy, of course, accompanies this; as ranchers and others are often opposed to having predators reestablished in areas where they can prey on livestock. Hopefully a suitable "balance" can be reached between nature and civilization and the wolf will regain his rightful "home" once again. Certain reintroductions of Gray and Mexican wolves has already resulted in shooting deaths of many of the animals.

Wolves are carnivores and their primary food is large mammals such as caribou, moose, and deer. A large pack will have a "home range" of 100 - 200 square miles to hunt, and often travel 30 miles a day in order to find prey. Hunting these large mammals is dangerous, and an injured wolf may be dispelled from the pack and left to hunt rodents, carrion, and fish on its own. Wolves usually live 10 - 15 years in the wild.

May the melodious "cry" of the Gray wolf continue to be heard reverberating across North America. It is truly a song that signifies freedom and wilderness.

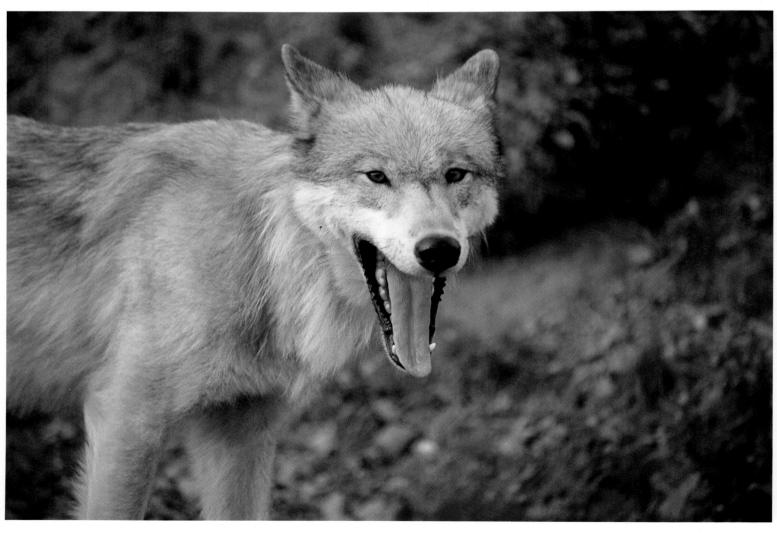

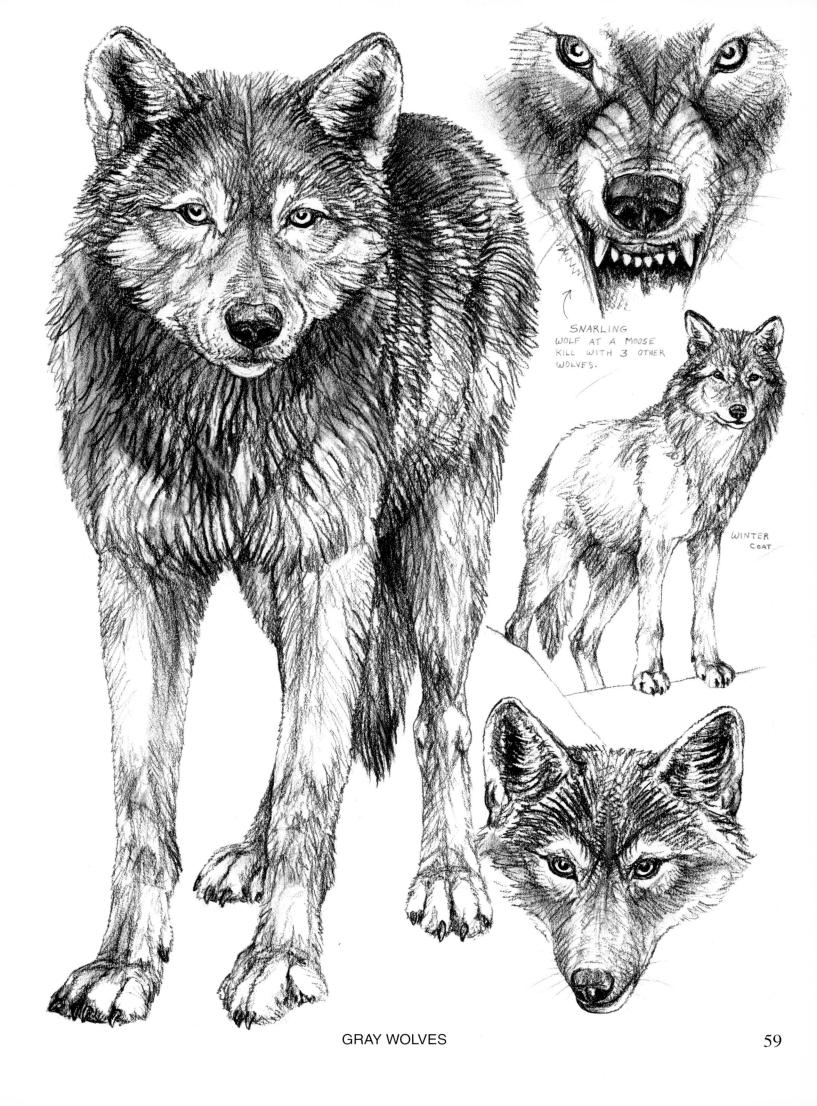

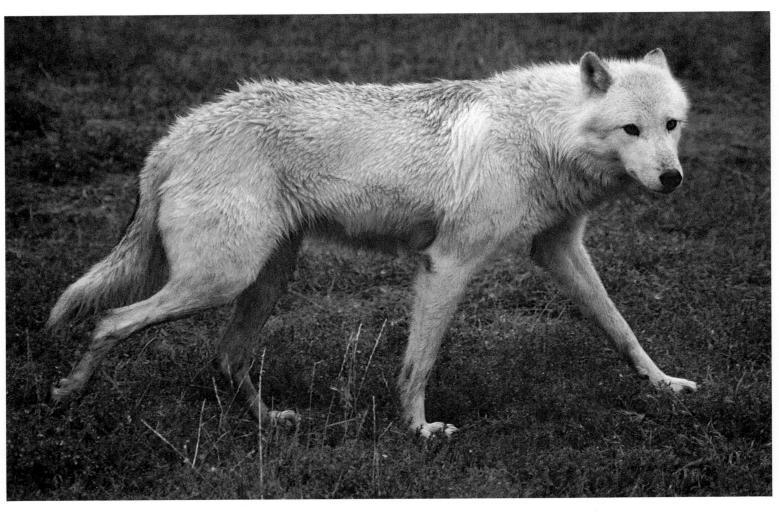

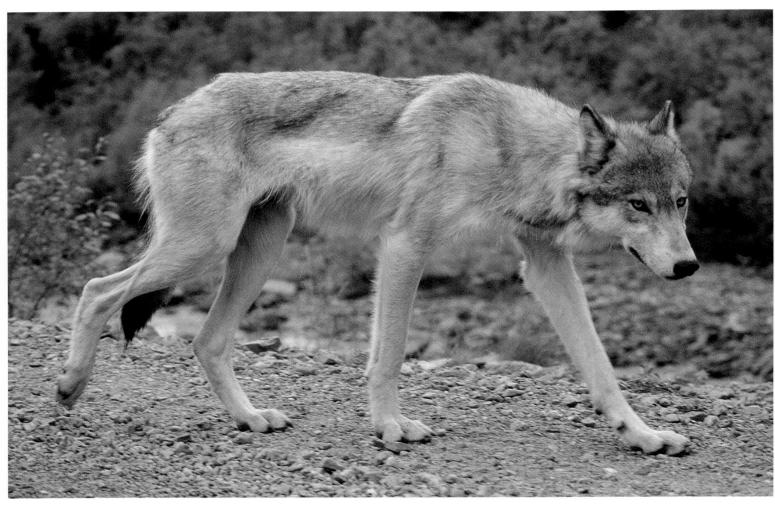

GRAY WOLVES (TOP: SEPTEMBER, BOTTOM: JULY. COLORS RANGE FROM WHITE TO BLACK.

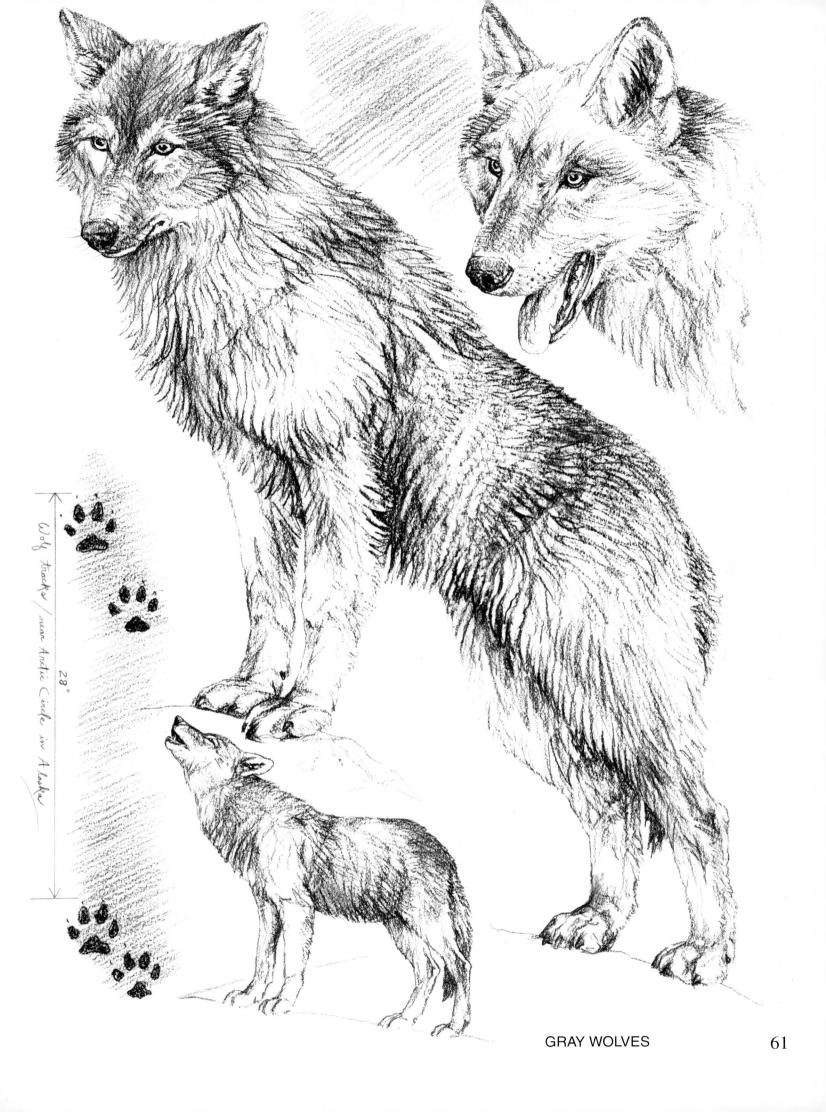

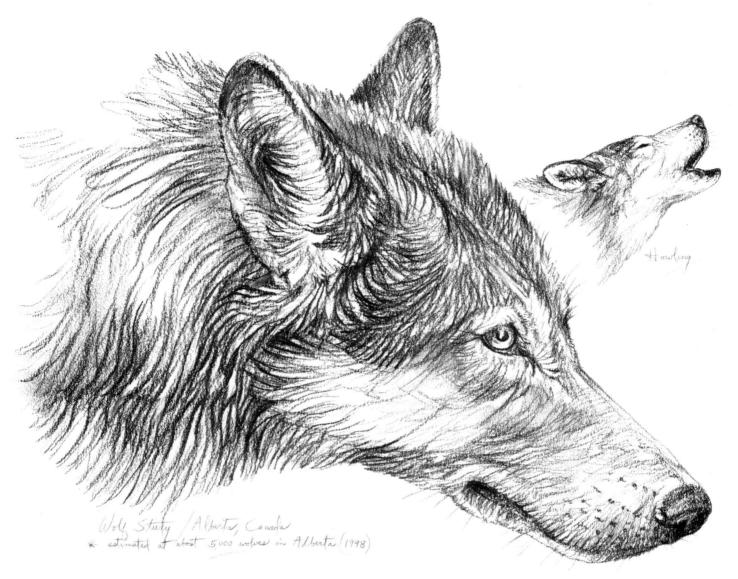

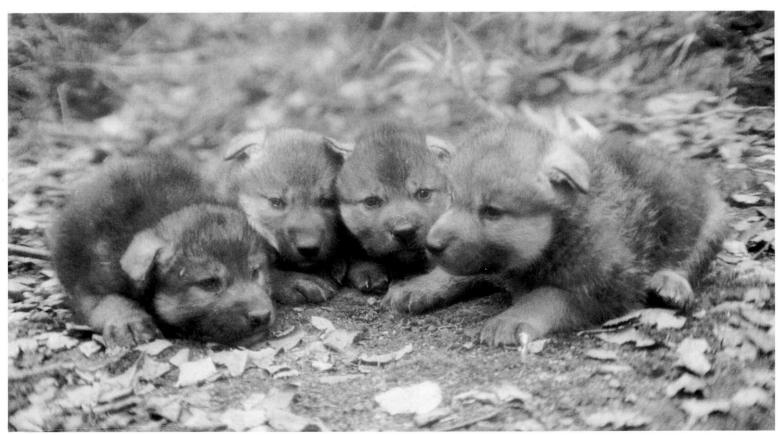

GRAY WOLF / PUPS (JUNE)

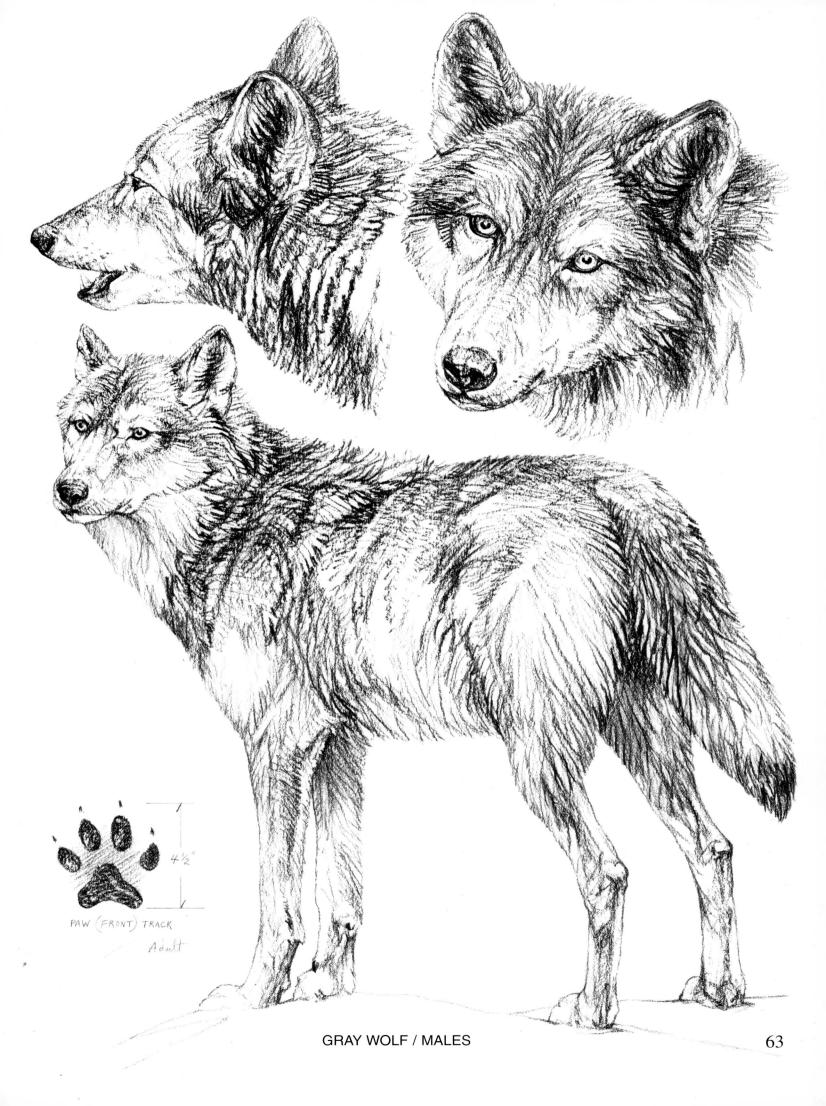

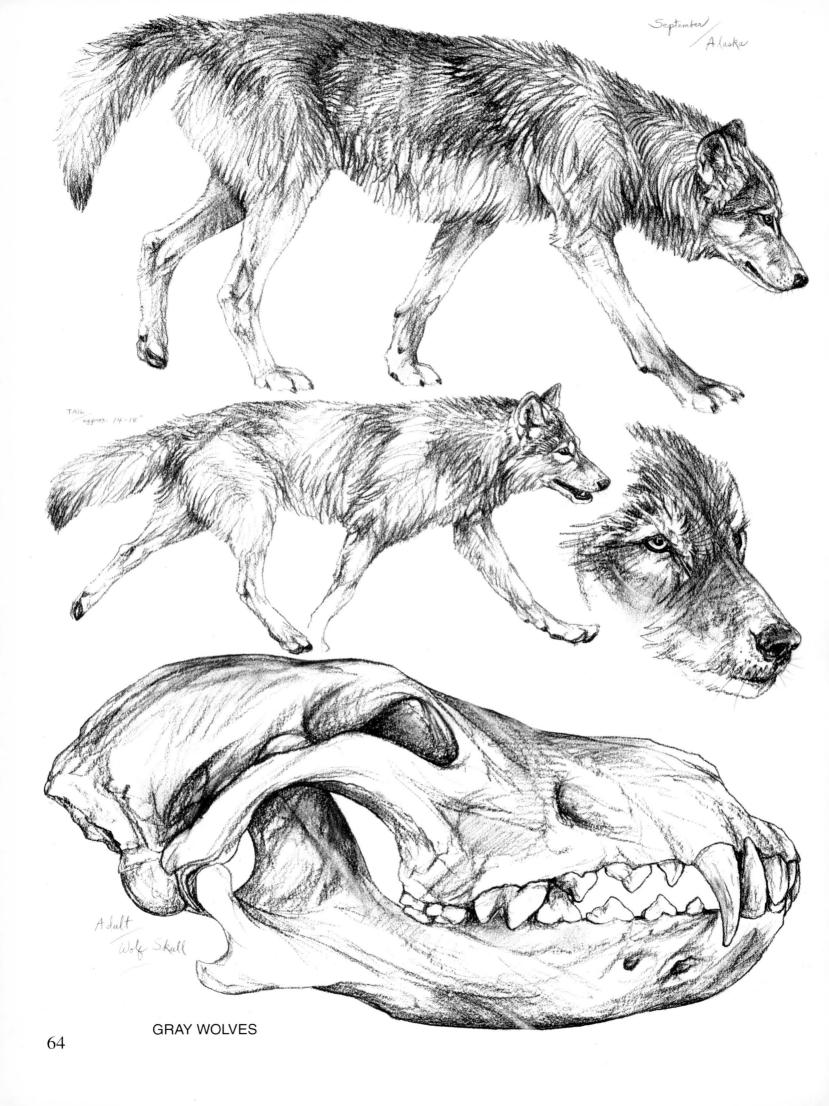

MOUNTAIN LION

This big, tawny cat is North America's largest unspotted cat and is second only to the spotted Jaguar in size. It is characterized by its relatively small head and long, dark-tipped tail. Although it was once widely dispersed, it is now confined to the western part of North America from British Columbia south to Argentina. A few rare cats still survive in the Florida Everglades, but that is the only population east of the Mississippi river. The Mountain lion (Felis concolor) is also called cougar, panther and puma, depending on the region.

A mature male will weigh 150 - 200#'s on average and have a length of 8' - 9' (including 24" - 36" tail). It stands about 30" at the shoulder and is about one-third larger than the female. In the wild, they normally live 10 - 15 years.

The Mountain lion has no fixed breeding season, but the young are usually born in litters of 2 to 4 in the Spring/Summer season. Males are polygamous, breeding with any female in their area. Usually the mating pair stays together for a week or two before separating. The "kittens" are spotted and will remain near their rocky denning site until they are old enough to follow their mother on her hunting treks. They normally separate after a year or so. By then the young are full grown and have practiced and refined their hunting skills at their mothers side. Their main prey is deer (especially Mule deer) and the Mountain lion does most of its hunting by stalking near enough to its quarry to launch a speedy attack. A kill is usually made by biting into the back of the deers neck and twisting its head, thus breaking its spine or neck. The Mountain lion covers its uneaten food with leaves and vegetation and will return to eat from it until it begins to spoil.

Mountain lions are solitary creatures and each mature cat often travels 20 miles every day seeking prey. It, like other wildlife, has been encroached upon by development and more and more conflicts are occurring. Terrain that once housed healthy populations of predator and prey animals have now been claimed by homes and golf courses where the residents often feed and welcome the deer and elk (prey), and shoot and fear the predators (Mountain lions, coyotes, etc.) that come into "their space" to hunt.

Those of us who have explored wilderness areas and are lucky enough to see Mountain lions in their natural environment, will never forget the moments. The secretive, elusive cat is seldom seen. Also, if you have ever heard their bloodcurdling screams during mating, you will never forget that either. Sometimes, at night, ones tent seems very flimsy. A friend and fellow wildlife photographer died recently when a bear attacked him while he slept in his tent.

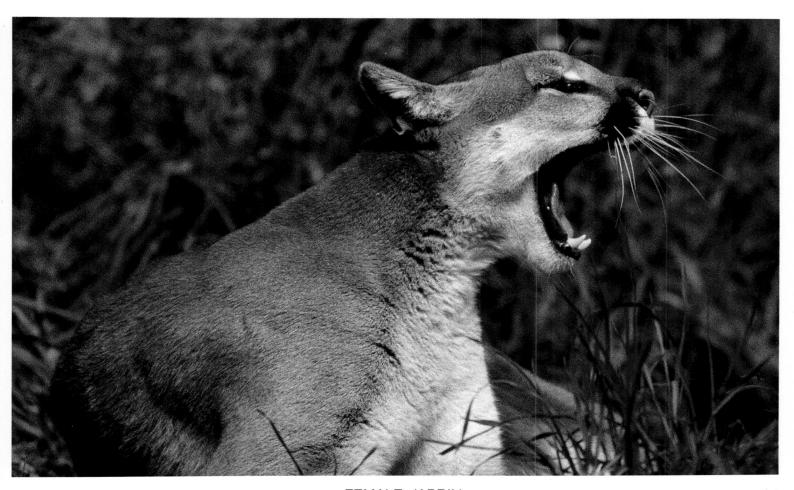

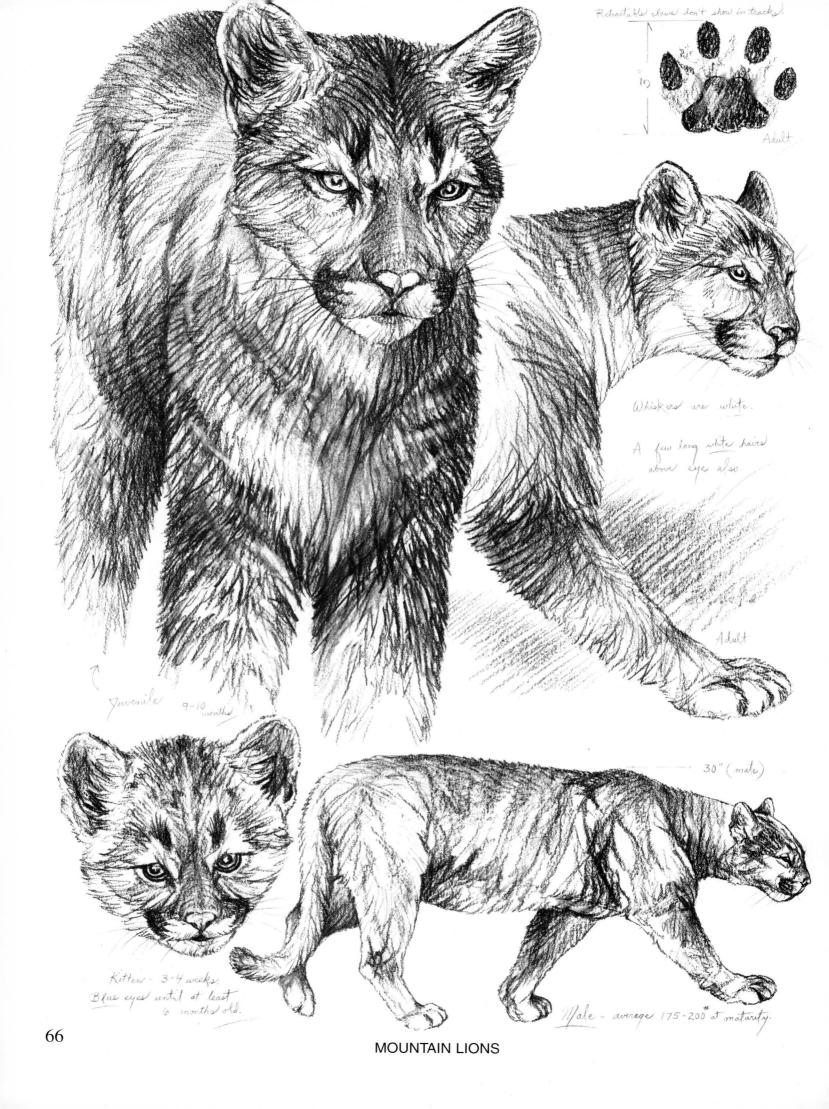

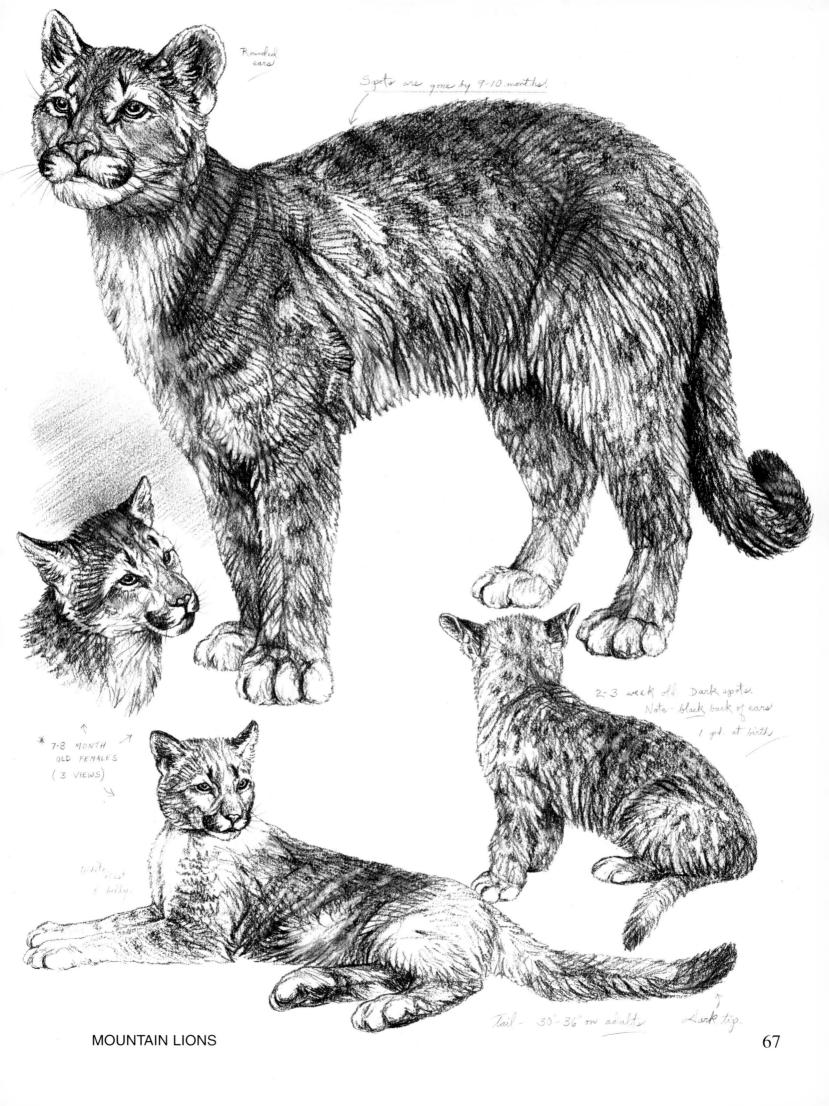

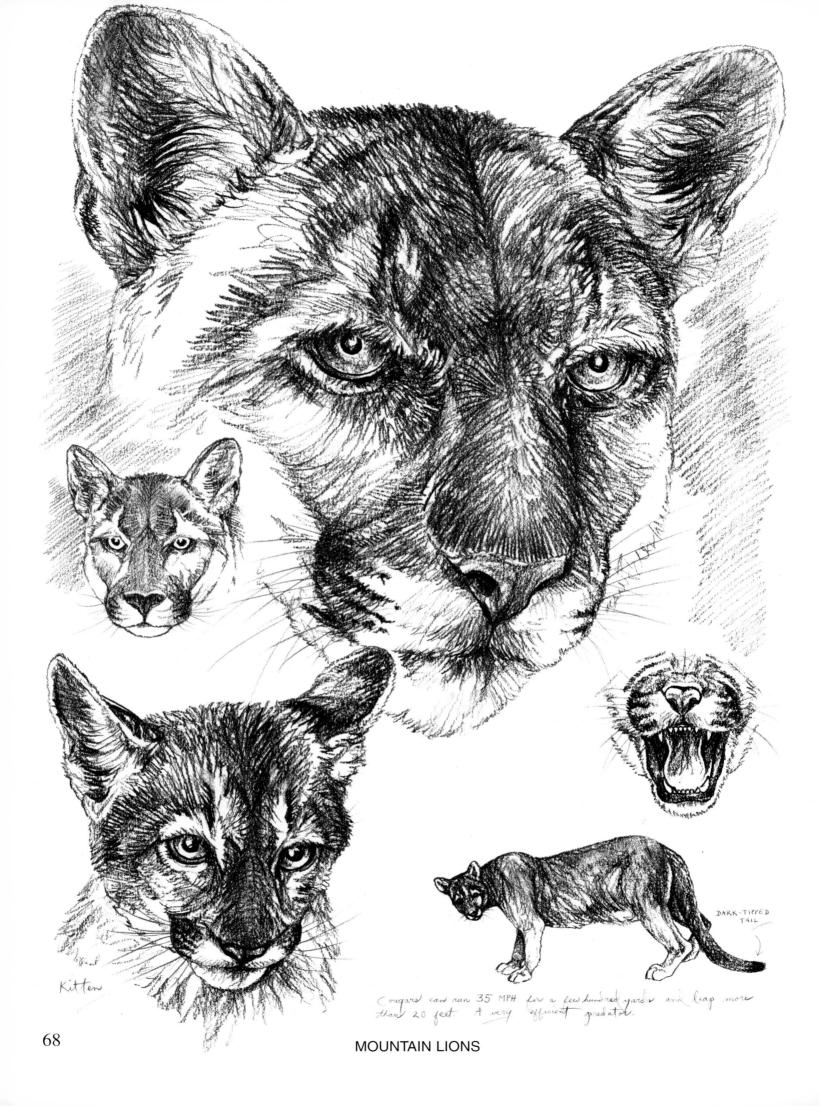

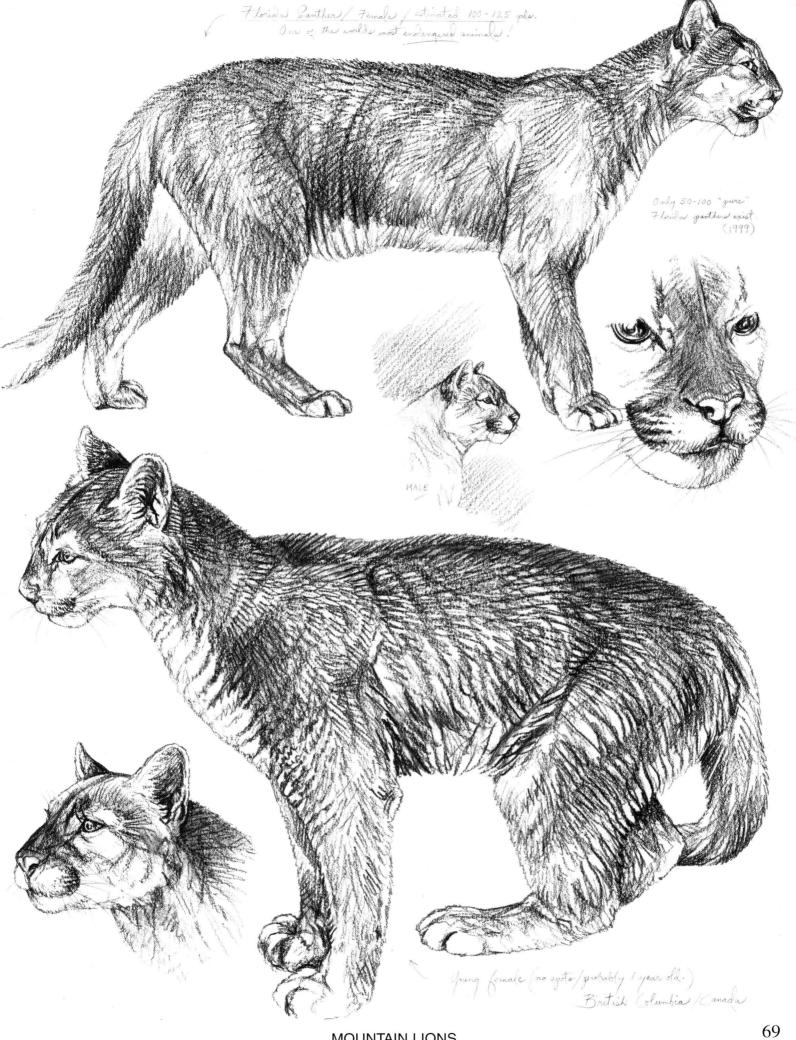

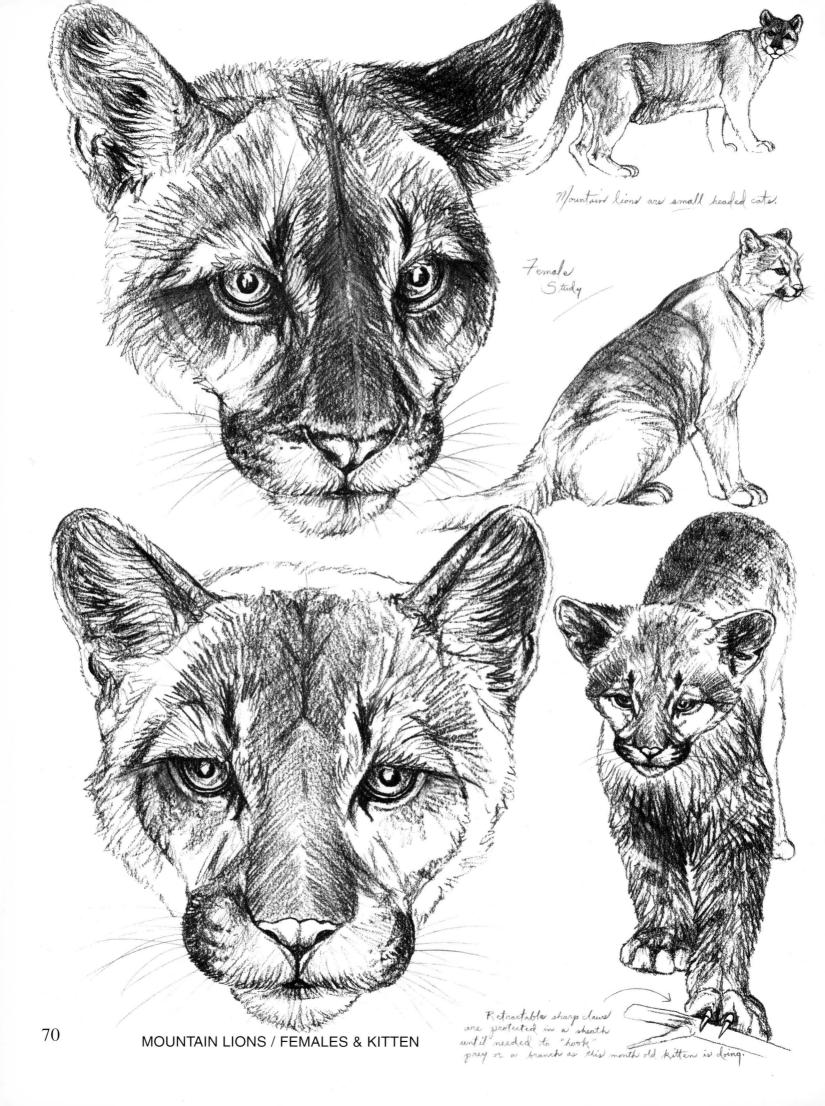

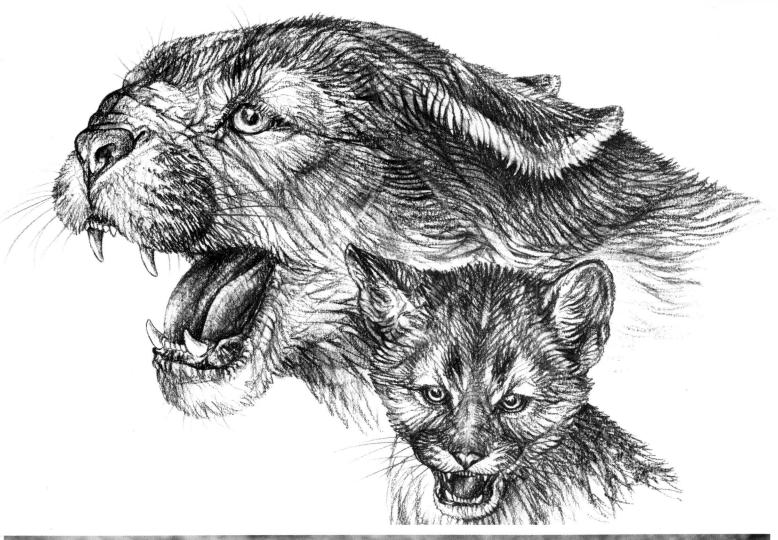

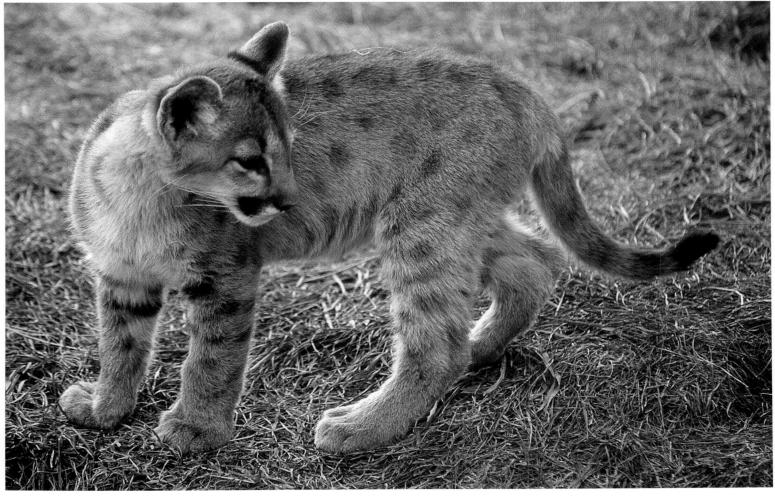

MOUNTAIN LION / KITTEN (SEPTEMBER)

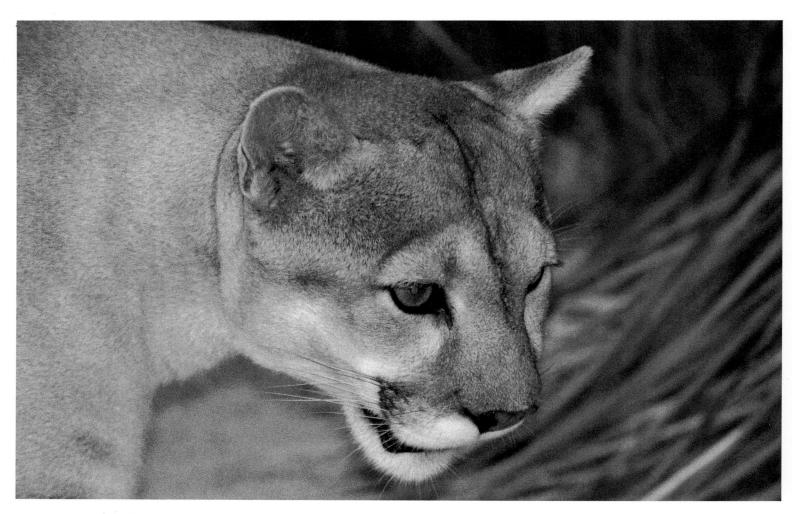

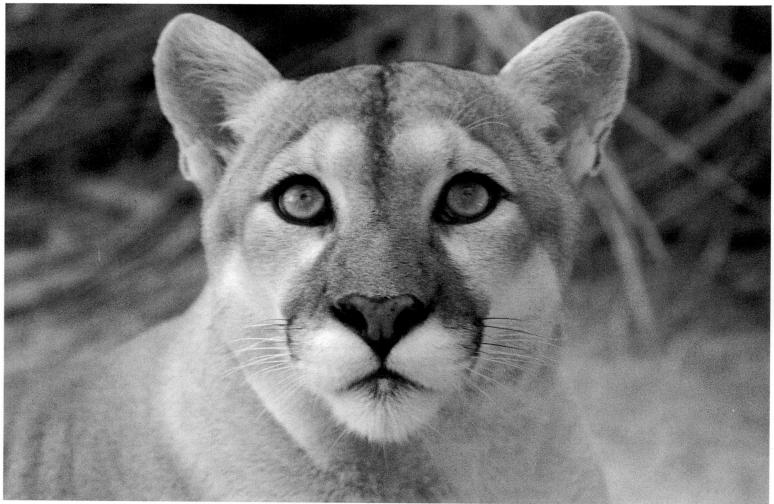

72

MOUNTAIN LION / MALE (AUGUST)

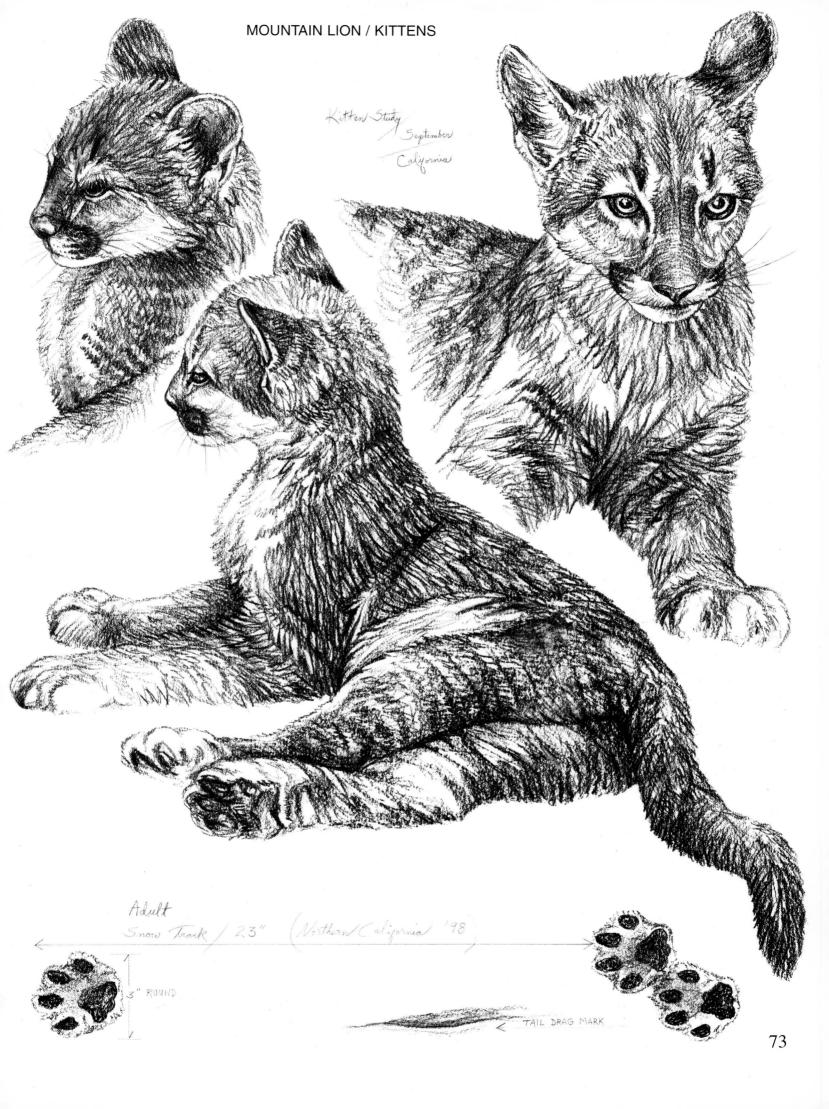

PRONGHORN

The pronghorn (Antilocapra americana) is often misnamed "antelope", but is not related to members of that family. It is the only animal in the unique family, Antilocapra, and it sheds its horns yearly just as antlers are shed by deer. All other "horned" mammals in North America retain their horns and which grow longer every year. The pronghorn is the fastest mammal in North America and has been clocked at 70 mph for short periods. It has no natural enemies because of its speed, and only newborn fawns are vulnerable to bears, coyotes, and Golden eagles. Pronghorns are confined to the western half of the United States and range from southern Saskatchewan to Mexico, with Montana and Wyoming claiming the biggest populations. It is associated with the open plains and prairies where its phenomenal eyesight can detect movement and danger from miles away. When danger is detected, the pronghorn "flares" their long rump hair and thus alerts others nearby. Because they evolved on open, treeless country, they never developed the ability to jump vertically. That is why you'll see them crawl under fences, rather than jump over them.

Adult males (bucks) are about 36" - 40" at the shoulder, 4' - 5' long, and weigh (on average) 90 - 140#'s. Females (does) weigh 70 - 100#'s. This deer-like "speedster of the plains" is tan and white in color and the bucks have a black neck patch and facial marks. Both sexes sport horns; a does seldom exceeding 4" and a bucks peaking at about 20". The unique black horns are lyre-shaped and have short "prongs" that jut forward.

Mating occurs in September/October and fawns (commonly twins) are born during early summer. Newborns weigh about 4 pounds and are able to outrun enemies and keep up with adults in 6 or 7 days. Until then they are virtually odorless and spend a lot of time huddled in the grass. It is an interesting observation of nature to witness a doe give birth to one fawn and then move to another place to bear her second. This hereby separates the newborns and makes it less likely that a predator would discover both. Pronghorns normally live 8 to ten years in the wild.

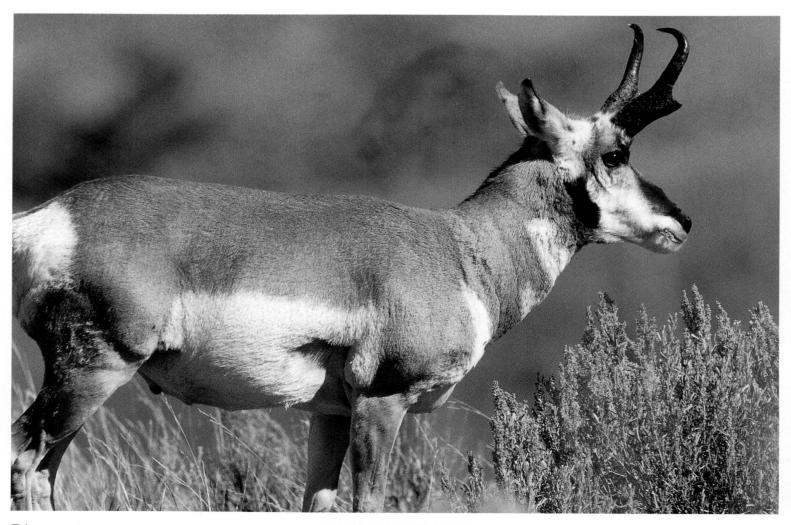

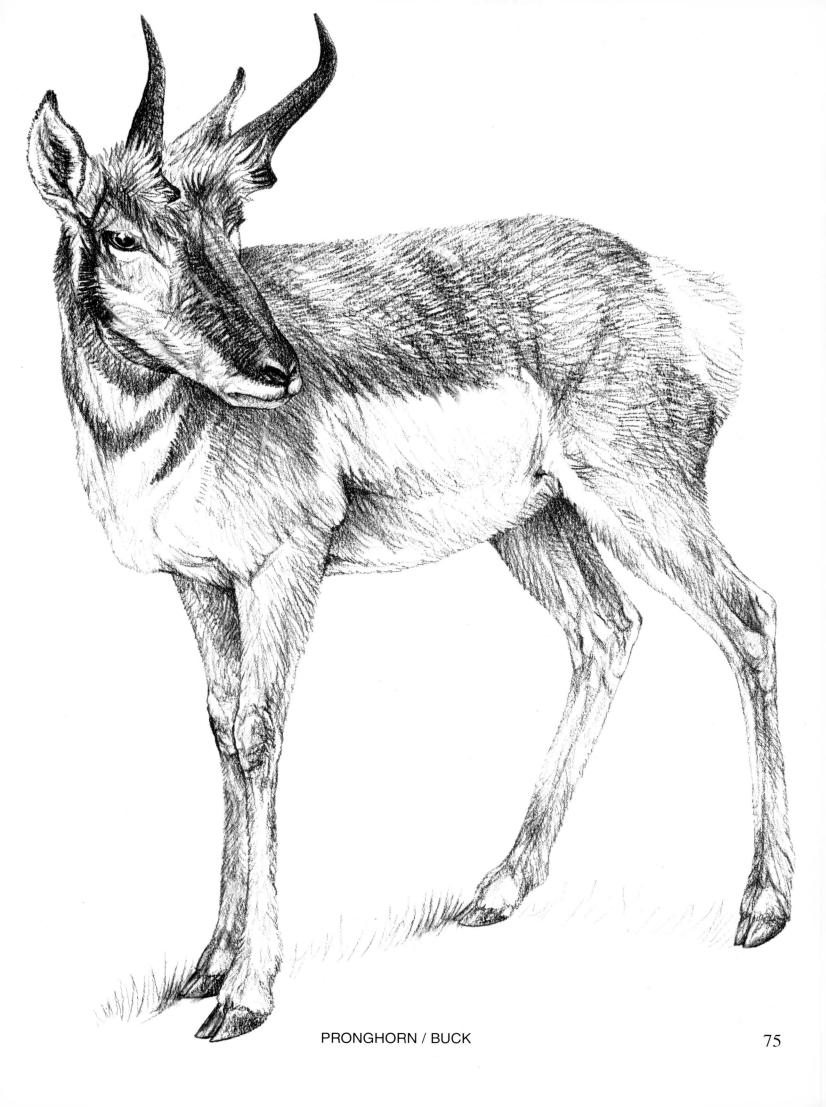

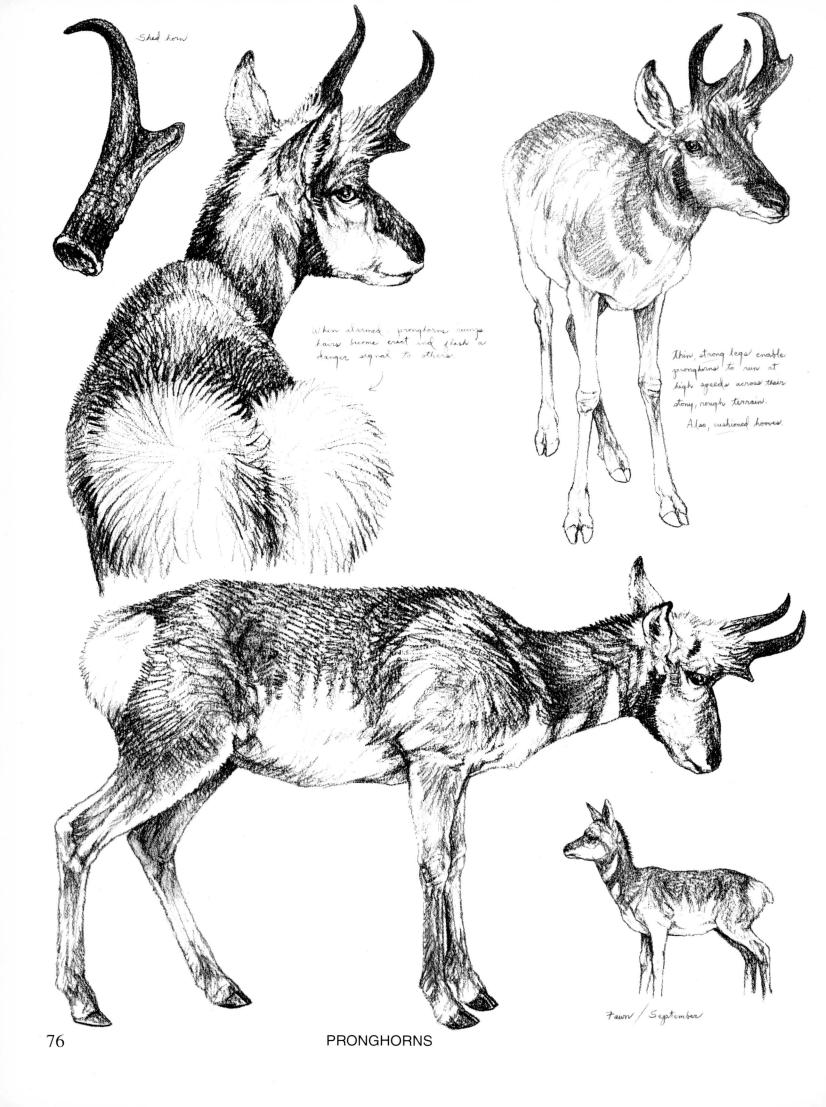

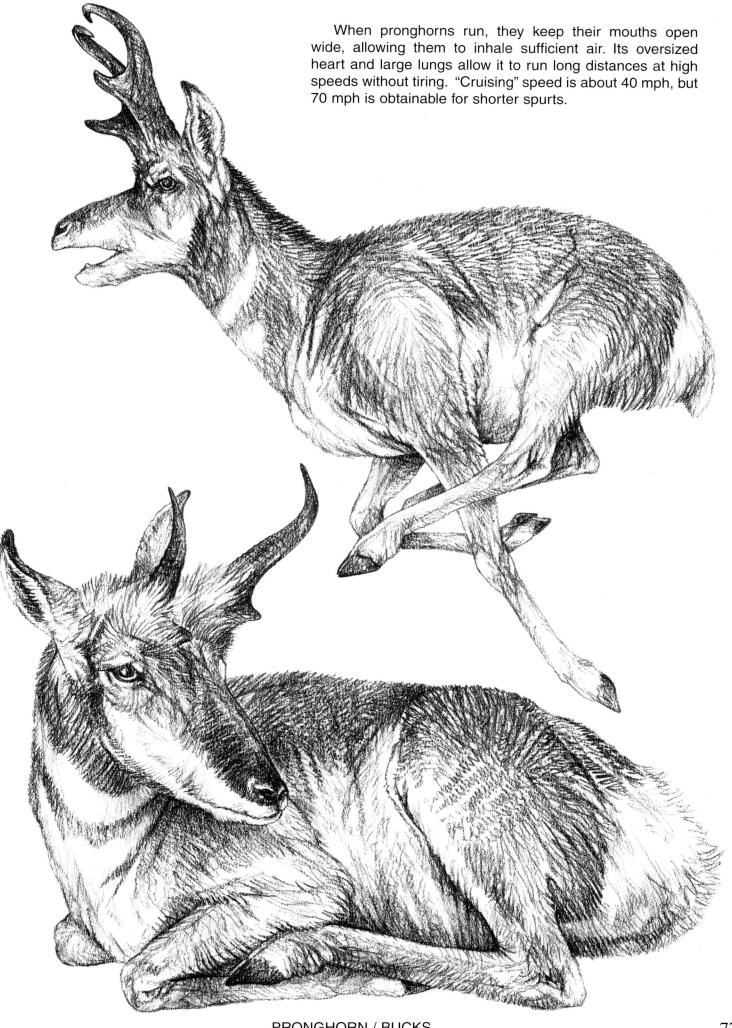

PRONGHORN / BUCKS

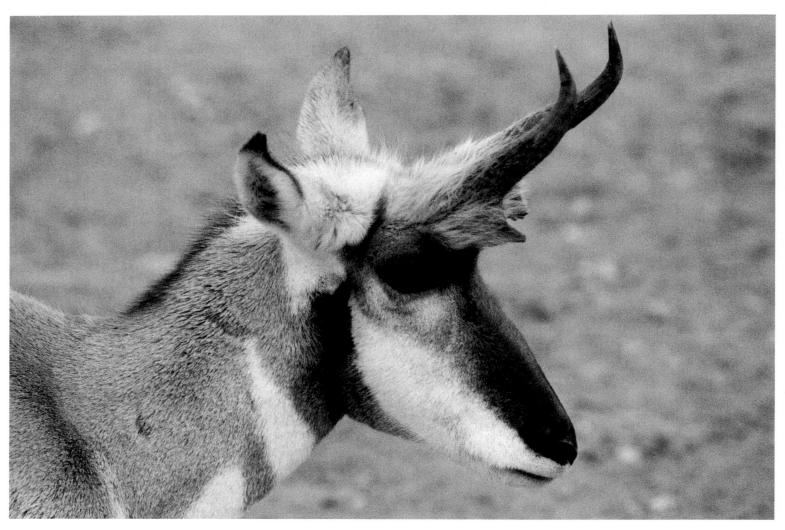

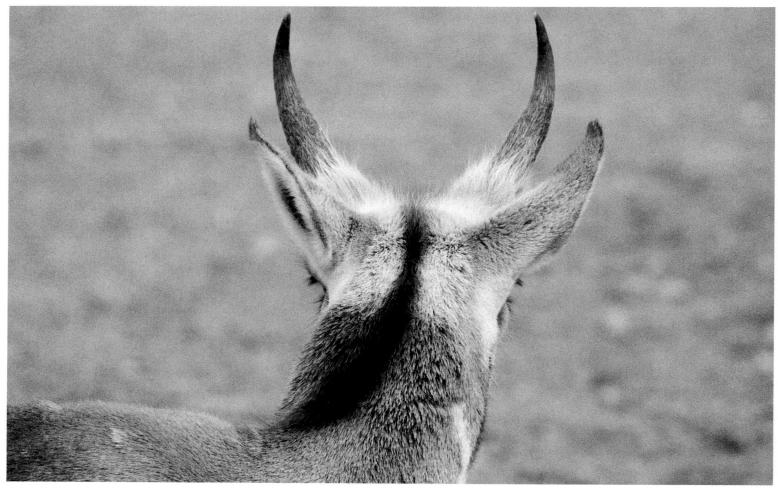

PRONGHORN / BUCKS (OCTOBER)

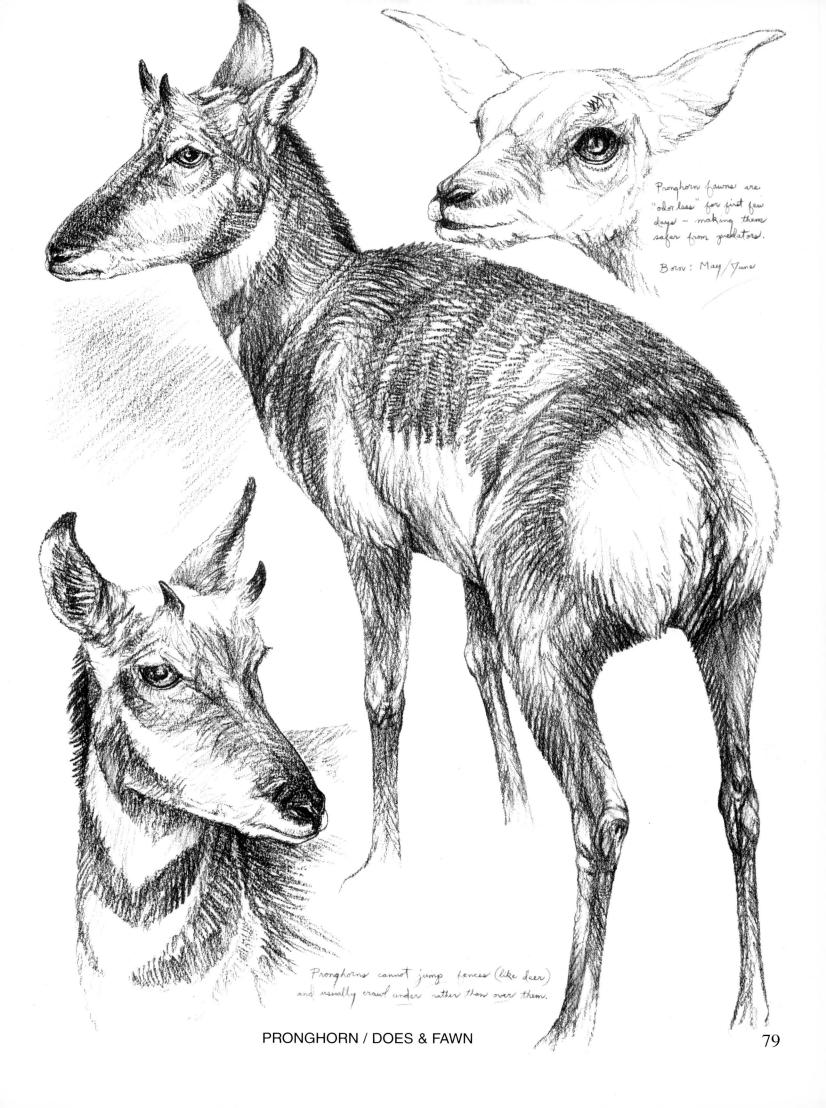

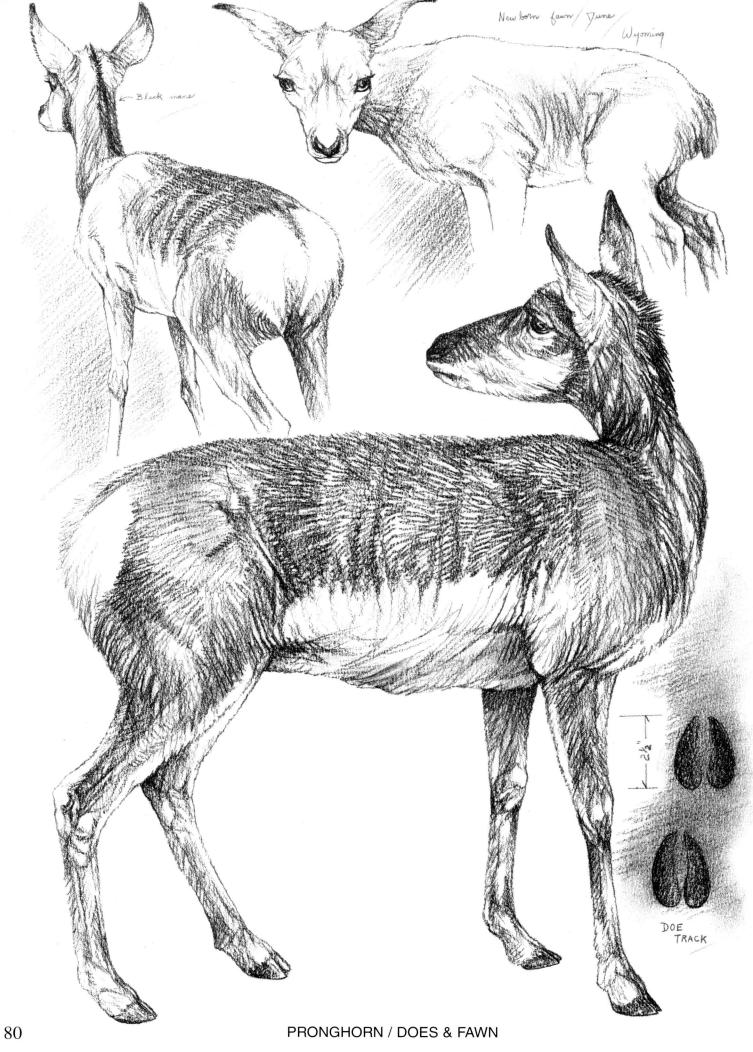

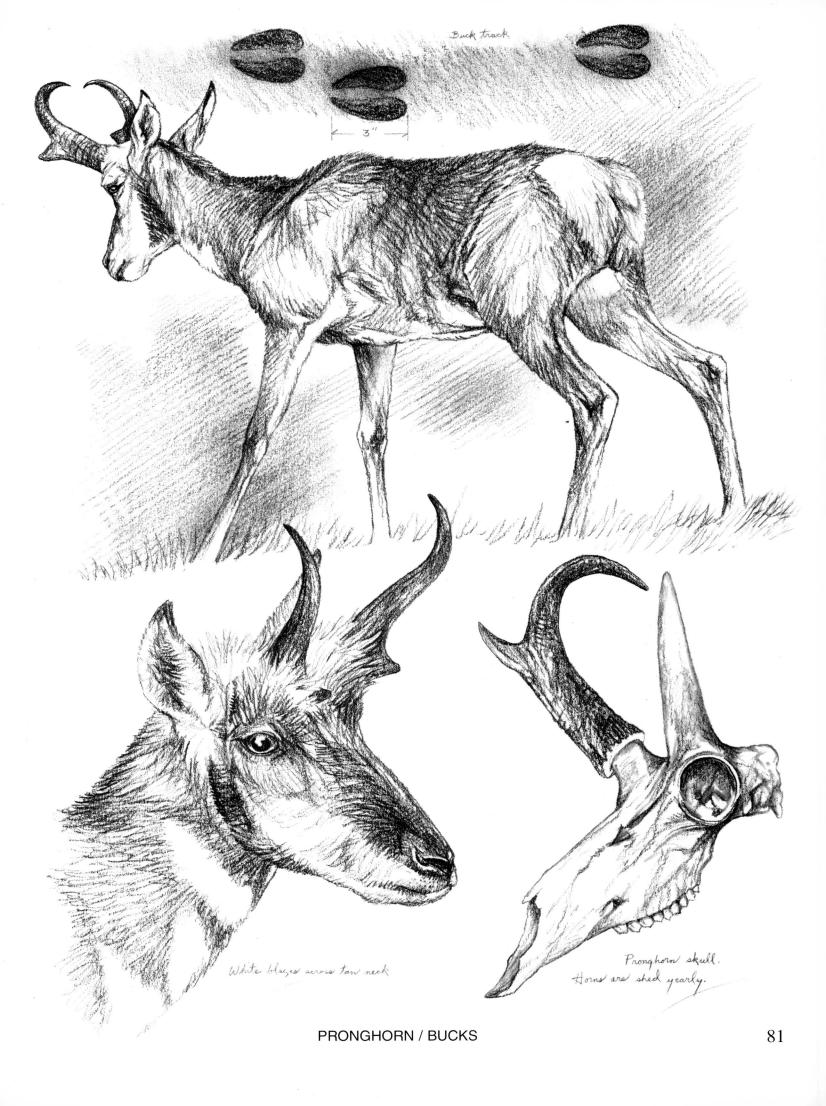

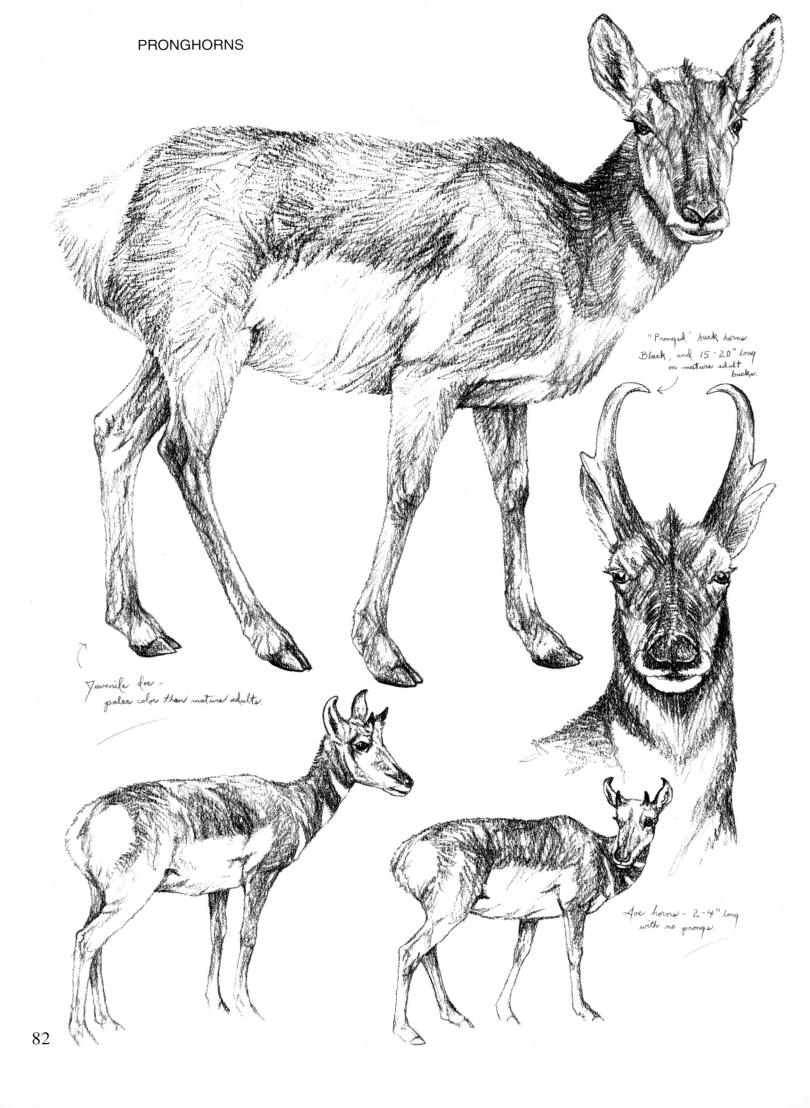

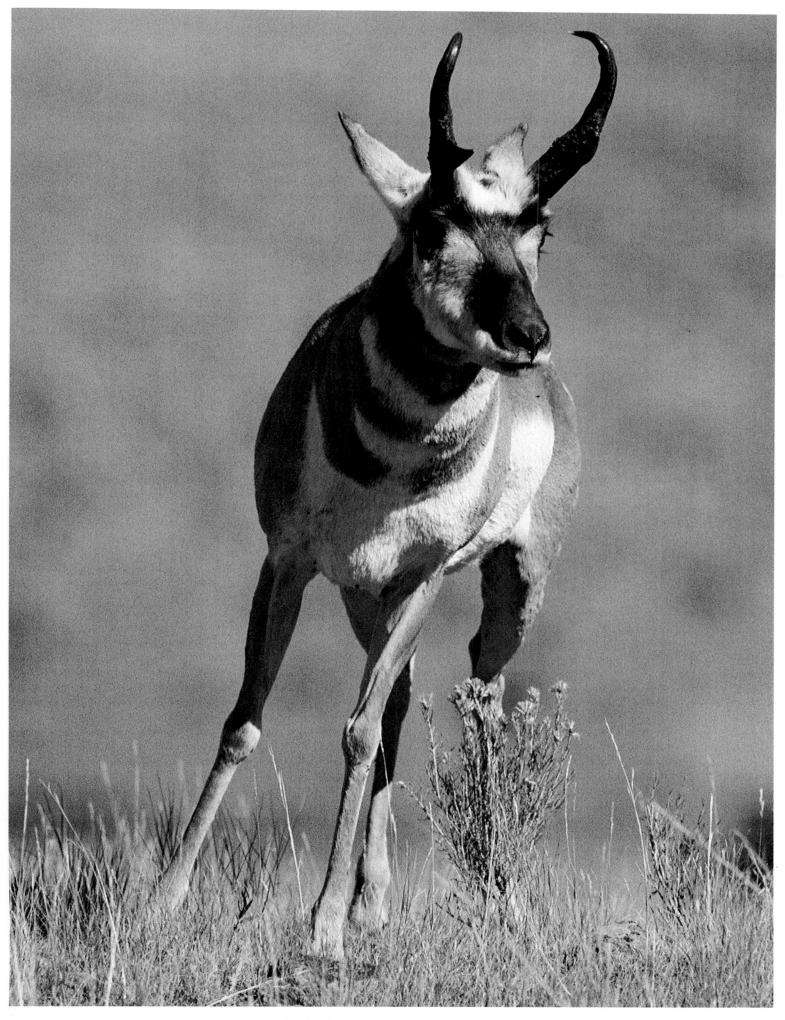

PRONGHORN / BUCK (SEPTEMBER)

BISON

The bison (Bison bison) is the largest terrestrial animal in North America and large males will weigh over 2,000#'s (females average 700 - 900#). A mature male will stand 6 feet at the shoulder and be 10 - 12 feet in length. The huge, bearded, shaggy maned, massive headed beast once roamed and migrated across a vast area of North America, but now mostly exists in National parks and private preserves. Small free-ranging herds do exist in a few areas such as Alaska, British Columbia and Northwest Territories. Wolves are really their only natural enemy nowadays and selected hunting is sometimes used to thin herds to keep them from overgrazing their habitat. Bison (also incorrectly called "buffalo") are dark brown in color, both sexes have upturned black horns, and are a grazing mammal that favors prairie grasses and sedges. During the frigid winters, their huge heads and wide hooves enable them to "plow" away the snow to reach the buried vegetation. Wild bison normally live about 25 years.

Bison mate in July/August, and the reddish-orange calves are born the following April/ May. Pregnant females (cows) usually separate from the herd during delivery and within a few days the calf is strong enough to run and keep up. The familiar "hump" of the bison begins to develop on the calves within three months. During the annual "rut" the huge breeding males (bulls) stage impressive fights between themselves. Charging one another with heads down, the mighty impact crash resonates across the plains. This battle continues until one finally flees. A herd bull will often mate with dozens of cows.

In centuries past, the bison numbered over 50 million strong and their thundering herds would stretch for miles and miles. By the early 1900's there were less than 1,000 bison surviving in the U.S. and Canada. It is heartening to see that bison numbers are improving due to conservation measures and protection. It would've been unforgivable to allow this noble and hardy "buffalo" to perish into extinction.

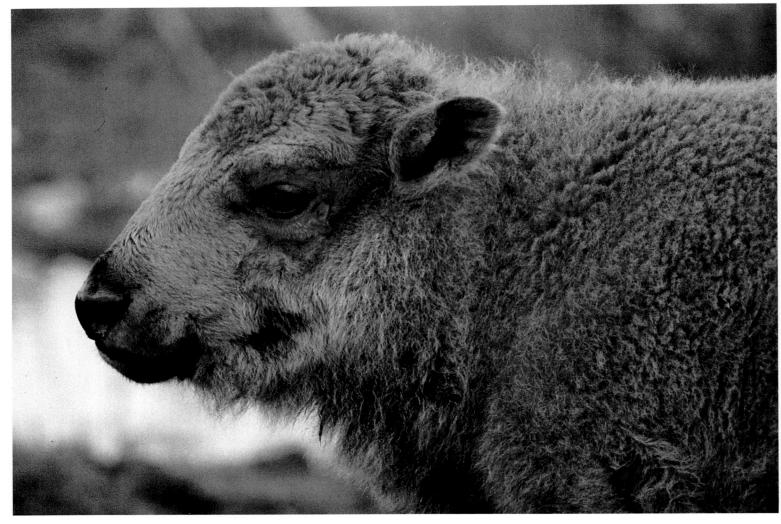

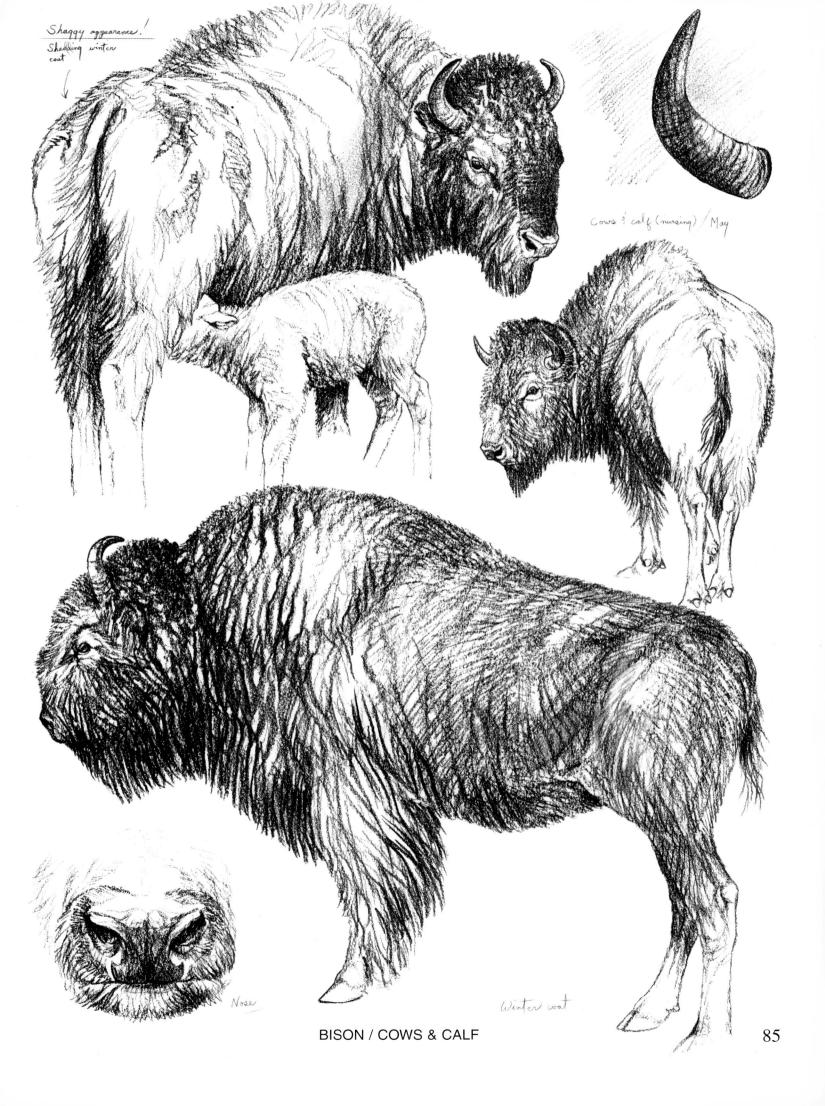

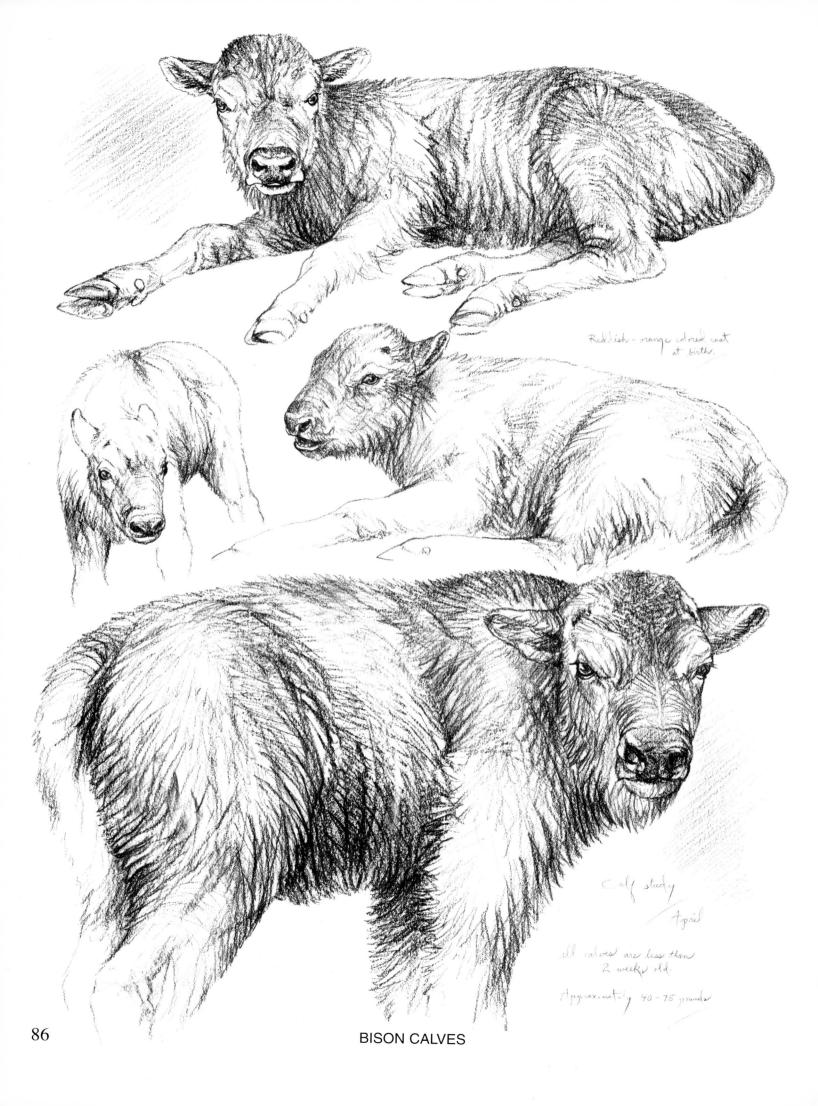

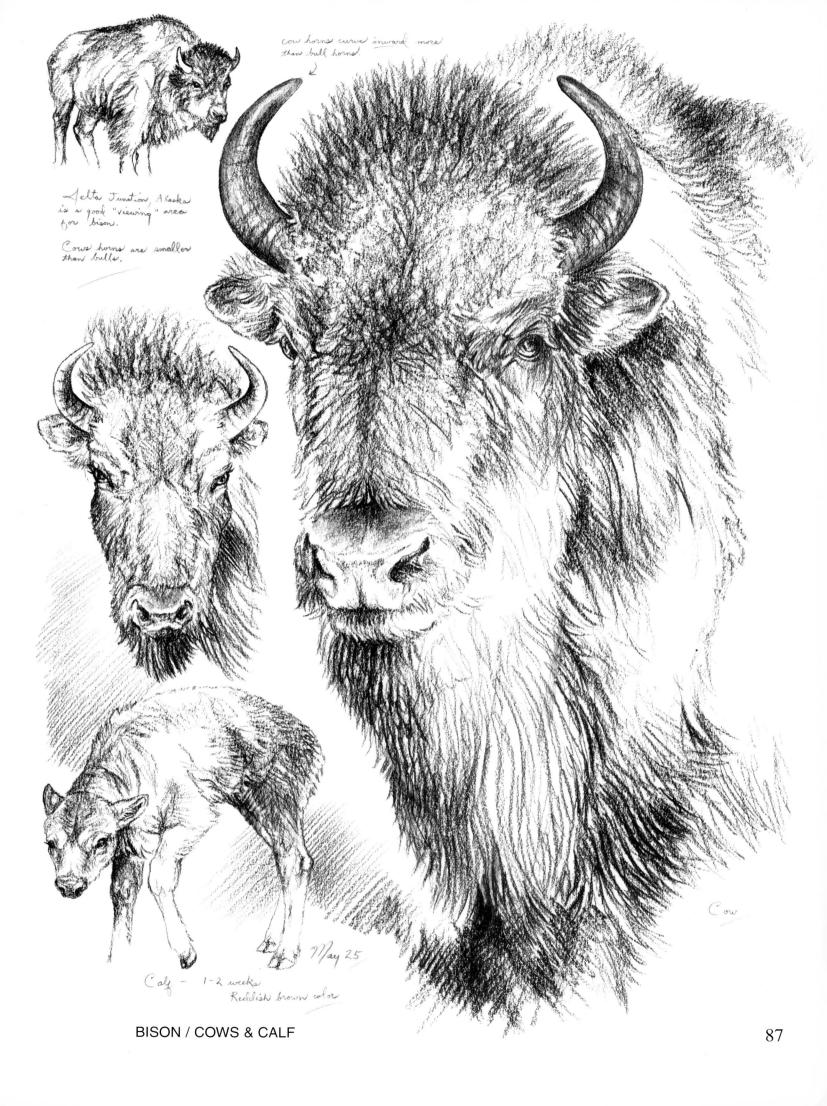

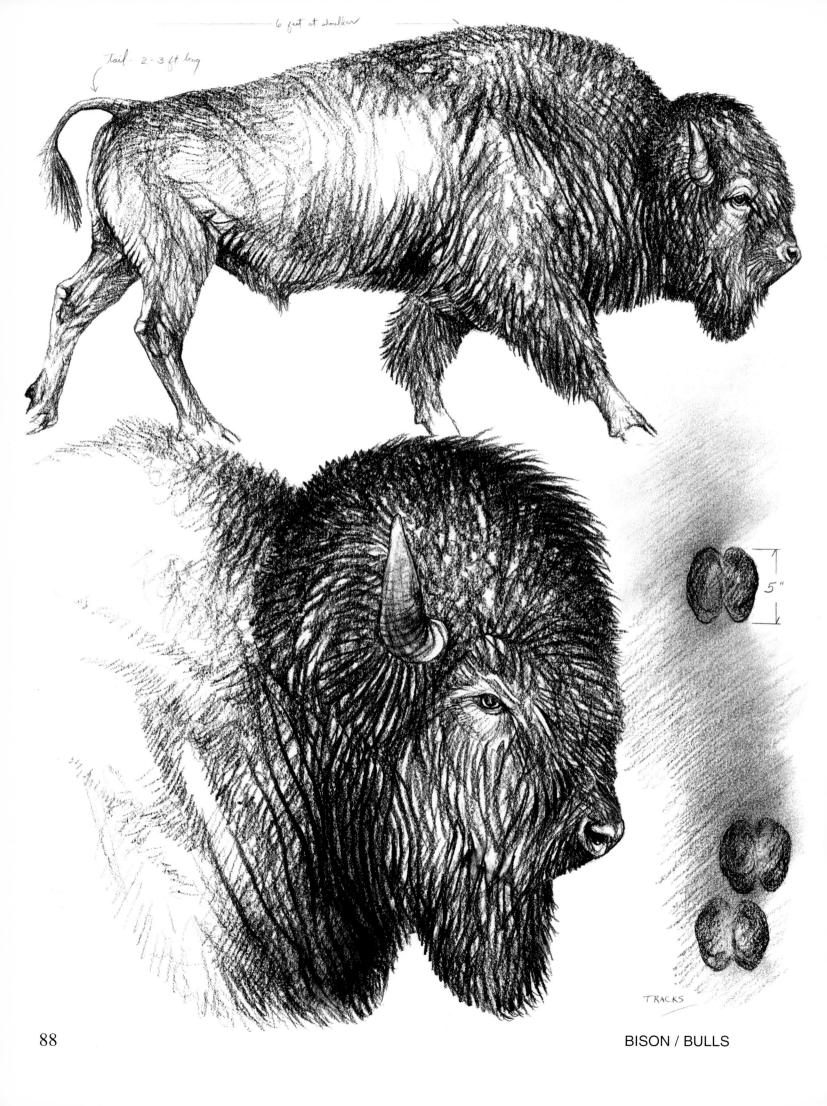

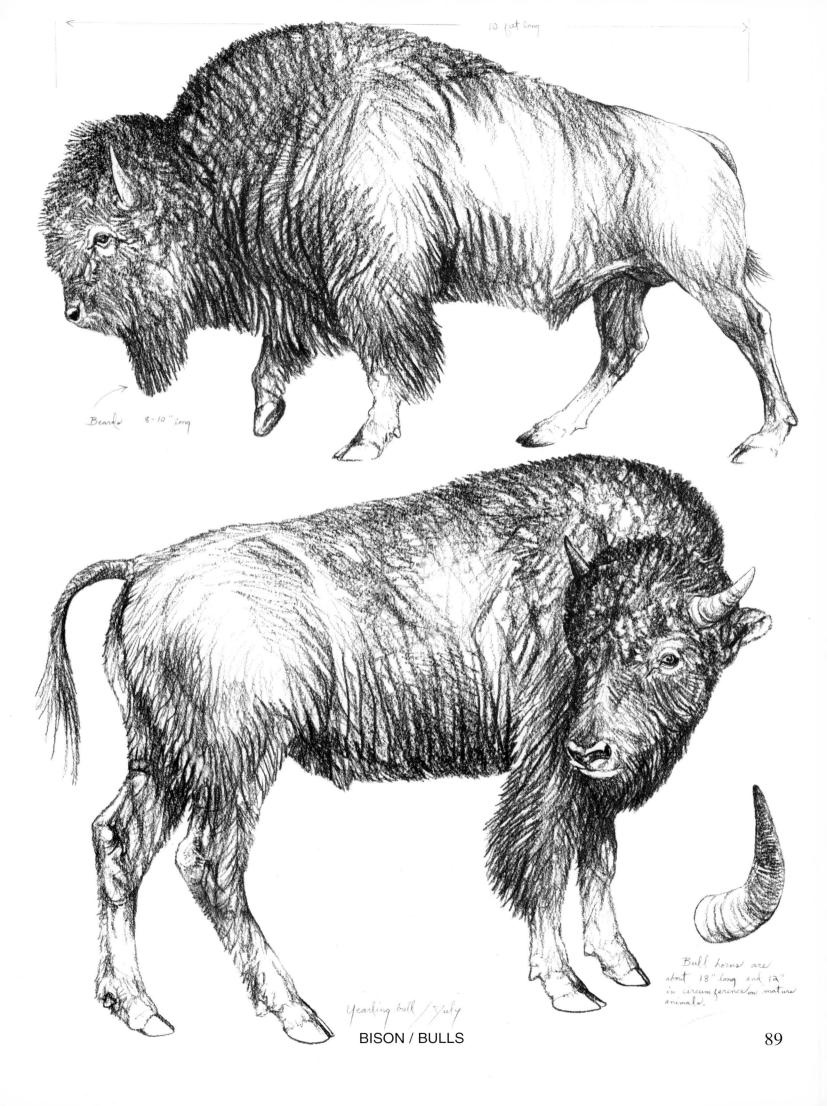

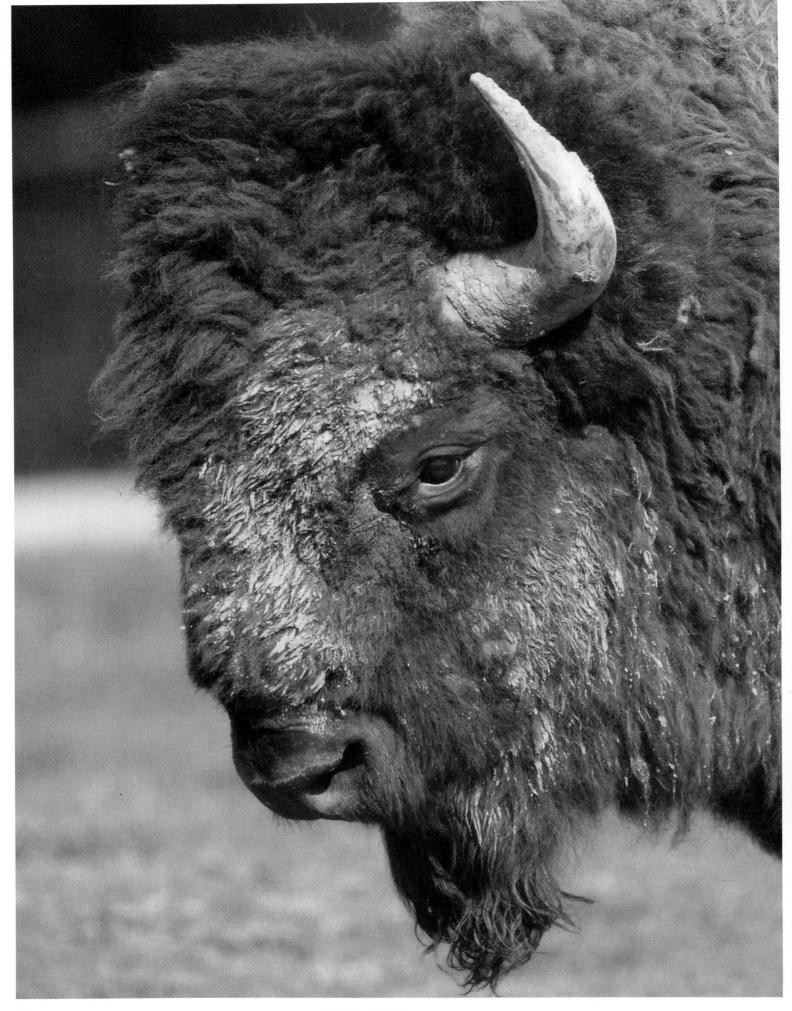

BISON / BULL

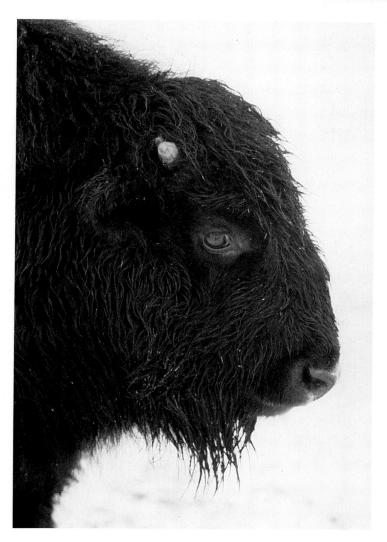

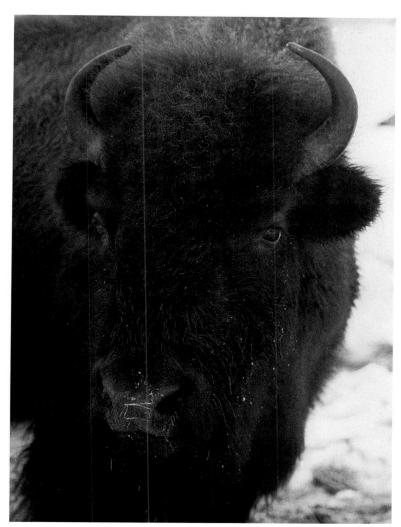

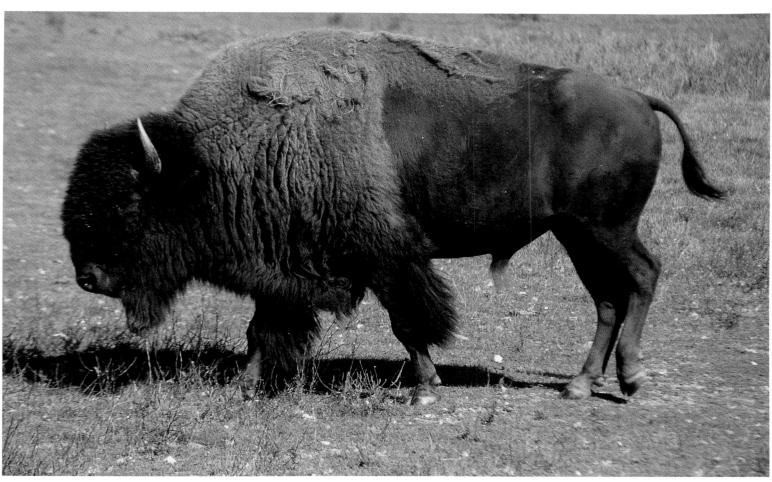

TOP: BISON CALF (7 months); COW (ADULT)

BOTTOM: BISON BULL (SEPTEMBER)

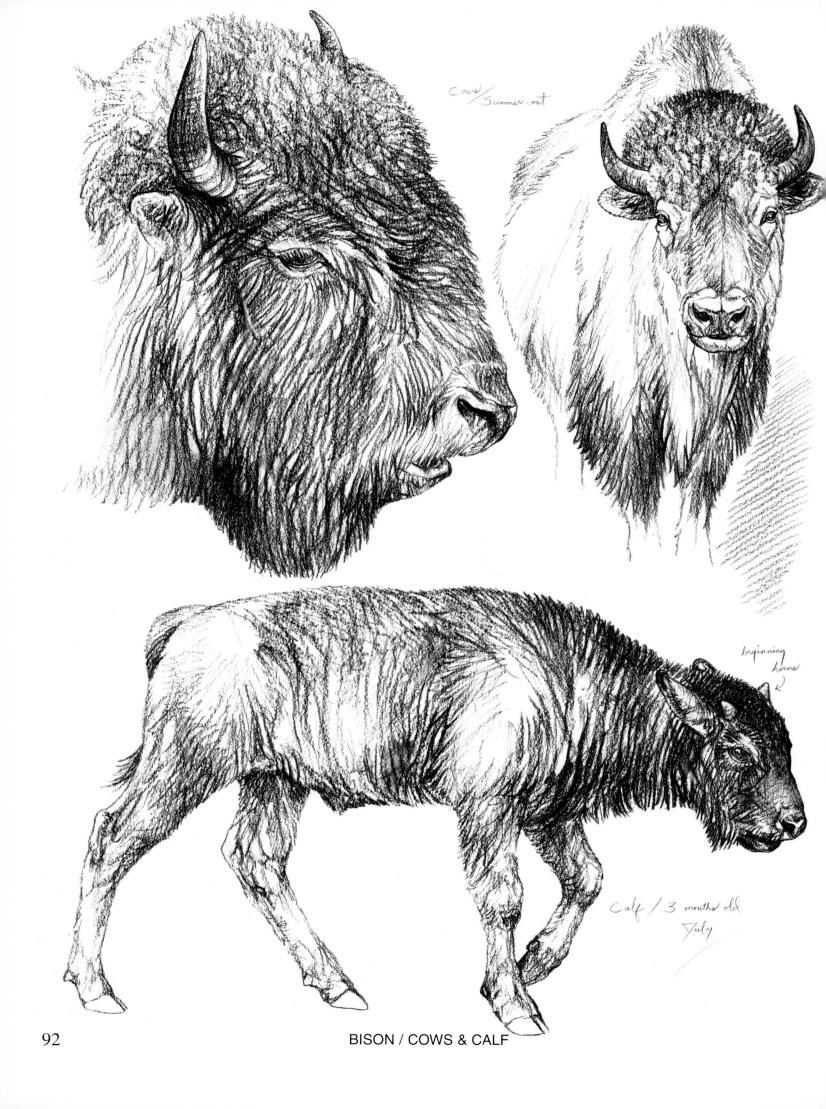

MOUNTAIN GOAT

The Mountain goat (Oreamnos americanus) is not a true goat and has no relatives in North America. Whereas a "true" goat's horns sweep up and curve back (and are "ridged"), the Mountain goat's horns are relatively smooth and curve back only slightly. North America's "goat" is white and has a black nose, horns, eyes, and hooves. It is a hardy, sure-footed creature who dwells in high mountain terrain of northwestern North America, and has natural populations from Idaho to Alaska. They are often confused with the Dall sheep who they often share ranges with; however, their black horns, longer hair, and "beard" should distinguish them. Although the Mountain goat males are larger, both sexes are similar in appearance (even horns are similar in length, but the females (nannies) are more slender). A mature male (billy) will weigh around 200#'s, stands 40" - 48" at the shoulder, and is 5' - 6' long.

Mating occurs in November/December, and the normally segregated males join the groups of females (and immatures) to breed. Billies do not collect harems of nannies and there doesn't seem to be the "rutting battles" that often accompany other species. Young (kids) are born the following May/June, and will stay near their mother until the next mating season. Mountain goats live in dangerous terrain but have few natural enemies besides the Golden eagle. Their lifespan is about 15 years in the wild.

Mountain goats are slow-paced animals. This may be due to their rugged, rocky terrain, or the fact that few predators pursue them. Goats are most active during the morning hours and their diet consists of grasses, mosses, lichens and brushy material. Most goats migrate from their high summer environment to lower (below treeline) terrain during the snowy winters. It is there where they are most vulnerable to predators such as Mountain lions and wolves, but their excellent eyesight and rubbery-soled hooves usually provide salvation.

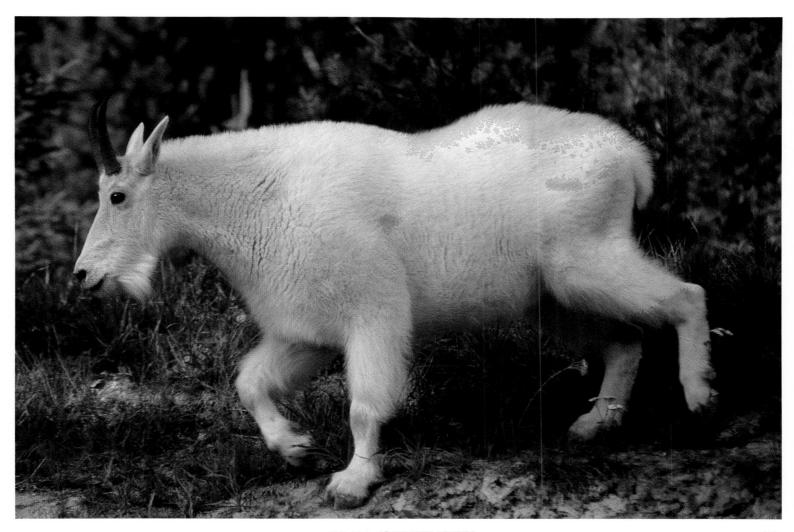

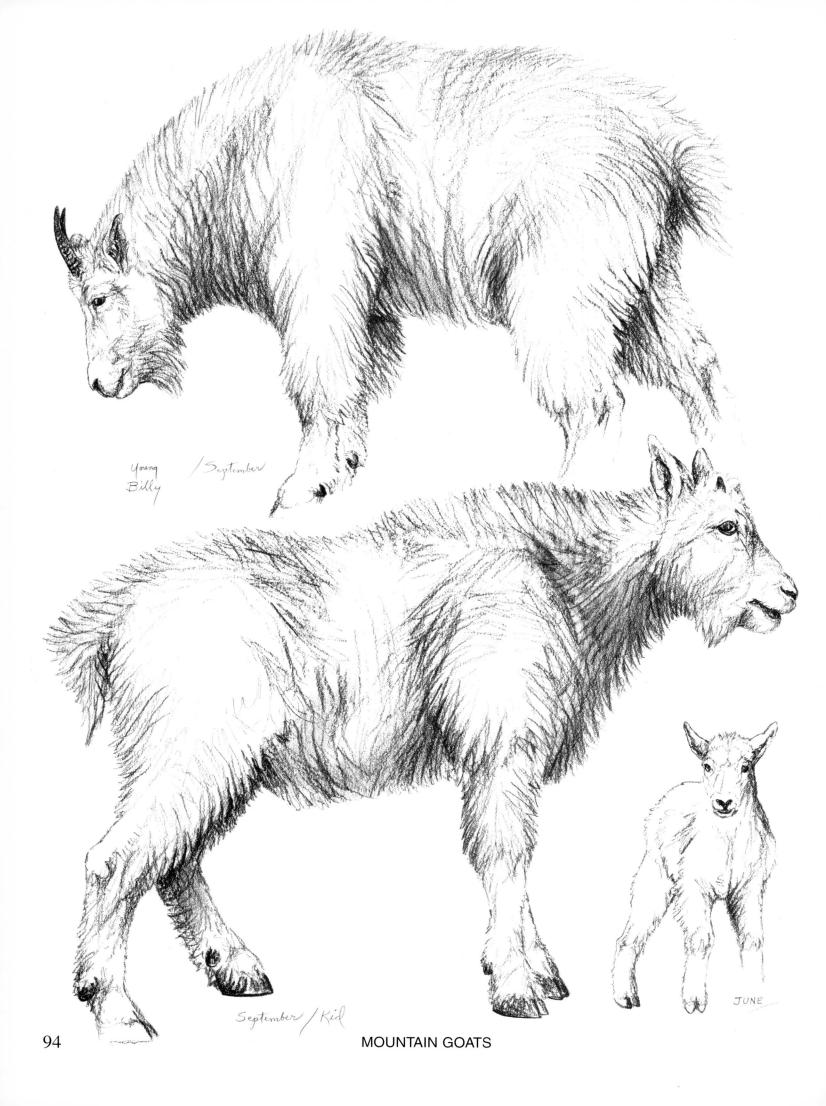

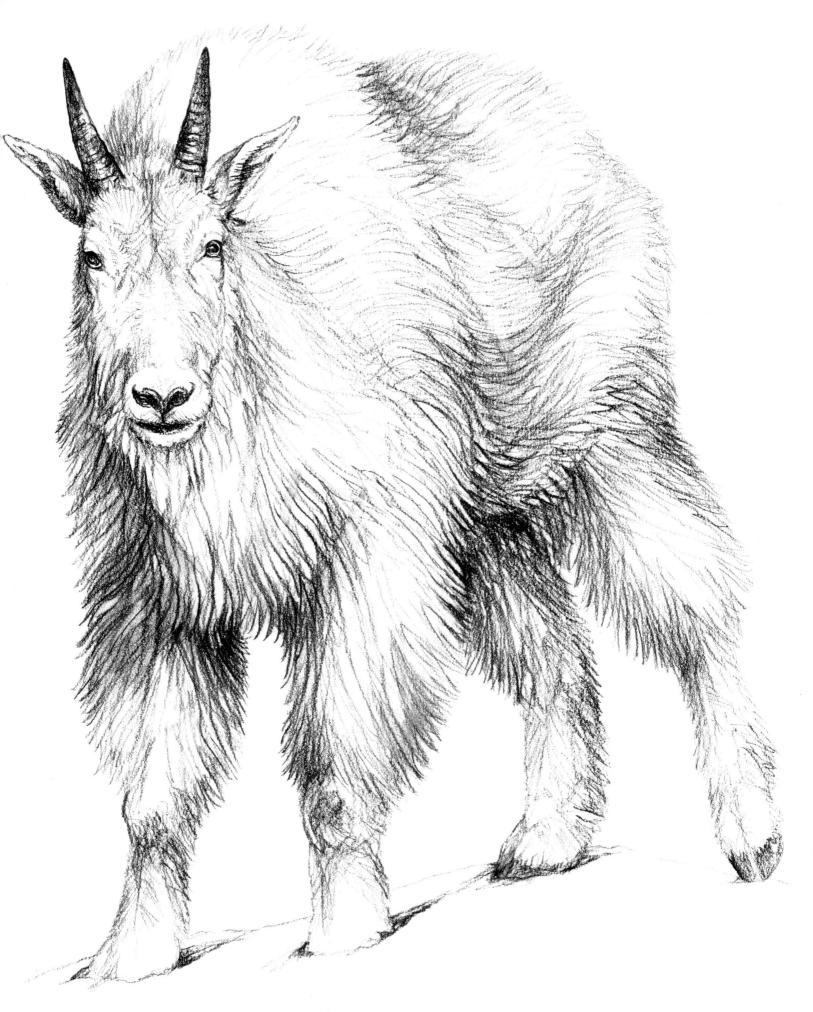

MOUNTAIN GOAT / BILLY

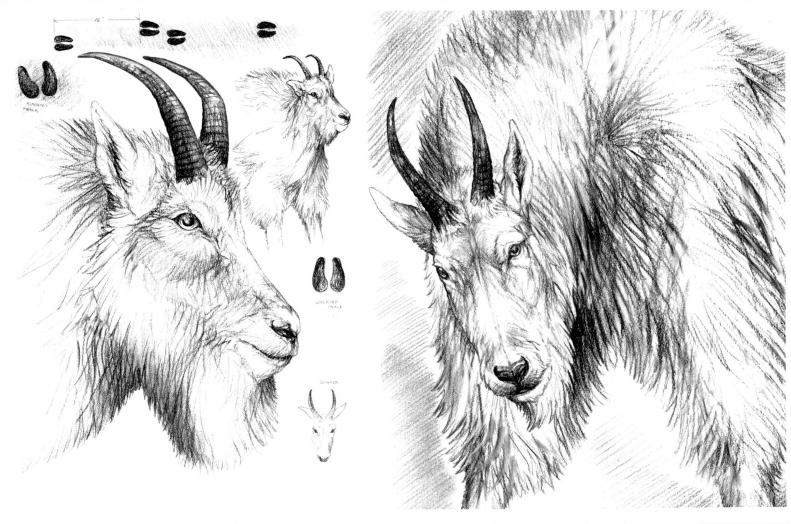

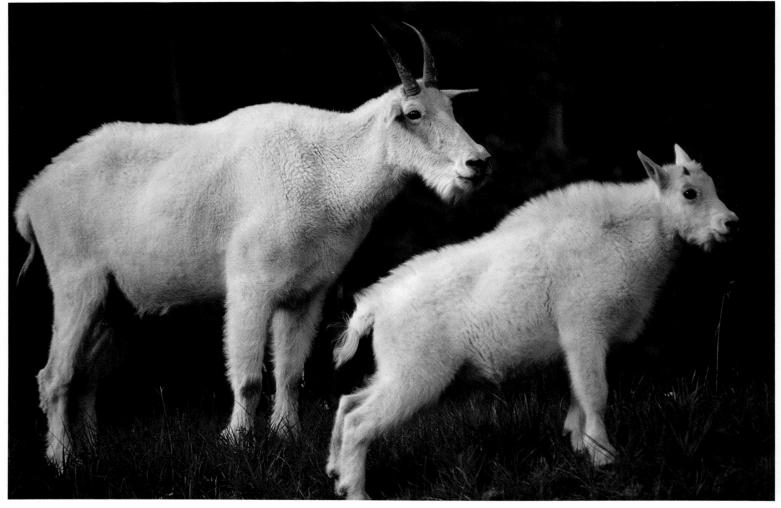

MOUNTAIN GOAT / NANNY & KID (SEPTEMBER)

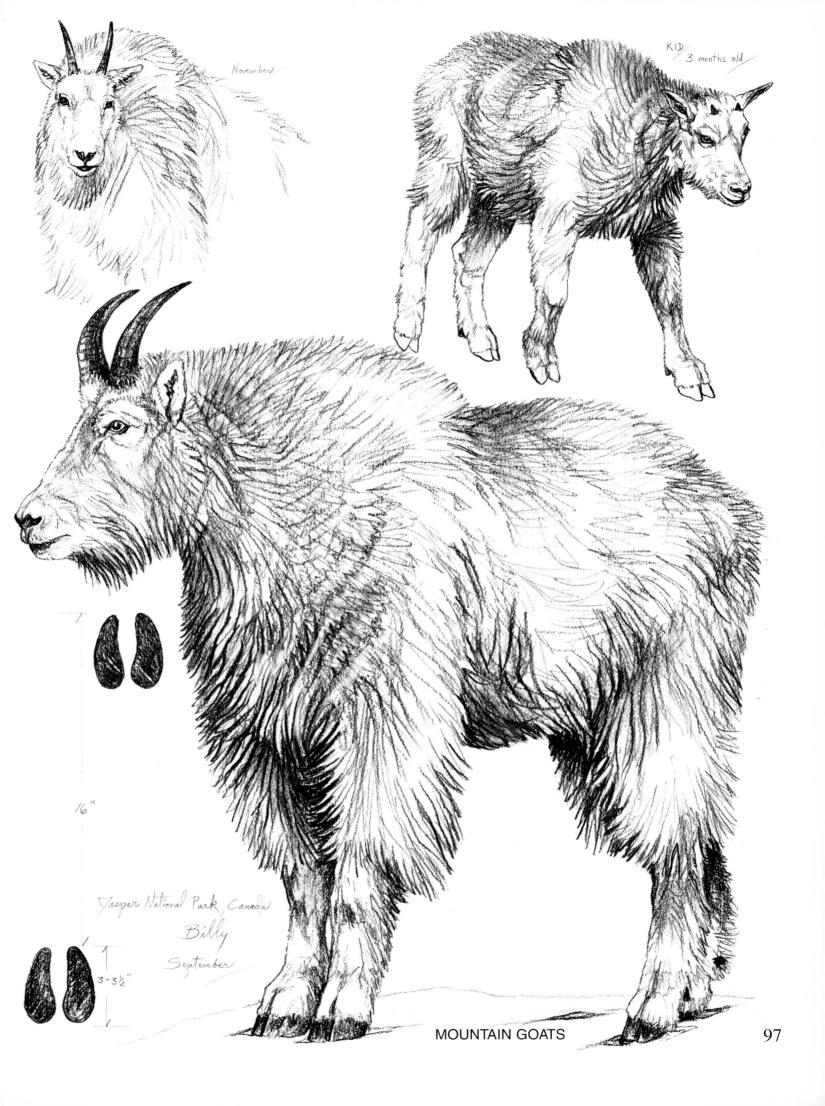

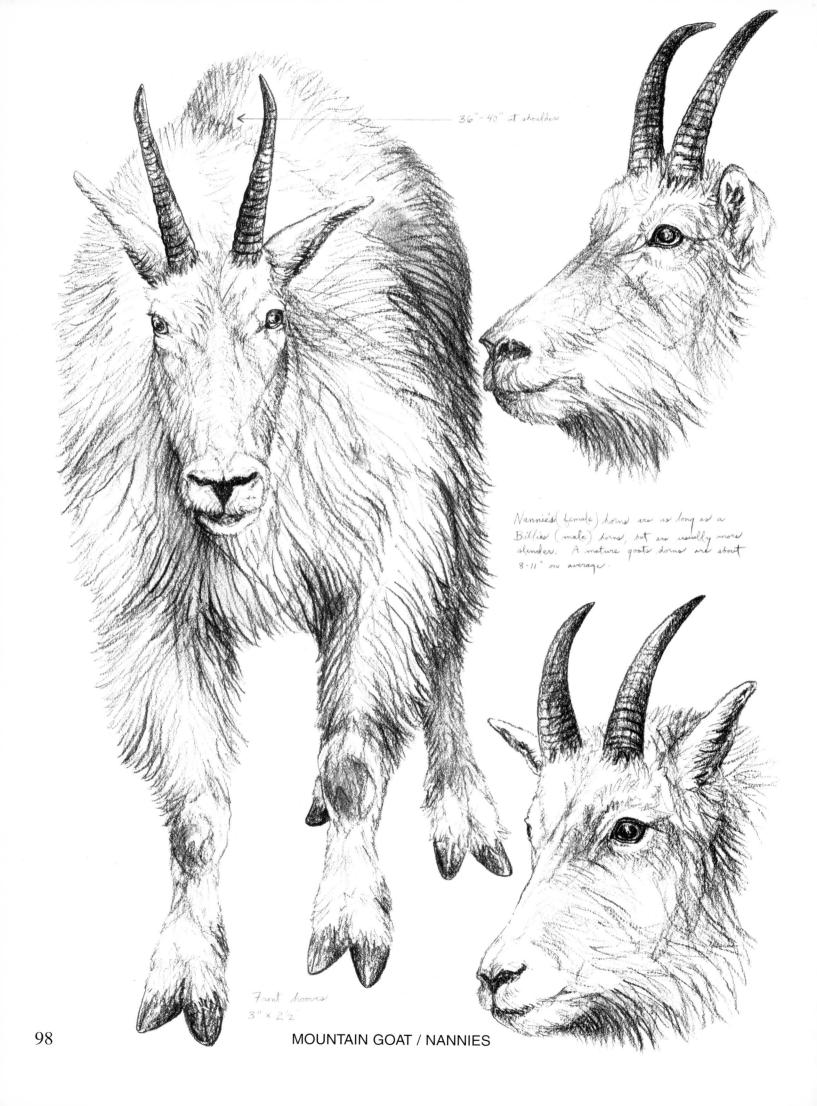

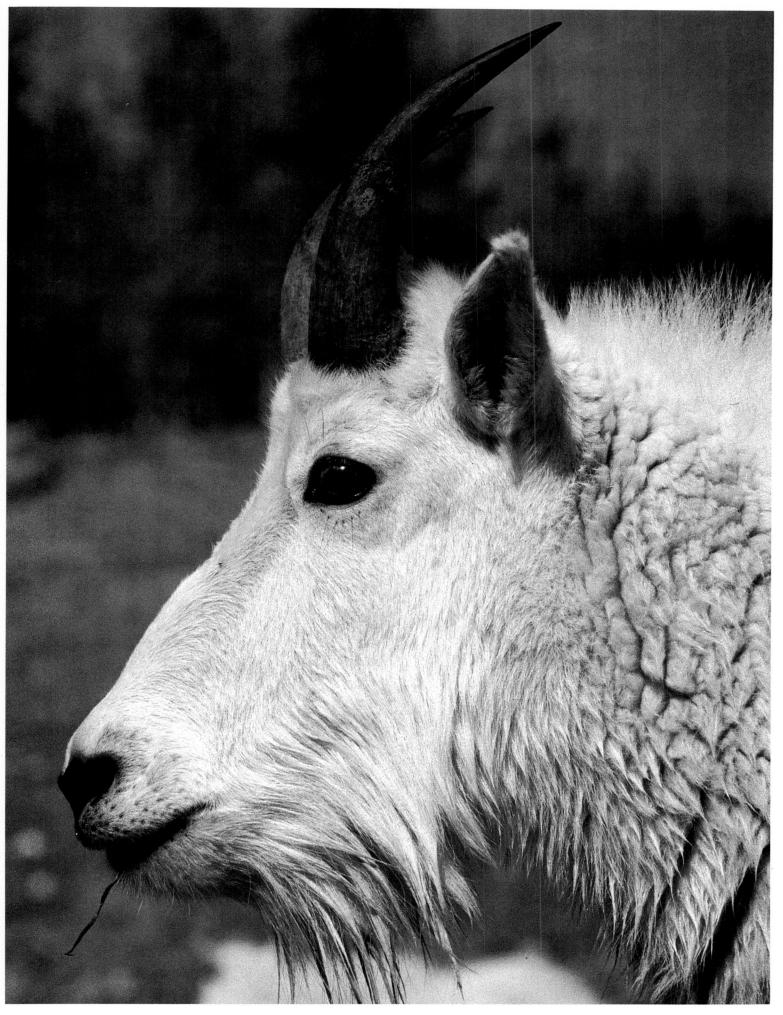

MOUNTAIN GOAT / BILLY (OCTOBER)

MUSKOX

The muskox (Ovibos moschatus) is a unique animal of the North. This stocky, longhaired animal is called "omingmak" by the Eskimos, and taxonomists classify it with the goats and sheep. The muskox has a dark brown coat with a light colored "saddle" on its back, whitish lower legs and cloven hooves. A mature male (bull) weighs 600 - 900#'s, stands approximately 60" at the shoulder, and is 7' - 8' long. Females (cows) are one-third smaller. Both sexes have horns.

Mating occurs from August/October, and young (calves) are born the following Spring (weighing about 25#'s). During the annual "rut" the bulls put on spectacular battles, trying to win the right to breed with the herds females. Competing bulls will charge one another at full speed and collide on their horn bosses (6" of horn and bone over the impact area protect their brains). These collisions are repeated over and over until one bull submits and leaves the area. The "crack" of smashing horns carries for miles across the northern tundra.

The range and numbers of Muskox are very limited due mainly to overhunting in the past. Their "defense position" of banding together with their heads facing the predator (and their vulnerable calves behind them) proved effective against wolves but was futile against men armed with rifles. Often times whole herds were shot. Muskox are now found free-ranging in Alaska and the Northwest Territories. Reintroduction into other former ranges is being considered. Their summer diet consists of green grasses and willows, and (because of the heavy snow cover) must survive on woody plants during the long winters.

Although it lives in seemingly barren and unforgiving country, the hardy muskox will thrive and expand its numbers if given the space and isolation it requires.

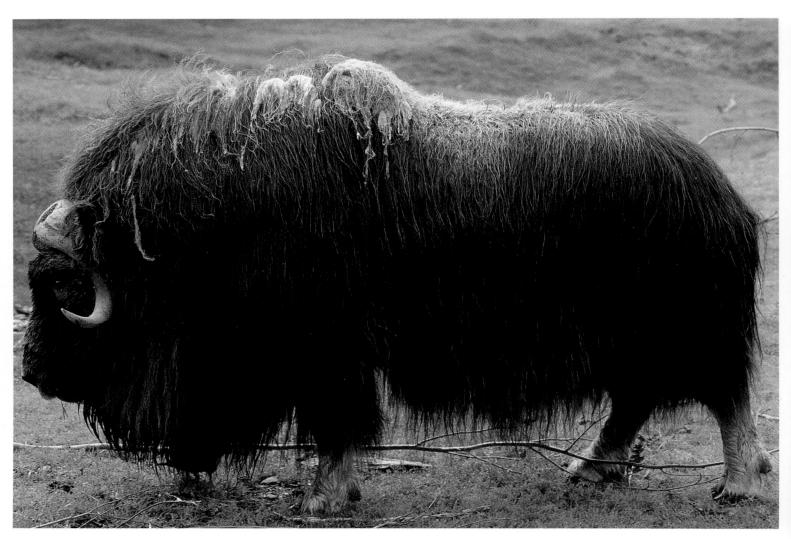

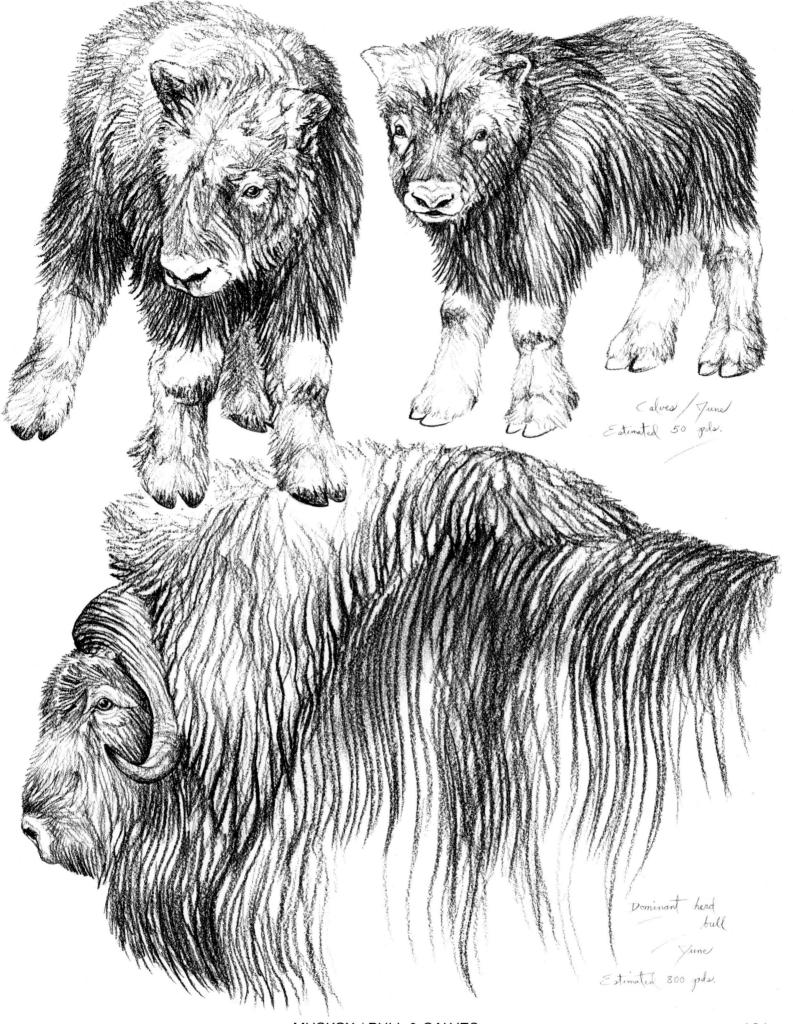

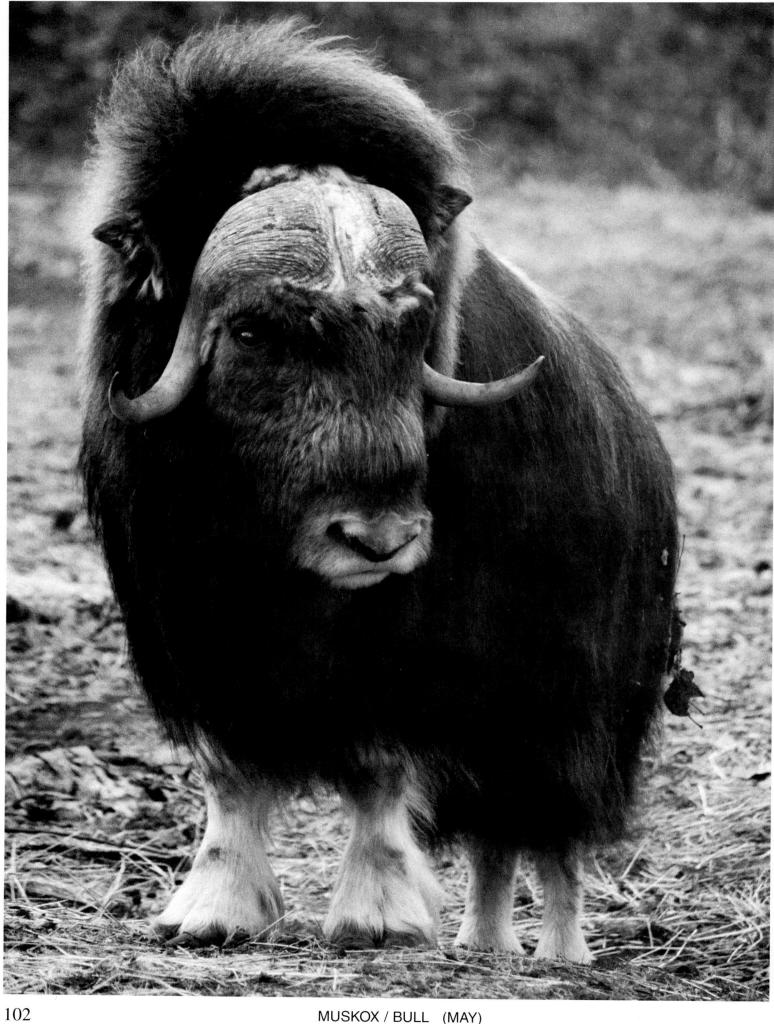

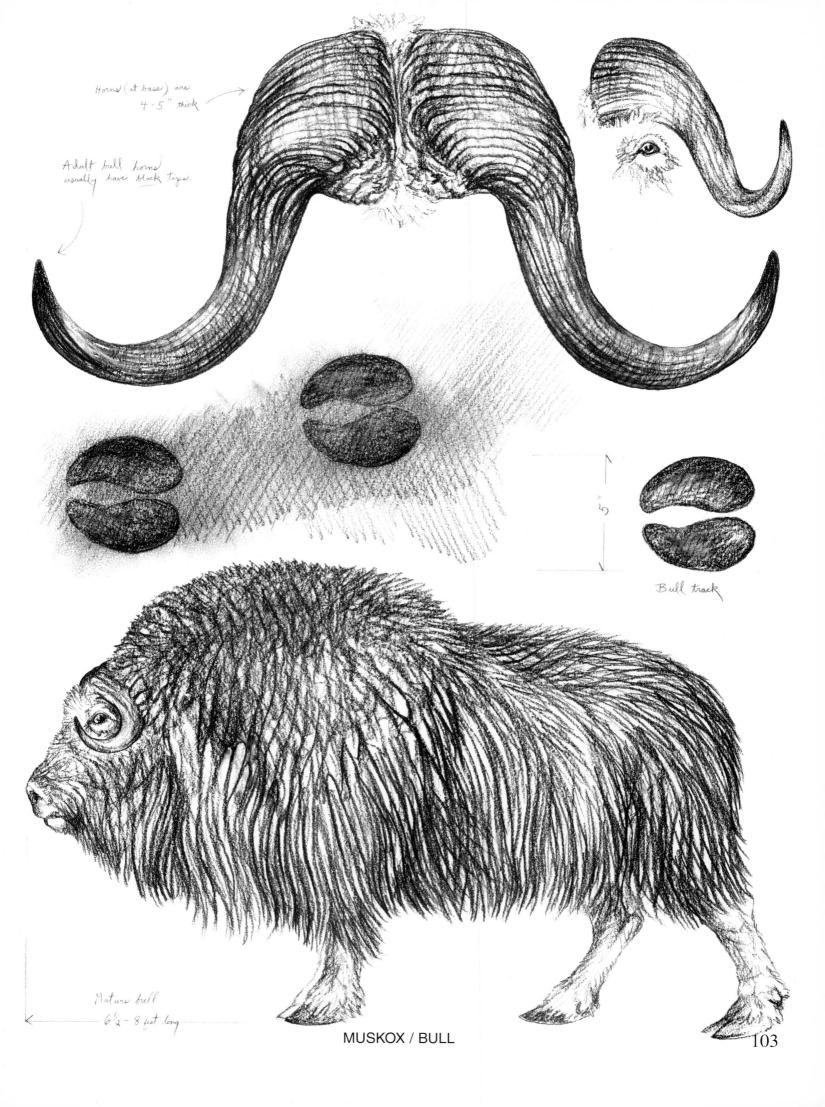

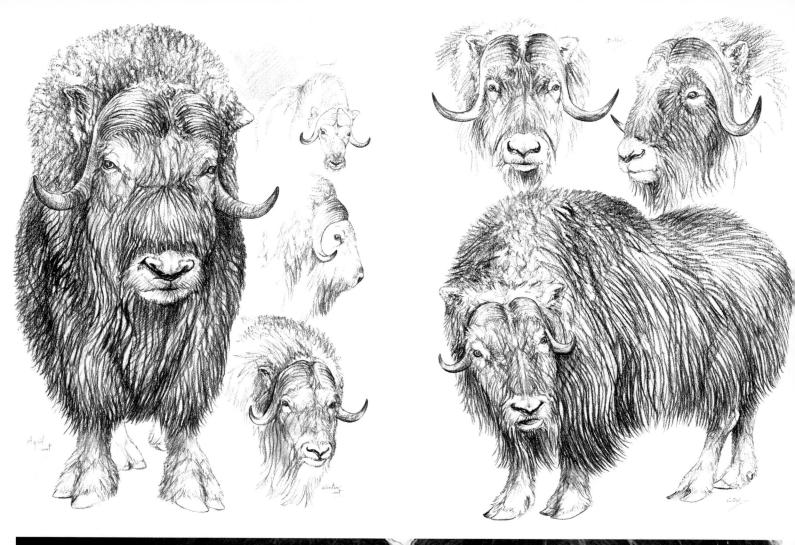

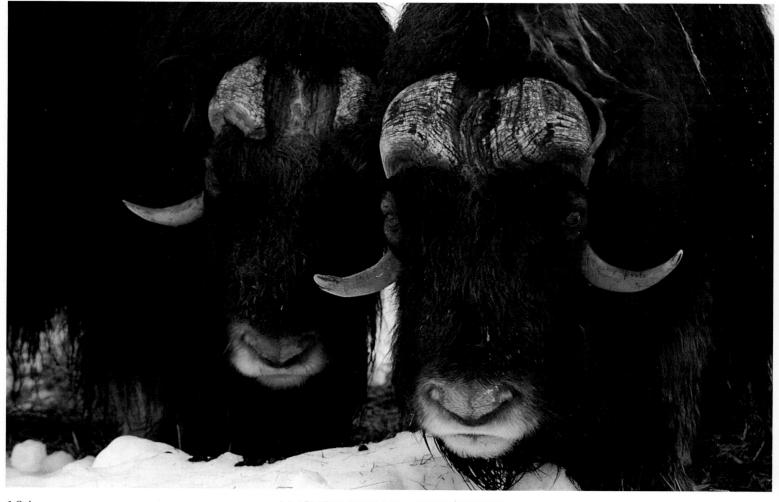

MUSKOX / BULLS (DECEMBER)

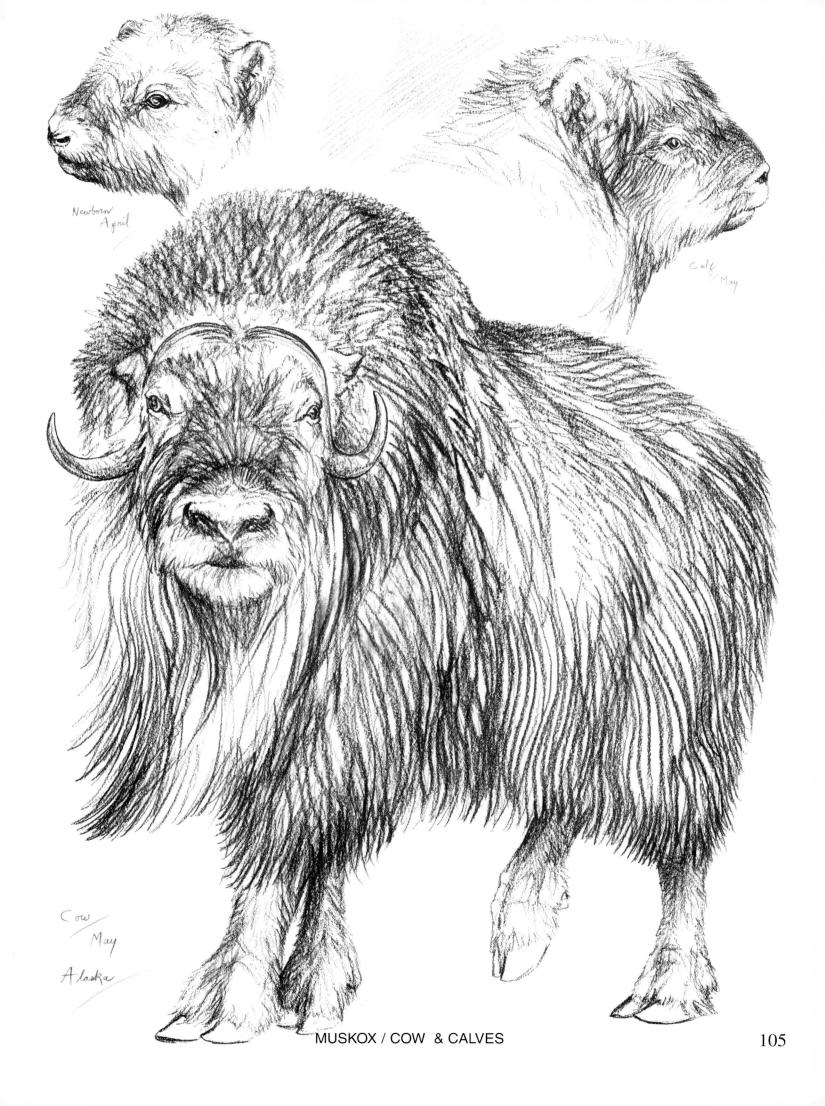

BIGHORN SHEEP

The Bighorn sheep (Ovis canadensis) is a member of the family Bovidae, which means it is cloven hooved, has hollow horns, and is a cud-chewer. It inhabits high, rocky areas and ranges from southern British Columbia and Alberta south into Mexico. In my drawings and photographs, I separated them by calling the northern bighorns "Rocky Mountain bighorns" and the more southern bighorns "Desert bighorns". They are the same specie but their appearance and habits are different due to their differing environments.

Bighorn males (rams) are distinguished by their massive curled horns, whereas the females (ewes) have shorter, straighter horns. A mature northern bighorn ram will weigh up to 300#'s, while his desert counterpart normally peaks at about 200#'s. Ewes will average 125 - 175#'s. Bighorns stand 36" - 42" at the shoulder and are 5' - 6' long. Their color ranges from dark brown (in the north) to pale buff (in the desert). Their muzzle, belly, back of legs, and rump are white, and they have a brown tail and a pale ring around the eyes.

Mating season normally peaks in November/December, but the Desert bighorns often breed earlier and the battles between competing males are less combative. During early autumn the rams begin "testing" one another with head-butting and these skirmishes slowly evolve into spectacular 20 mph "crashes" into one another. Usually only rams with similar sized horns will fight to determine dominance. Large, heavily-horned rams may go unchallenged. Bighorn horns are normally more massive and less flared than those of the Dall/Stone specie. Also, their horns are more frequently "broomed" in order for them to see to the side better (and, of course, due to falls or battles). During May/June (and earlier in the desert) the pregnant ewes seek out safe quarters in the cliffs to bear their young (lambs). After the mating season, the rams again band together and separate from the ewes, lambs, and immatures. Life span is about 12 - 15 years in the wild.

Because of their rugged terrain, the Bighorn sheep have an advantage over predators, but Mountain lions, Golden eagles, and wolves still take a significant toll. Their summer diet consists mainly of grasses and sedges, and in winter (in the north) they must switch to woody plants and brush.

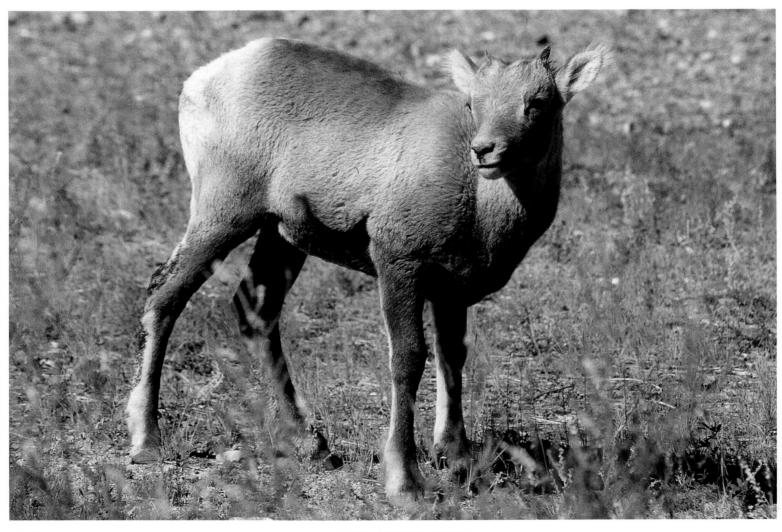

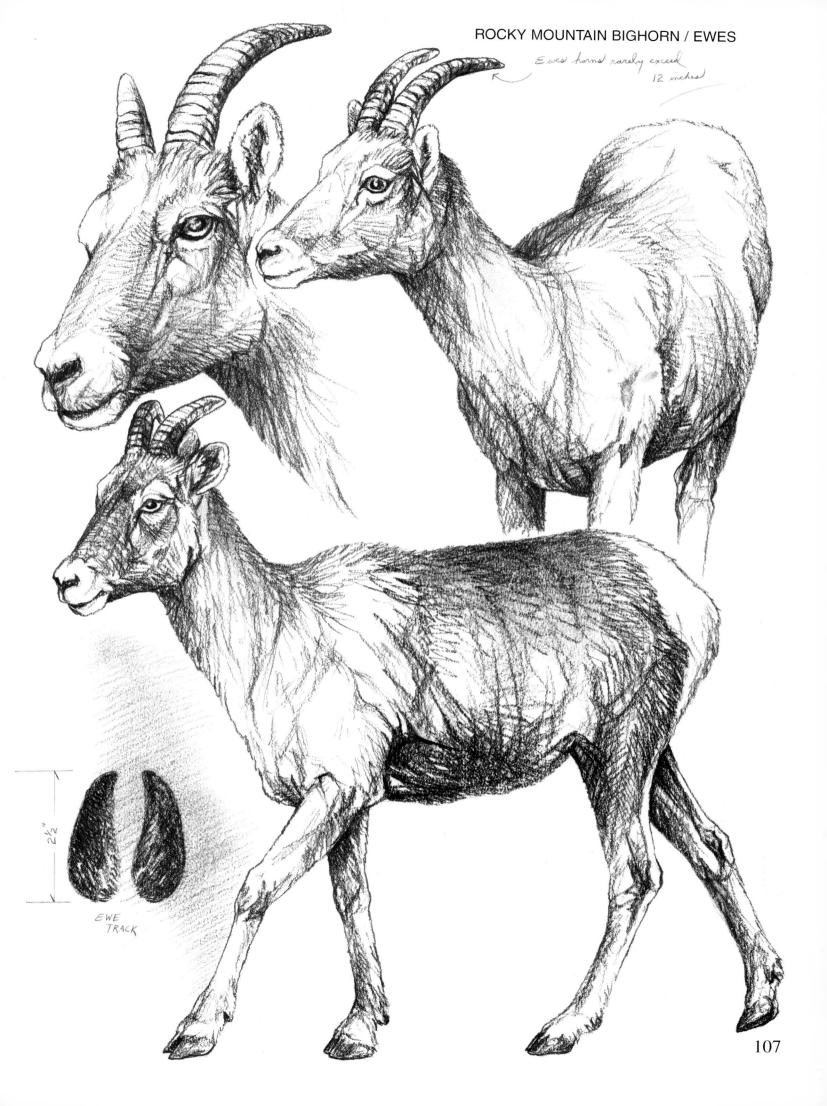

During the autumn "rut" rams will determine an ewe's breeding receptivity by scent. A ram will hold his head high, curl his upper lip, and the ewe's odor is evaluated.

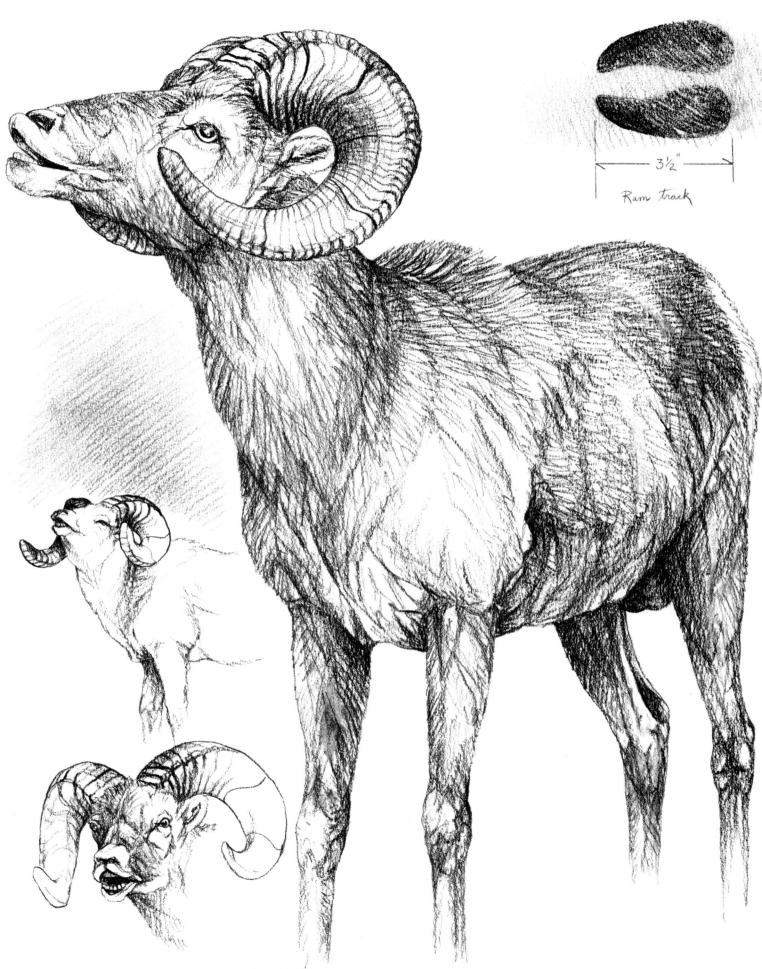

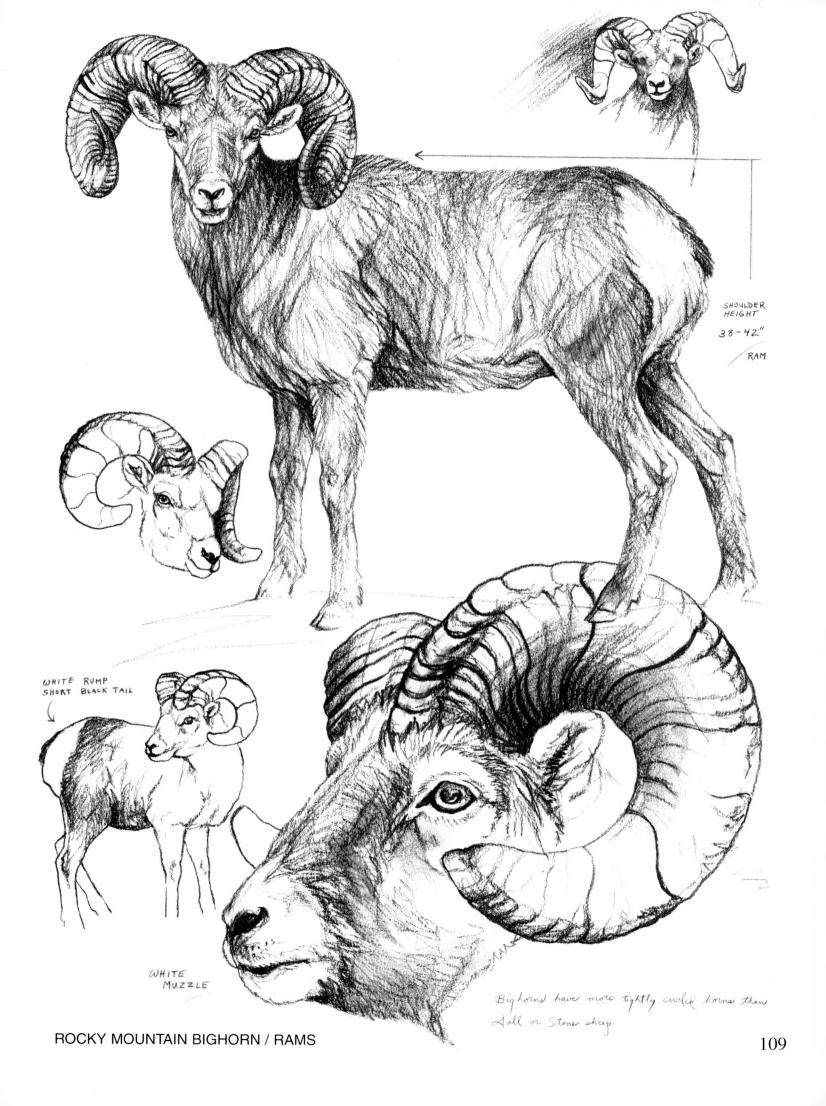

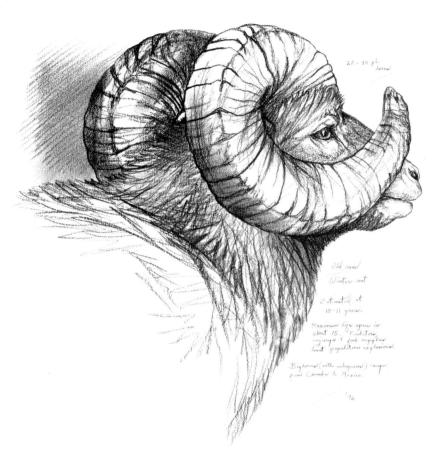

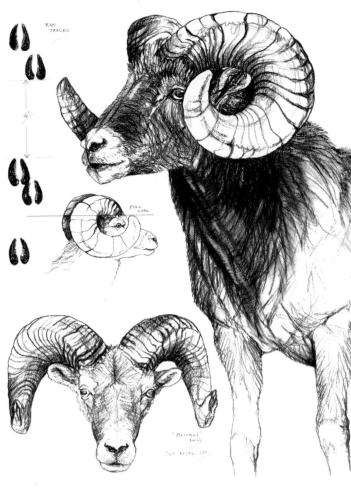

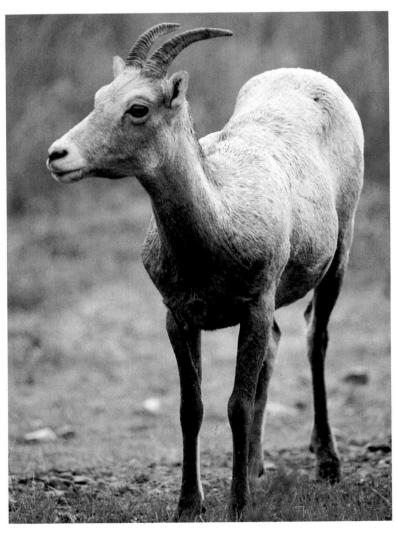

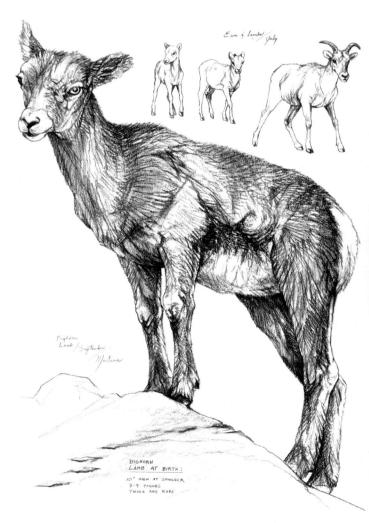

ROCKY MOUNTAIN BIGHORNS

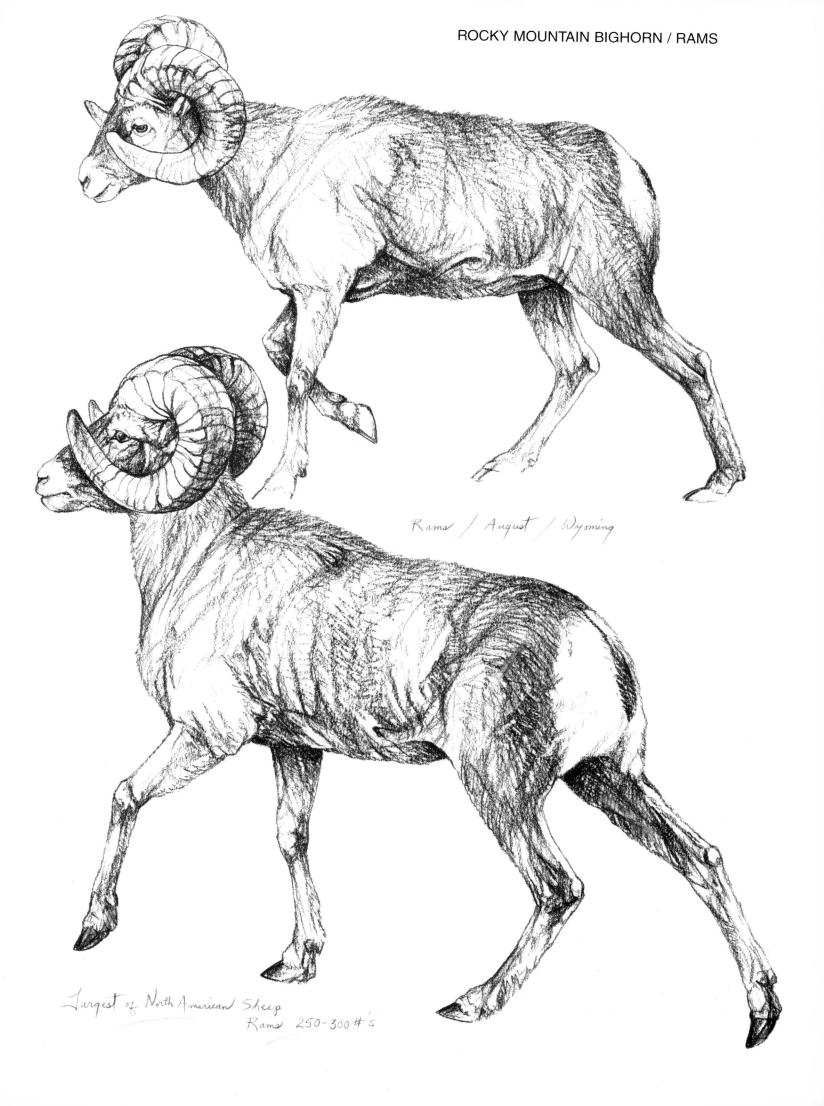

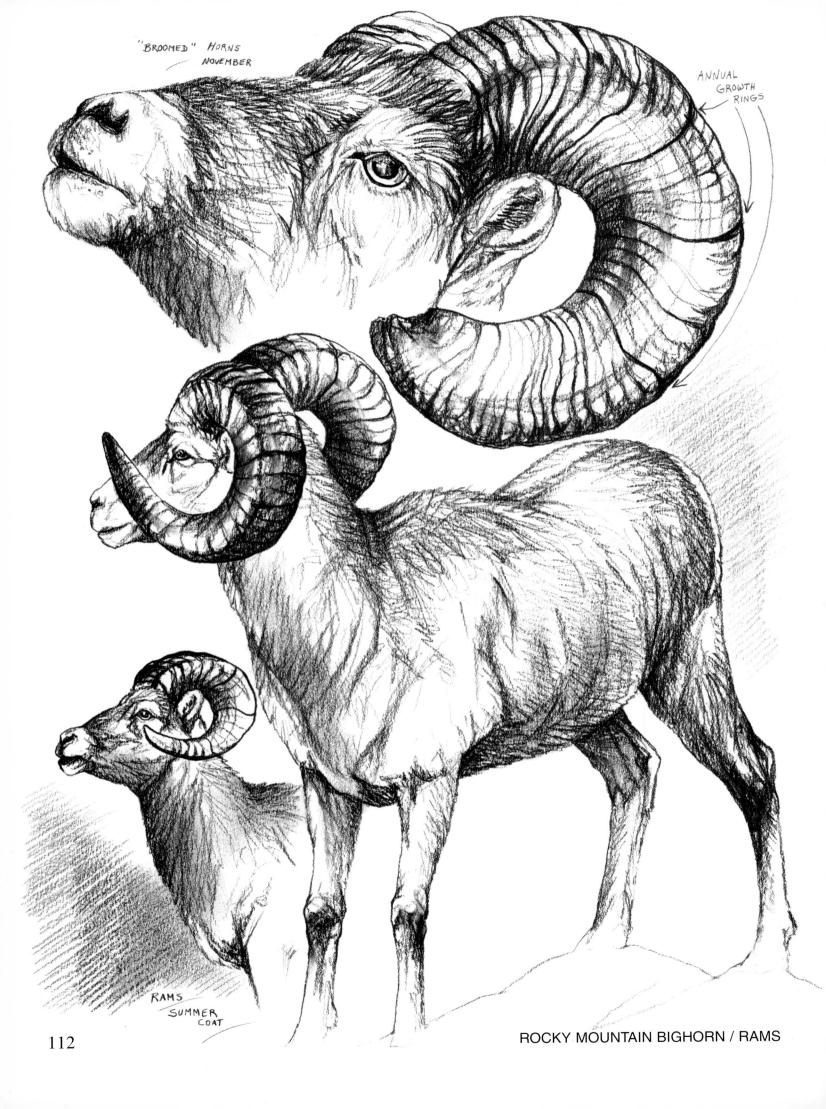

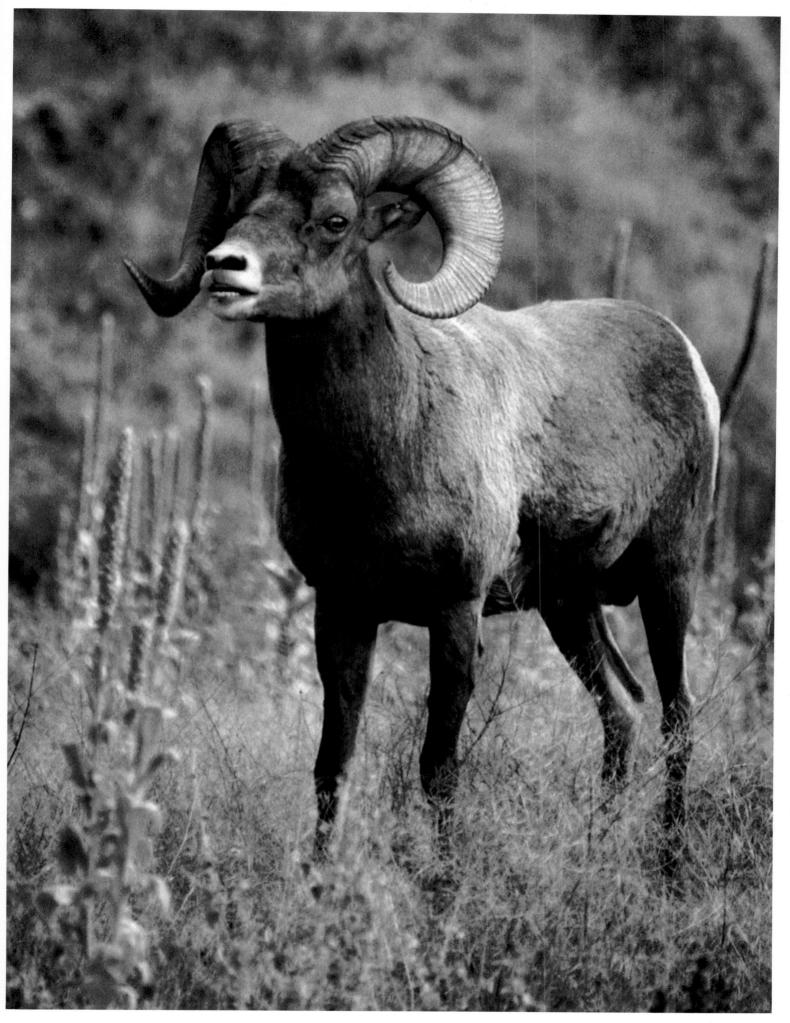

ROCKY MOUNTAIN BIGHORN / RAM (SEPTEMBER)

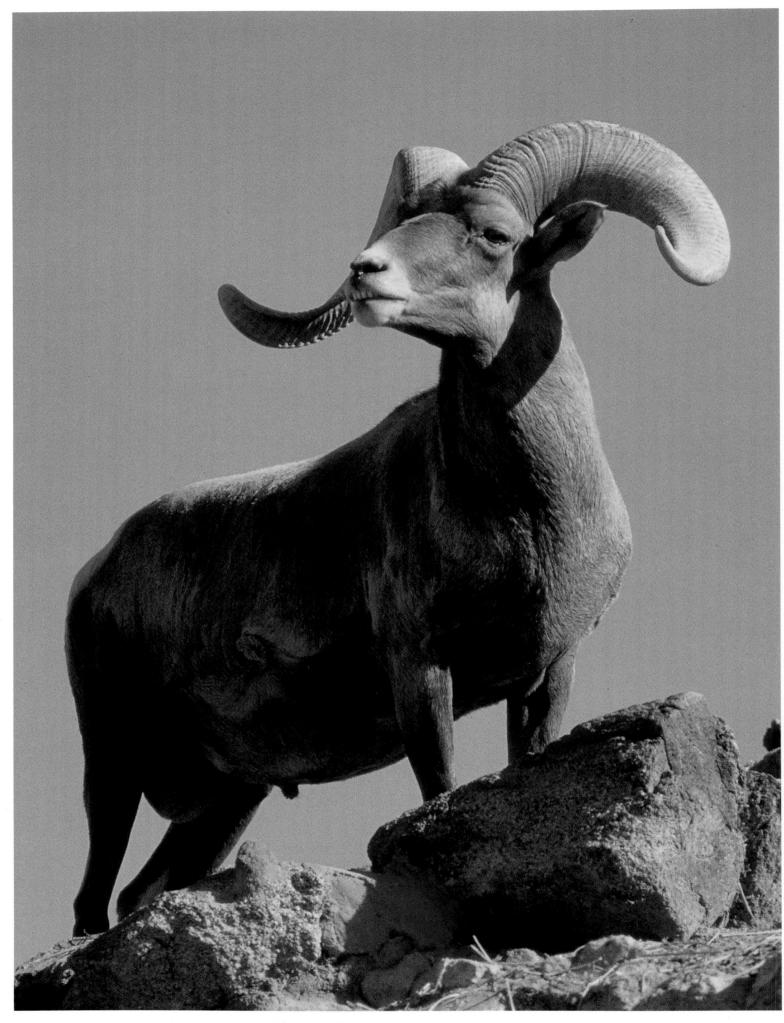

DESERT BIGHORN / RAM (SEPTEMBER)

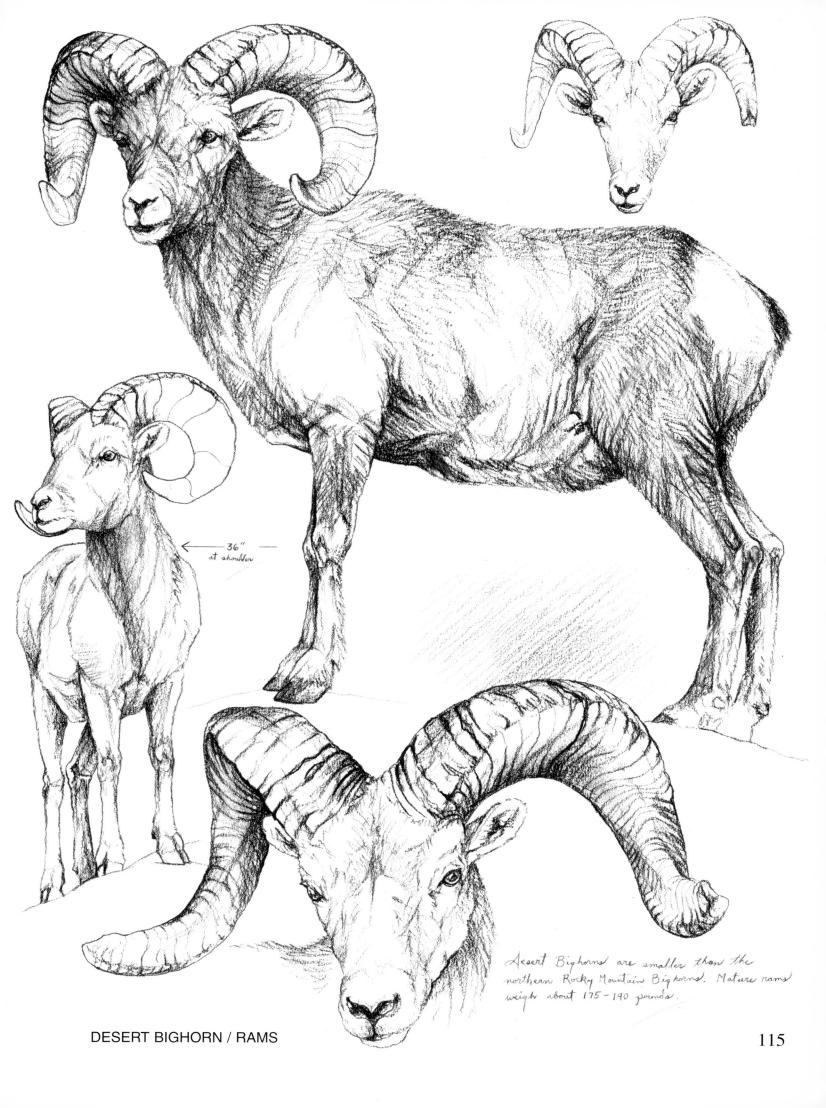

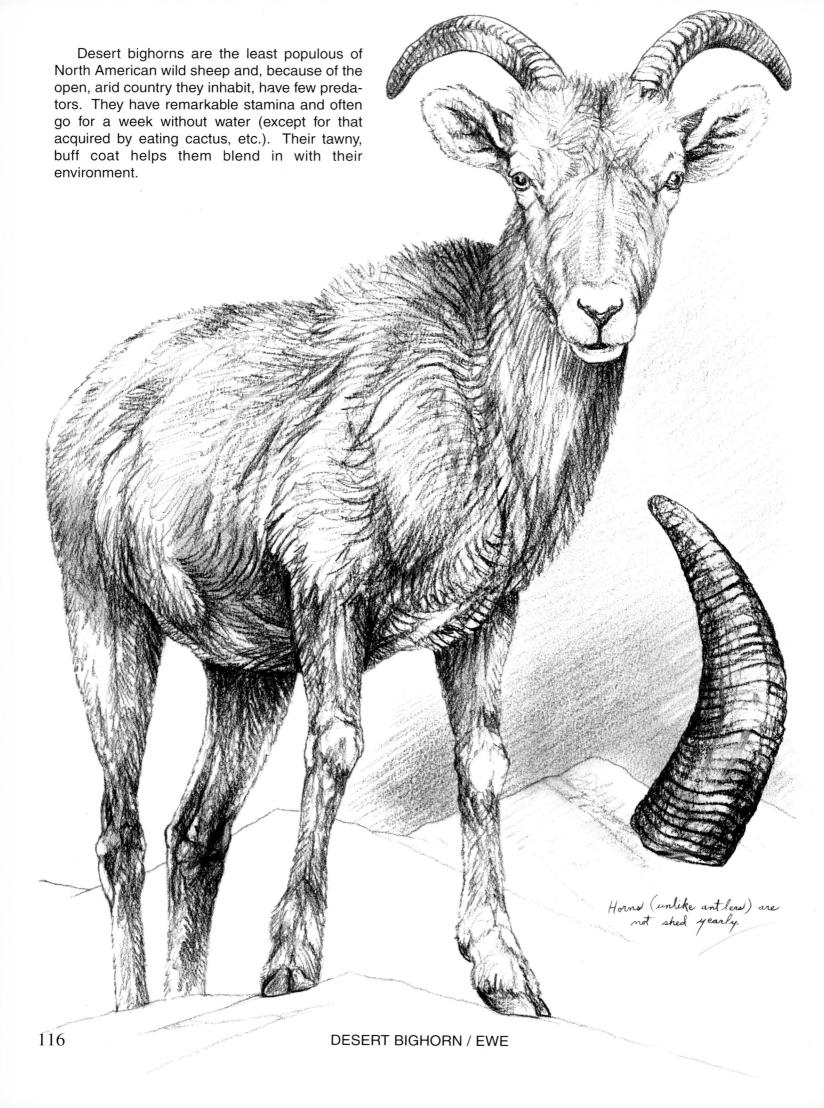

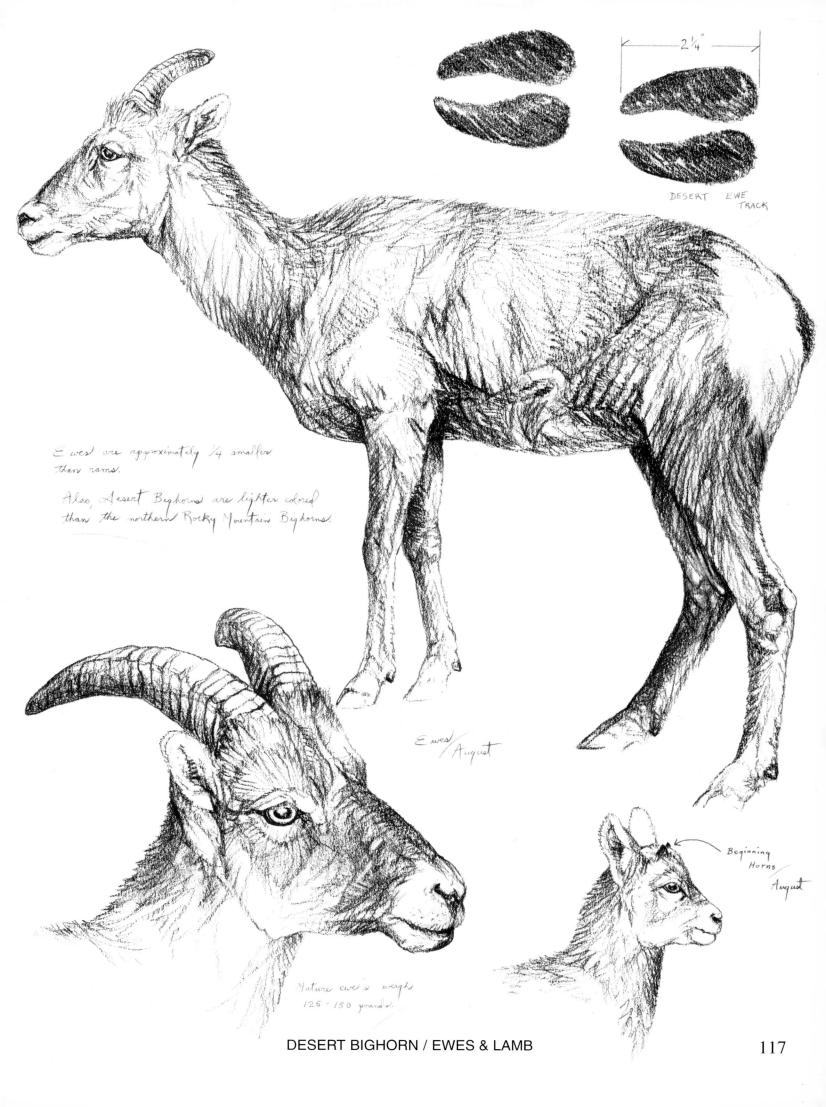

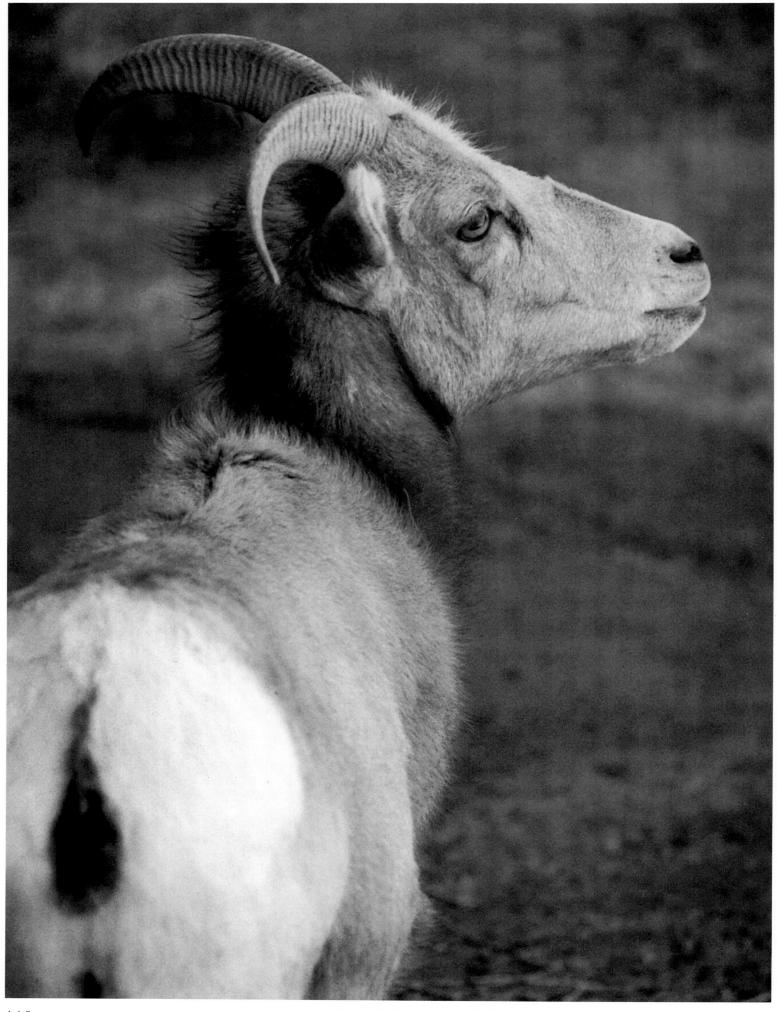

118

DESERT BIGHORN / EWE (MARCH)

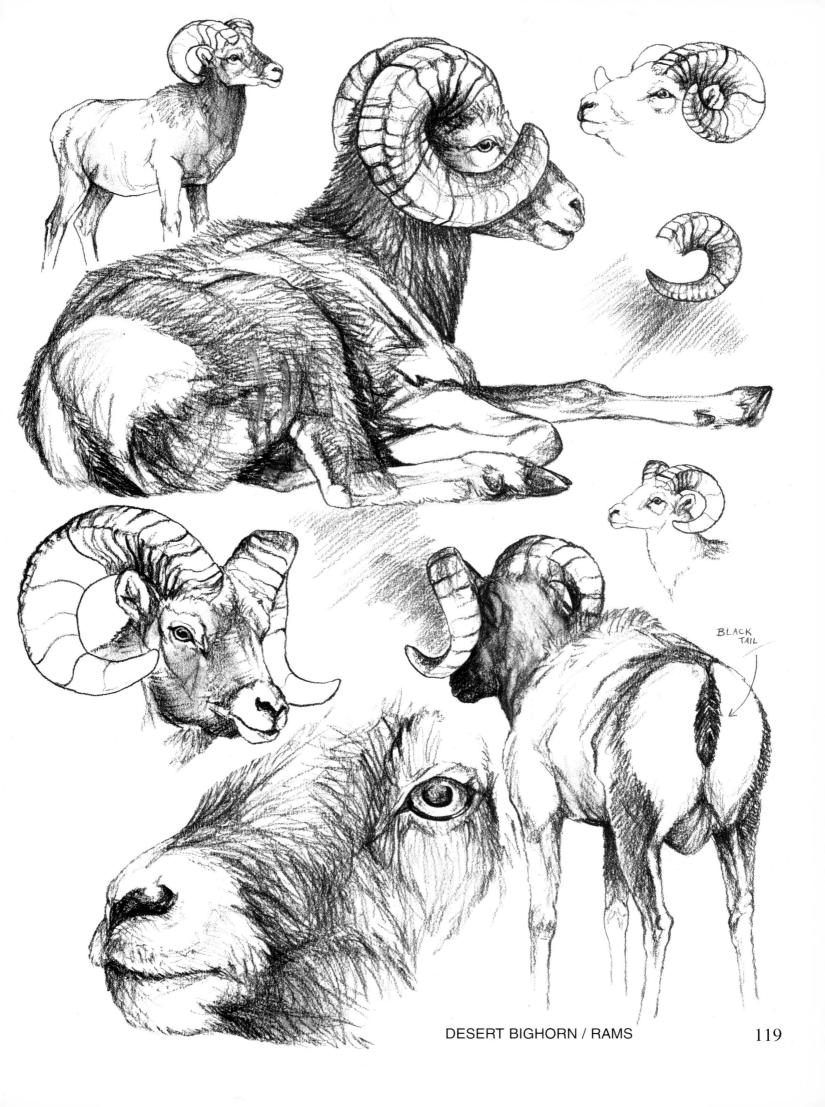

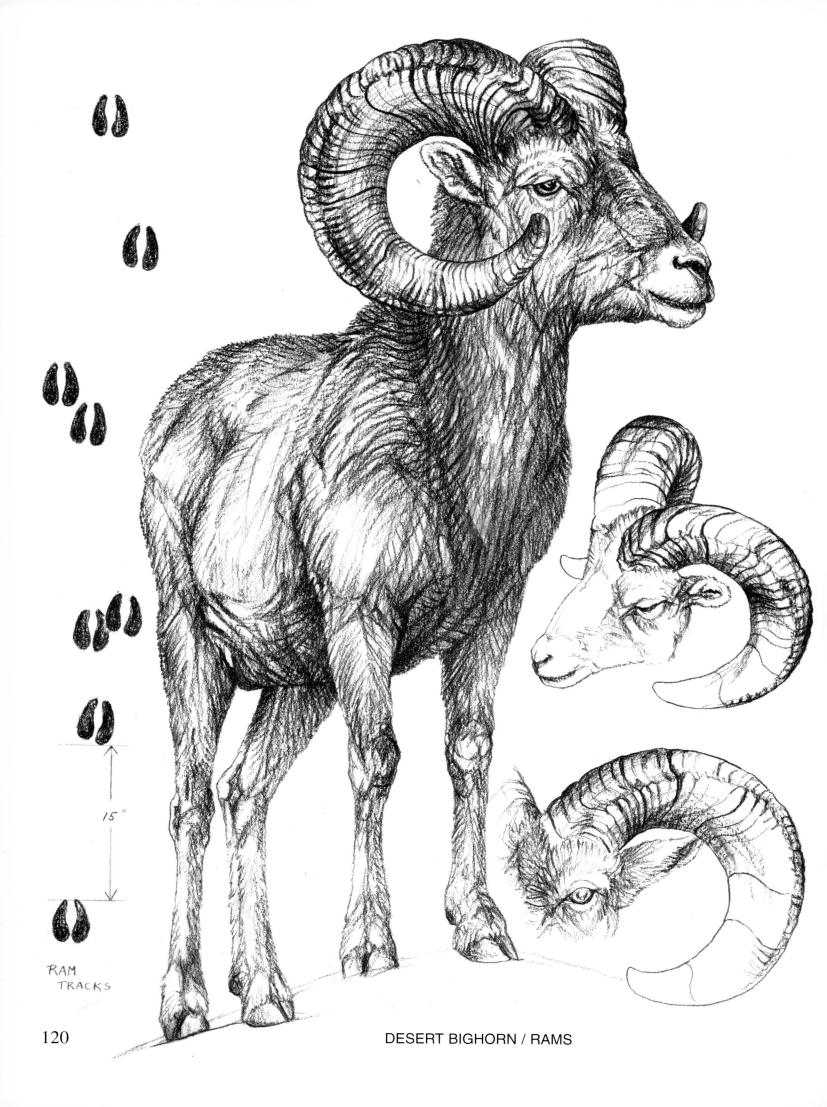

DALL SHEEP

The Dall sheep (Ovis dalli dalli) is the white sheep of Alaska. It is the smallest of North American sheep and a mature male (ram) weighs 175 - 225#'s. Females (ewes) weigh, on average, 120 - 150#'s. The rams sport yellowish, wide-flaring horns, while the ewes have short, straighter horns that seldom exceed 12". Because the wide flare allows better sideways vision, the rams seldom "broom" their horn tips as is common with the Bighorn sheep. Different areas of Alaska seem to have different horn configurations; some more flared than the more tight curls of other regions. A mature ram is 36" - 40" high at the shoulder and is approximately 5' long. Because, perhaps, I have spent so much time in the mountains with these beautiful and magnificent creatures, they have become my "favorite". To behold a full-curled autumn ram silhouetted against a blue sky is a memorable scene. A "full-curl", incidentally, occurs in about 7 or 8 years. Most sheep don't live over 12 years in the wild.

Dall sheep inhabit high alpine meadows and steep sloped terrain. They have excellent vision, and if danger arises they escape to the rocky crags above. Wolves are its main predator, but occasionally a Golden eagle, wolverine, or lynx claims a lamb or injured/sick adult. The diet of Dall sheep is limited and consists of grasses, sedges, brush and lichens. Severe winters and springs can claim many sheep by making food unavailable or difficult.

Mating occurs in November/December and the young (lambs) are born in May/June on a secluded rocky cliff. The frisky, snow-white lambs are able to run within a few days and often spend their first summer frolicking and drinking their mothers rich milk. If there is a ram that is much larger than the others, he will often intimidate the smaller rams into not challenging him. Otherwise the rams will challenge and battle one another until a victor emerges. It is natures way of passing on the genetics of the strongest and healthiest to the upcoming generation.

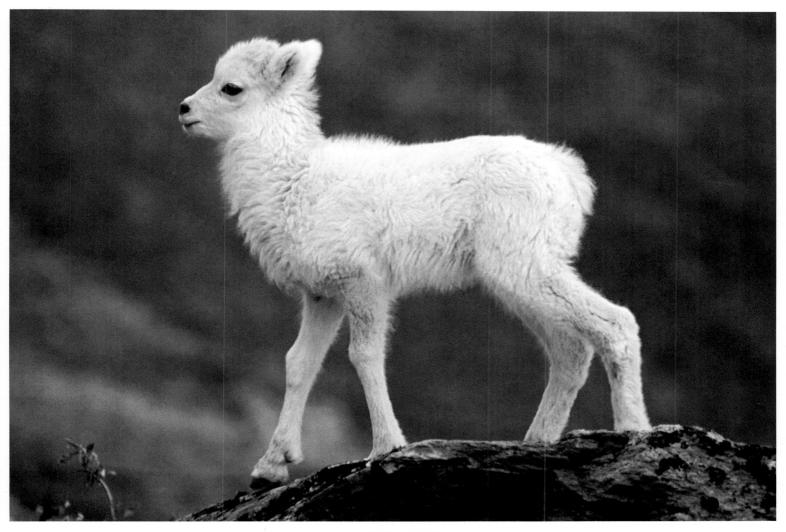

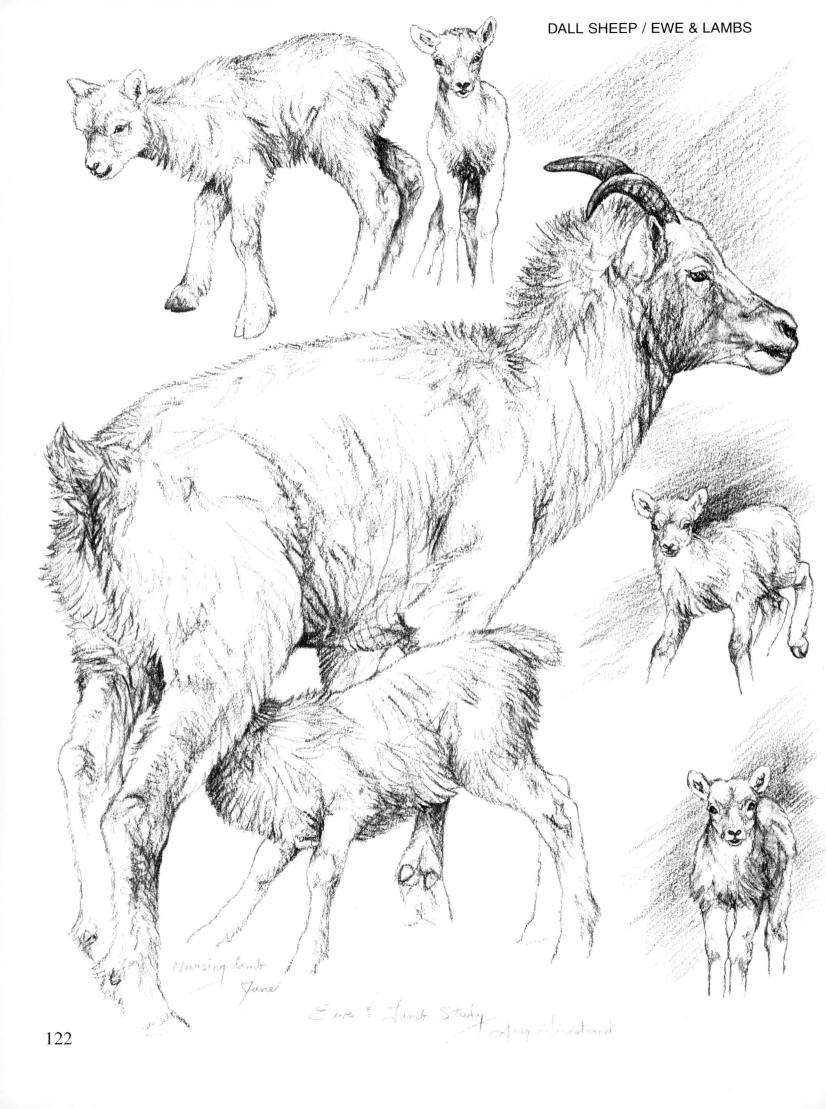

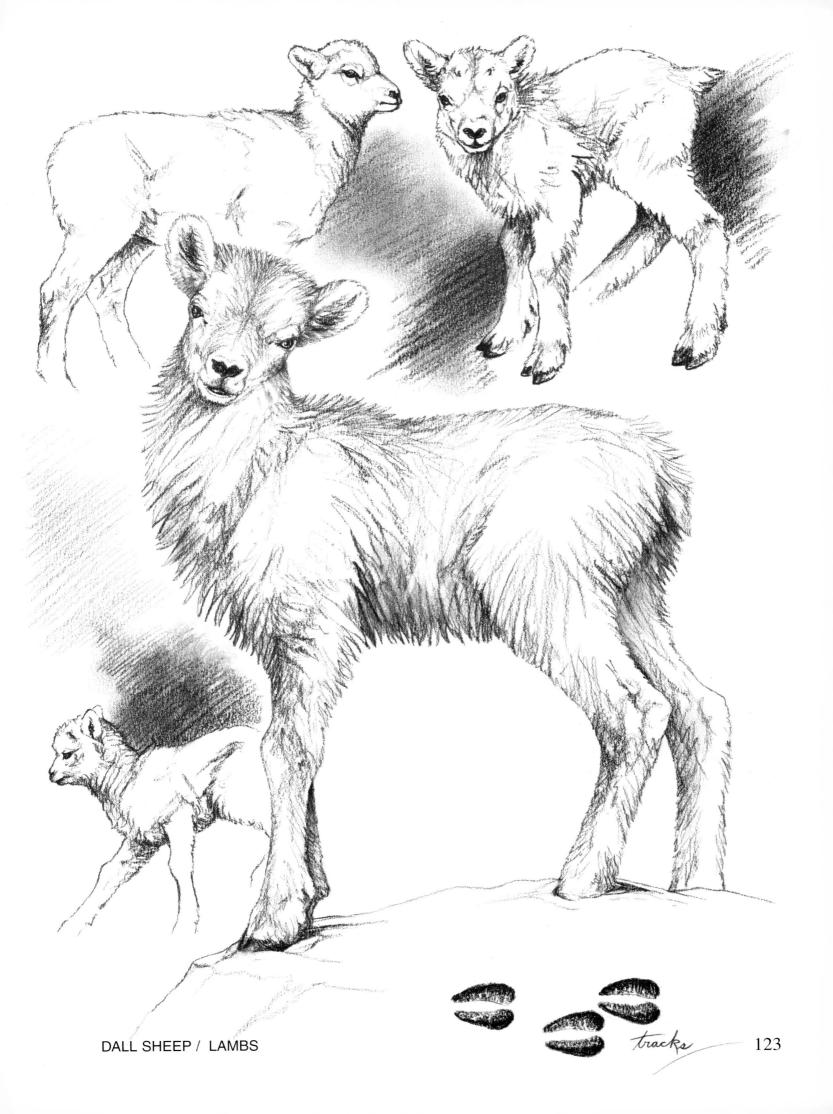

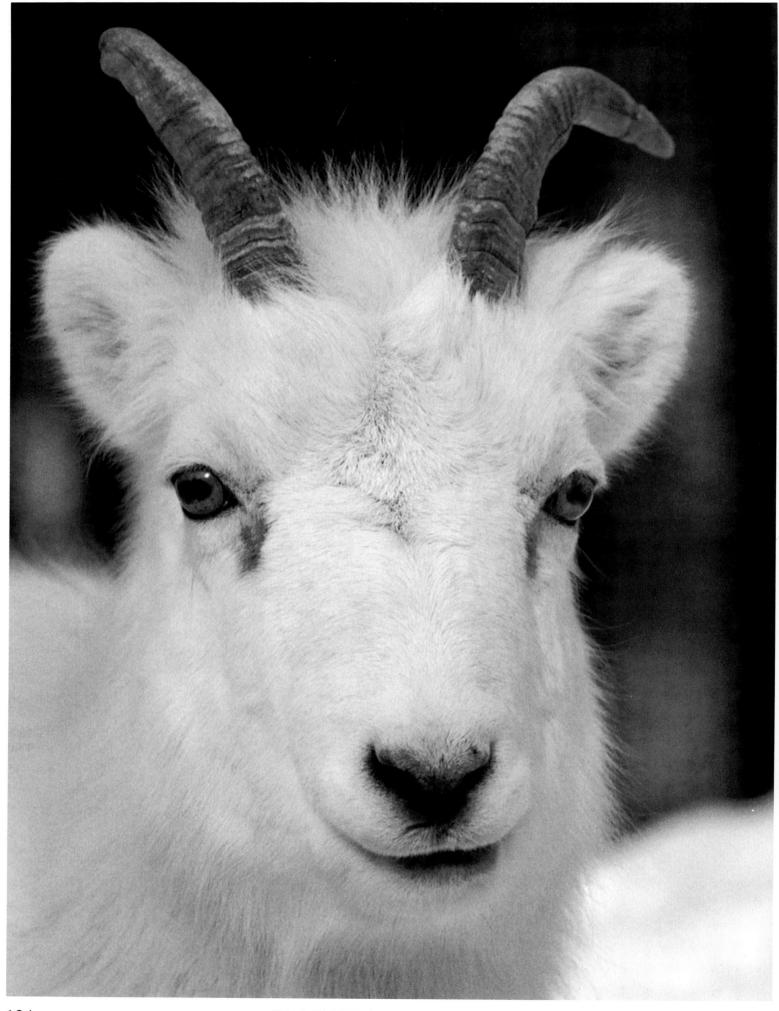

124

DALL SHEEP / EWE (FEBRUARY)

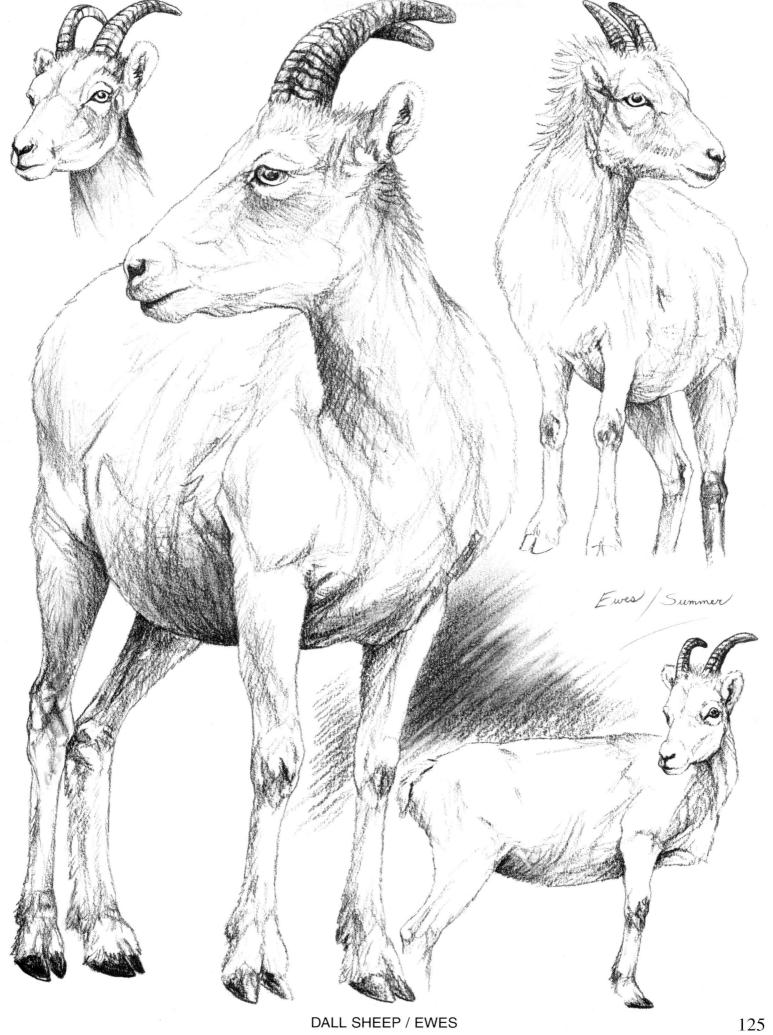

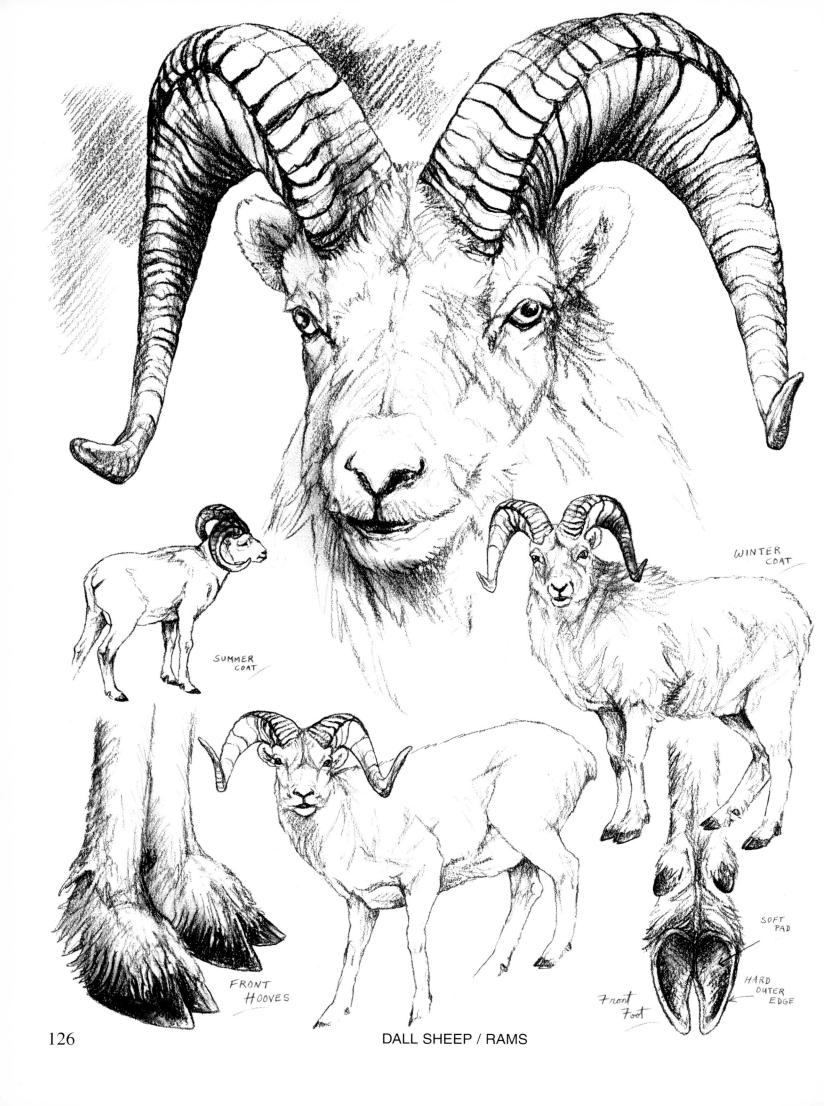

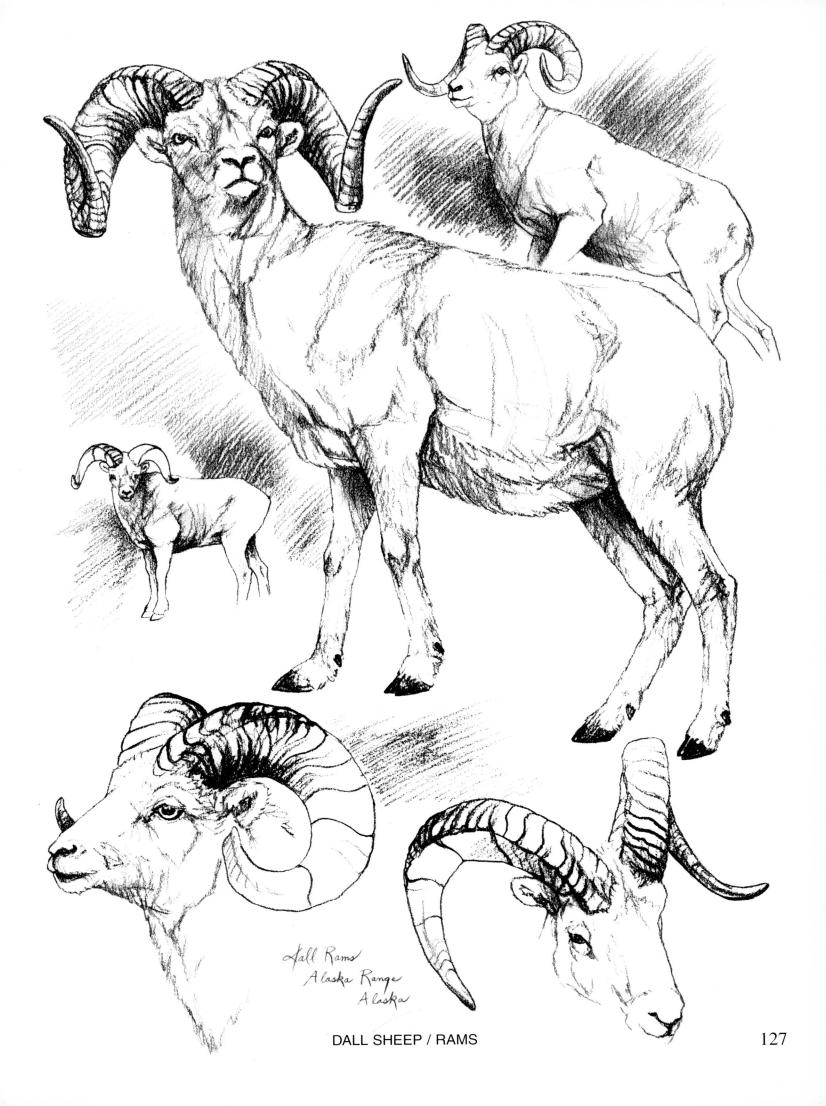

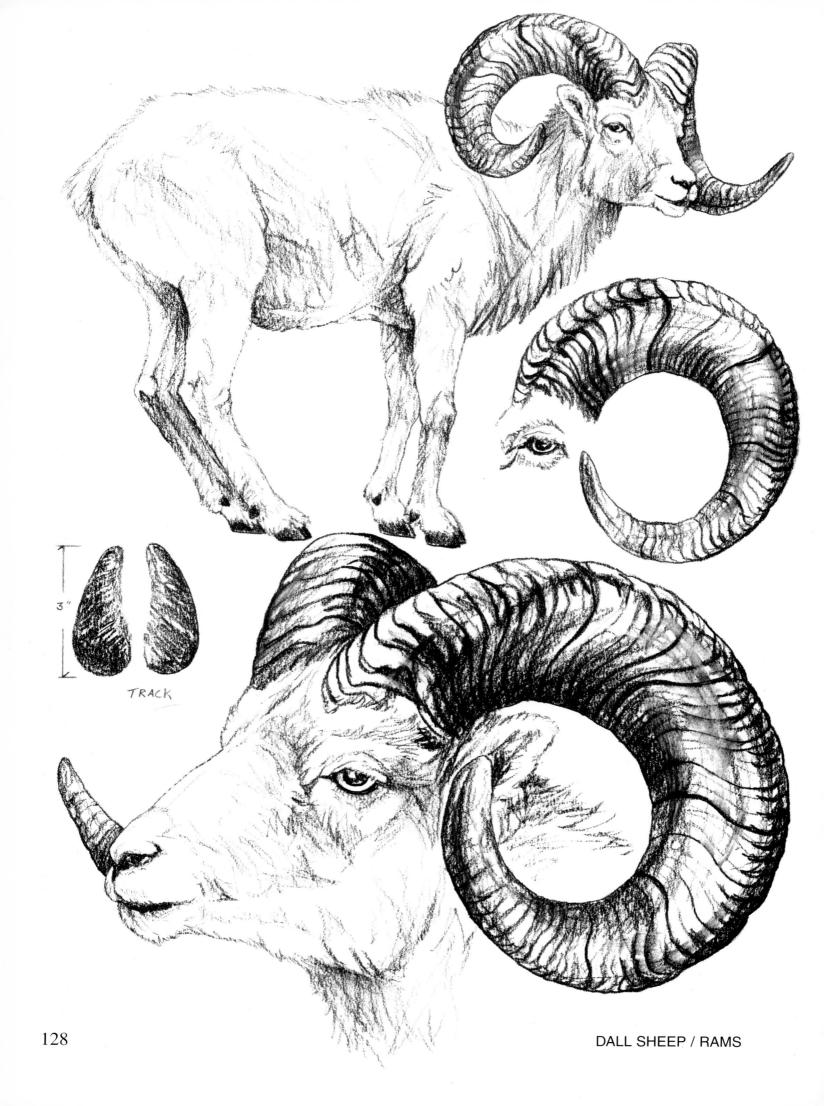

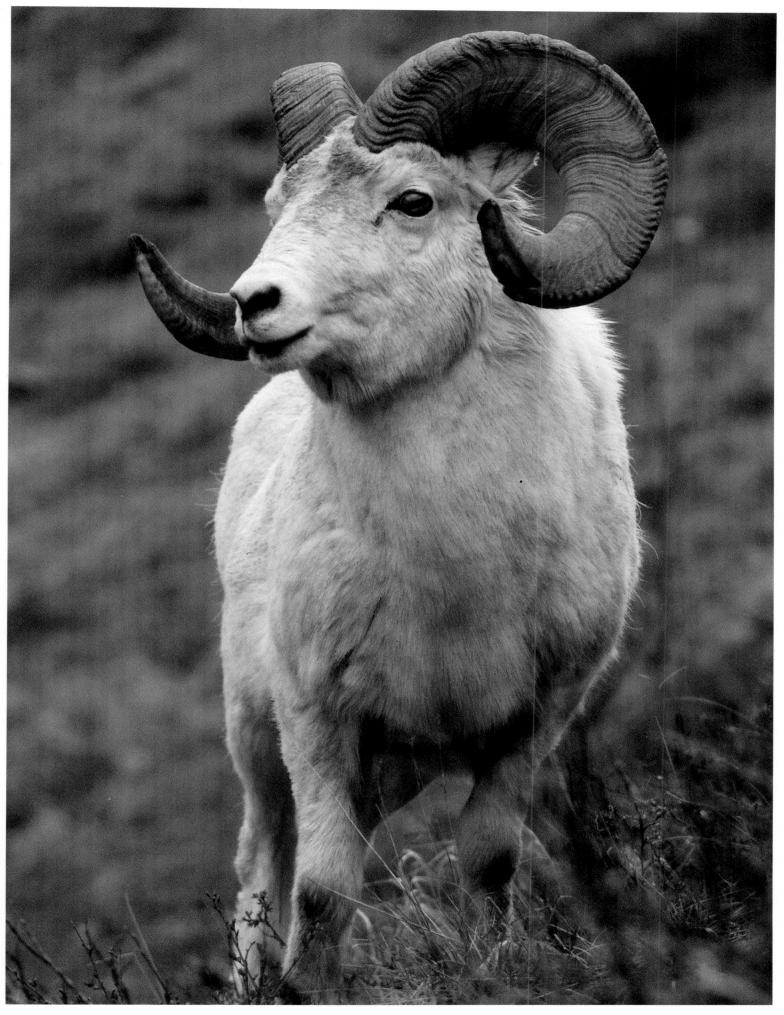

DALL SHEEP / RAM (SEPTEMBER)

STONE SHEEP

The Stone sheep (Ovis dalli stonei) is a subspecie of the all-white Dall. It ranges from the Yukon south to British Columbia's Stikine river. It is slightly larger than the Dall and its blue-black coloration pattern is that of the bighorn; that is, its dark body is contrasted by its white rump and belly, and the white edging running down the rear of its legs. It also has some white on its face and the horns of the males (rams) are normally heavier than those of the Dall. In between the more northern Dall and the more southern Stone are sheep with characteristics of both.

Rams usually weigh over 200#'s at maturity and stand 38" - 40" at the shoulder. They are about 5' long, have black hooves and amber-colored, flaring horns. (Incidentally, the longest set of horns ever recorded on any North American sheep belongs to a Stone; both horns are over 50" long and have a base circumference of 15".) Females (ewes) are just as colorful as males but are smaller (150#'s). They bear their first young (lamb) at age 3, and have a single lamb every year after. The mating season is November/December and the lambs are born May/June of the following year in a secluded, rocky area. During this rutting season, the rams must battle one another to determine who will sire the next generation. These battles are frequent and during the "fights" the two opposing foes will separate, and then, after rearing on their hind legs, drop and charge. The collision is intense and broken horns and noses are the result of not making exact contact. After about a month, all the eligible ewes are mated, and the rams band together and separate from the others. They'll normally stay separated until the following October, unless the restrictions of winter food again reunites them on windswept slopes.

Grazing animals, the Stone sheep feed on the grasses of the alpine meadows. In areas where predators (such as wolves) are scarce, the sheep will feed low in the valleys where food is plentiful. Stone sheep usually live about 12 years, but those that reach 14 or 15 are the "trophy" animals that hunters, artists, and photographers relish. An excellent place to see "Stones" is along the "Alcan highway".

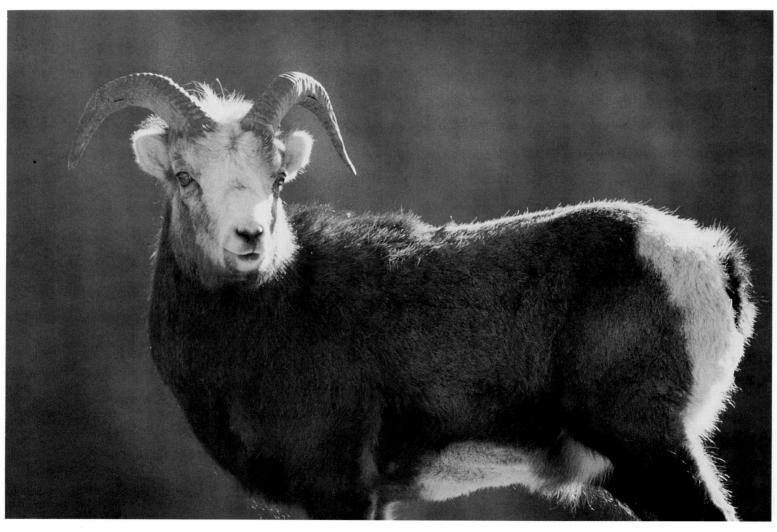

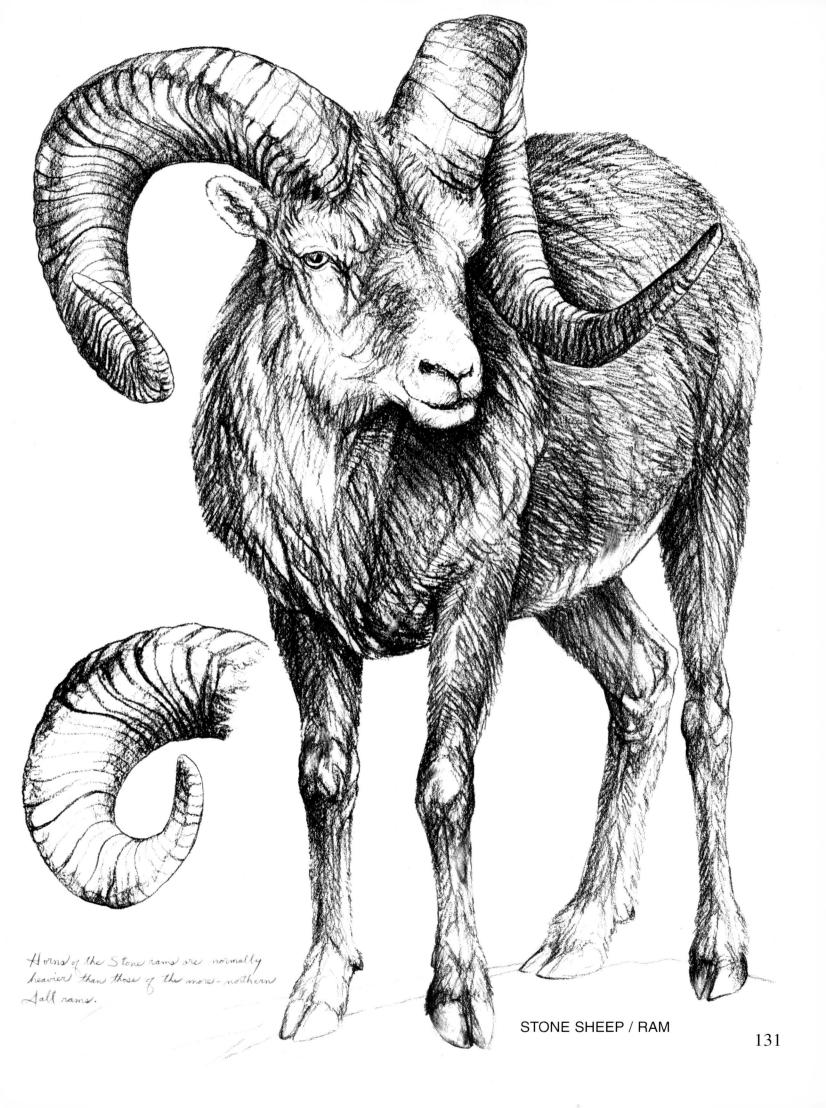

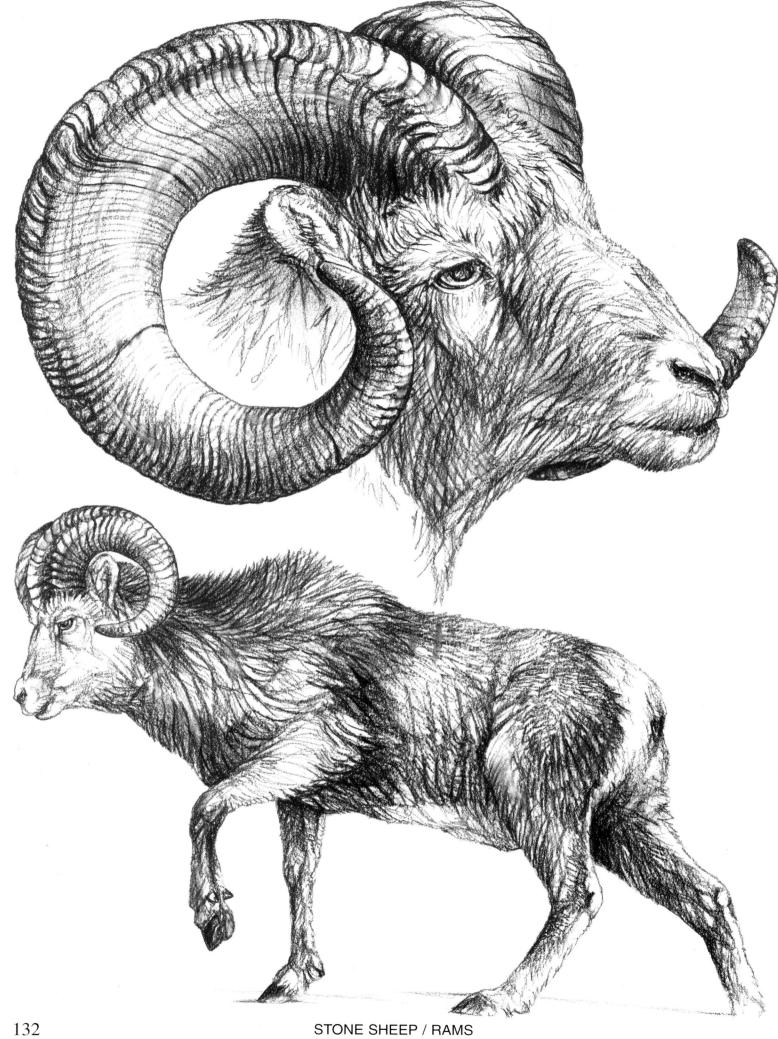

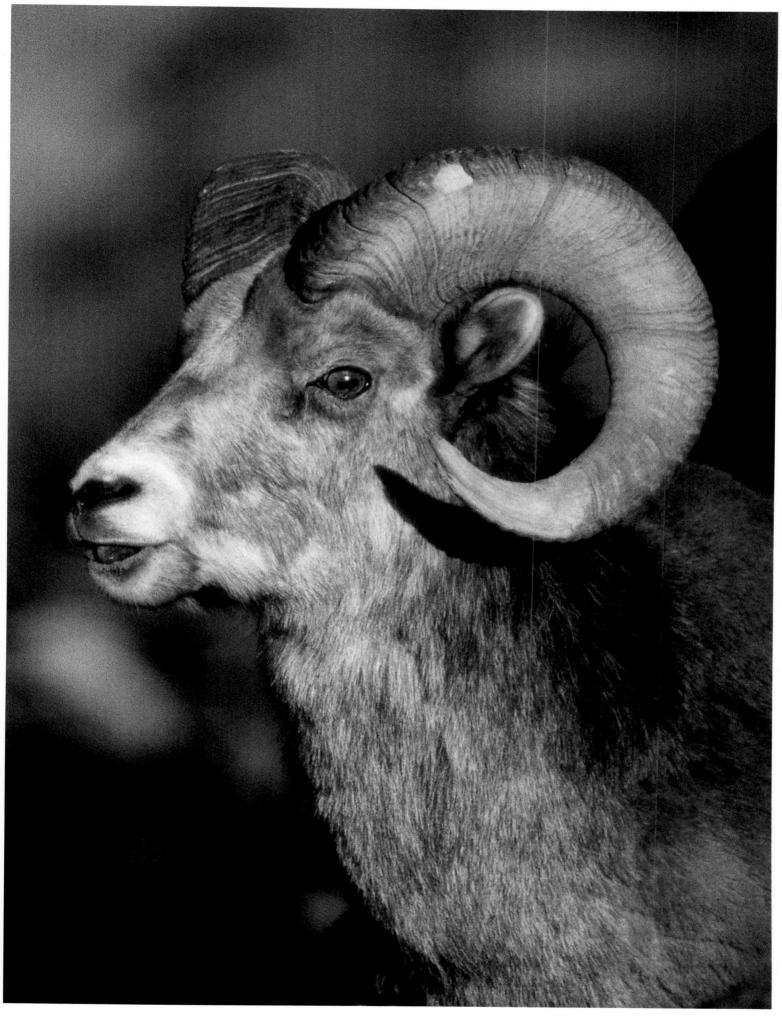

STONE SHEEP / RAM (APRIL)

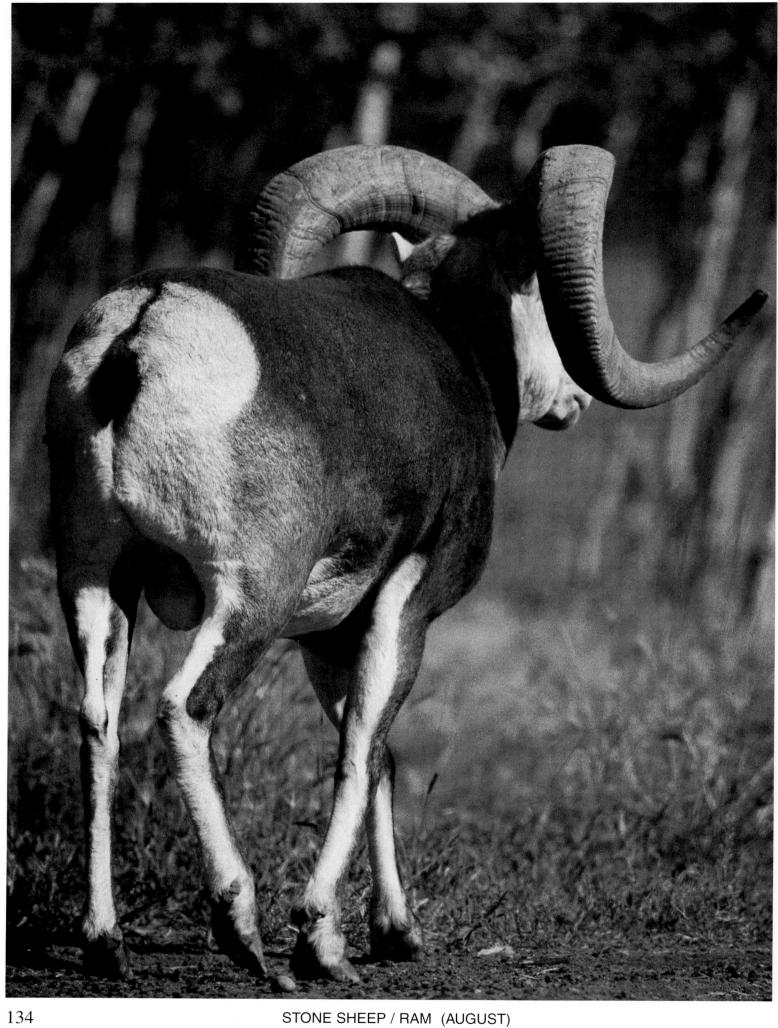

STONE SHEEP / RAM (AUGUST)

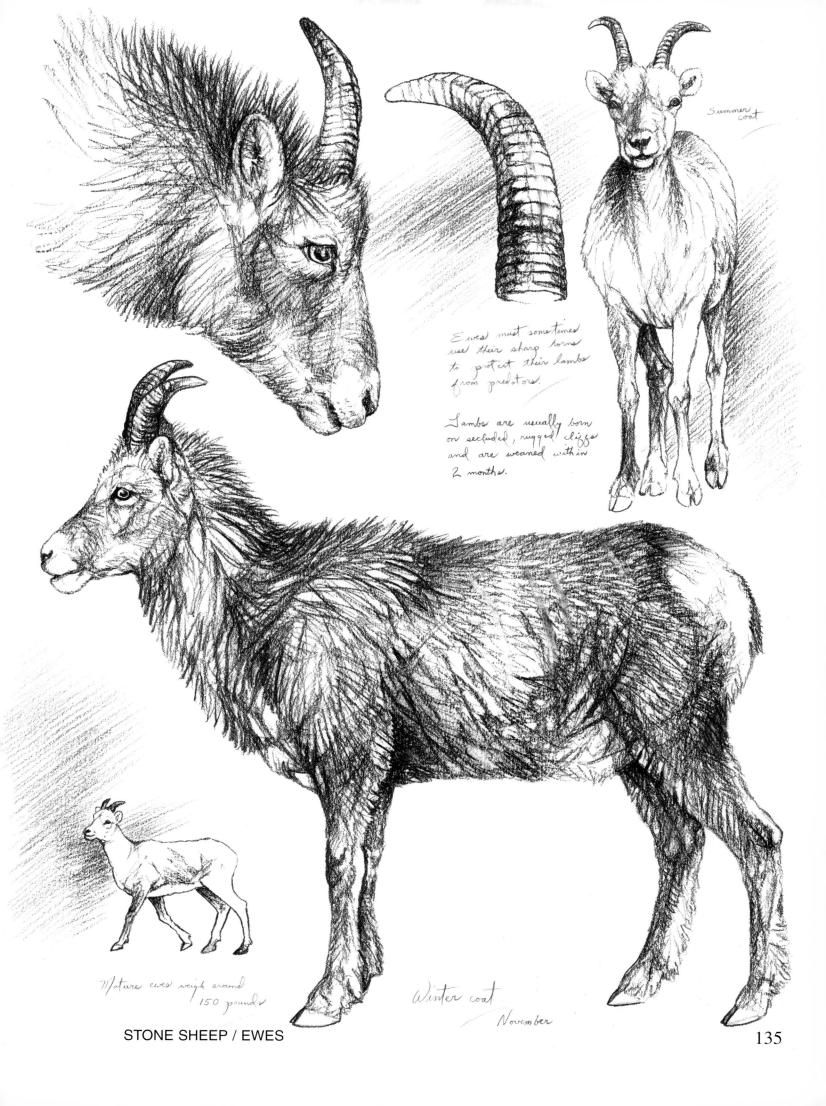

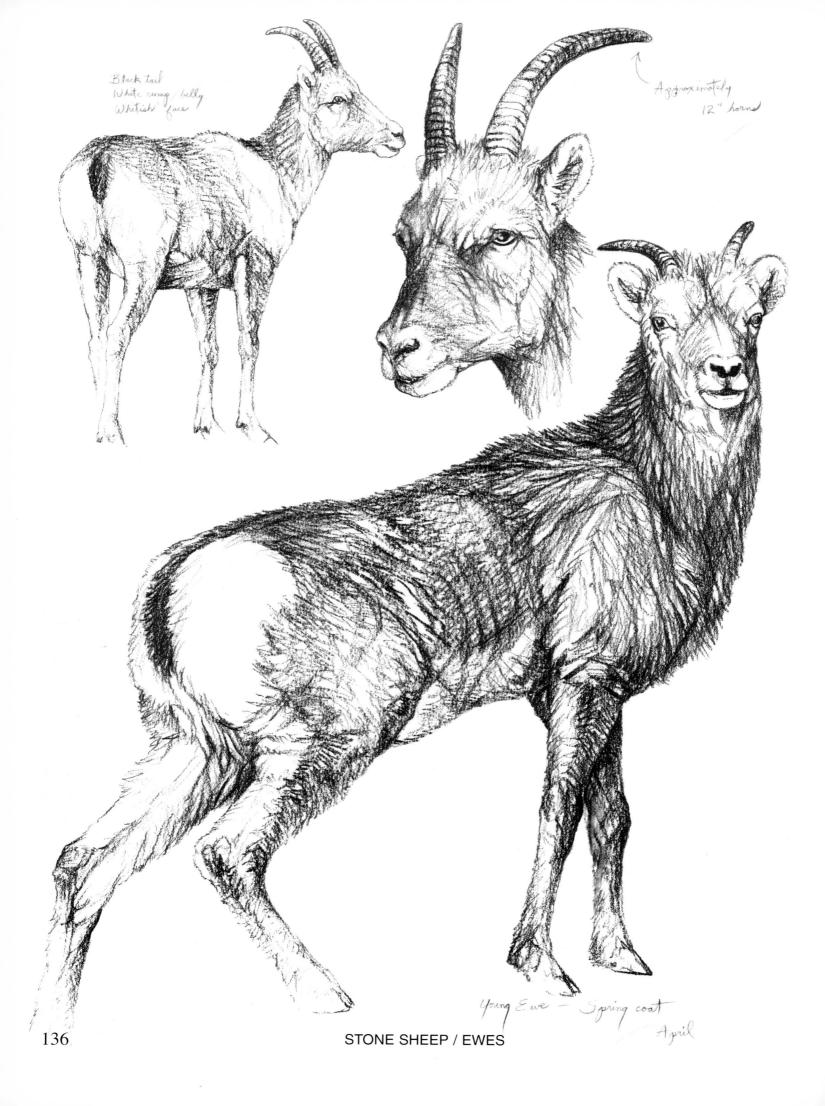

CARIBOU

The caribou (Rangifer tarandus) is a large, stout member of the deer family and is usually associated with the northern tundra areas of North America. Caribou are generally brown with a white belly, rump and neck. Their shaggy, tannish-colored summer coats give way to the splendid rich coats of autumn. Both males (bulls) and females (cows) have antlers, but the cows are relatively small and spindly compared to the magnificent long, palmated antlers of the mature bulls. Weights vary widely, but a mature bull will average 275 - 400#'s, stand 45" - 55" at the shoulder, and be 5' long. (Large bulls of Alaska's Aleutian Islands will often weigh over 700#'s.) Females are 175 - 225#'s.

All caribou (and reindeer) throughout the world are considered to be the same specie. Subspecies are: the Barren-ground, the Woodland, and the Mountain caribou. All have distinguishing characteristics, but are generally similar in appearance. Alaska has only the Barren-ground, while Canada, Greenland, Labrador, and Newfoundland have a variety of subspecies. Very few caribou are found south of the Canadian border. The caribou is a migratory animal that must keep moving in order to find adequate food. Summer vegetation (willows, grasses, and plants) is plentiful and the caribou are able to put on fat-reserves that will help sustain them through the long arctic winters; where they must survive on a meager diet of lichens and reindeer moss.

The bulls lose the "velvet" of their antlers in August/September, and the mating season will usually be over by November. During the spring (May/June) the caribou cows migrate to their particular "calving grounds" to bear a single "calf". The calves are able to keep up with the moving herd within a few days. Also, during this period, the wolf (who usually accompany the migrating herds) preys heavily on the newborns in order to sustain the ravenous appetites of their own young. Perhaps because of the protection it affords them, the cows retain their antlers until after their calves are born.

The caribou has large, concave hoofs which support the animal in soft ground and in snow. It is also an excellent swimmer and is able to swim wide, icey rivers swiftly and easily. The domesticated caribou, the reindeer, is an important animal to many northern people who need it to survive. Also, when wild caribou change their normal migration routes, many of the Native people (who rely upon it for their food and clothing) are faced with hardships. A wild caribou normally lives 10 - 12 years.

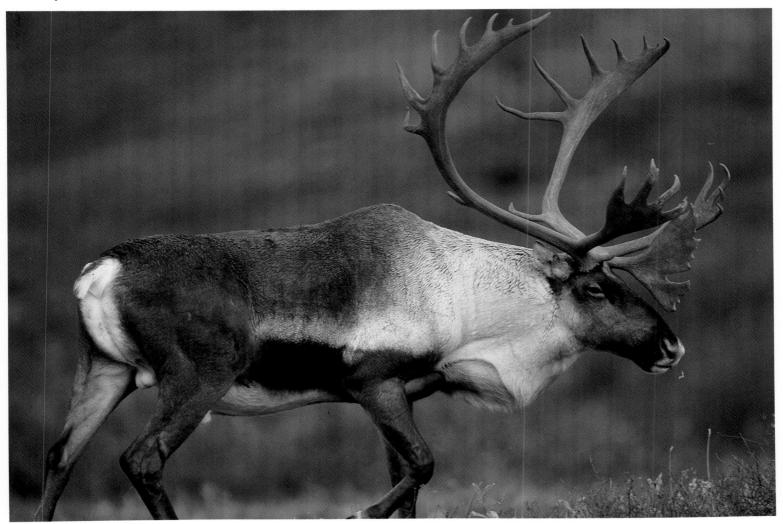

BARREN-GROUND CARIBOU / BULL (SEPTEMBER)

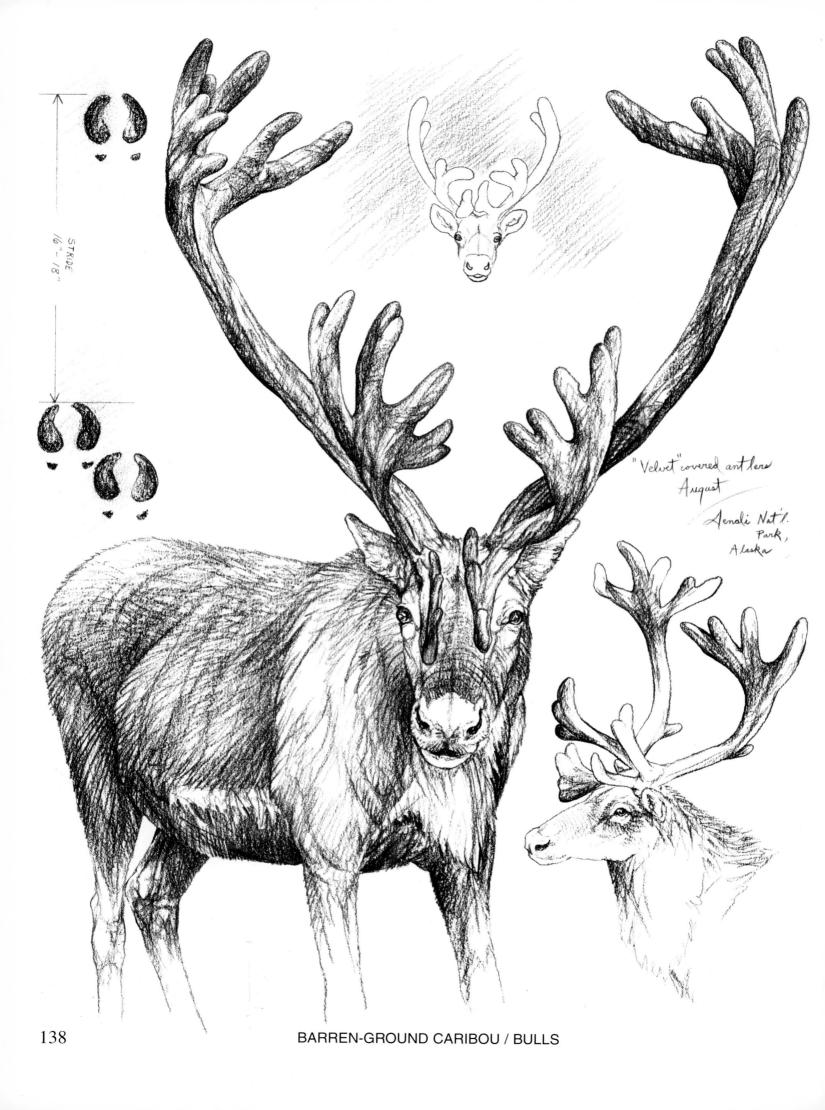

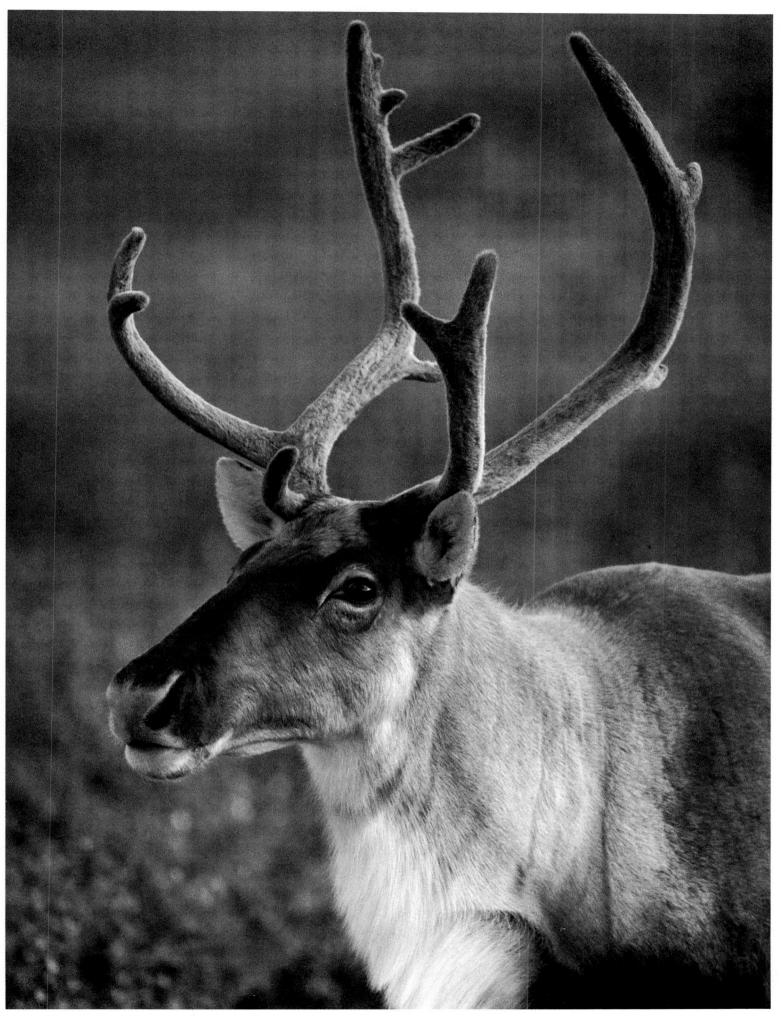

BARREN-GROUND CARIBOU / IN "VELVET" (AUGUST)

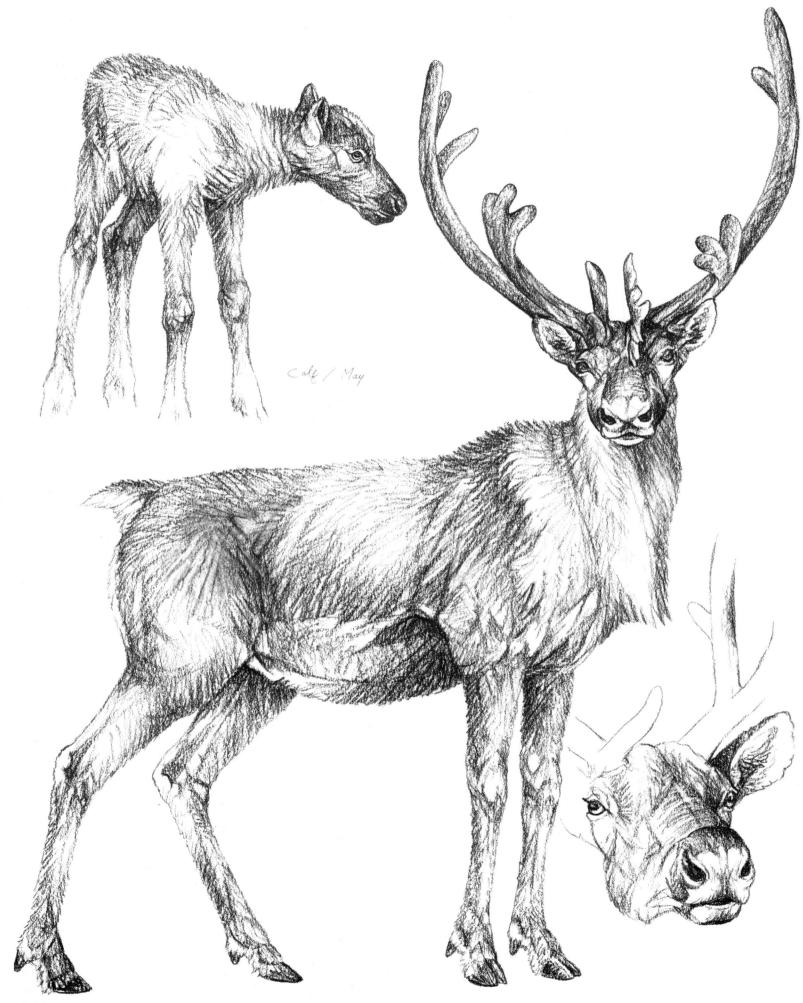

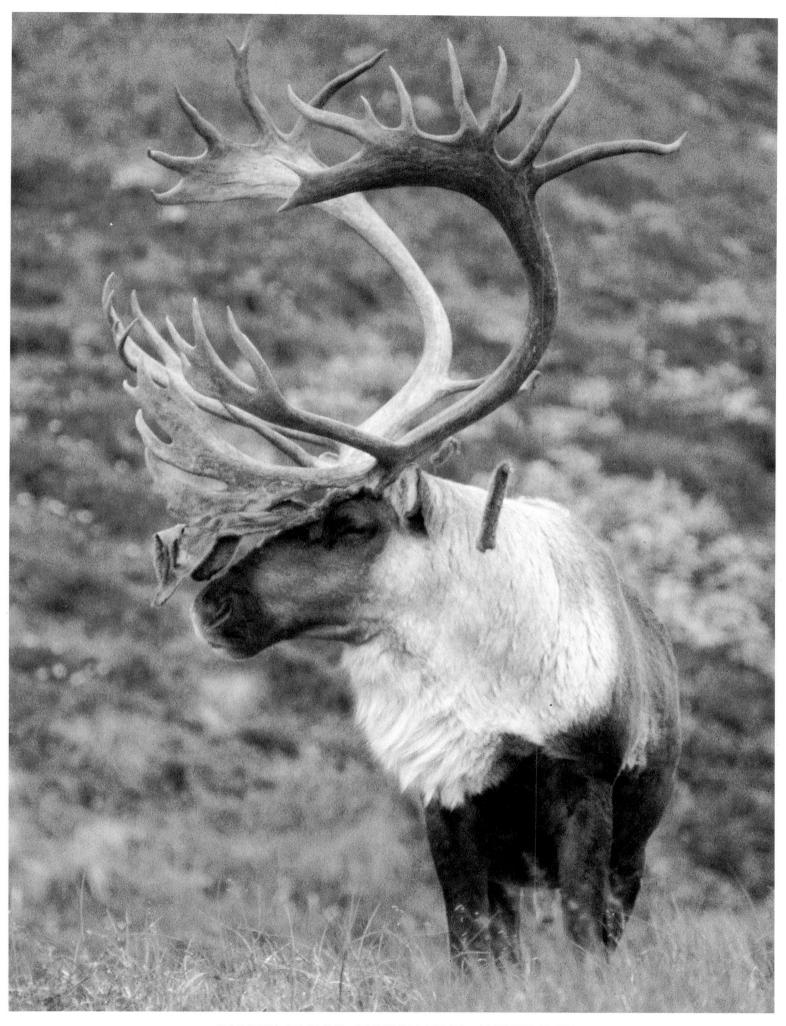

BARREN-GROUND CARIBOU / BULL (SEPTEMBER)

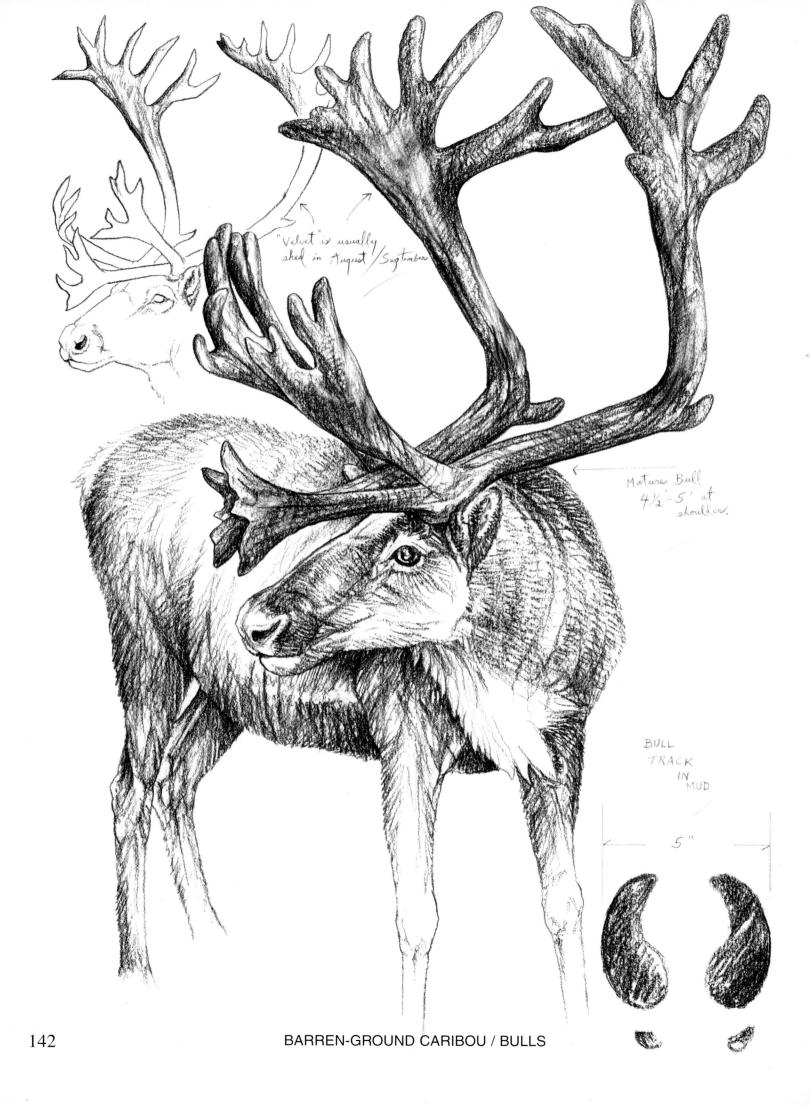

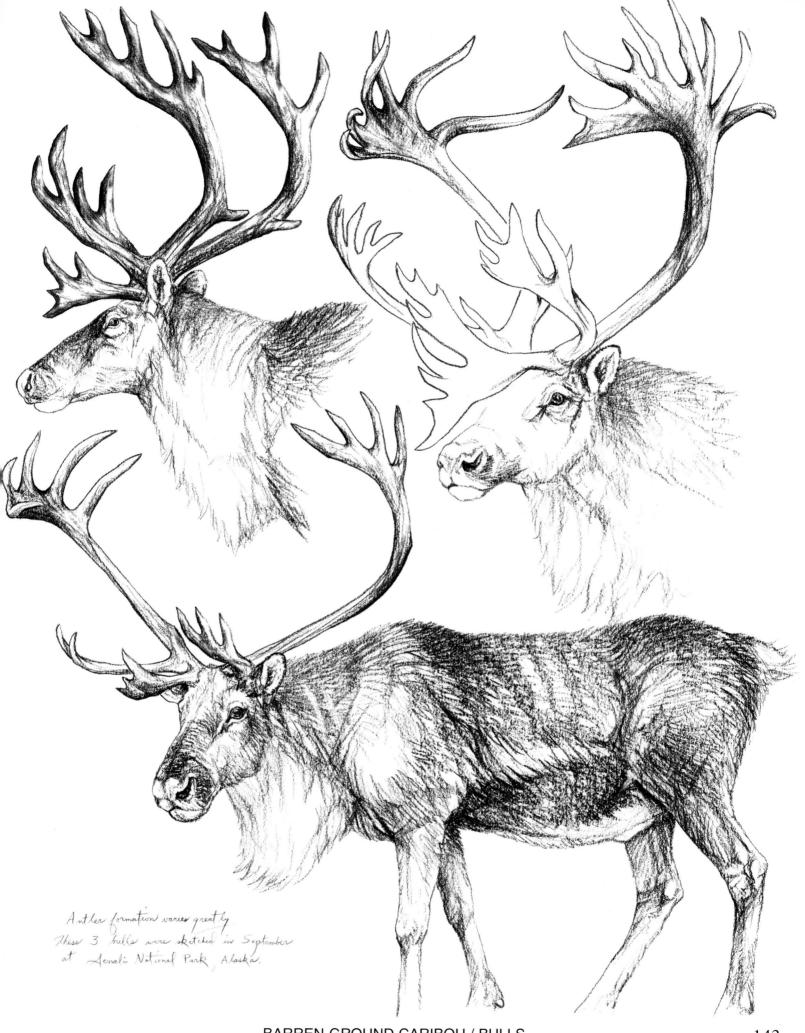

BARREN-GROUND CARIBOU / BULLS

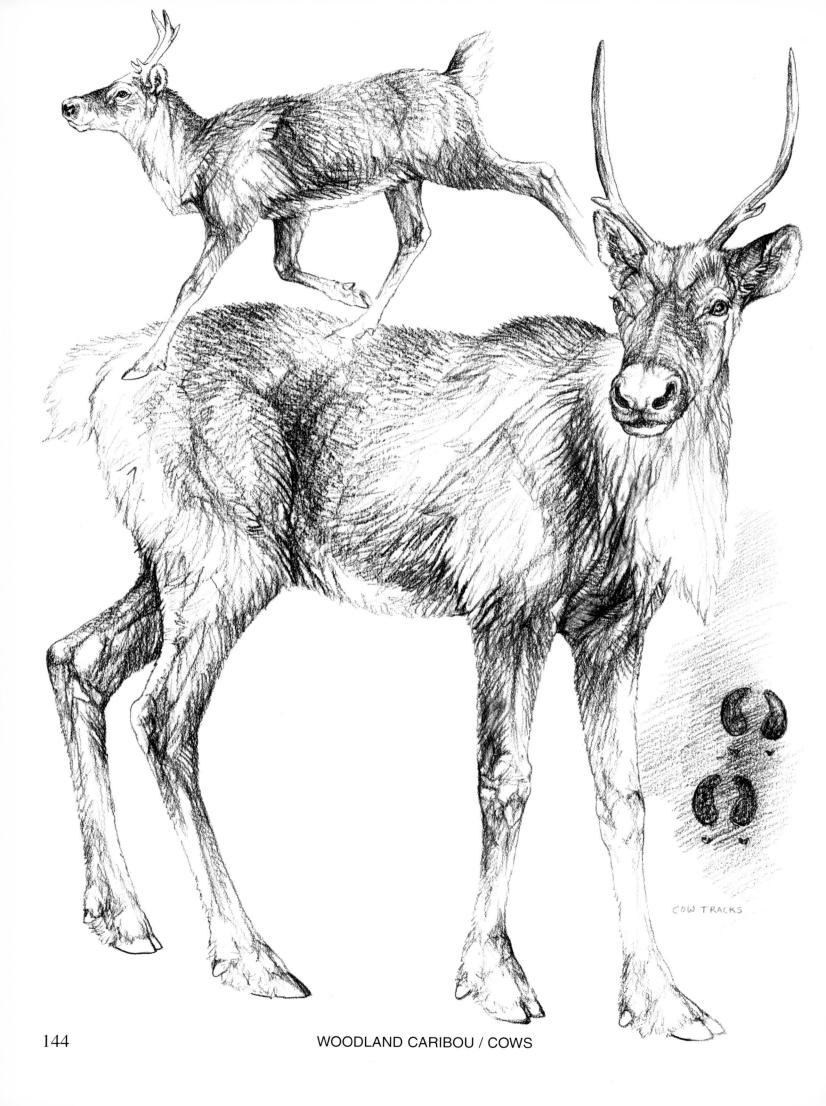

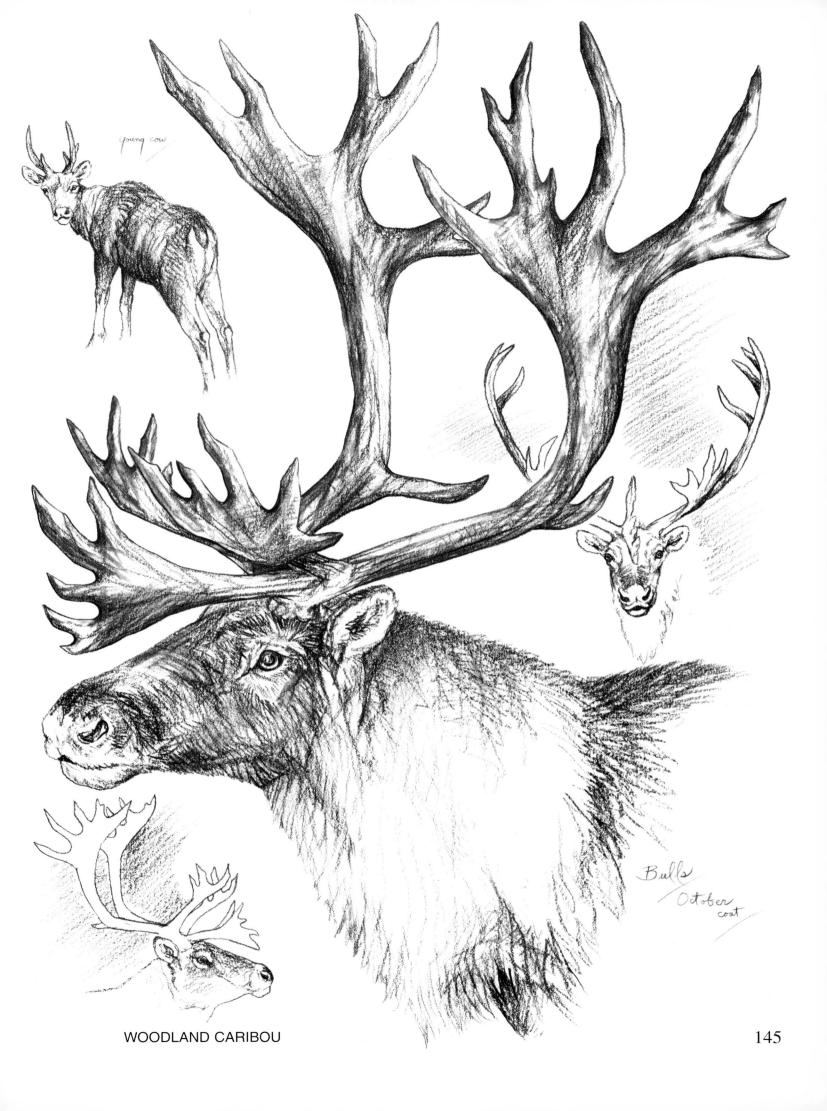

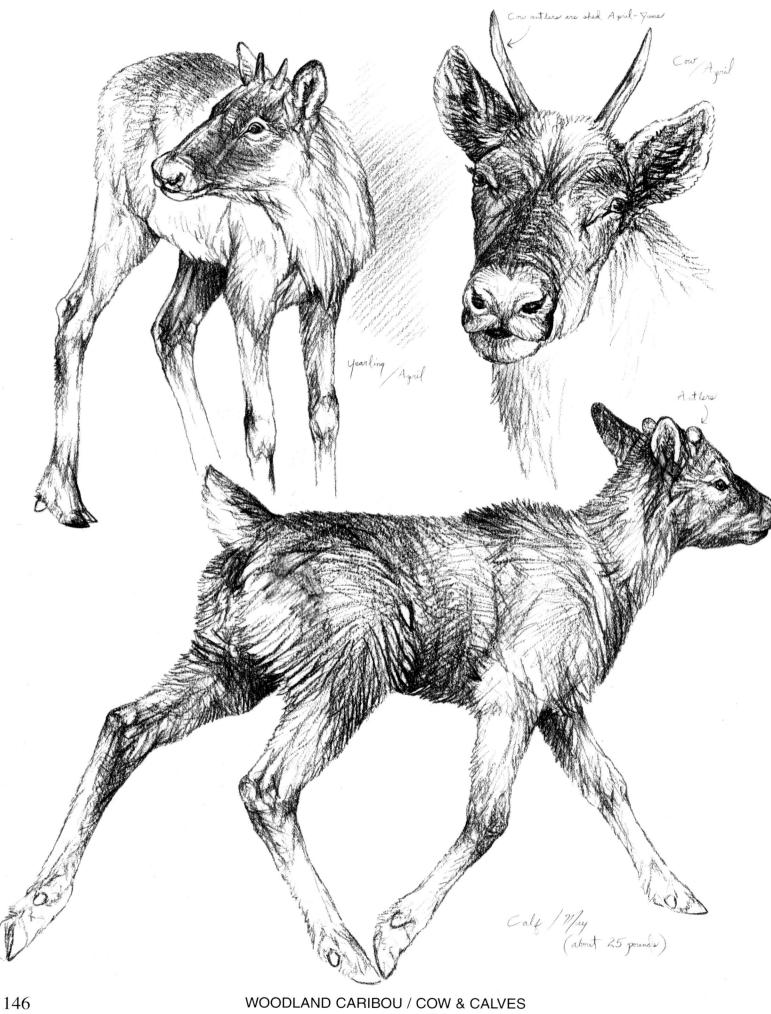

BLACK-TAILED DEER

The Sitka black-tailed deer (Odocoileus hemionus sitkensis) is the deer of the Alaskan rain forests and the northern coast of British Columbia. It is smaller than other blacktails and has a shorter-face. They have a typical blacktail antler branching, with three points (including the eyeguard tine) on each side. A mature male (buck) weighs about 110 - 150#'s, stands 36" - 38" at the shoulder, and is about 5' long. Females (does) average 75 - 95#'s. The blacktails coloration resembles that of a whitetails but has a dark horseshoe-shaped mark on its forehead. The blacktails tail is black on the top and white underneath.

Mating season is October/November and the 5# "fawns" are born the following May/June. They, like other deer and elk fawns, are born with a camouflaged "spotted" brown coat, and they spend much of the first few weeks hidden in the grass. Soon, however, the rich milk of nursing has given them the strength to stay at their mothers side and to escape most predators. Although predators such as the wolf and bear take a certain percentage of the fawns and adults, the main cause of population declines is severe winters and the loss of quality winter range due to clearcut logging.

During summer the blacktails feed on the plentiful herbaceous vegetation and shrubs, but during the winter they are often reduced to surviving on evergreens and woody browse. A wild Sitka black-tailed deer seldom lives past 10 - 12 years.

The other North American blacktail subspecie, the Columbian blacktail (Odocoileus hemionus columbianus), ranges from the British Columbia coast south along the western coasts of Washington, Oregon, and California. They are not as short-faced as the Sitka, and are generally larger. Their main predator is the Mountain lion who flourishes through these regions.

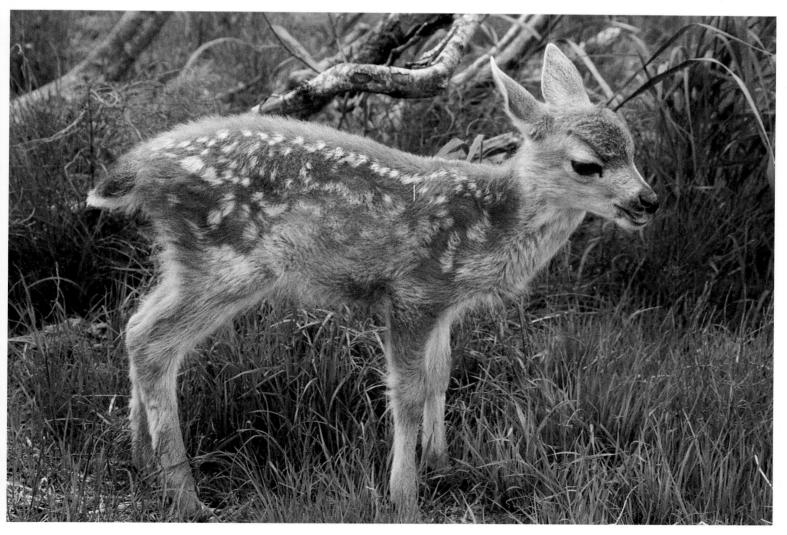

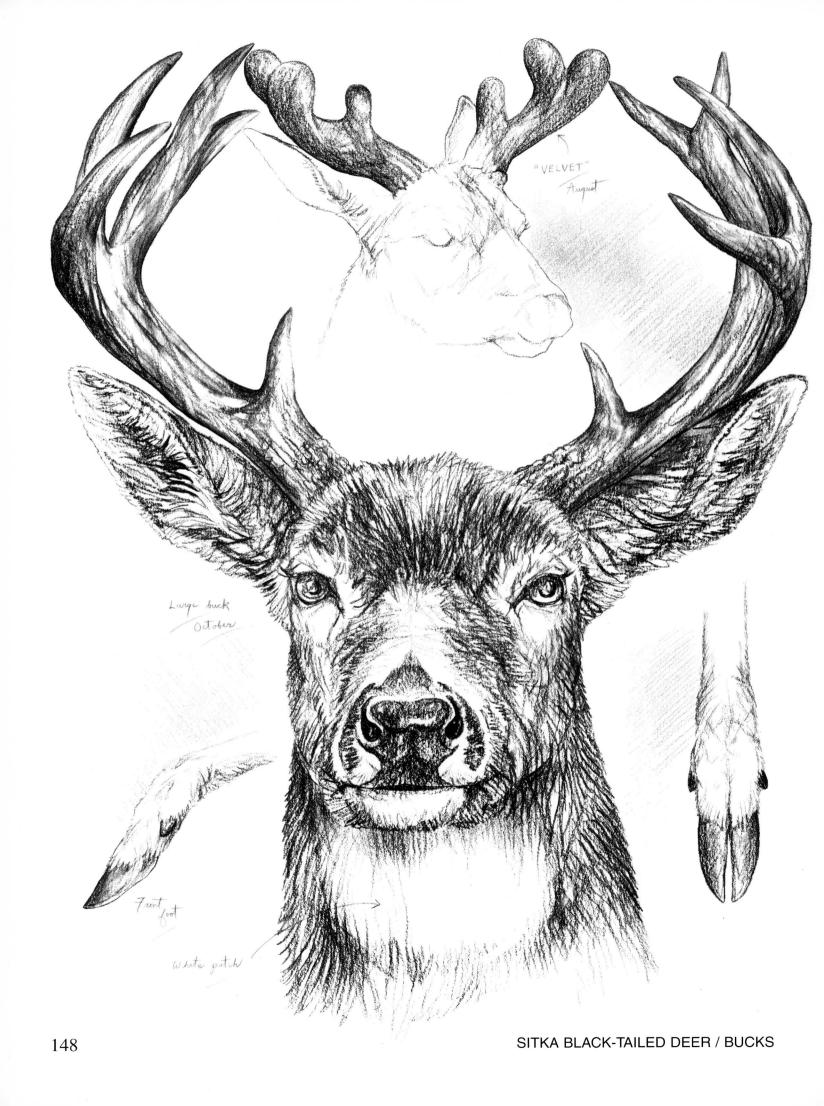

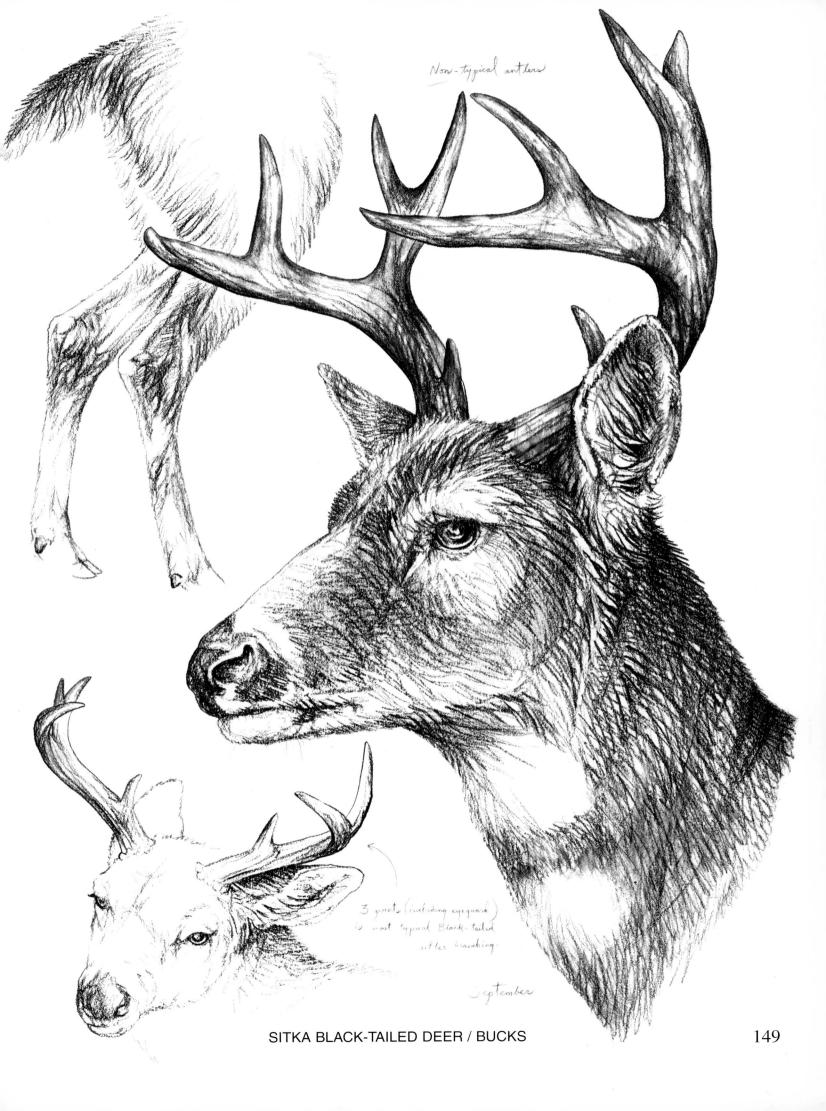

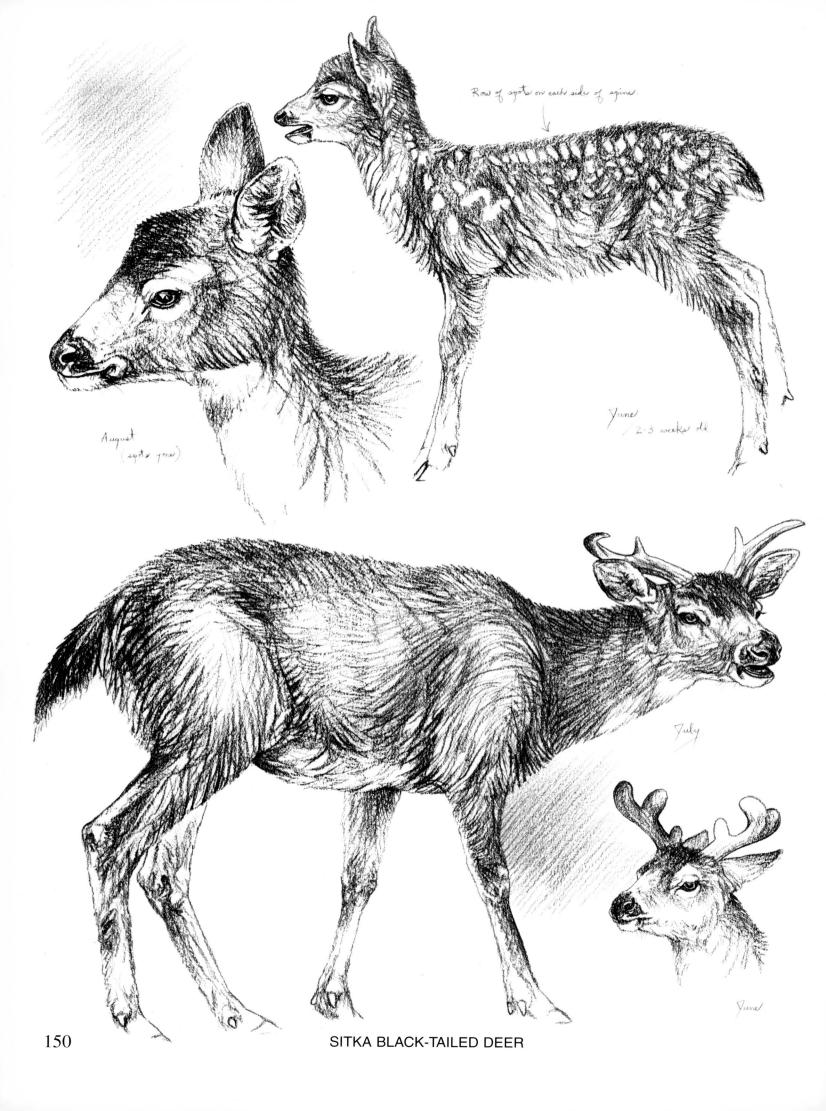

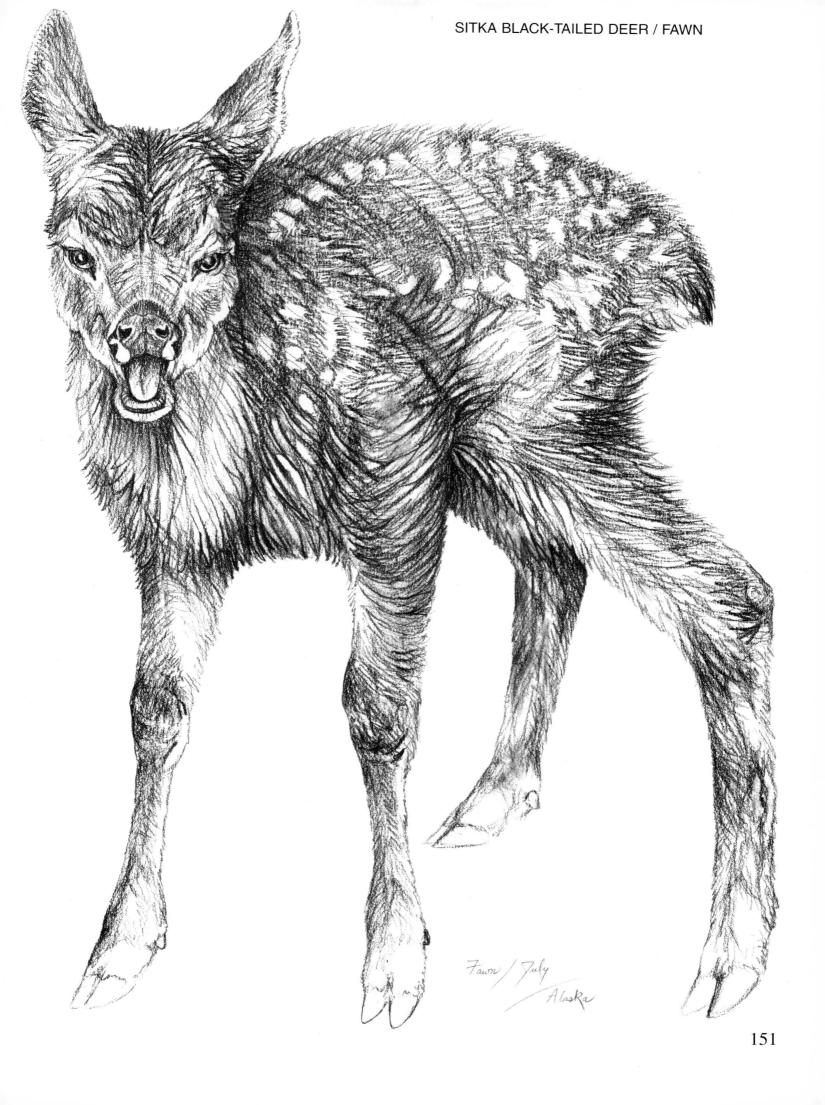

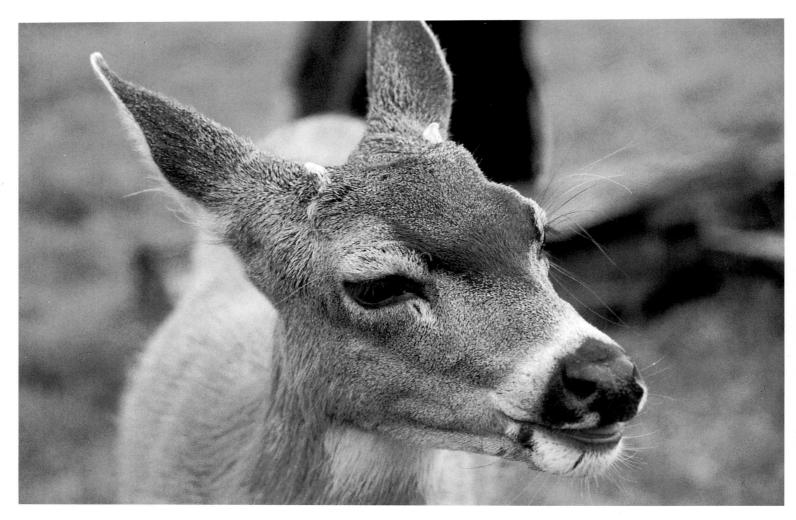

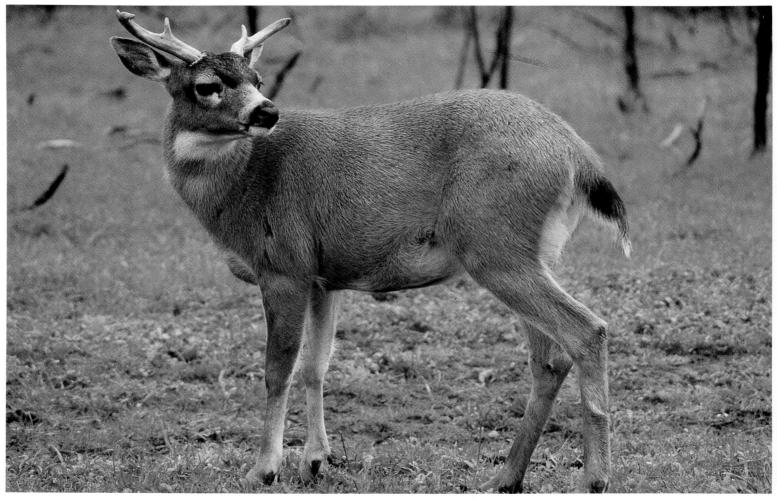

SITKA BLACK-TAILED DEER (AUGUST)

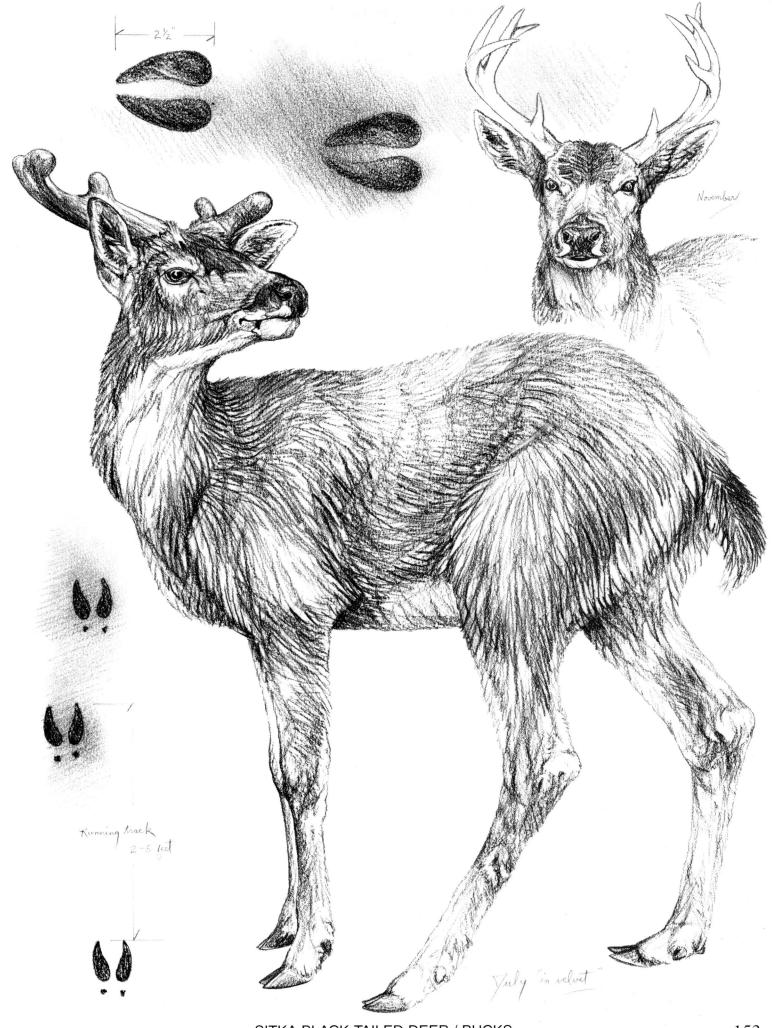

SITKA BLACK-TAILED DEER / BUCKS

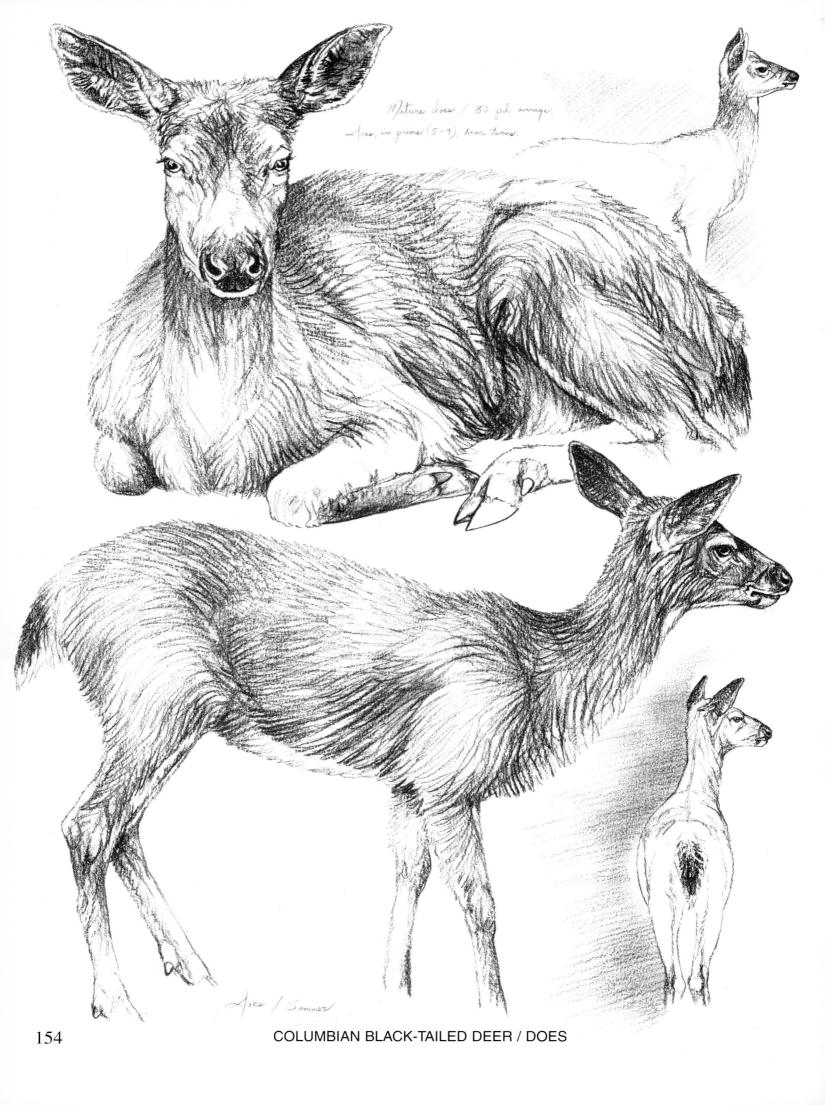

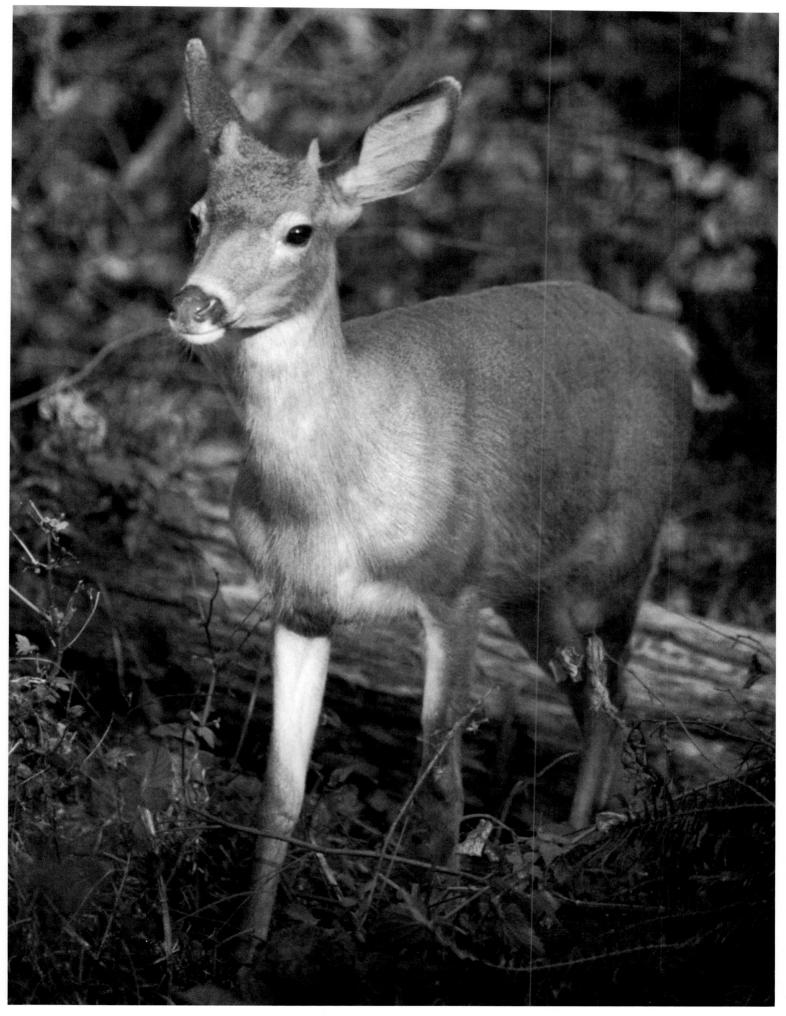

COLUMBIAN BLACK-TAILED DEER / "SPIKE"

MULE DEER

The Mule deer (Odocoileus hemionus) inhabits the prairies, hills, and open spaces of the Rocky Mountain region from Alberta to Mexico. Colorado, California, Oregon, Montana and Wyoming have the largest populations. Also, the Blacktail deer is considered a subspecie of the Mule deer, but because of their different characteristics, I will separate the two here in my writing, art, and photographs. The big-eared "Mulie" prefers rough, mountainous country as opposed to the more wooded terrain of the Whitetail.

A mature male Mule deer (buck) is a stocky animal that stands 42" high at the shoulder, is over 6' long, and averages 175 - 250#'s in weight. Its antlers differ from the Whitetails in that each antler beam forks twice, forming long, straight points. Also, the Mule deer's antlers often lack the brow tines that are often very prominent on a Whitetail rack. Deer are normally a reddish-brown during the summer and turn a more grayish color in winter. Other characteristics include a round, black-tipped tail, creamy-white belly, and white throat patches, rump, and insides of legs and ears. Females (does) have no antlers and weigh 100 - 150#'s.

Mule deer usually migrate between summer and winter ranges. They seem to prefer early morning and late afternoon feeding, and often retire to shady, protected areas for the mid-day. However, during nighttime, they more likely will "bed" in the open. Their diet consists mainly of grasses during the summer months and brush and browse during the winter. They, unlike other large mammals, don't "paw" through the snow to reach the frozen grasses. All deer have an excellent sense of smell but their eyesight does not seem to detect stationary objects that may be a threat. Main predators are the Mountain lion (a mature cat will kill 2 or 3 Mule deer every 10 days) and (in the more northern areas) the wolf. Normally 10 years is the life span of a wild Mule deer.

Most mating has occurred by December and the young "fawns" are born the following summer. Most weigh about 6#'s, are "spotted", and nurse from their mother until winter. By then they have lost their camouflaged spotted coat and become independent. Does will breed when they are 1 1/2 years old. After the initial "single" fawn, twins are most common.

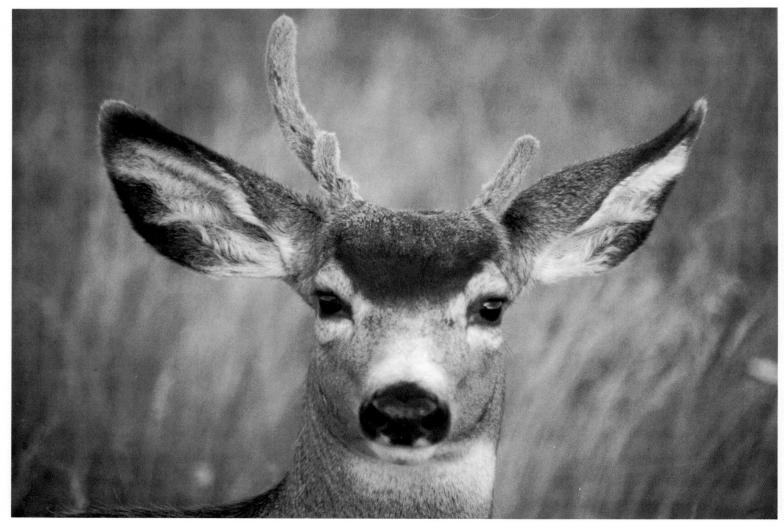

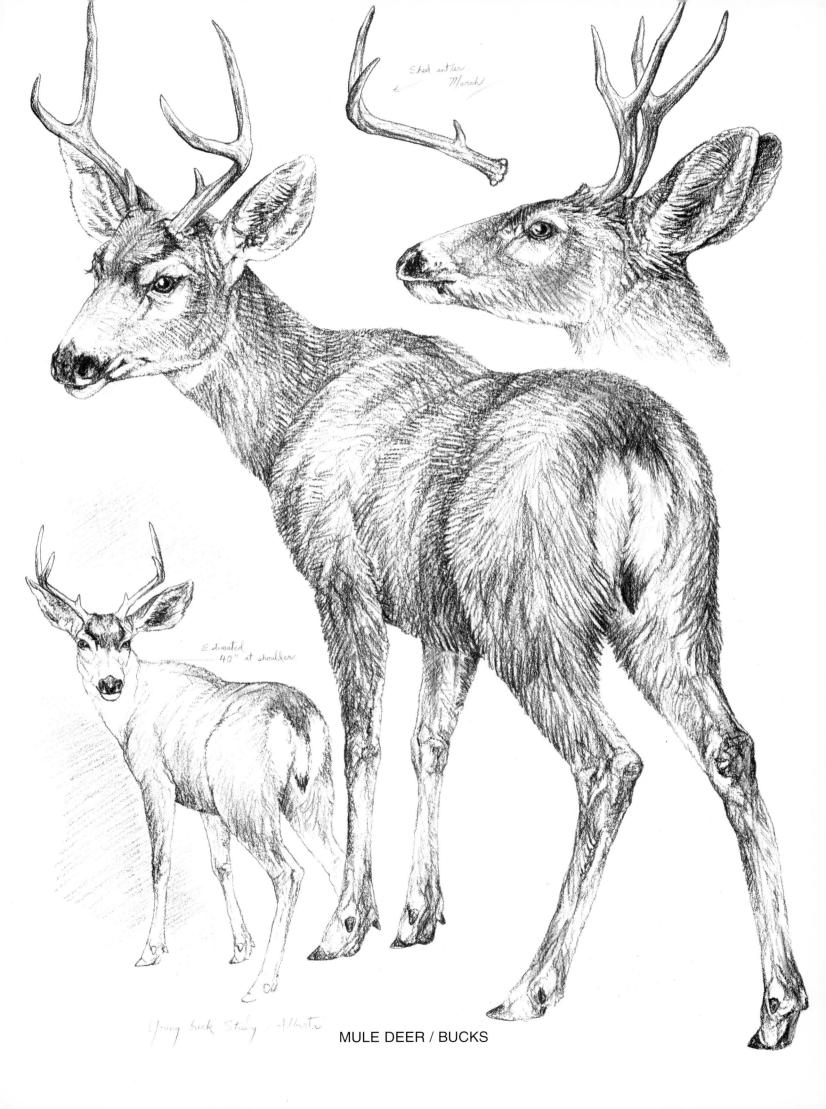

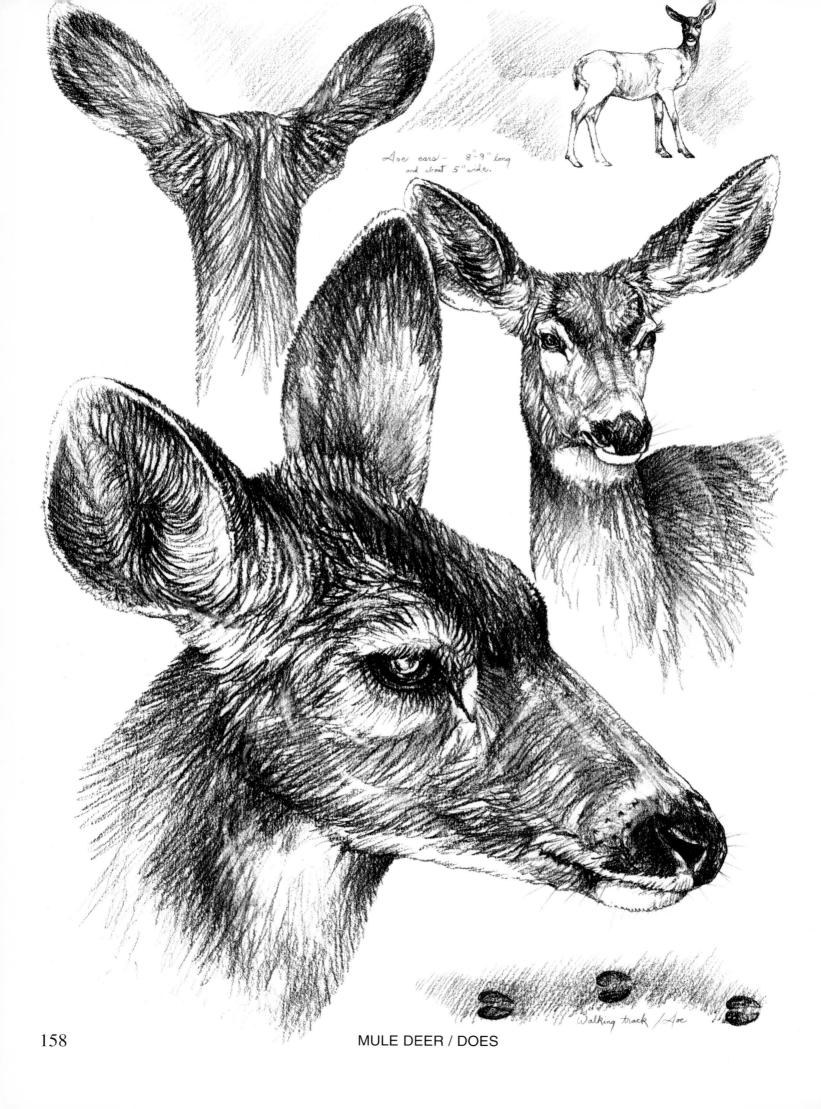

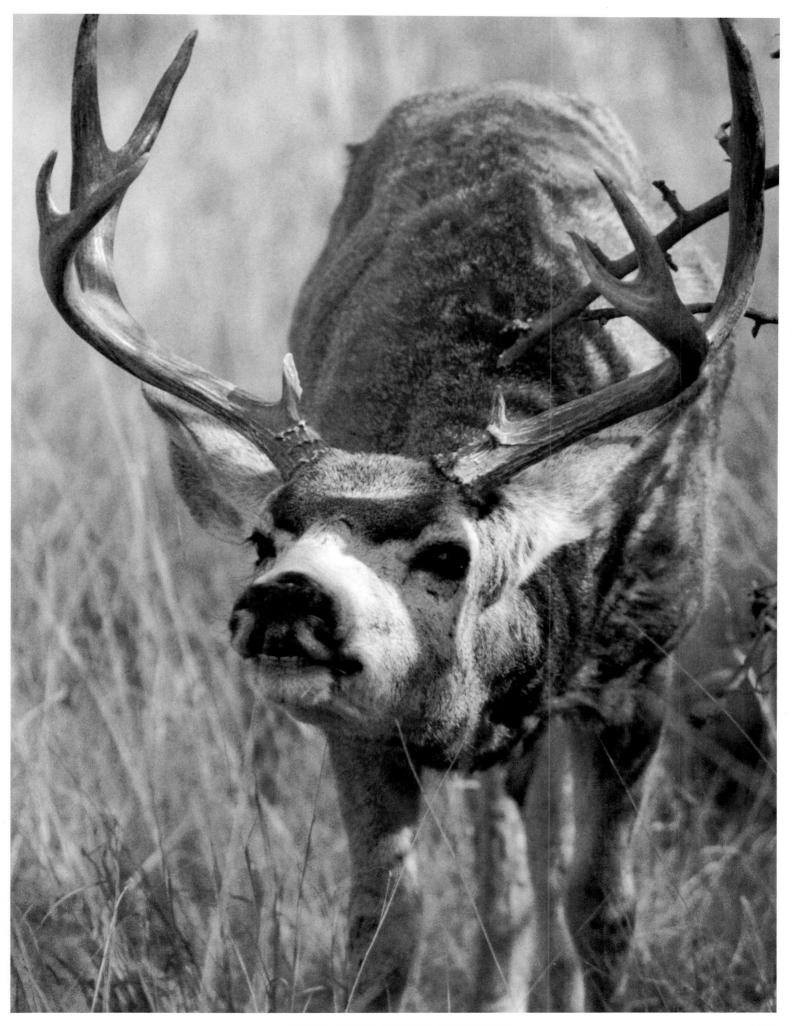

MULE DEER / BUCK (JANUARY)

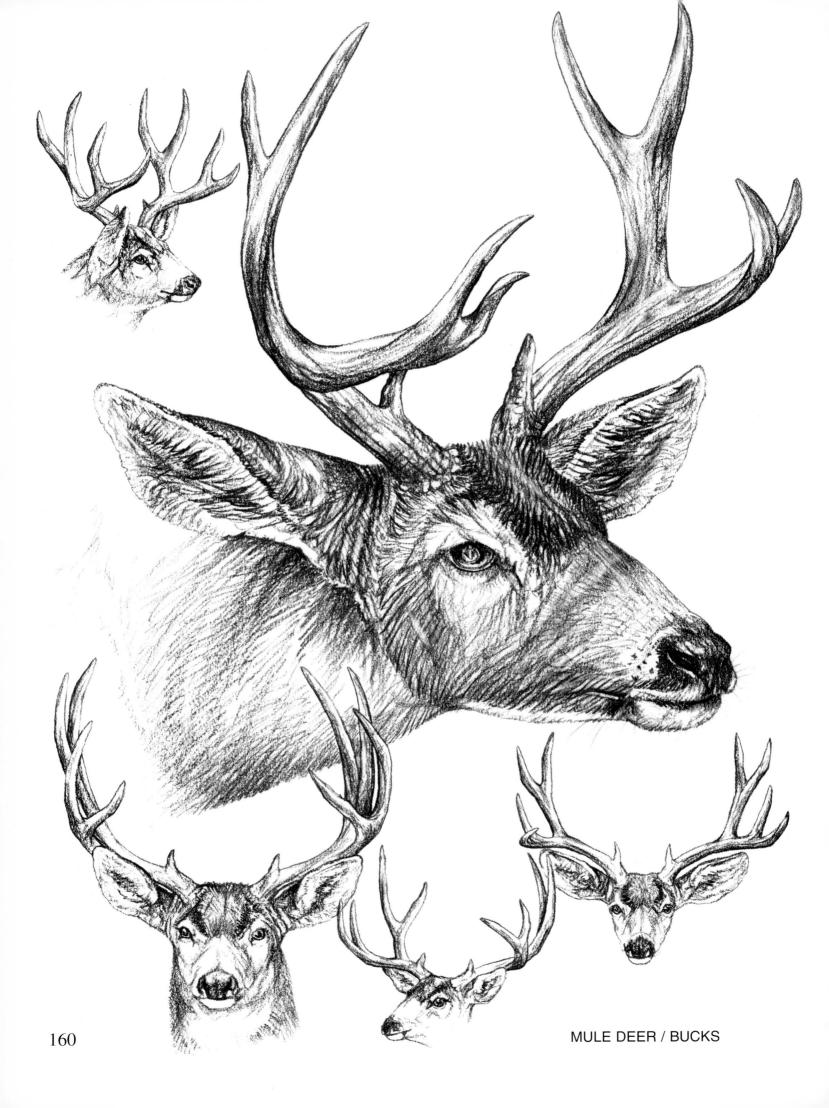

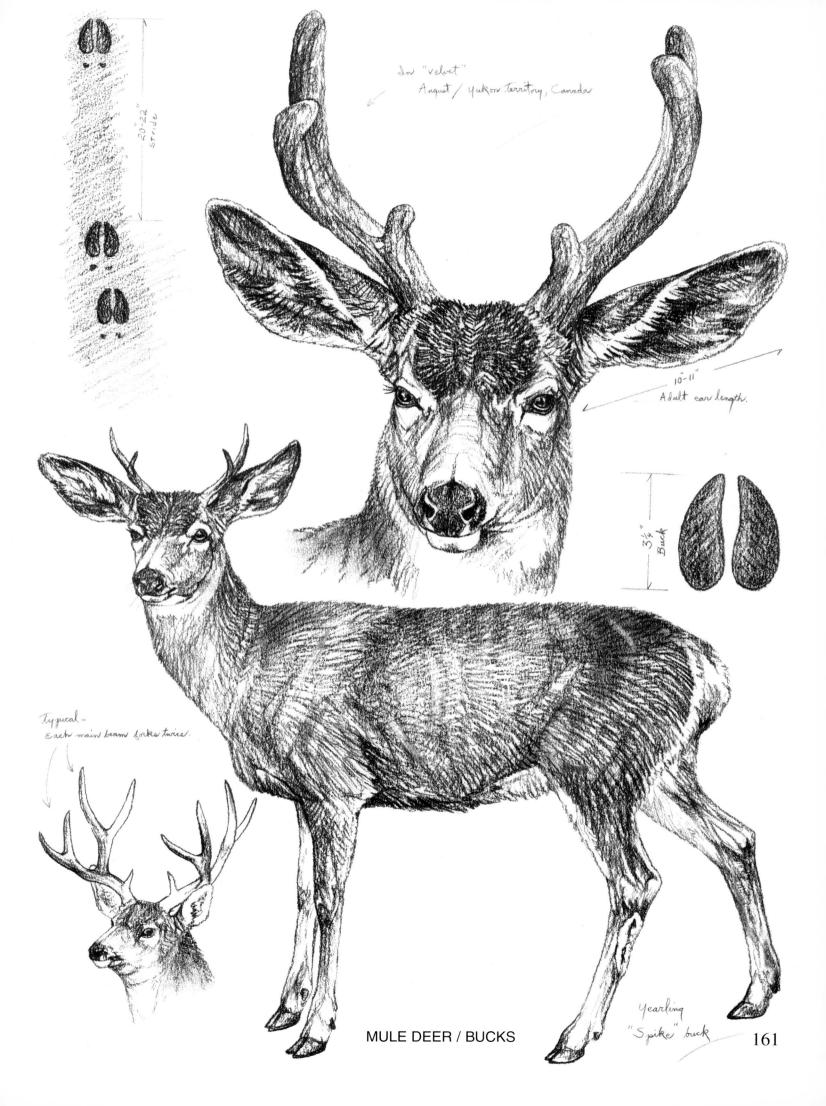

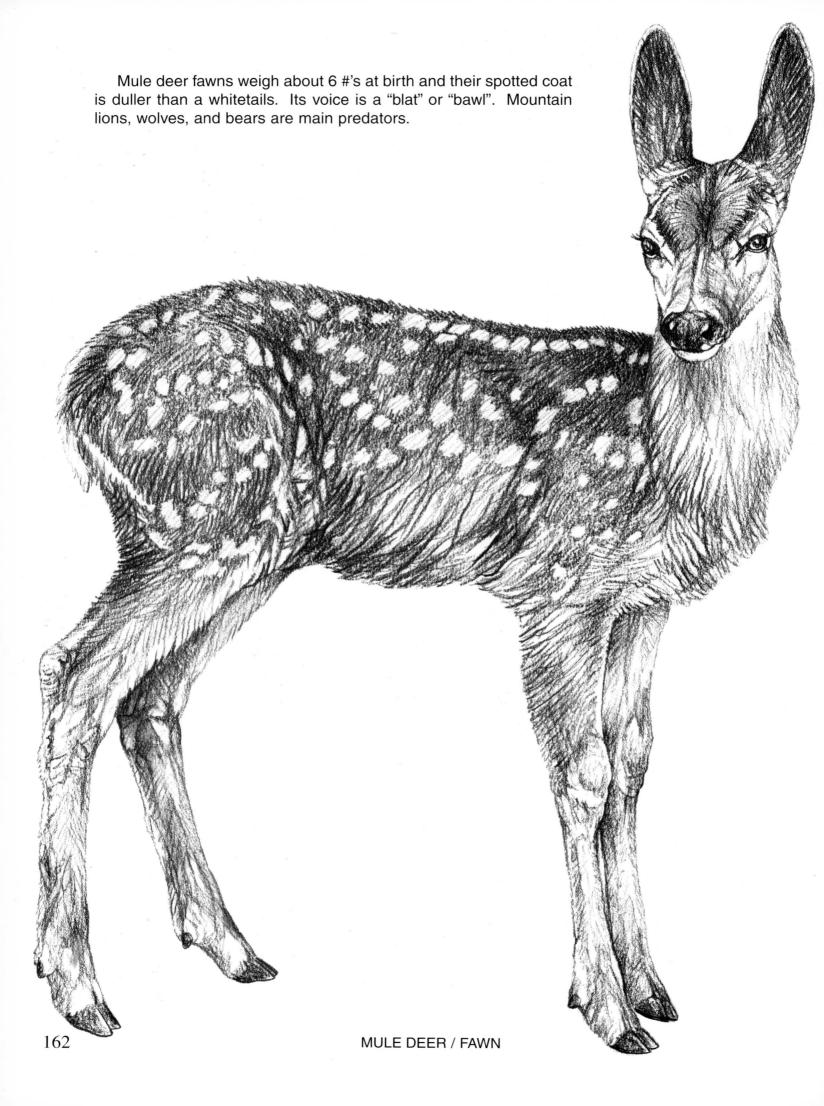

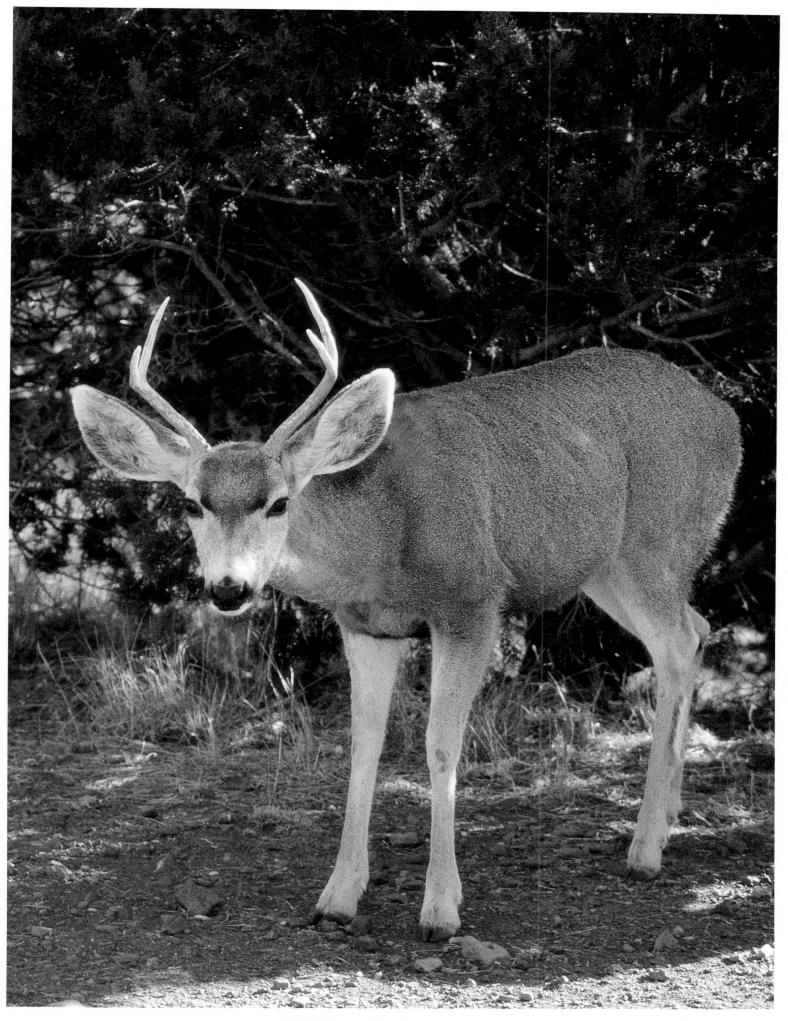

MULE DEER / BUCK (FEBRUARY)

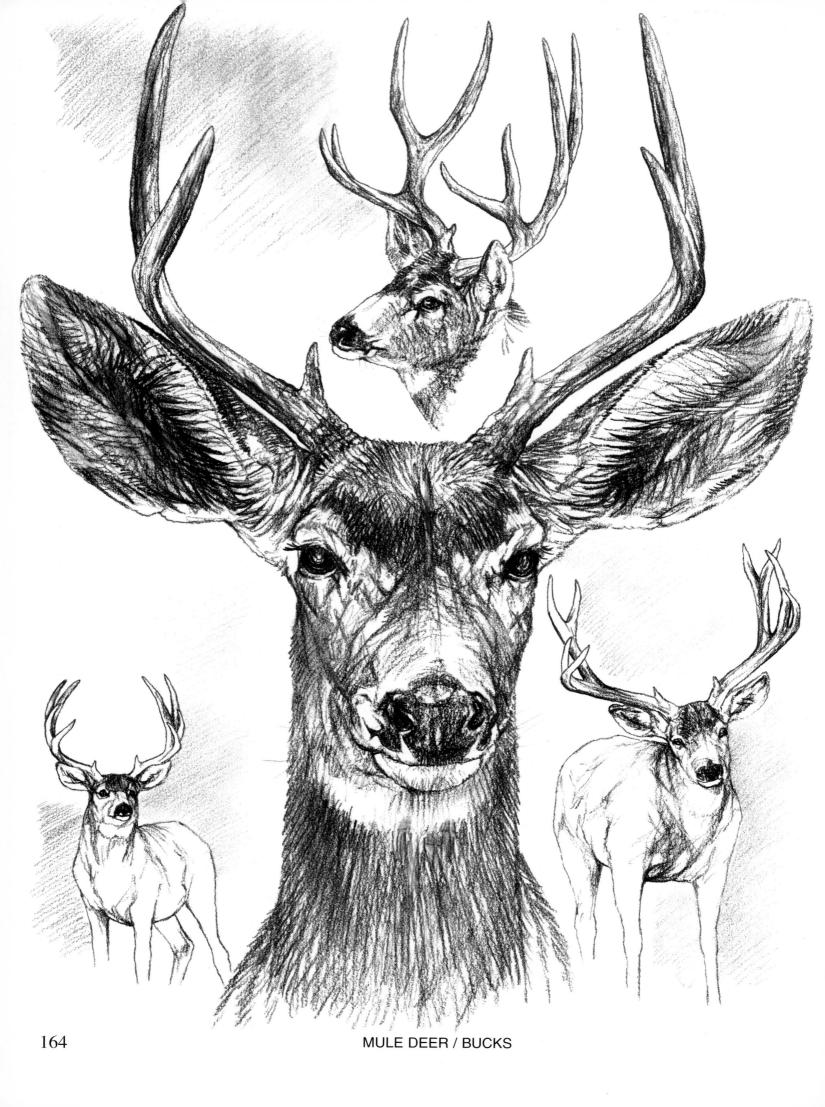

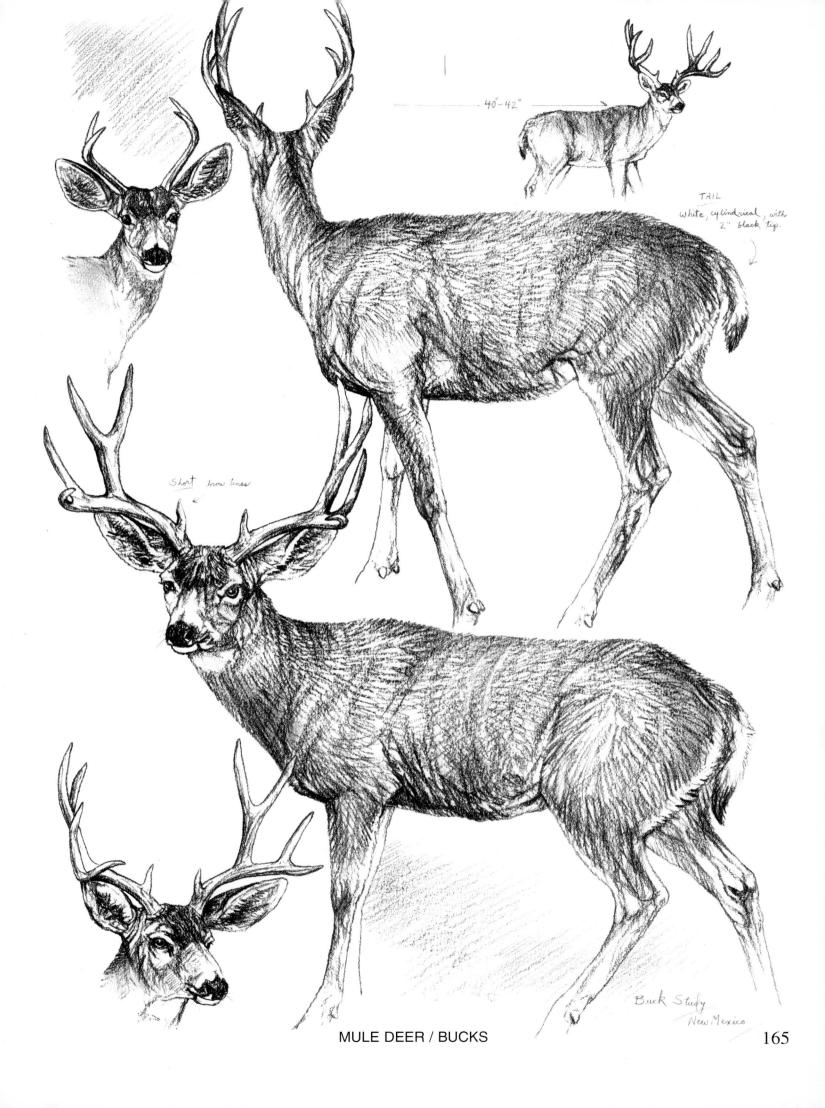

WHITETAIL DEER

The Whitetail deer (Odocoileus vIrginianus) is the most plentiful big-game mammal in North America. It is native to North America and, because of its adaptability, has flourished in modern times; despite the elimination of much of its original territory. Estimates state that the 500,000 whitetails of 1900 have grown to over 19,000,000 in 1999. Whitetails range over much of the United States (except the West's driest areas) and the southern parts of Canada. It has various subspecies, and ranges in size from the large northern deer to the tiny Florida Key deer. Weights for mature northern males (bucks) is 150 - 225#'s on average, and usually less than 90#'s for the Key whitetail. Shoulder height for the large deer is 38" - 42", with a 5' - 6' length. Despite regional differences, whitetails are basically similar in coloration. Brownish-gray coats with a white belly, throat patches, and chin. Its black nose is offset with white and the dark eyes are circled in white. Its coat changes from the brownish-gray of autumn/winter to a reddish tinge during the summer months. Its antlers consist of a main beam from which numerous tines grow upwards from; they do not "fork" like those of the mule/blacktail specie. When alarmed, a whitetail will "flash" his large tail, exposing the white underpart,

Whitetails have a wide range of foods throughout its vast range, ranging from apples and acorns to twigs and grasses. Whitetails also frequent corn fields, grain fields, and vegetable gardens. During September the bucks lose their antler "velvet" and by October their necks begin to swell for the "rut" which occurs until December. After the females (does) are bred, the bucks will shed their antlers (usually by January) and not begin to regrow them until late spring. "Fawns" are born May/June in most regions. Although the whitetail has many wildlife predators, the main reason for whitetail deaths (besides severe weather and food shortage) is their harassment by dogs. Often times packs of "pets" will literally run down and kill (or cause to die) every deer in an area. Whitetails normally live 10 - 12 years in the wild.

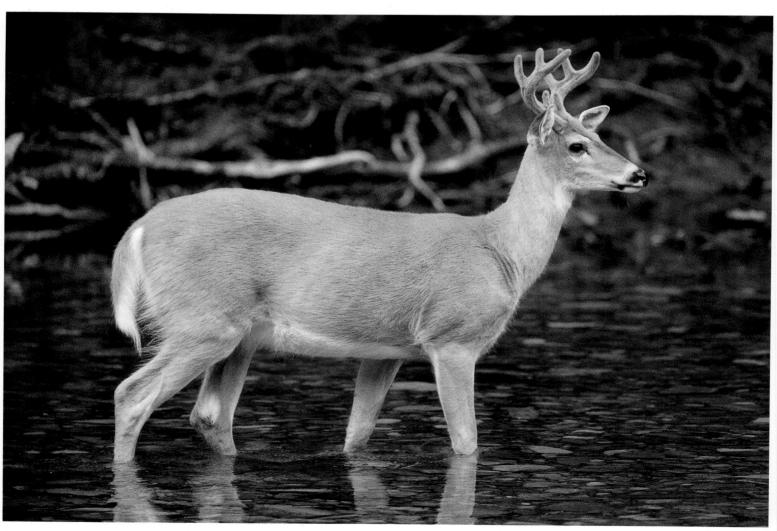

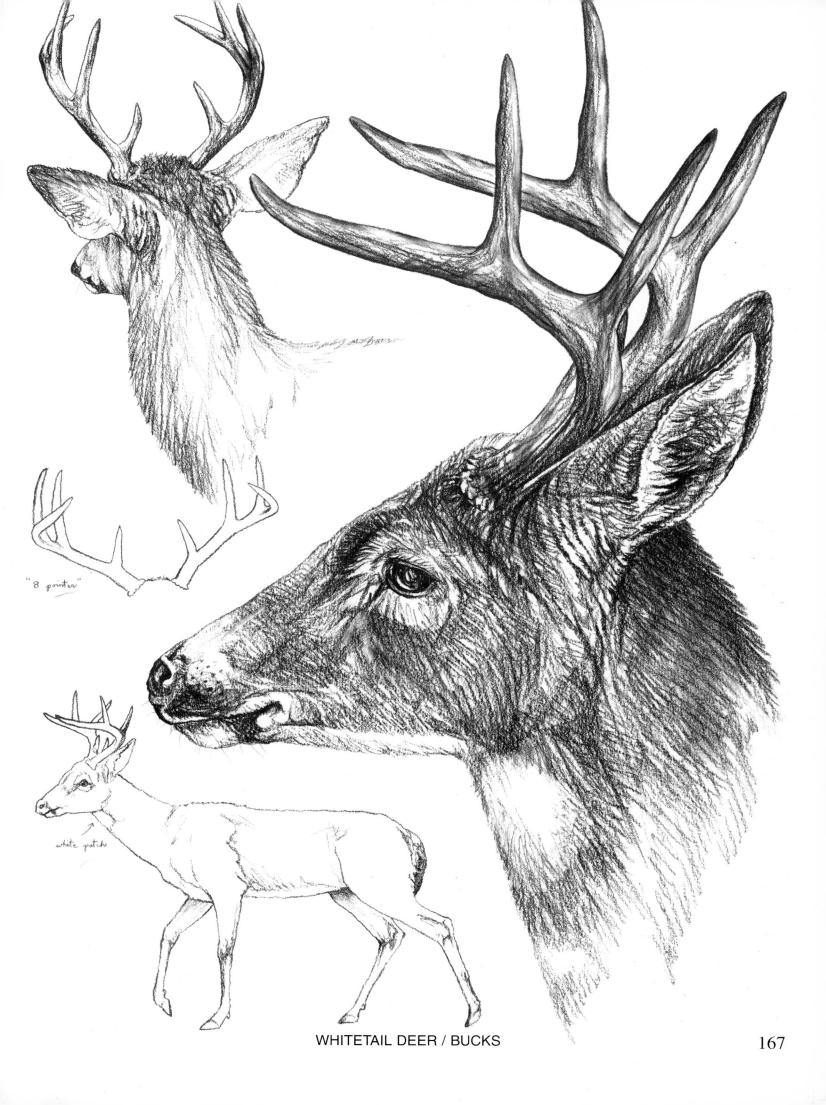

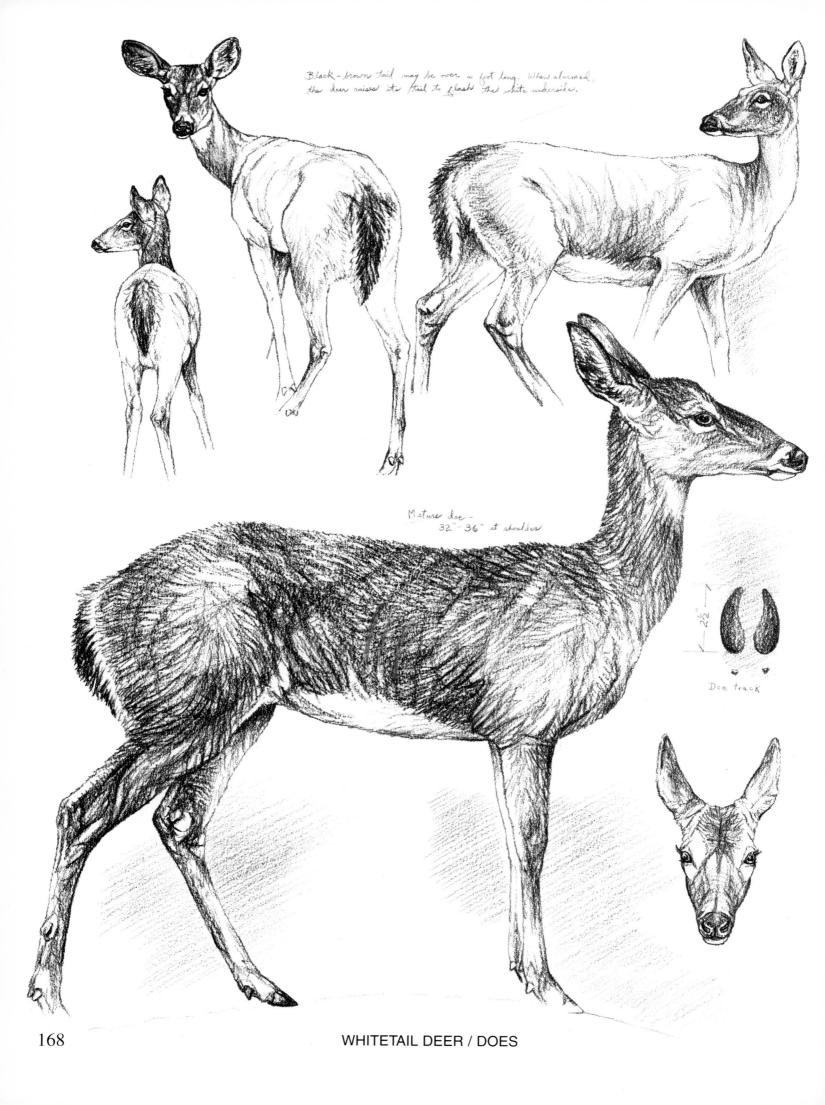

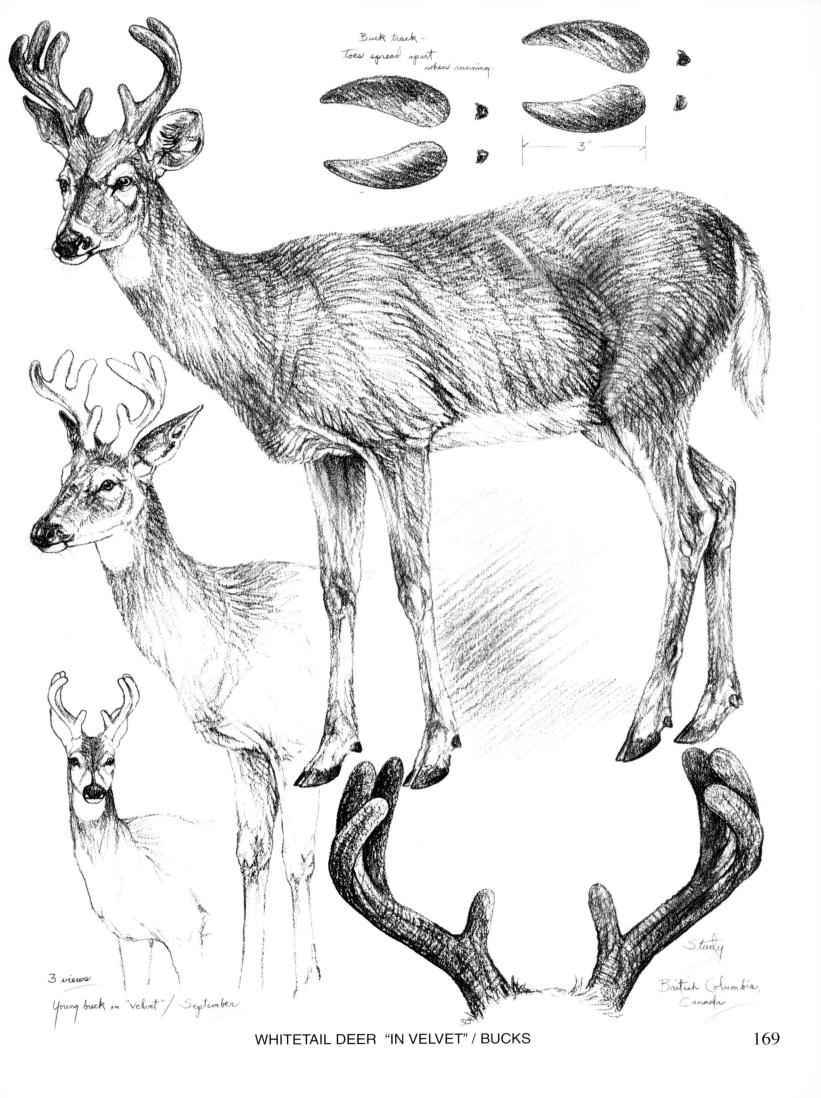

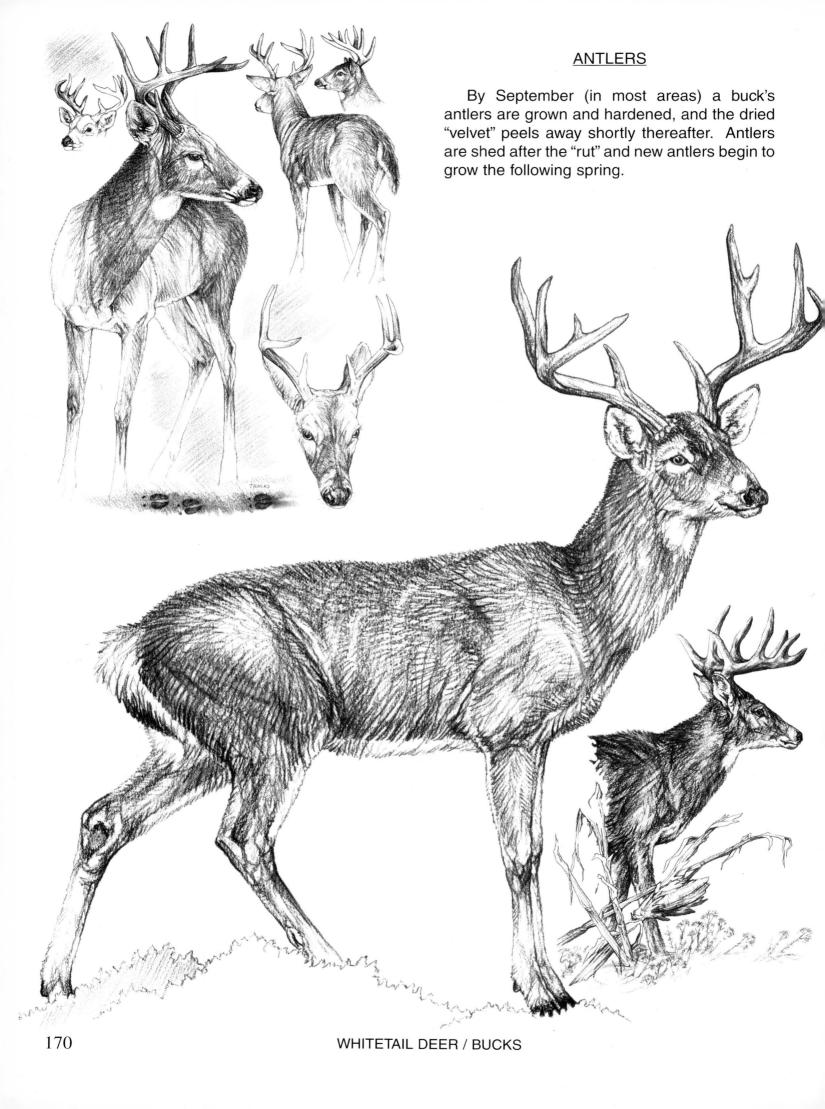

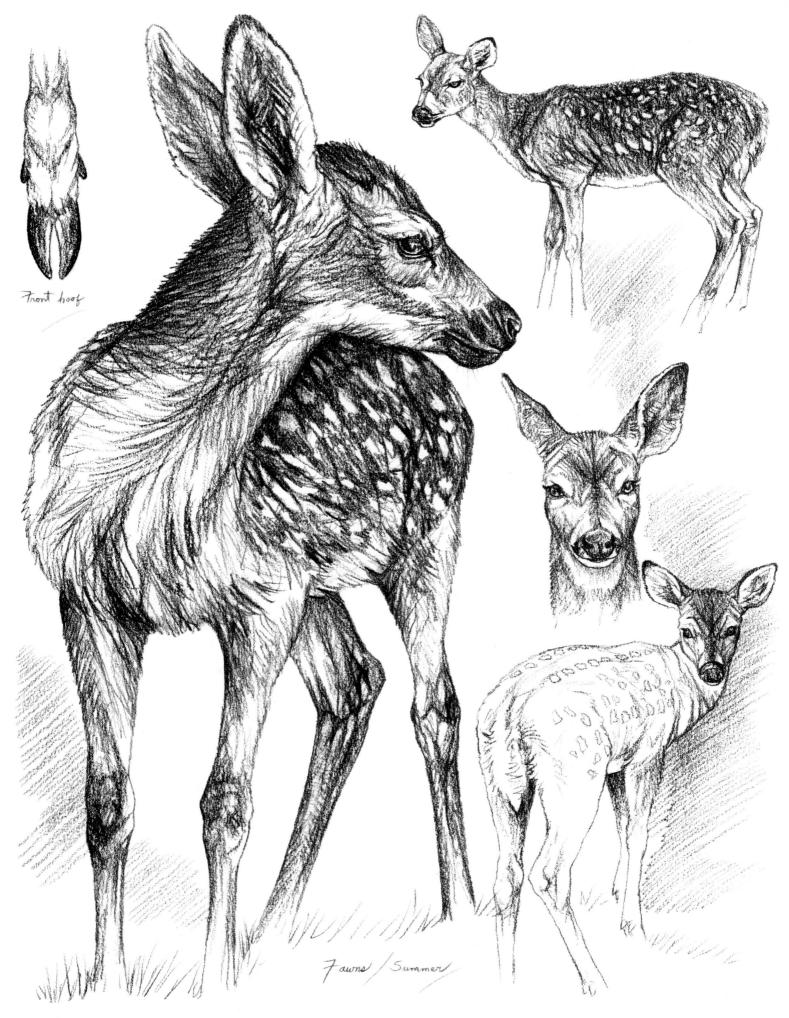

WHITETAIL DEER / FAWNS

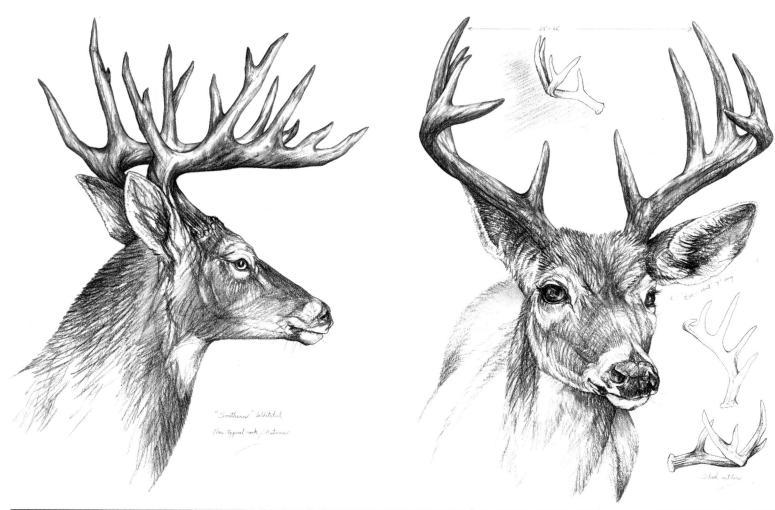

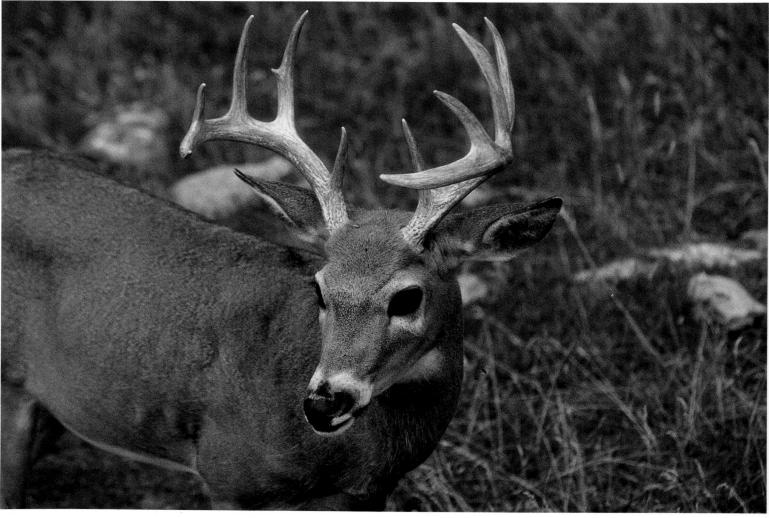

172

WHITETAIL DEER / BUCK (OCTOBER)

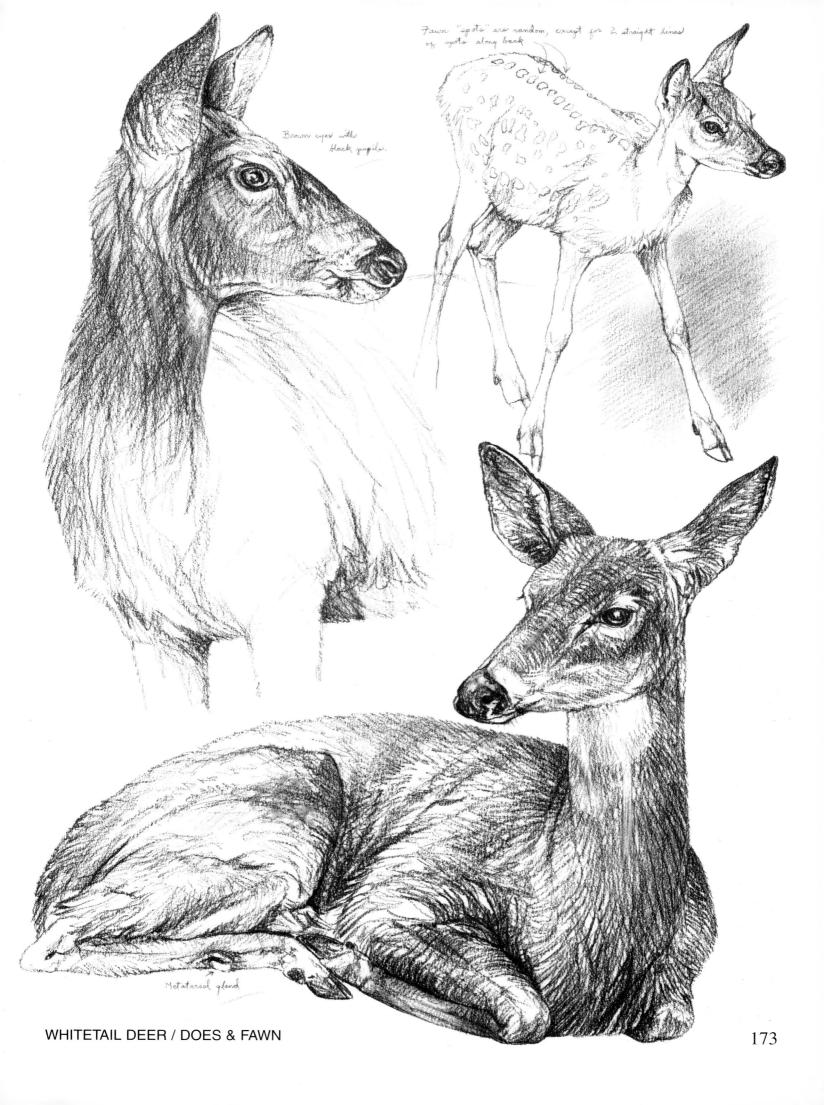

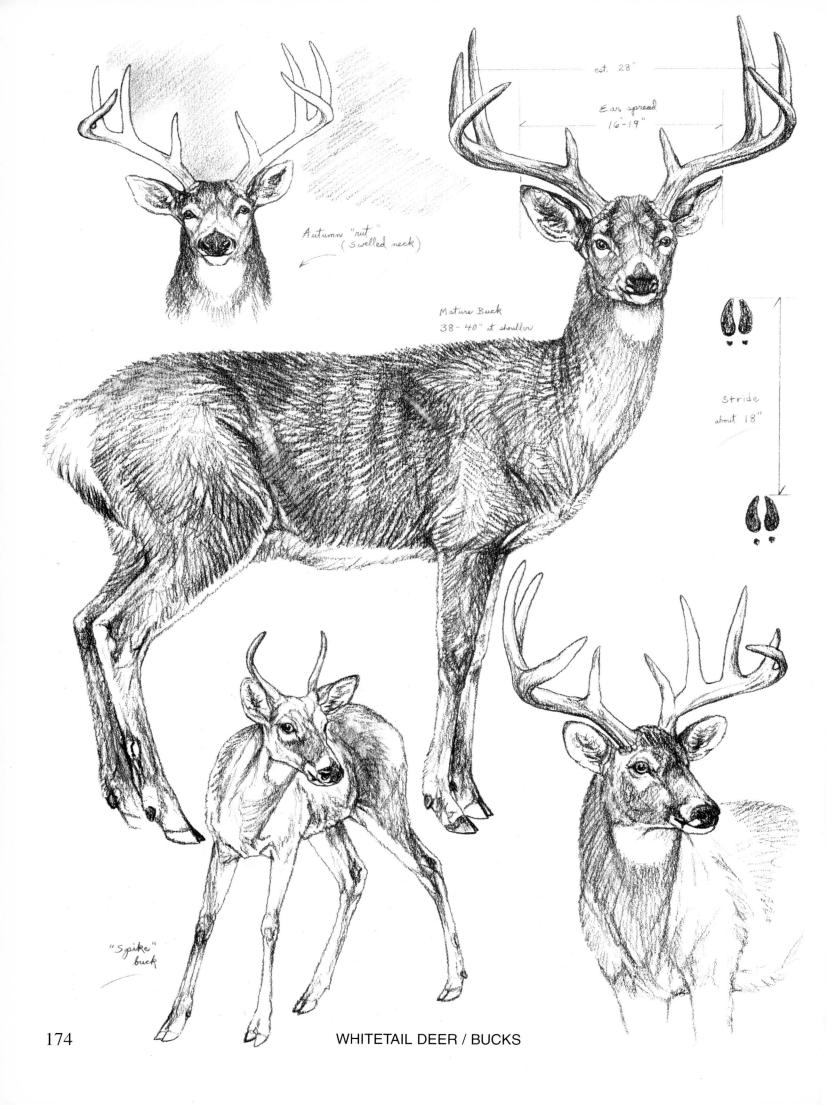

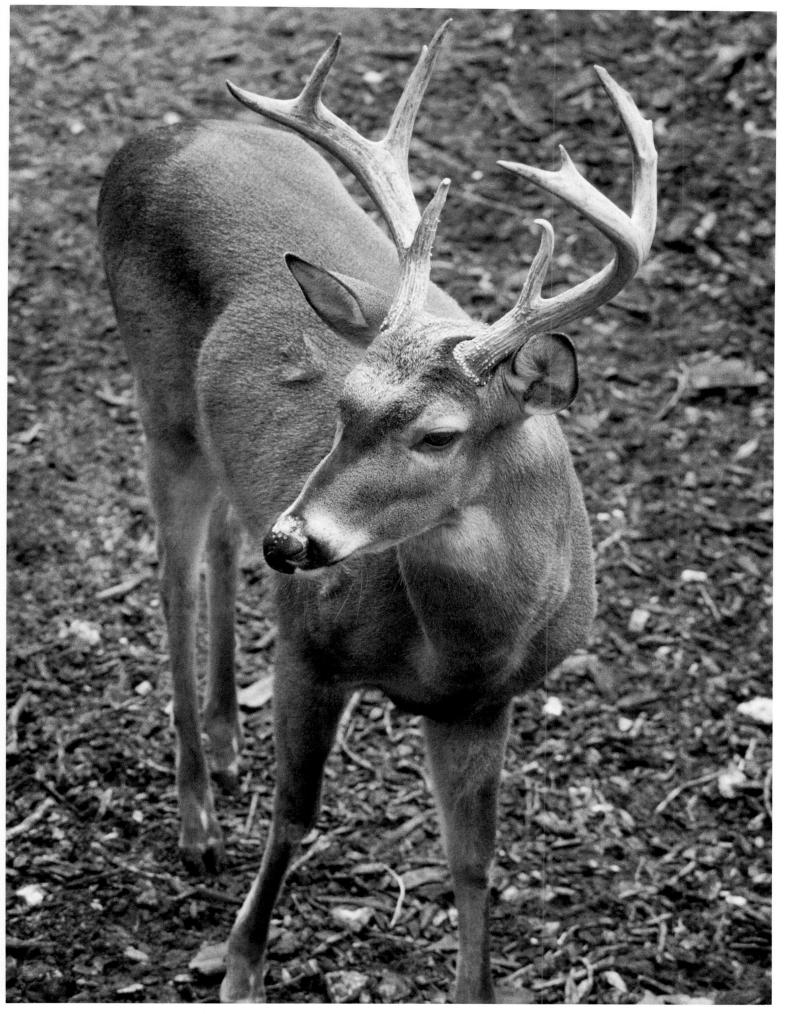

WHITETAIL DEER / BUCK (NOVEMBER)

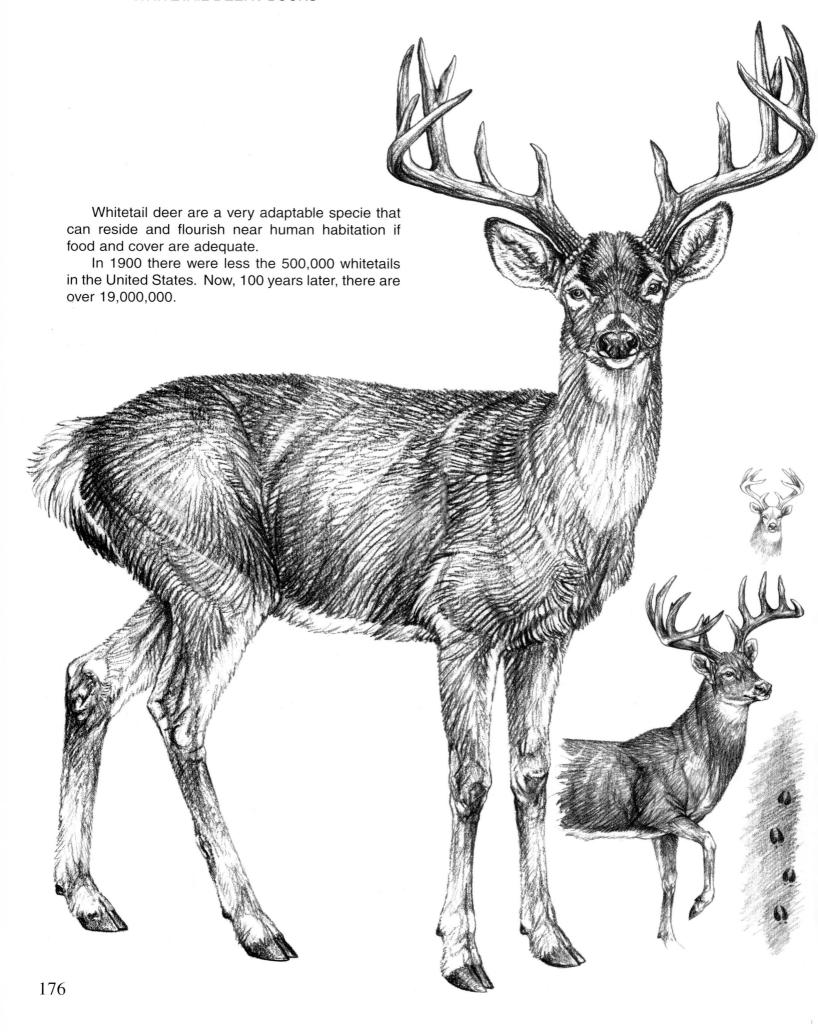

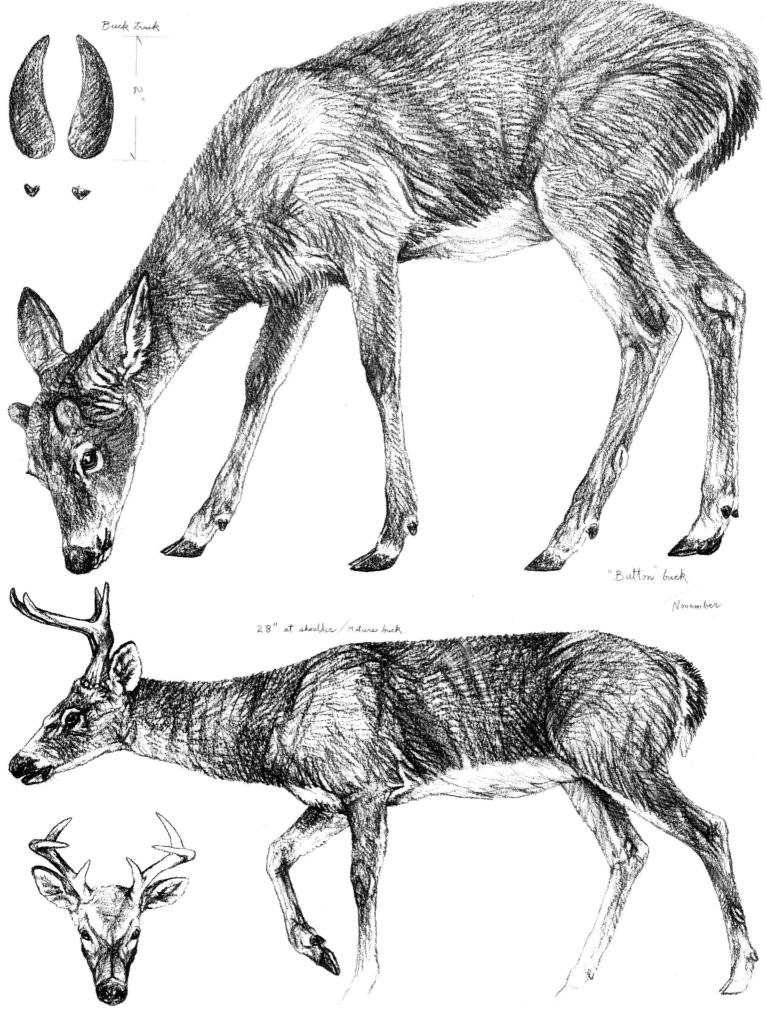

FLORIDA "KEY" DEER / BUCKS

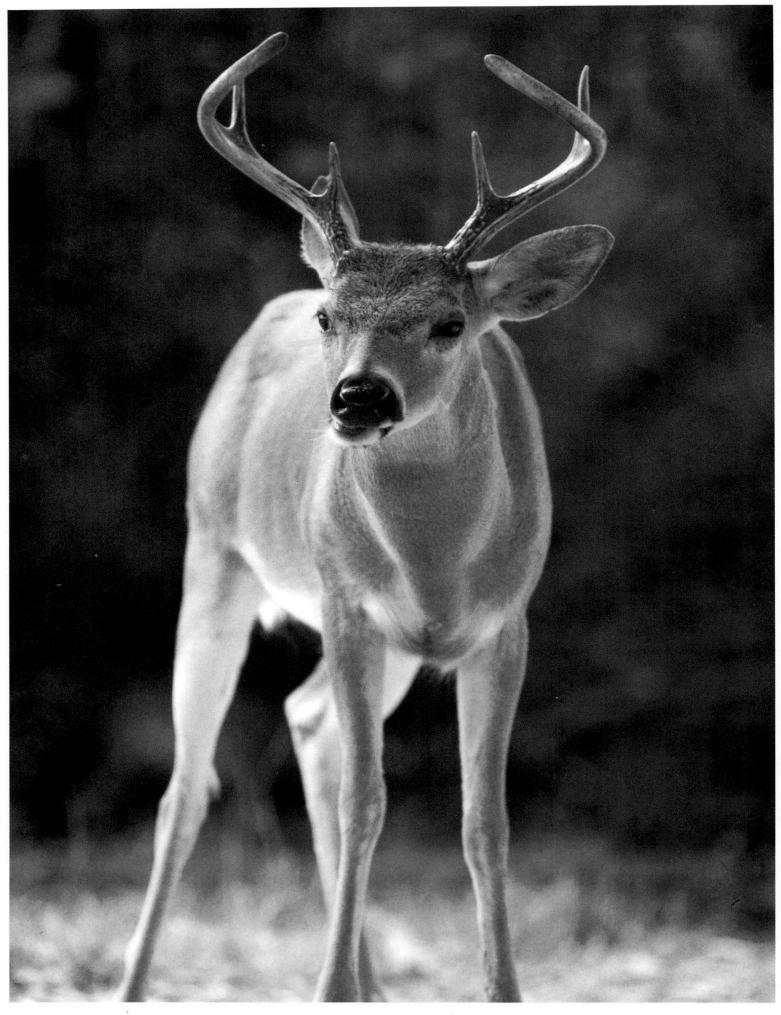

FLORIDA "KEY" DEER / BUCK (NOVEMBER)

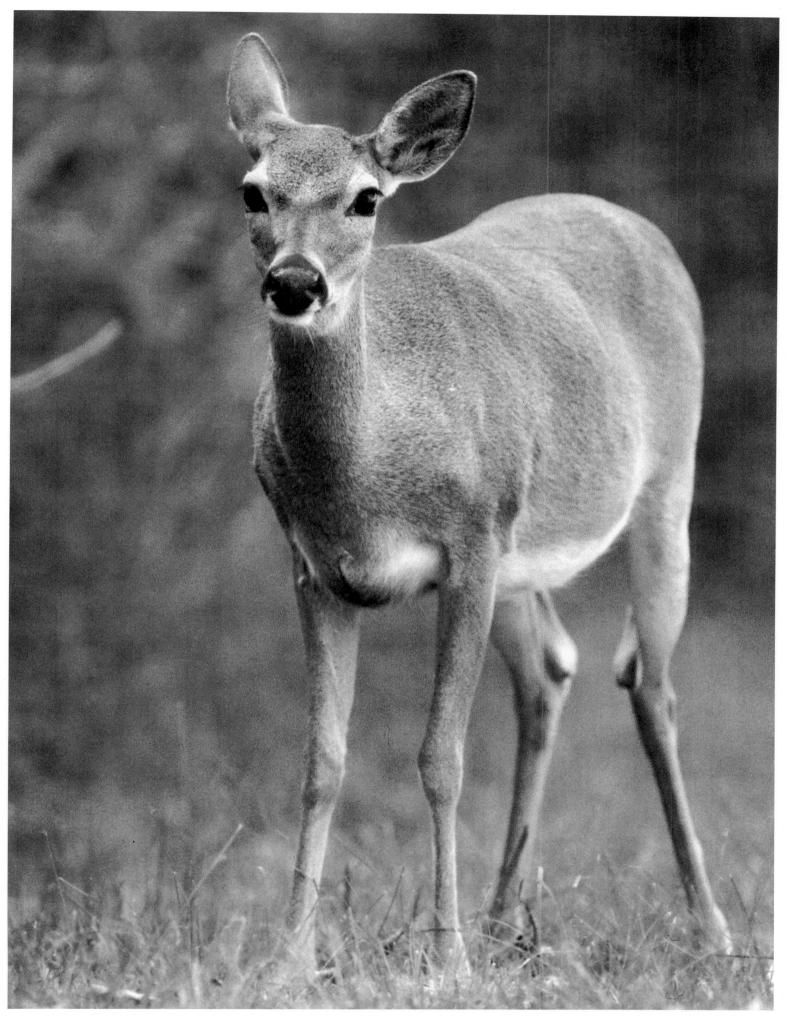

FLORIDA "KEY" DEER / DOE (NOVEMBER)

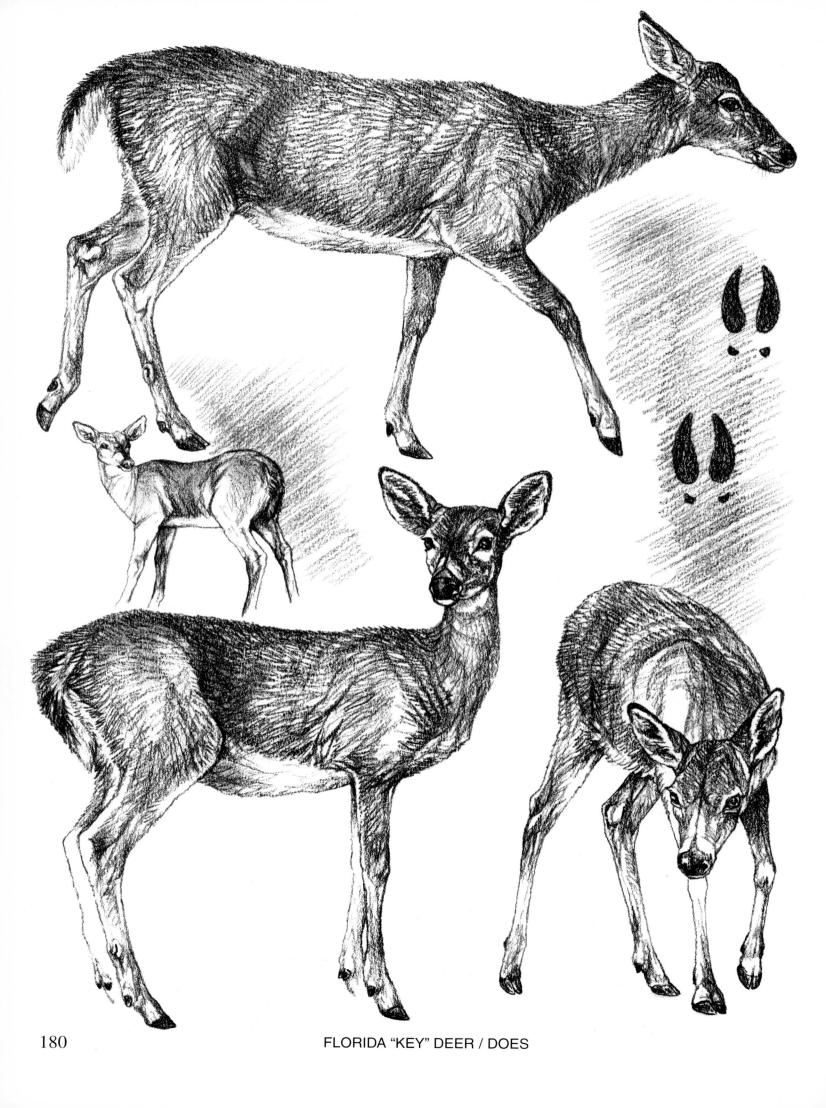

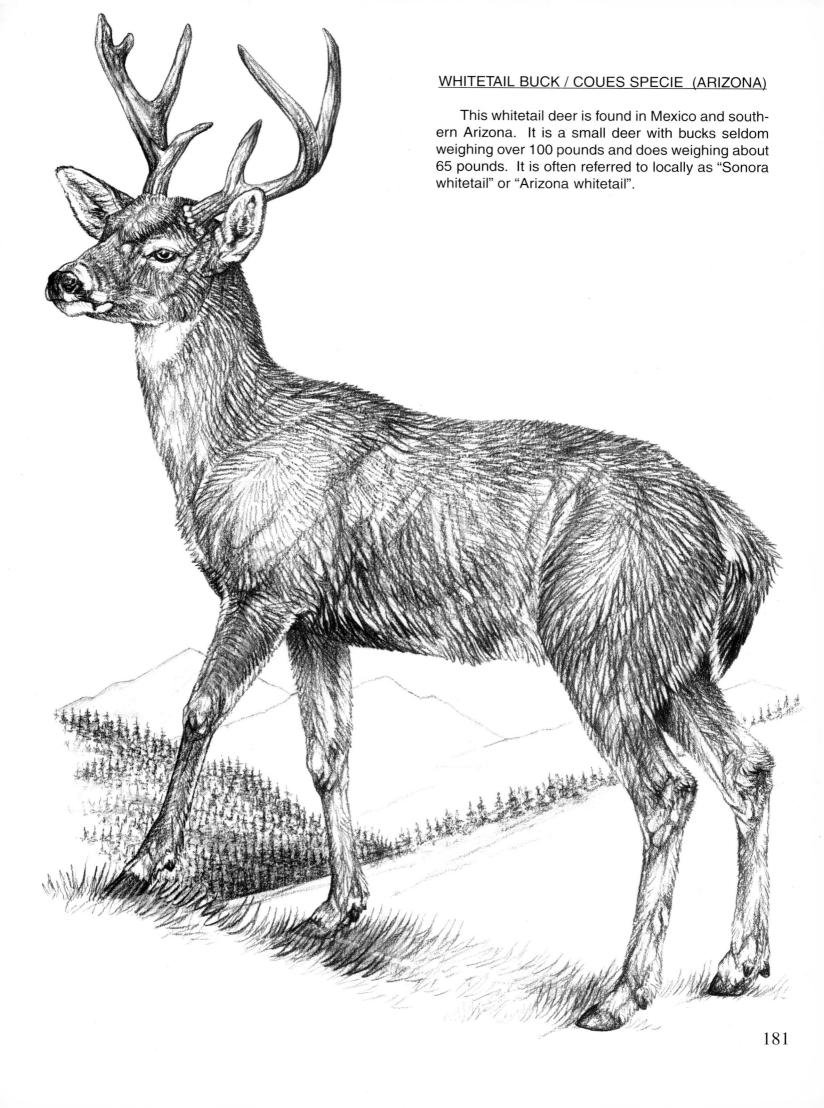

ROCKY MOUNTAIN ELK

Rocky Mountain elk (Cervus canadensis nelsoni) range from British Columbia, Alberta, and Saskatchewan south through the Rocky Mountain states. It is also being reintroduced into various other locations in North America. Adult Rocky Mountain males (bulls) will normally weigh about 700 - 800#'s, and mature females (cows) about 500#'s. The shoulder height of bulls is about 5' and they are 8' - 9' long. They have brown coats with dark brown heads and necks, blackish belly and legs, and a whitish rump. They are slightly smaller and lighter-colored than the less numerous Roosevelt elk of the Pacific Northwest.

Bulls sport long, majestic, wide-spreading antlers, and during the autumn "rut" will use these impressive "racks" to either battle or intimidate other area bulls. September is the time when "velvet" is shed, necks are swollen, "bugles" echo across the hills and valleys, and herd bulls gather harems of cows. The mating season is normally complete by November, and the bulls become more tolerant of one another and begin to feed heartily in order to replenish their strength. Spotted "calves" are born May/June and weigh about 30#'s. Elk cows "hide" their newborn calves in cover until they are strong enough to join the herd. Sometimes one cow will "babysit" the herds calves while the others feed. This sharing of duties allows each cow time to feed undisturbed. An elks diet consists mostly of grasses, but it also browses on other vegetation. Sometimes elk are fed during the winter months, as is done at a refuge near Jackson Hole, Wyoming.

Elk, when undisturbed by man or predators, prefer to feed in early morning and late afternoon. This is usually a time of "poor light" for photographers, but by using fast film (and tripod) you can usually get suitable reference photo's. The mating season, however, is the time to concentrate your efforts, as the elk are less "shy" and are in their prime coats and antlers. Rocky Mountain elk usually live about 15 years in the wild. Mountain lions, wolves, and bears take occasional elk, but the adults are formidable "foes" and so only young, sick, or injured animals are normally preyed upon successfully.

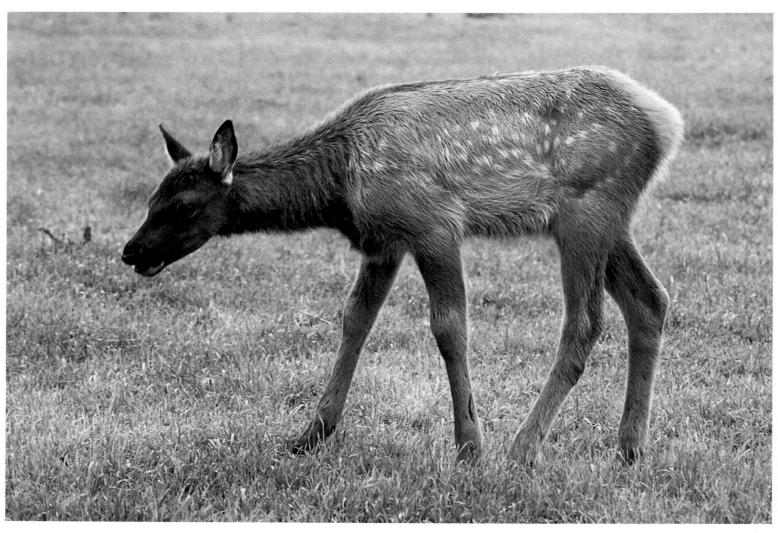

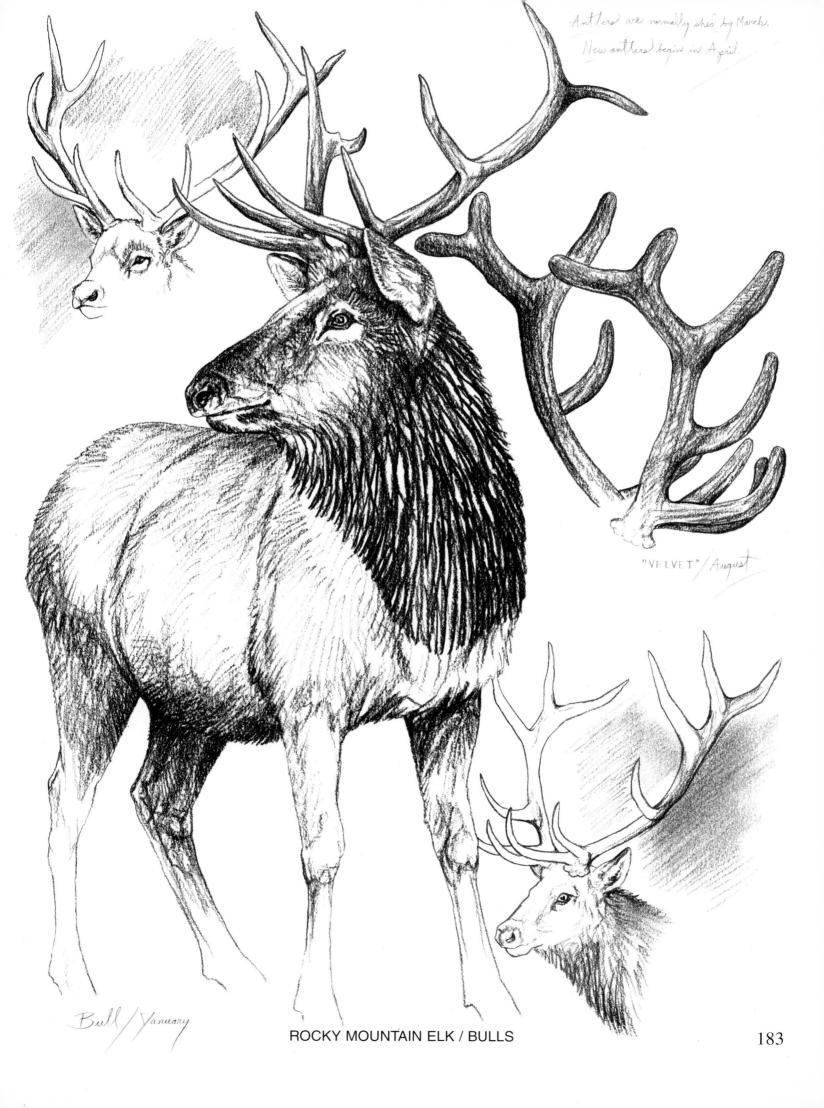

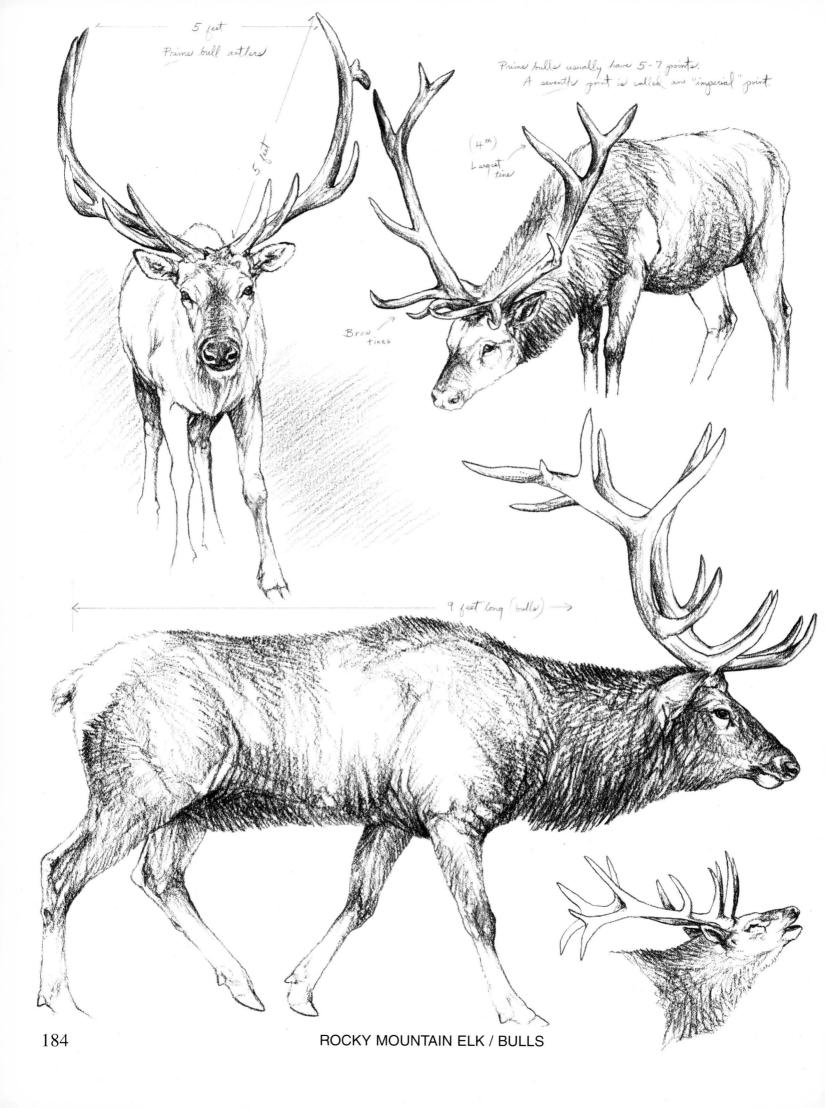

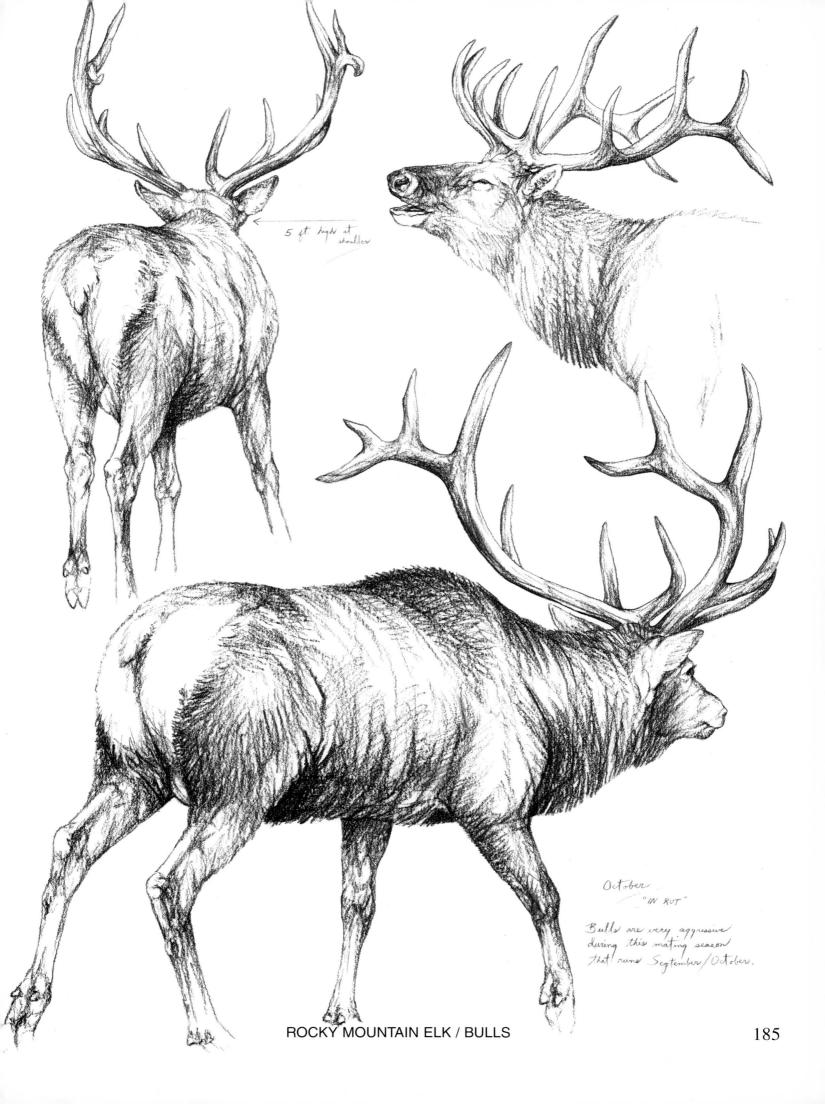

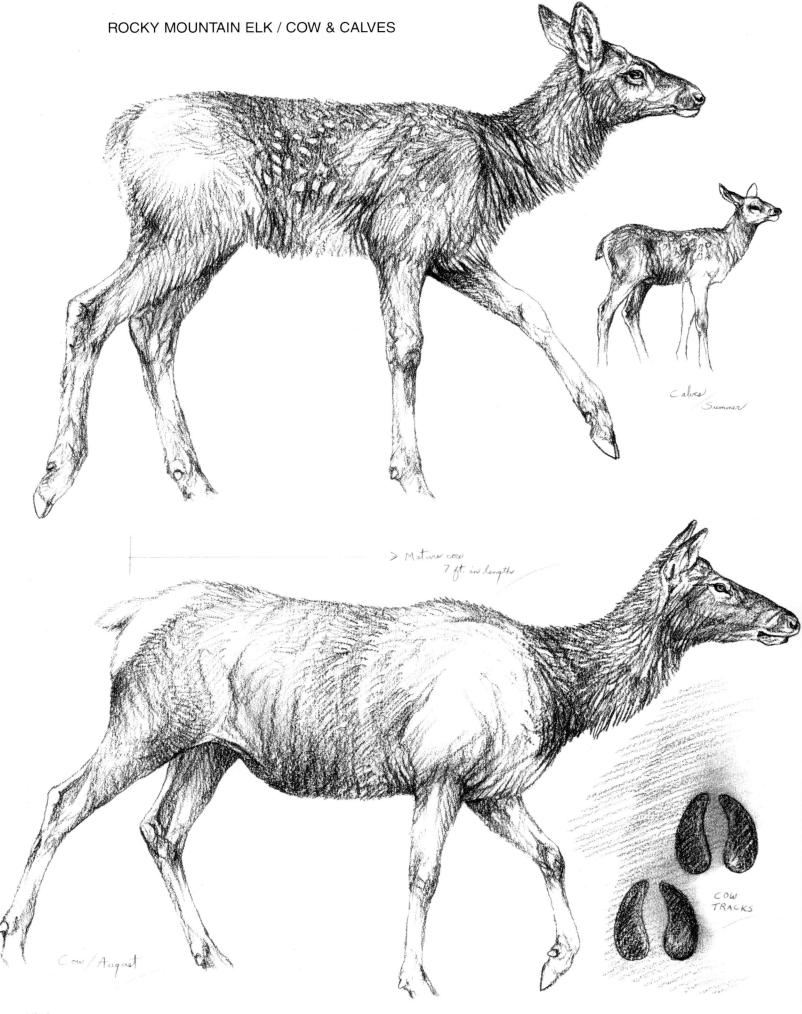

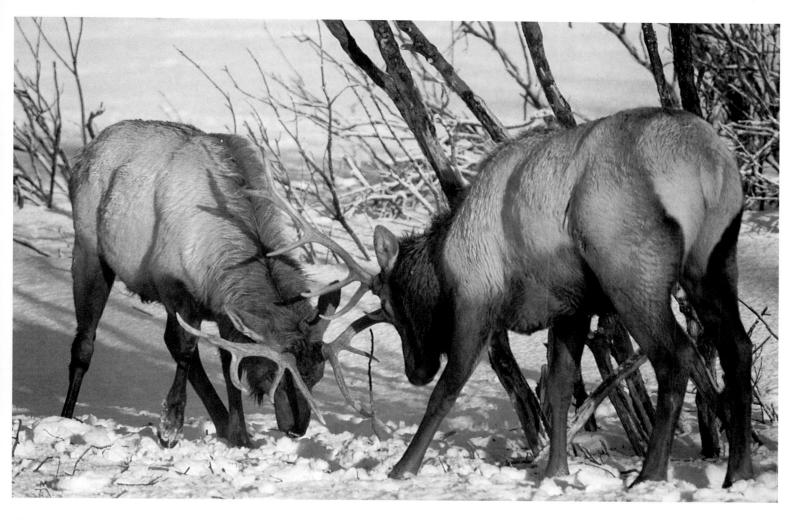

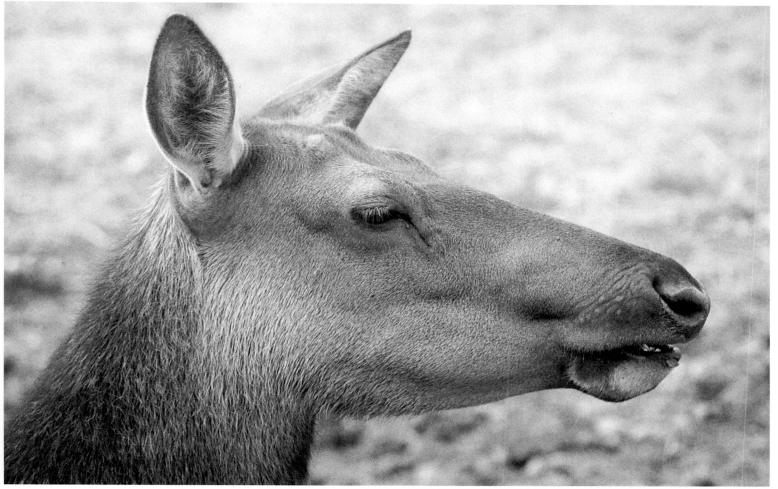

TOP: ROCKY MOUNTAIN ELK / BULLS "SPARRING" (DECEMBER)
BOTTOM: ROCKY MOUNTAIN ELK / COW (JULY)

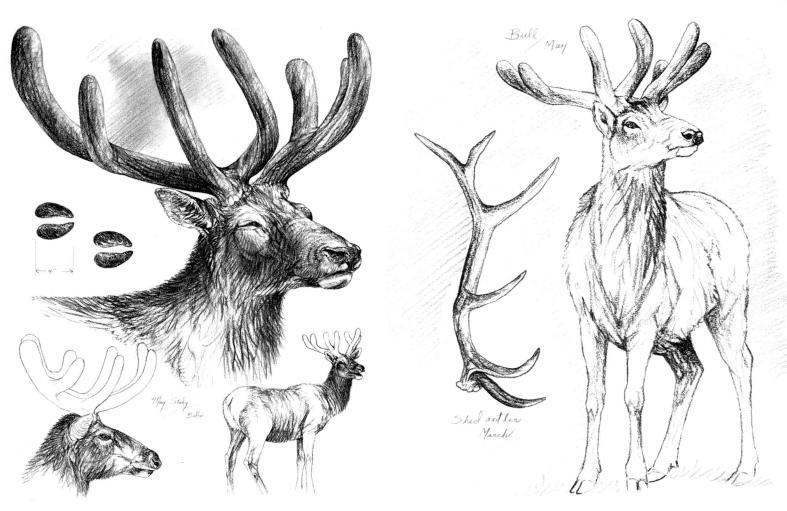

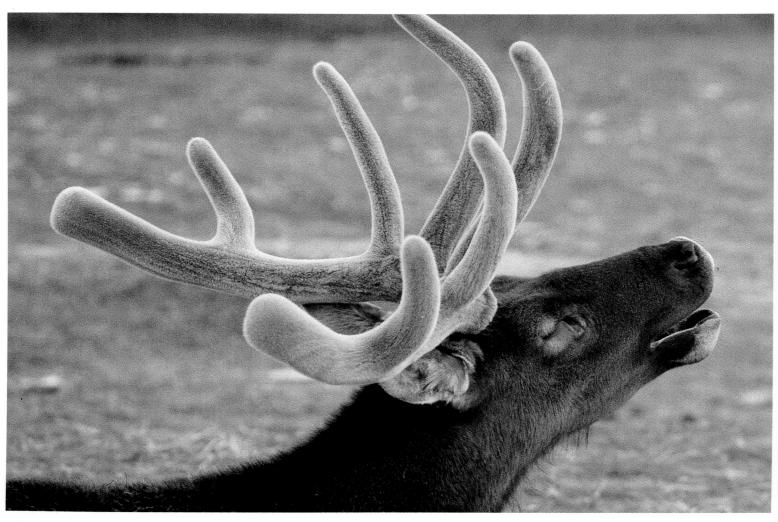

ROCKY MOUNTAIN ELK / BULL (JUNE)

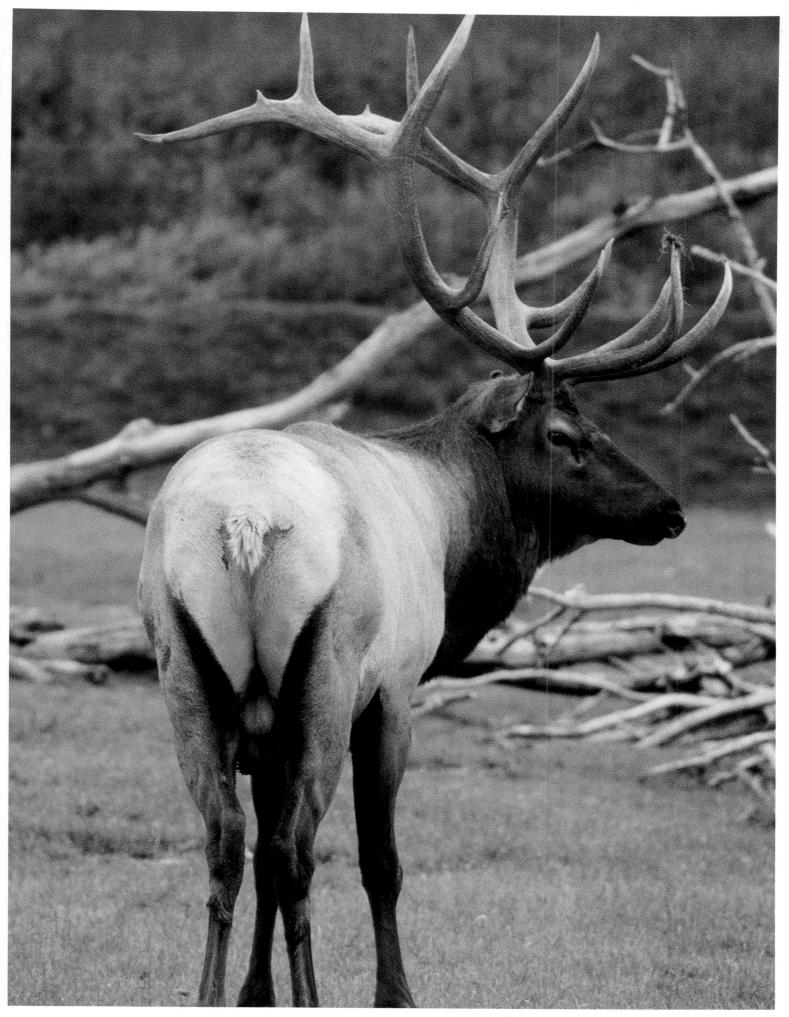

ROCKY MOUNTAIN ELK / BULL (SEPTEMBER)

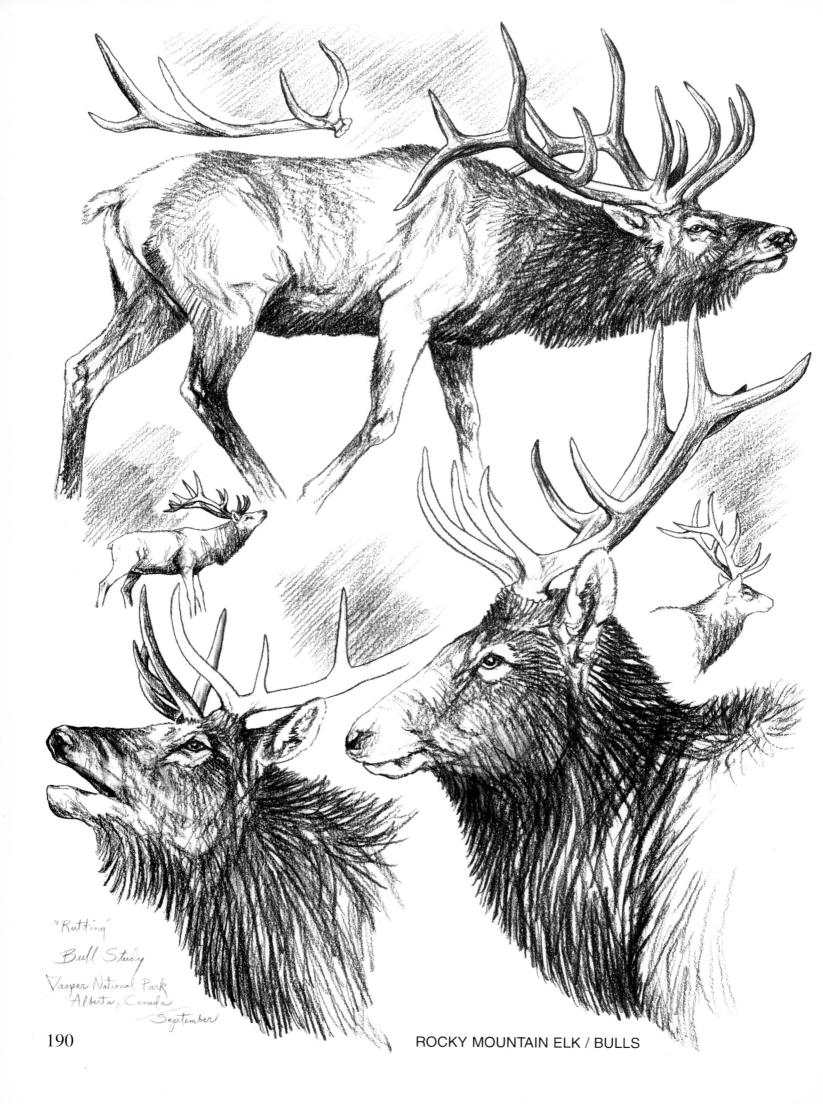

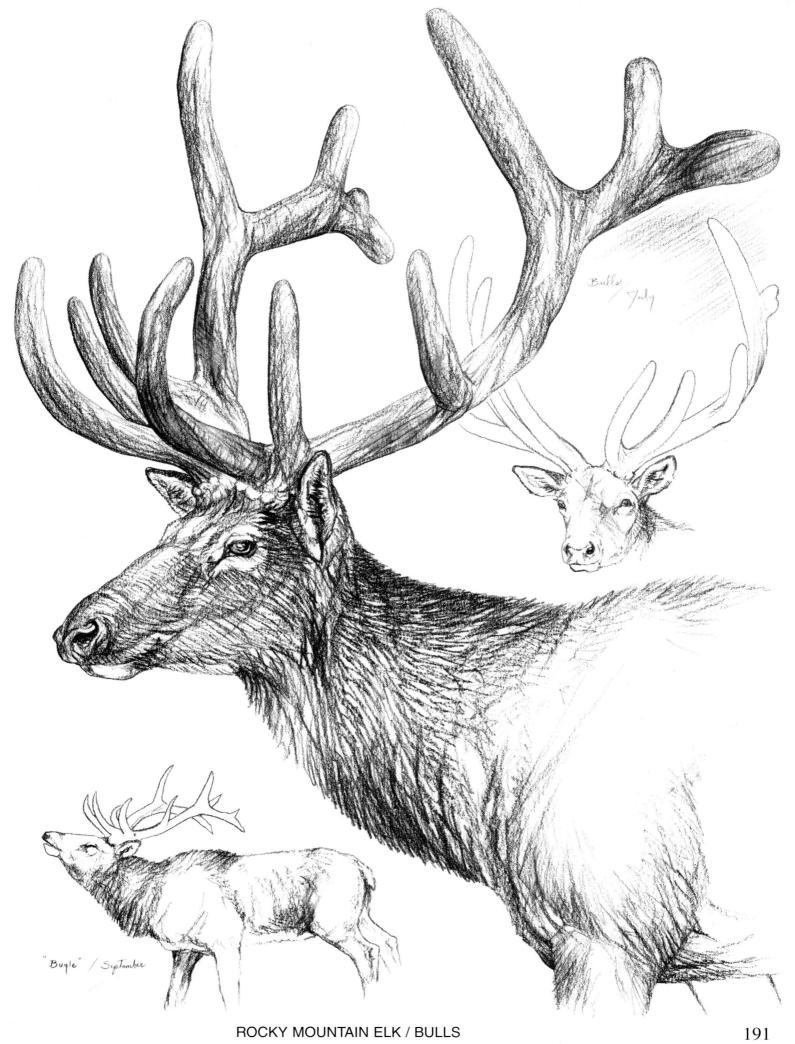

ROOSEVELT ELK

The Roosevelt elk (Cervus canadensis roosevelti) is found scattered about the Pacific Northwest. It is larger, darker colored, and sports more massive antlers than do the Rocky Mountain elk that are found east of the Cascade mountains in the United States and Canada. Large males (bulls) on Alaska's Afognak Island will often weigh over 1300#'s, but a more average weight is 700 - 900#'s. Adult females (cows) normally weigh around 500 - 600#'s. Elk cows (unlike caribou cows) don't grow antlers, but a bull elk in its prime may don magnificent antlers over 5' long. Large bulls stand 5' at the shoulder and are 9' - 10' long. Roosevelt elk have brown bodies and dark brown heads and necks. The belly and legs are almost black and it has a whitish-yellow rump. During the summer months the elks coat lightens to almost tan.

The elk, or wapiti (as the Shawnee Indians called it), has recently been reintroduced into various areas of North America and seems to be thriving and multiplying. In fact, a recent survey estimated that the 40,000 elk of the early 1900's has grown to over 800,000 today. It is truly a wildlife success story. Elk are hardy eaters and their diet ranges from grazing foods to browsing vegetation. Elk, like deer, often overeat their range if they become too populous, and are then subject to massive starvation. Most governments have departments of Fish & Game that monitor these situations. Mountain lions, wolves, and bears are occasional predators. Fifteen years is an average life span for a Roosevelt elk.

The mating season begins in September and it is then that the bulls eery, high pitched "bugle" resonates across the meadows and through the timber; trumpeting a challenge or warning to all other bulls. By late October the fighting and mating is complete and the elk disperse to their wintering grounds. The spotted "calves" are born the following May/June, when mild weather and plentiful food increases their survival odds.

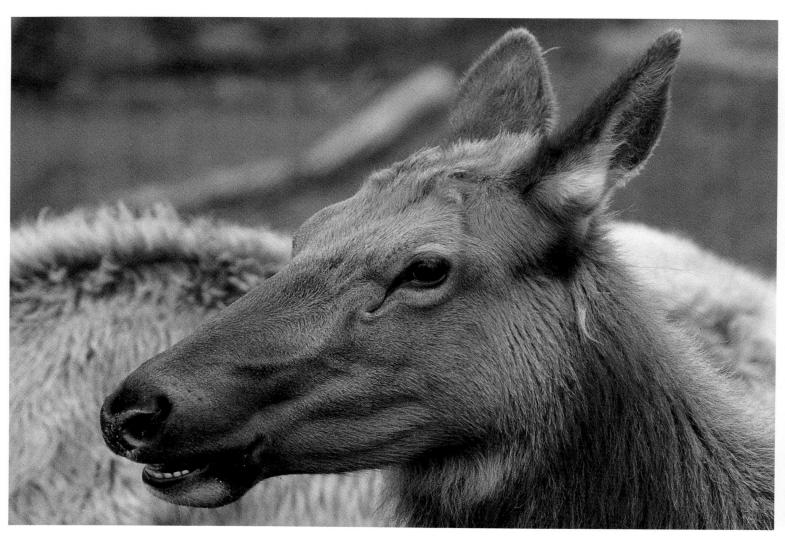

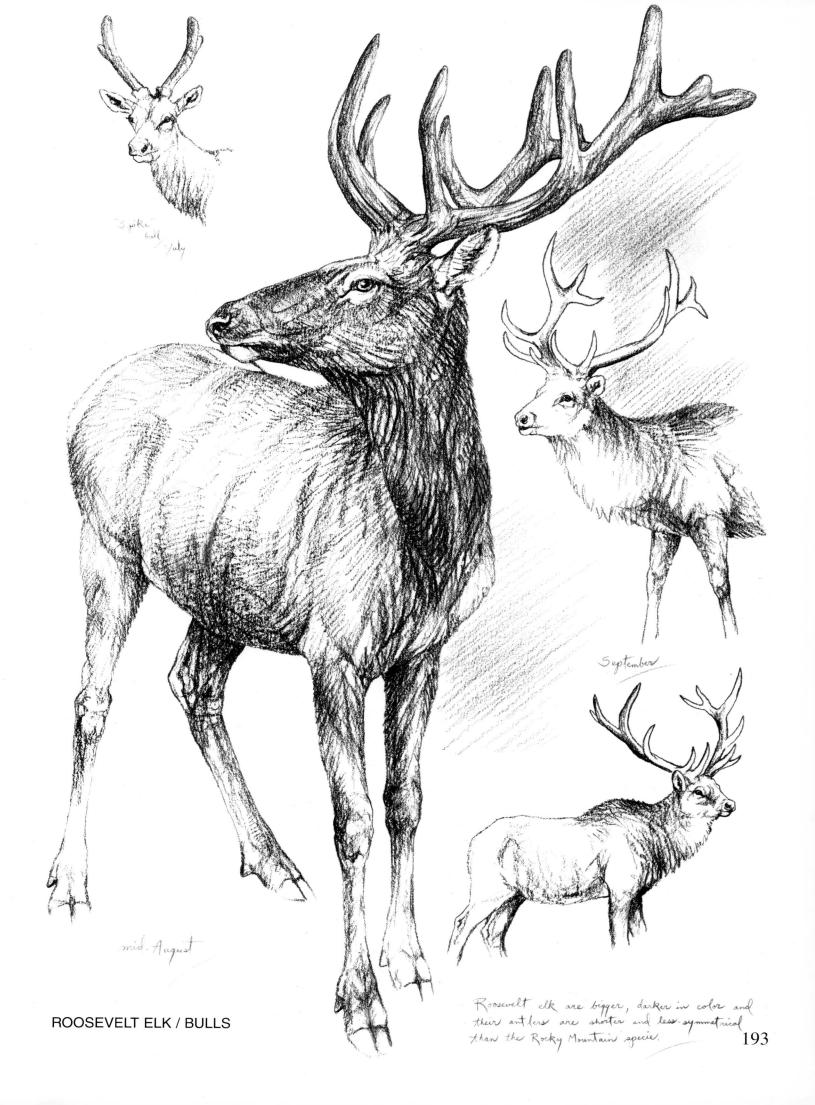

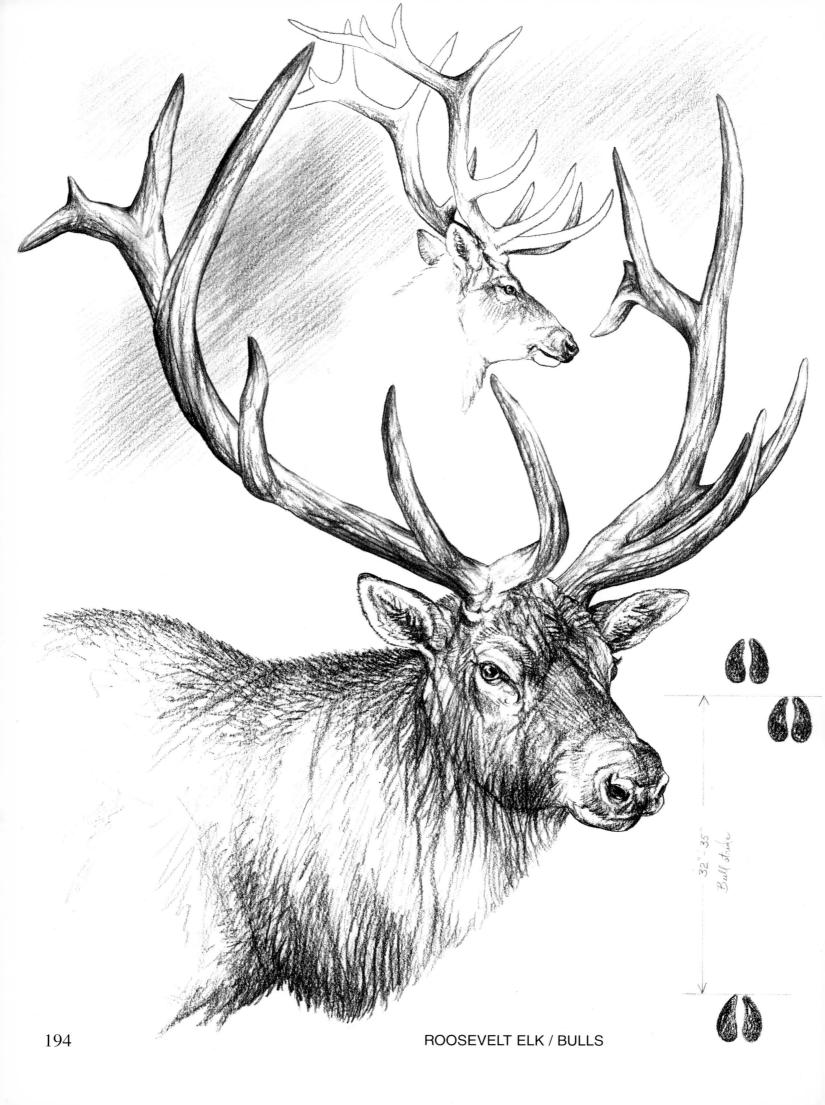

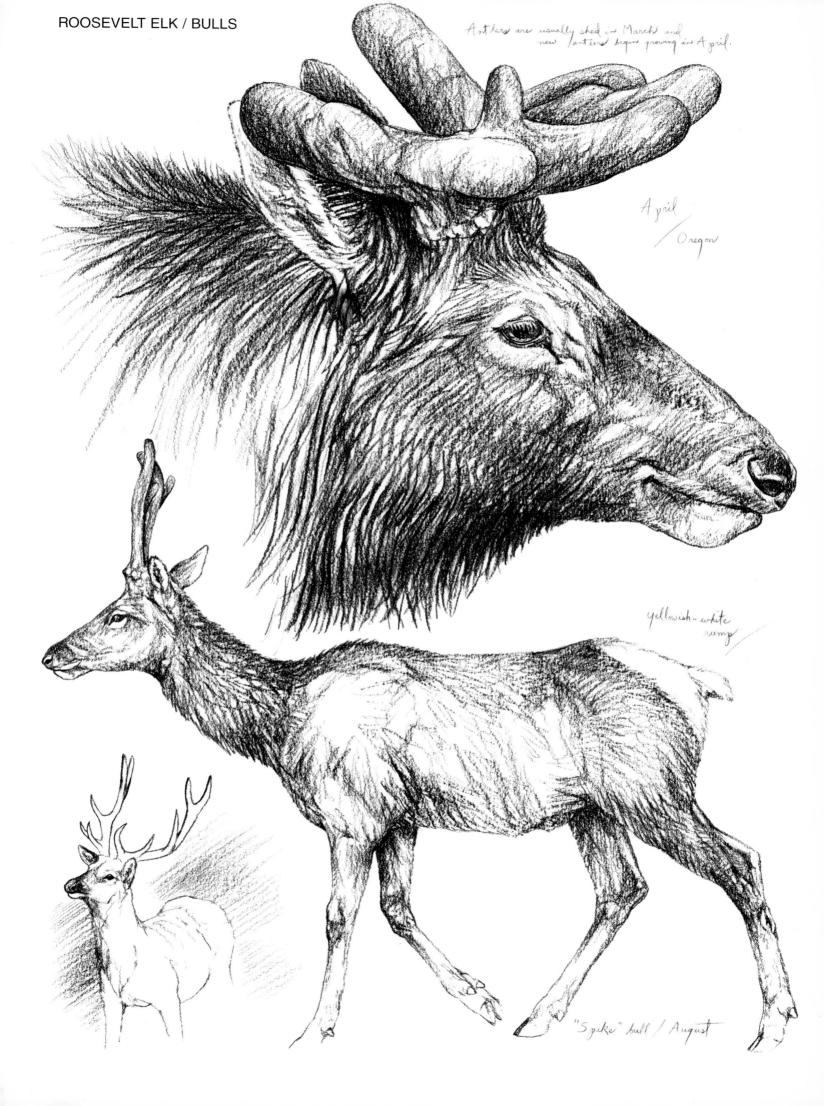

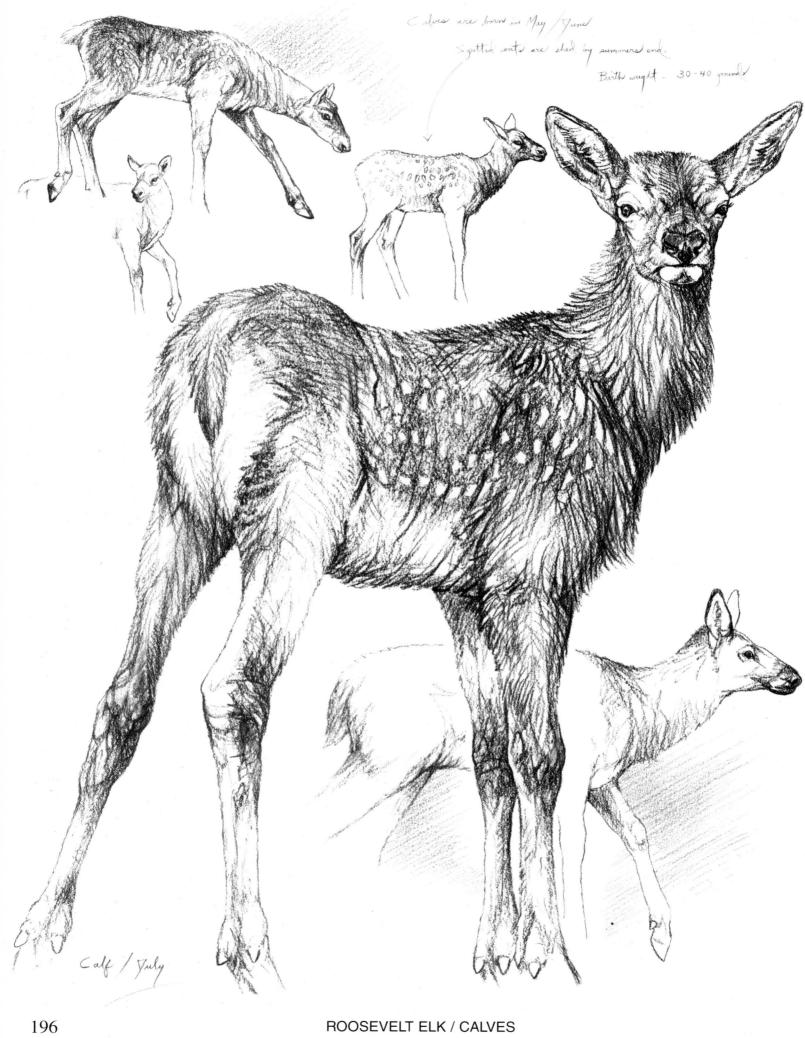

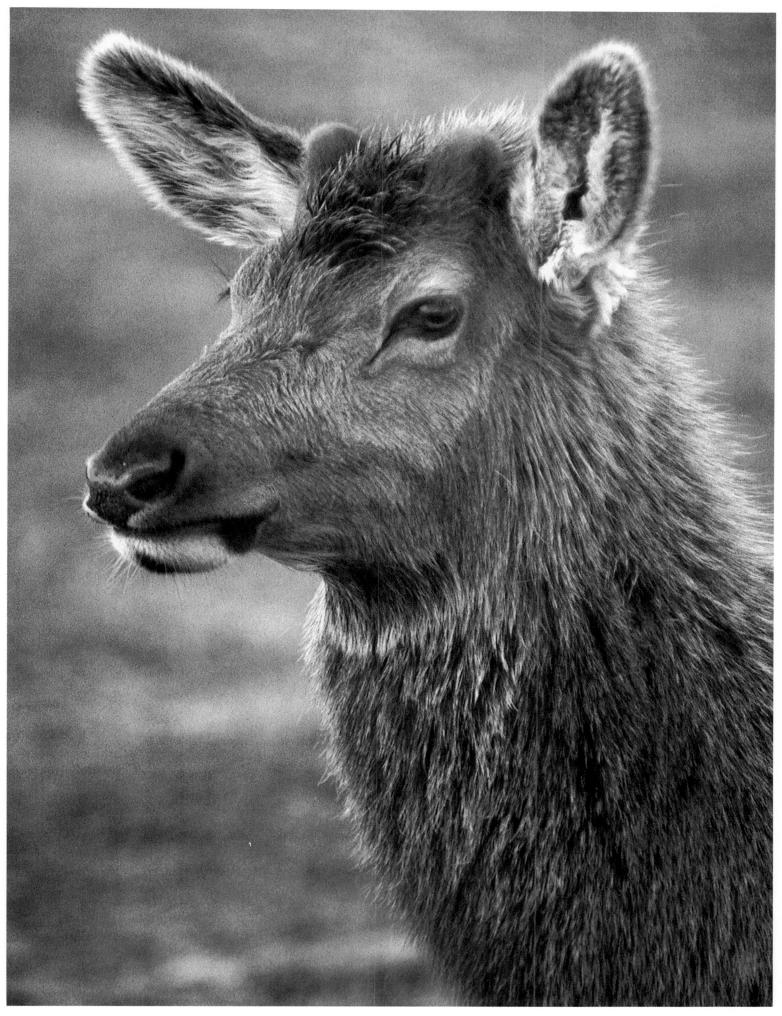

ROOSEVELT ELK / BULL (APRIL)

MOOSE

The moose (Alces alces) is the largest member of the deer family. In North America it is found from coast to coast throughout most of Alaska, Canada, and Newfoundland. South of the Canadian border they are found in the Rocky Mountain region south to Colorado. Maine, Minnesota, and Michigan (as well as other states, in smaller numbers) also have populations. Sometimes a moose will roam far from its "normal" range and become a local celebrity. Moose don't, however, normally migrate from their home-range, and if food is available will seldom leave their 5 square mile "home". During spring and summer the moose feeds on vegetation in ponds, grasses, and leaves of willows, aspen, and birch. In the winters they must sustain themselves on the twigs and bark of these trees. During winters of deep snow, moose often "herd up" to share their trail blazing, but starvation is always a threat to the younger and less able adults.

The moose is a large, brown creature that may stand 7 1/2' at the shoulder and be over 10' long. There are various subspecies of moose in North America and the Alaska race is the largest. A mature Alaskan male (bull) will weigh 1200 - 1600#'s and a female (cow) is usually about one-third smaller. This long-legged, droopy-nosed beast is well suited for the marshy, cold country it inhabits. A wild moose seldom survives over 15 years.

Only bulls grow antlers, and these huge racks may weigh 60#'s and be 5' - 6' wide. The "velvet" covering the antlers is shed in August/September and the annual "rut" usually peaks in October. During this time the largest bulls seldom feed and spend the months either fighting other bulls or mating with their harem of cows. This hectic period often depletes the bulls fat-reserves and they enter the harsh winters weak and undernourished; making themselves vulnerable to predators and starvation. Young (normally twins) are born the following May/June and these 25#, reddish-brown, un-spotted "calves" often weigh 250#'s by winter. Predators such as wolves, grizzlies, and Mountain lions take a toll, and usually only one calf survives the first few months. In Denali National Park (central Alaska) I know of areas where few calves survive due to the area grizzlies who have perfected the art of preying on vulnerable young moose.

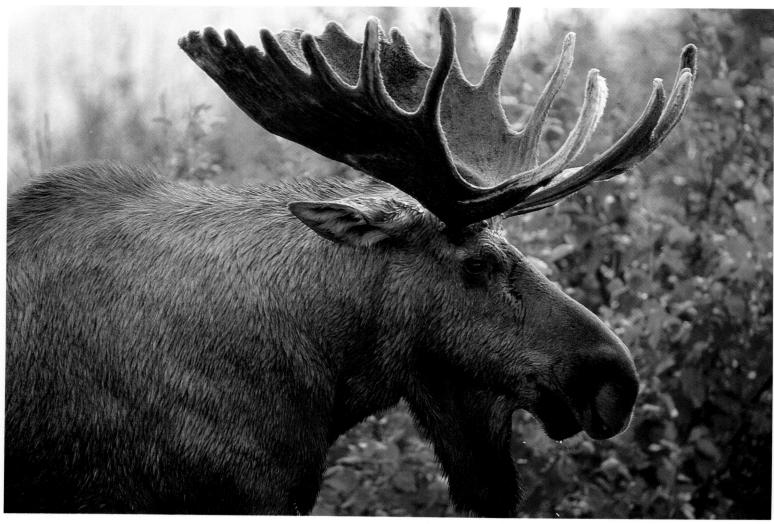

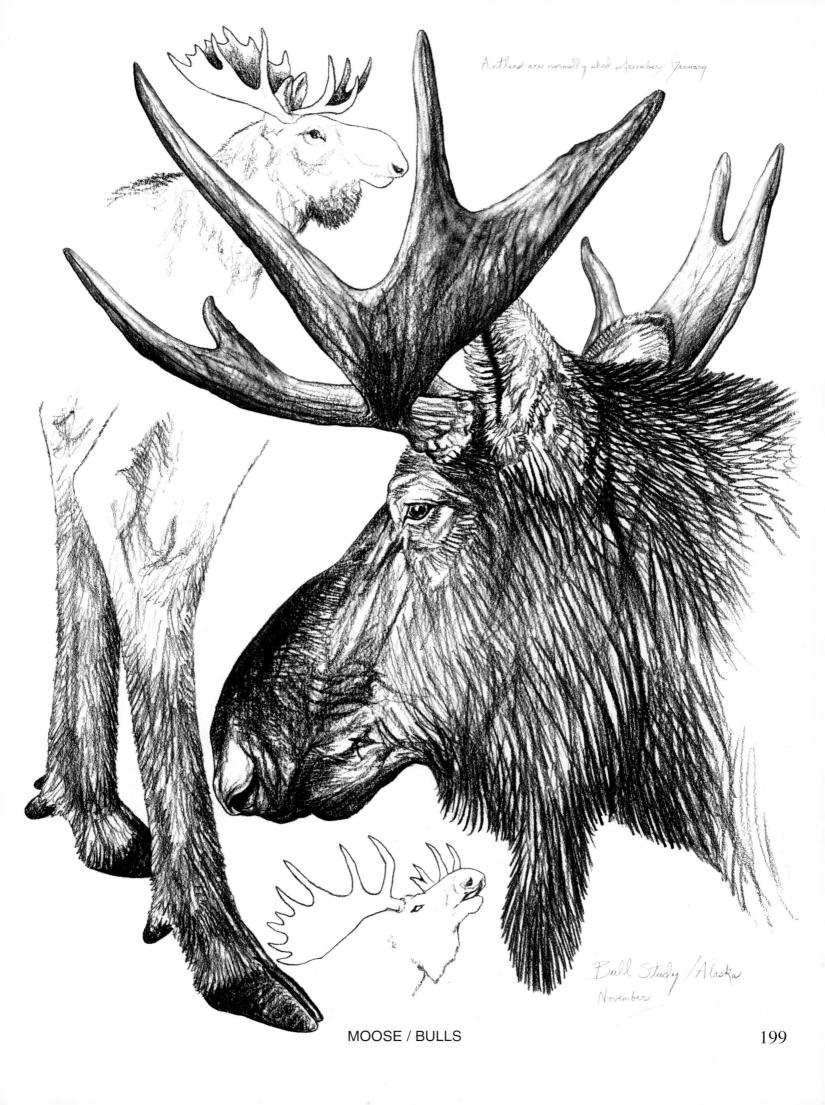

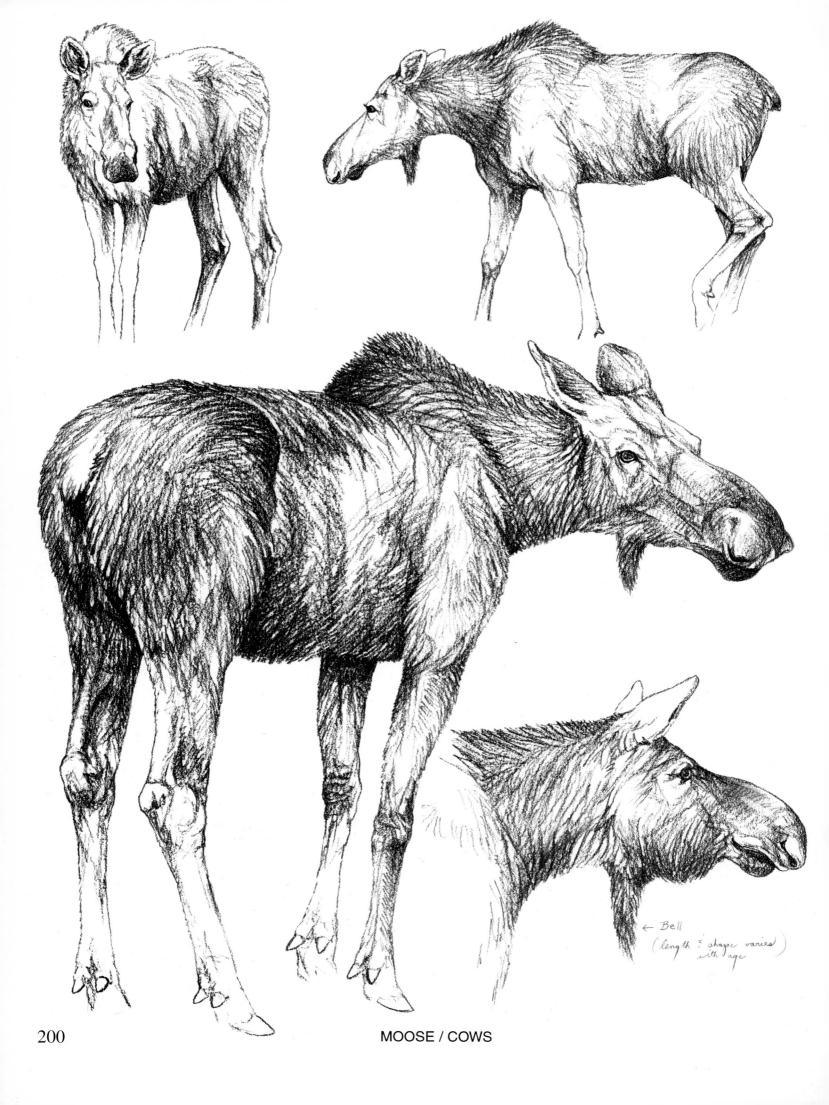

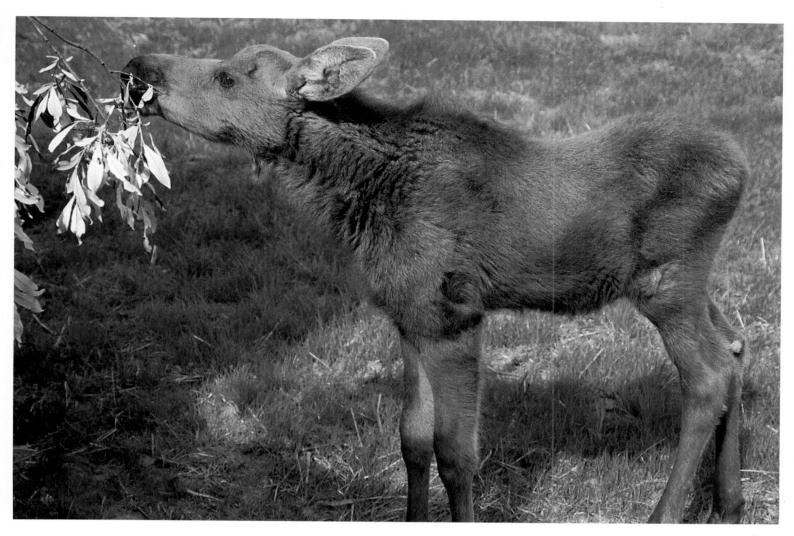

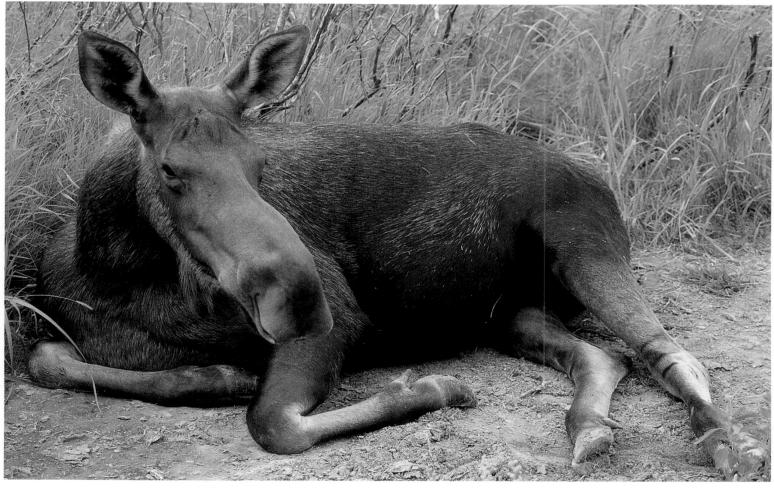

TOP: MOOSE CALF (JUNE)

BOTTOM: MOOSE COW (JULY)

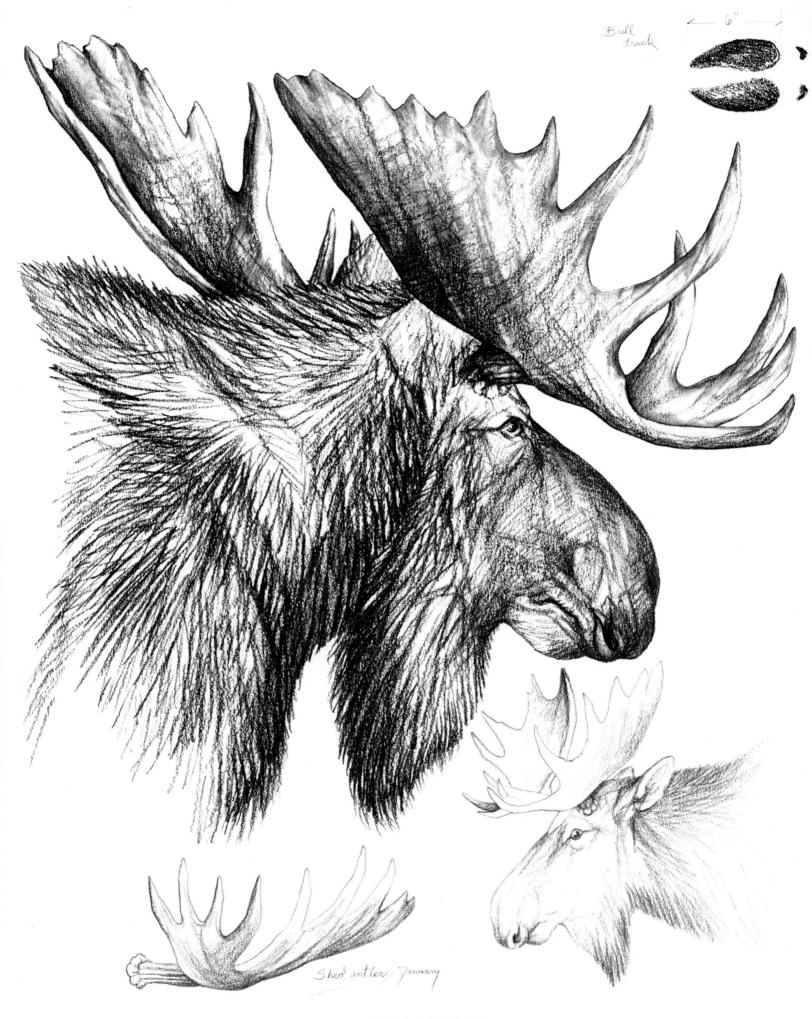

MOOSE / BULLS

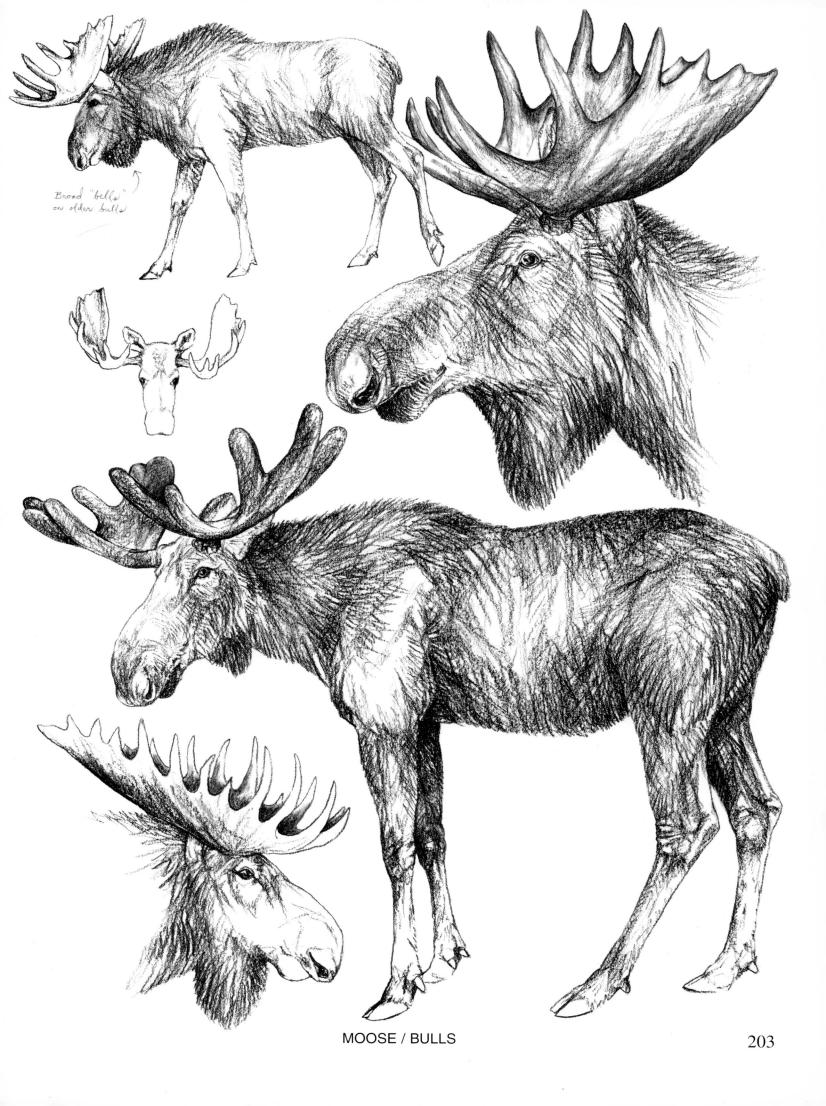

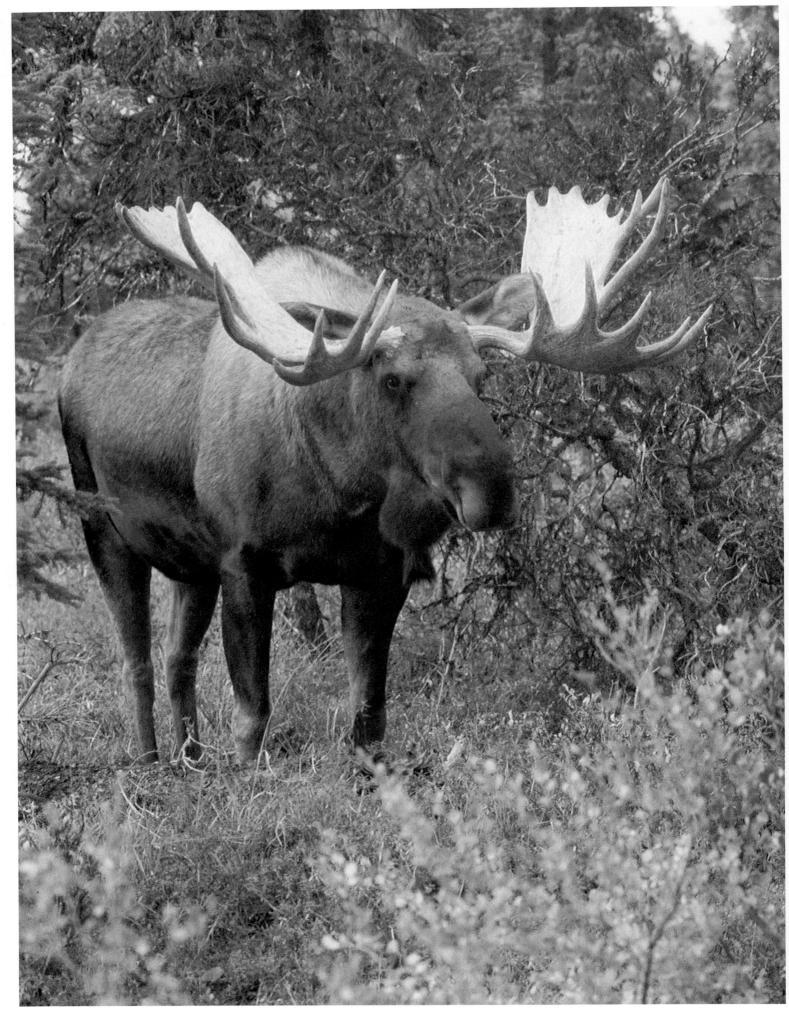

MOOSE / BULL (SEPTEMBER, ALASKA)

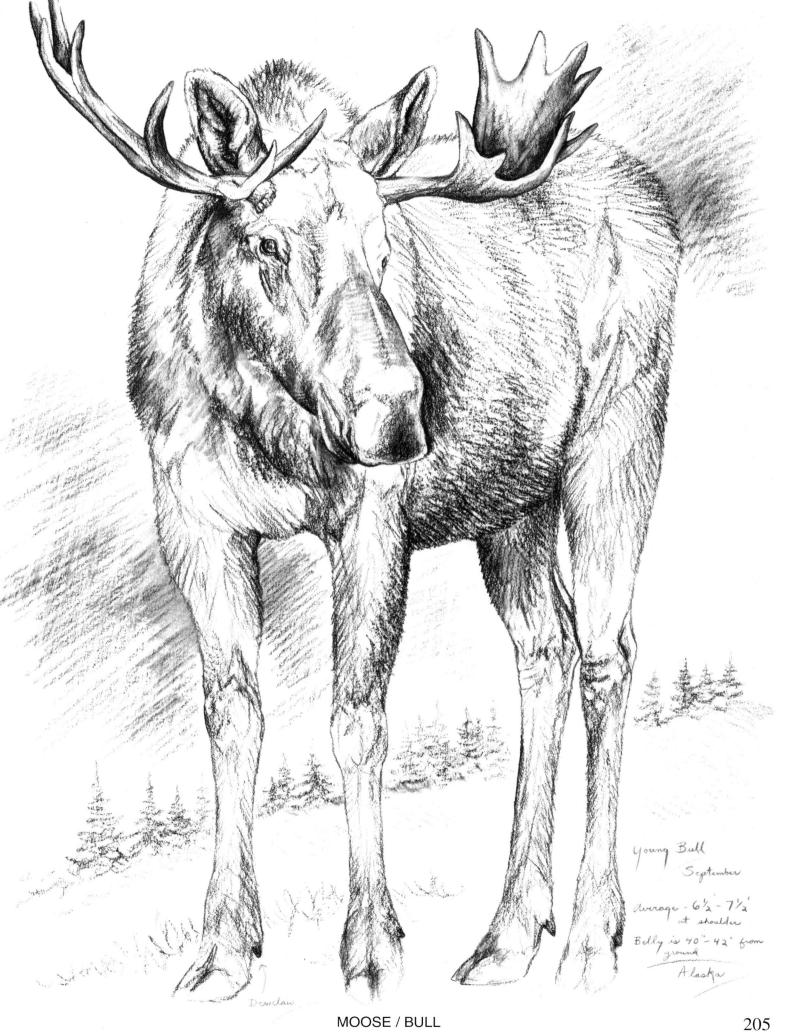

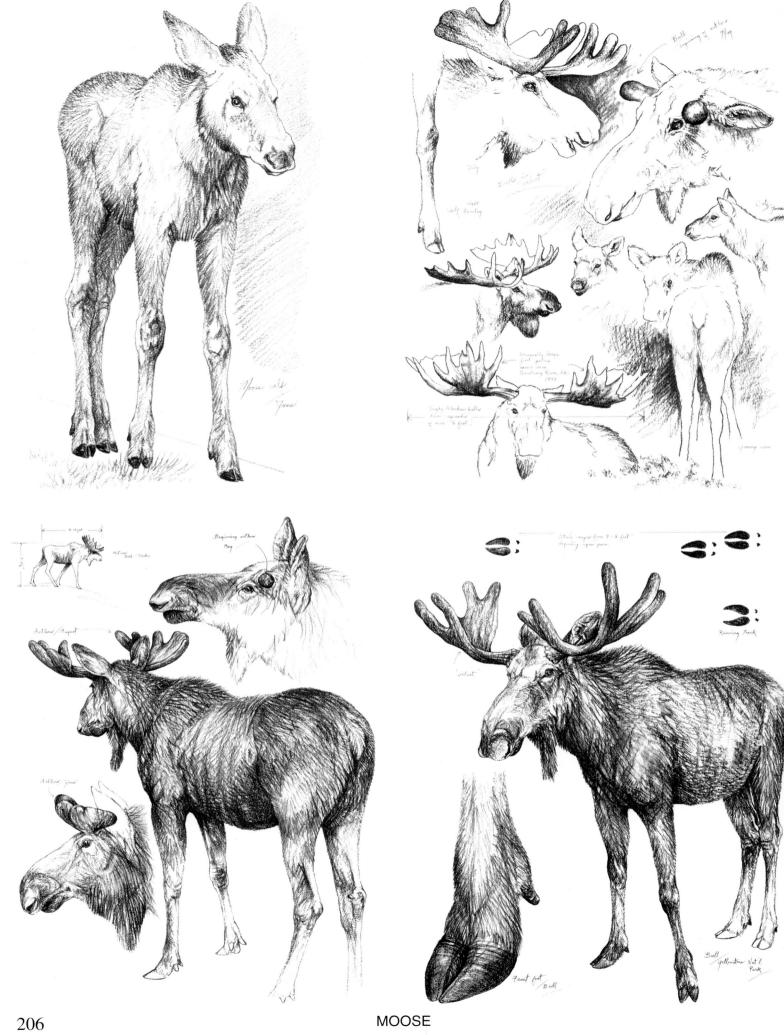

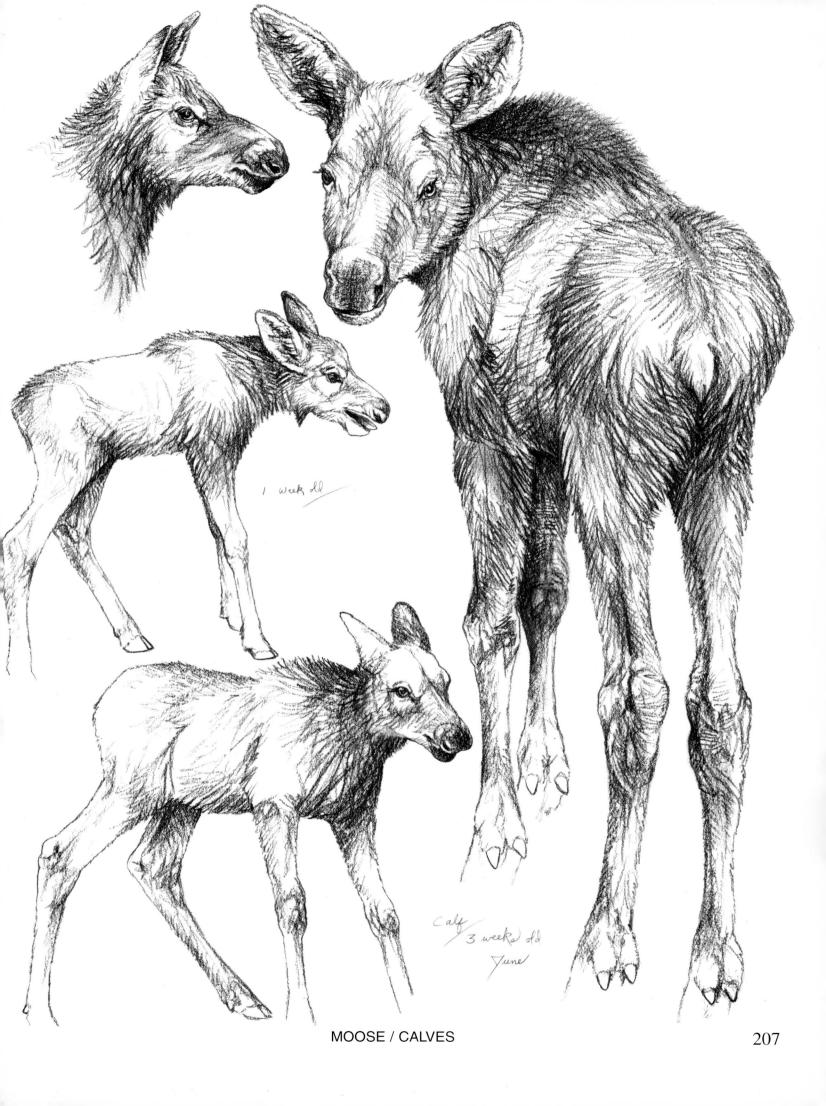

Joug Indshand

THE ARTIST

Doug Lindstrand, a native of Winthrop, Minnesota, grew up doodling and chasing wildlife around the woods and meadows. Later, after completing college (art/biology) and a stint in commercial art, he moved to Alaska to become a free-lance wildlife artist/photographer.

His company, Sourdough Studio, publishes his art prints, cards, and books. Recent books include: "Drawing Mammals", "Drawing America's Wildlife", "Drawing Alaska's Big Game", and "Alaska Sketchbook".